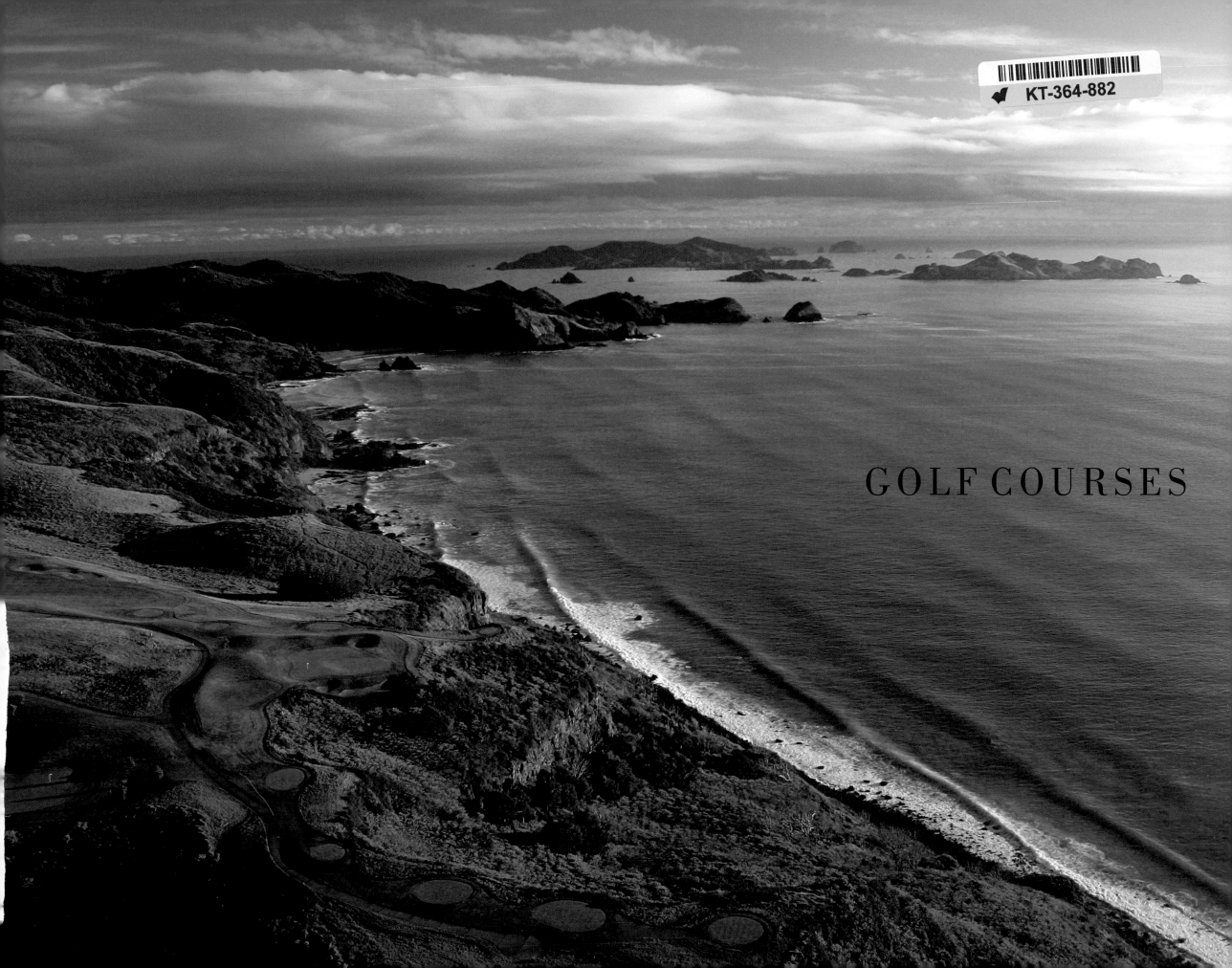

GOLF COURSES

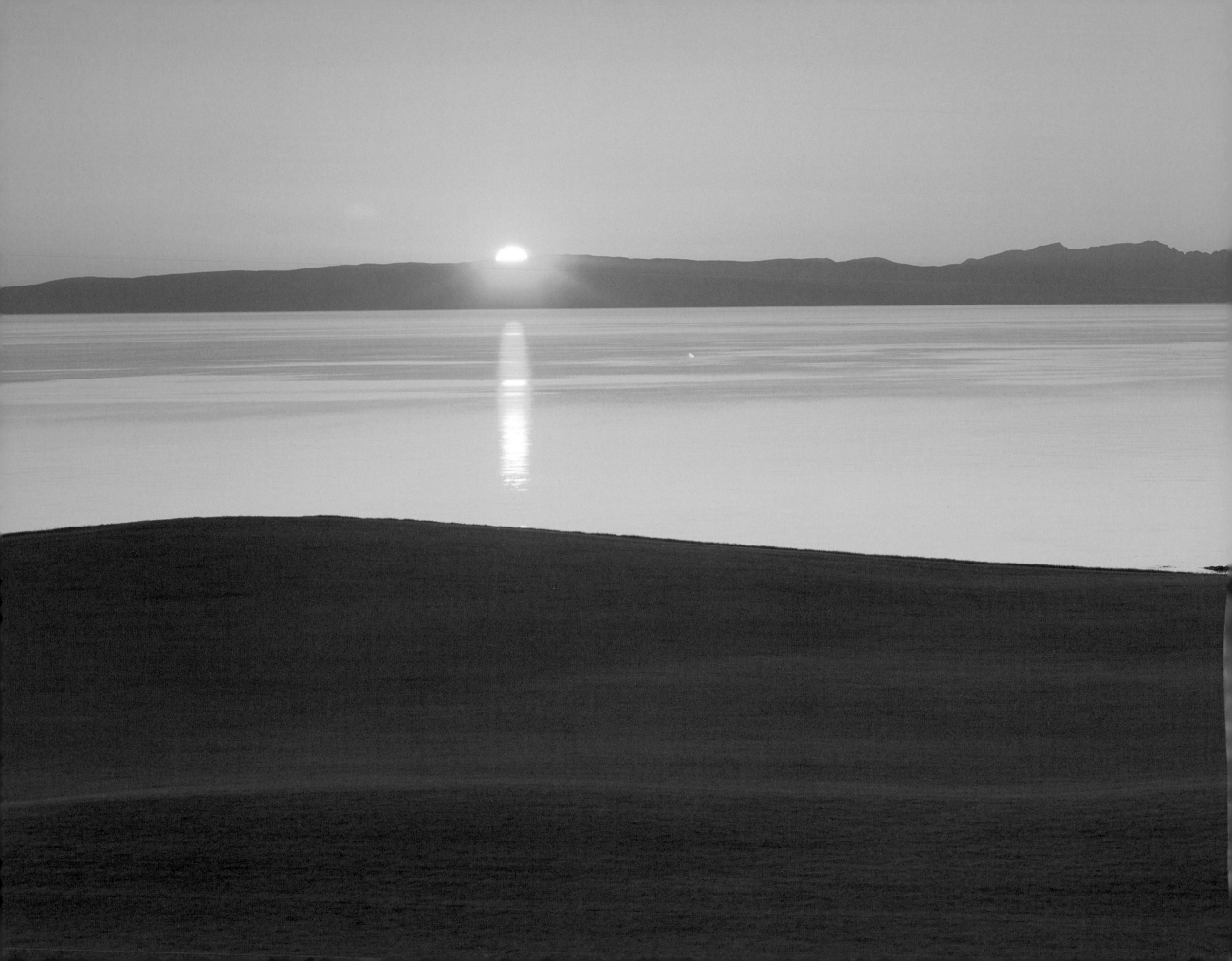

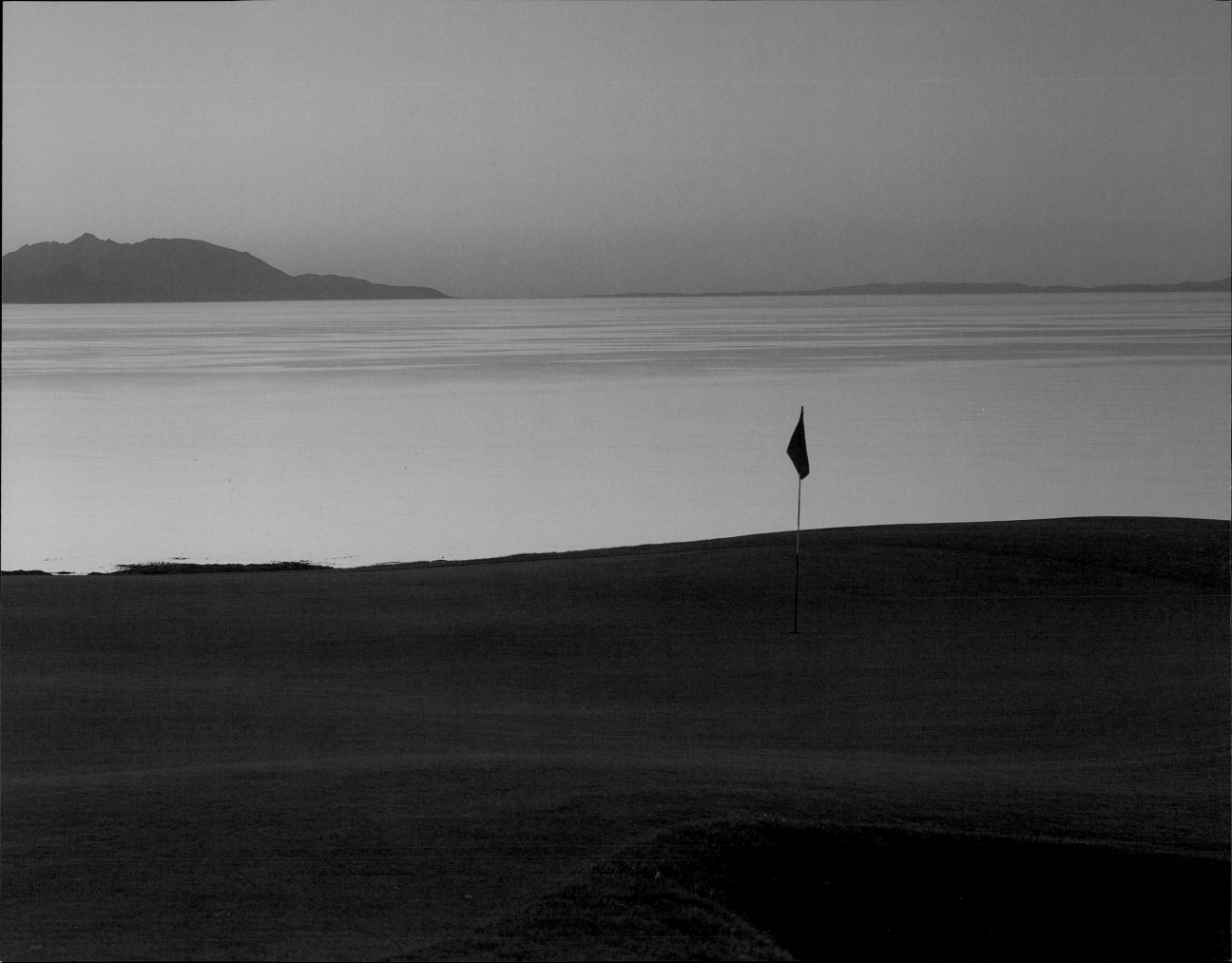

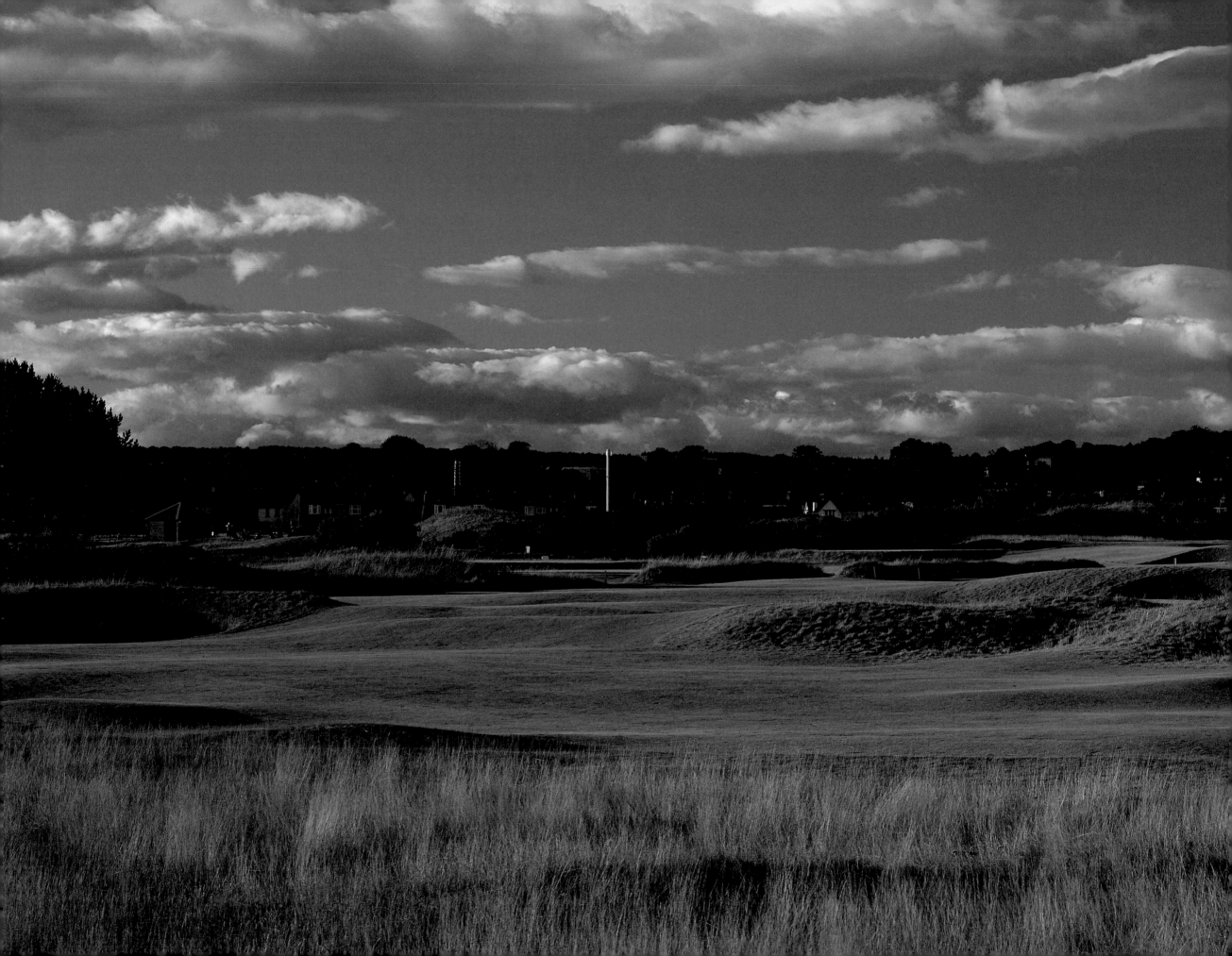

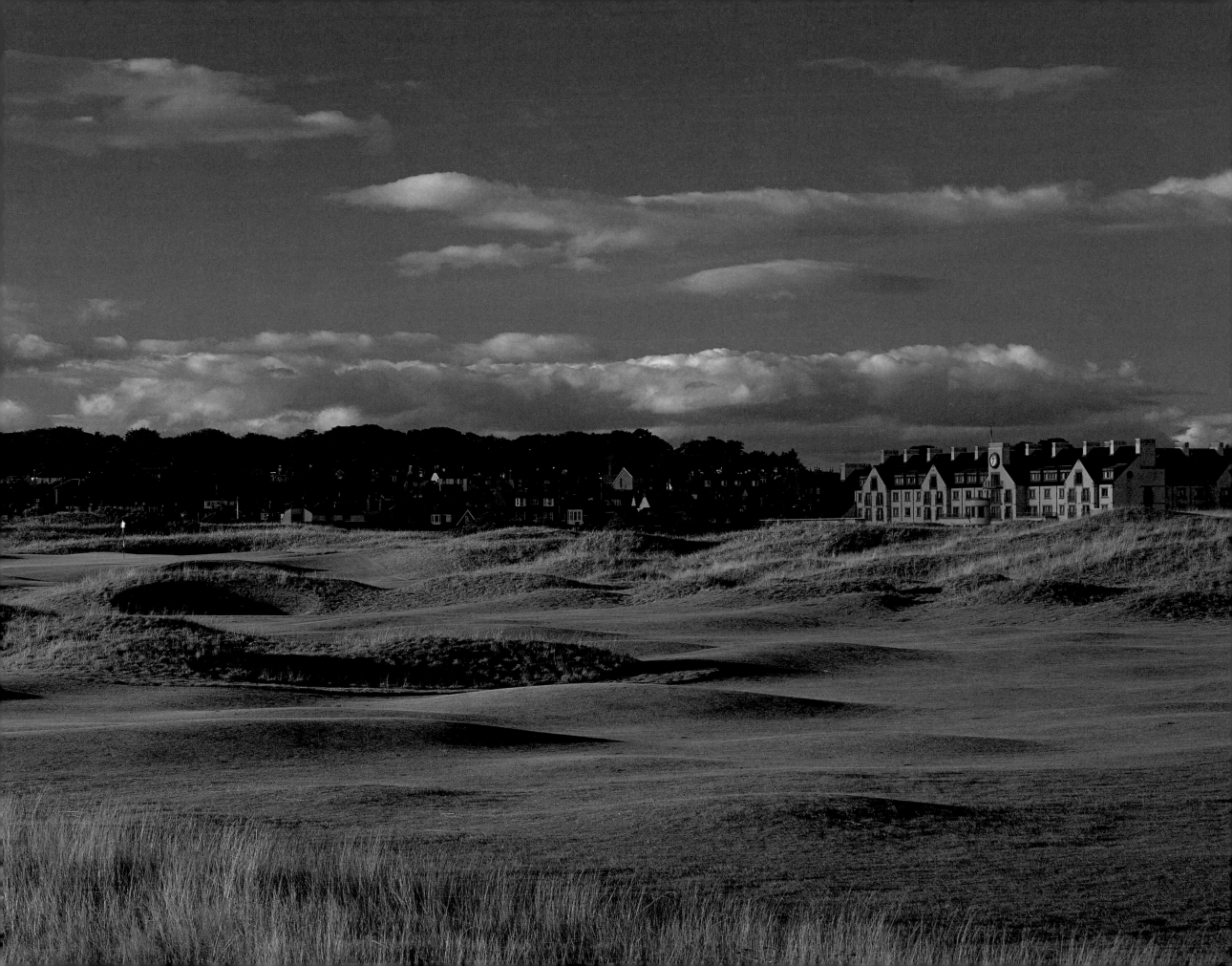

GOLF COURSES FAIR

WAYS OF THE WORLD

PHOTOGRAPHS BY DAVID CANNON FOREWORD BY ERNIE ELS TEXTS BY SIR MICHAEL BONALLACK AND STEVE SMYERS

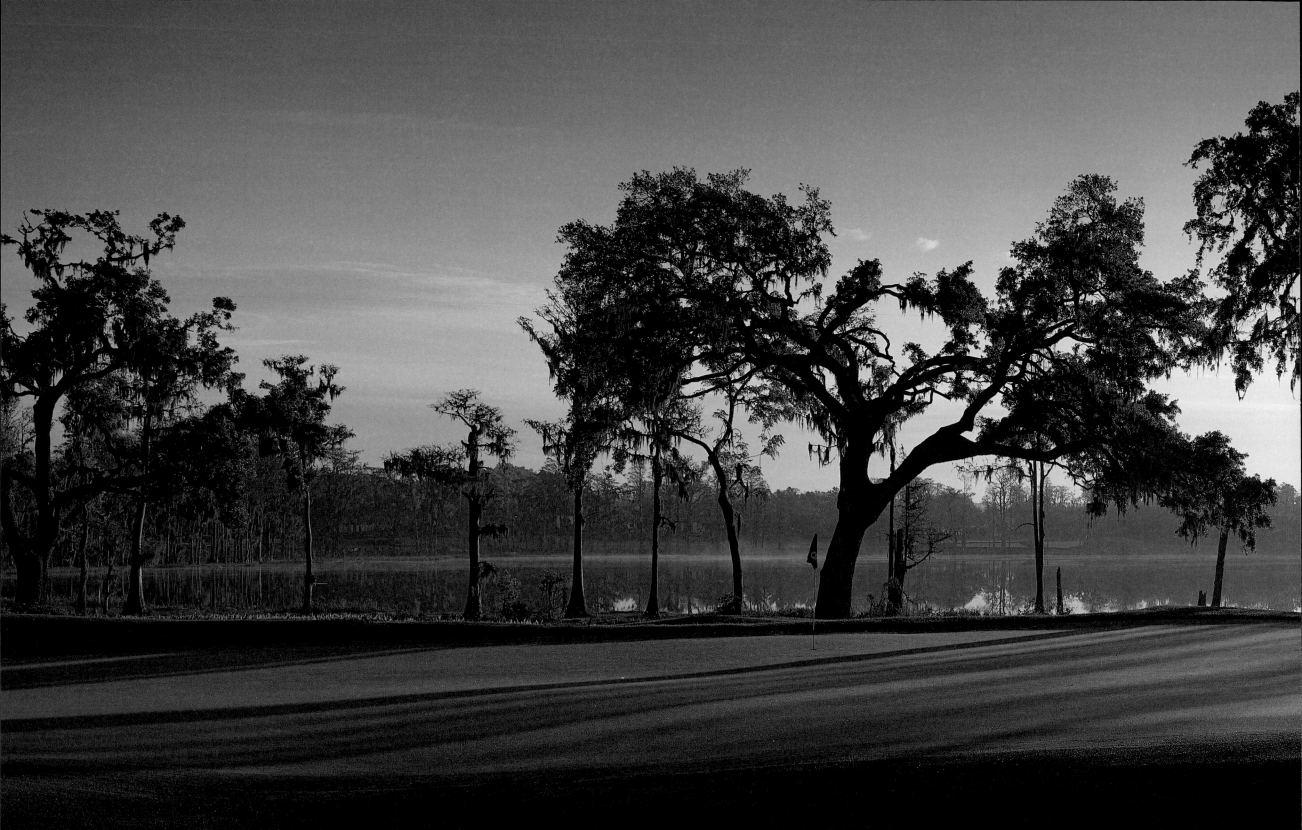

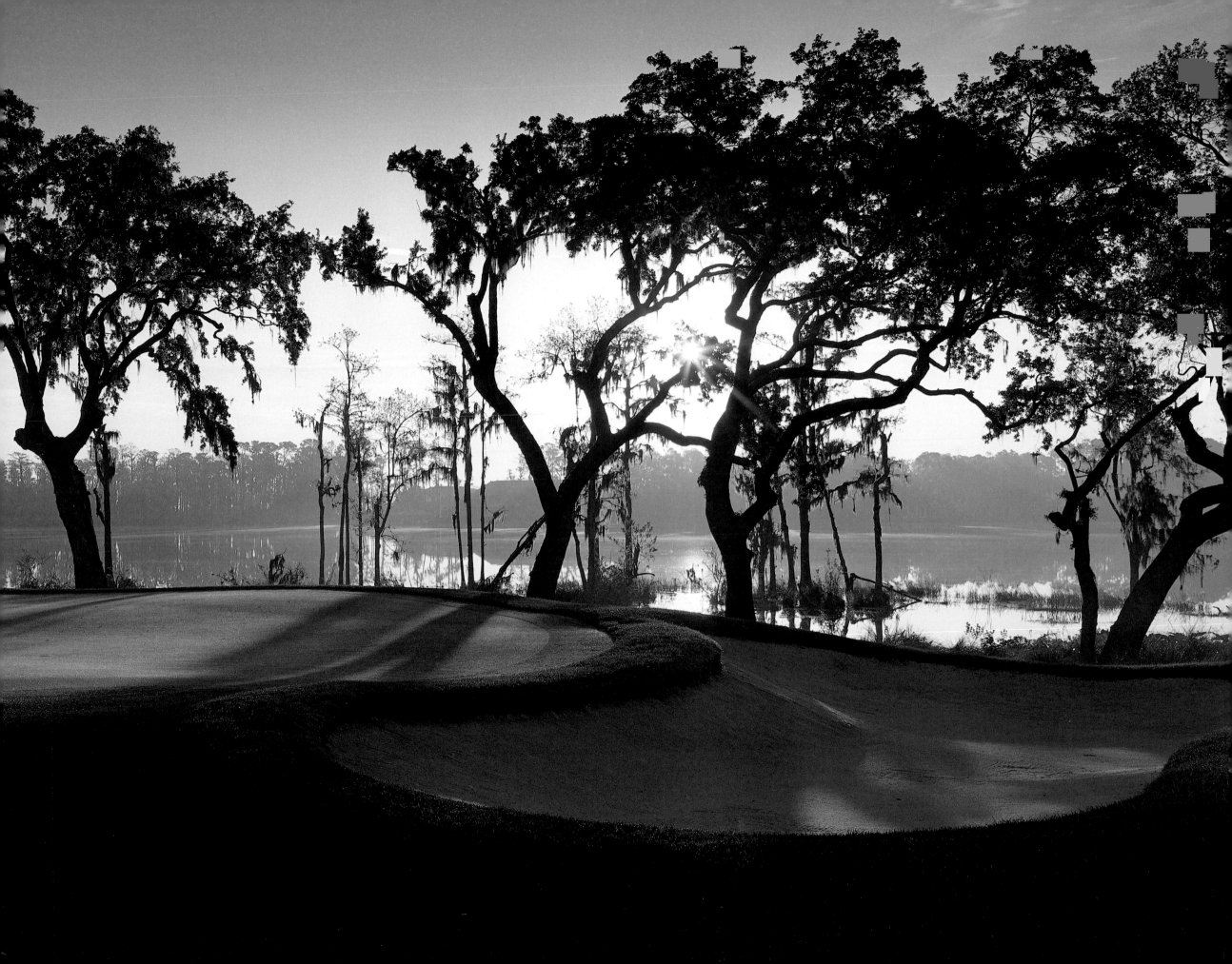

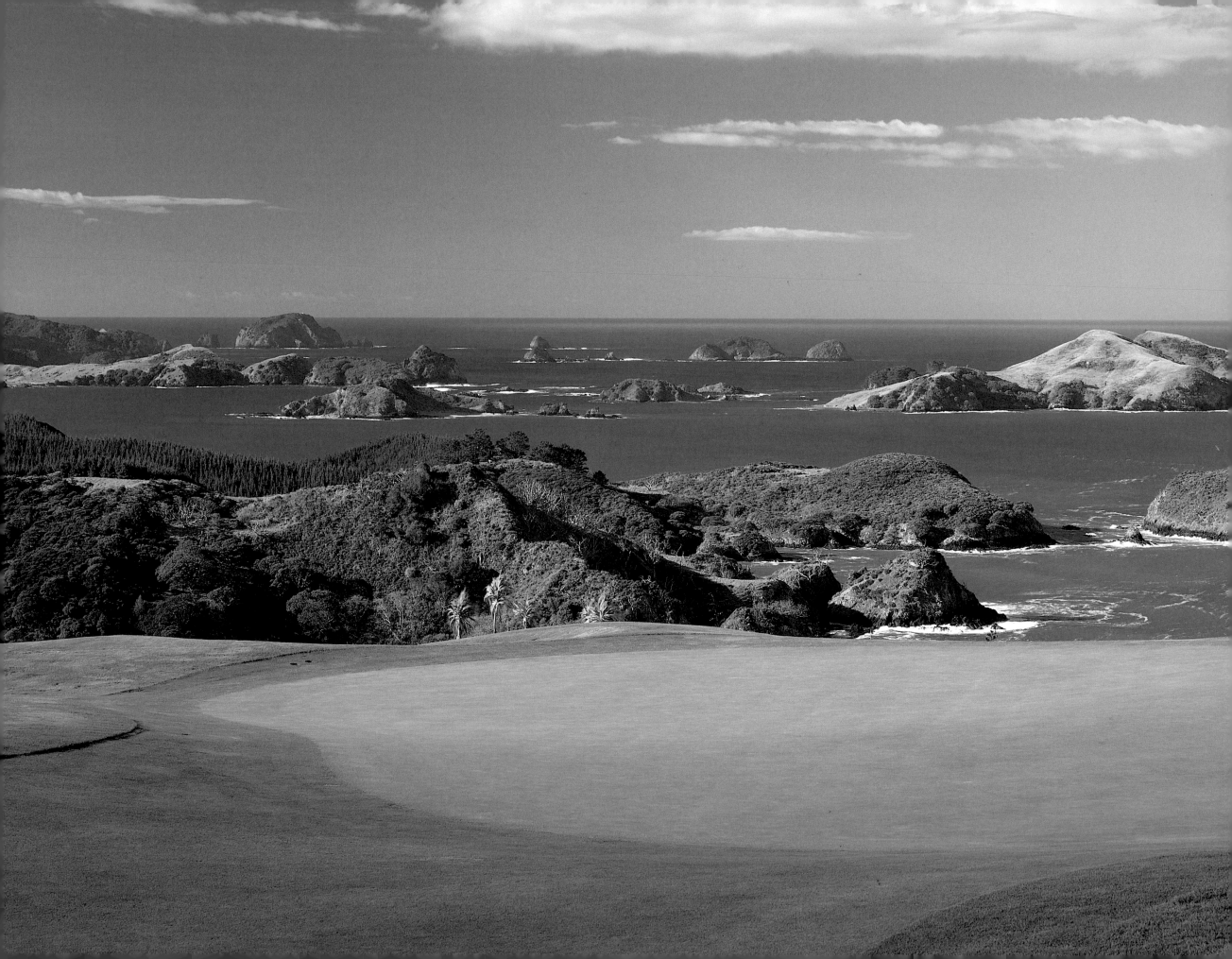

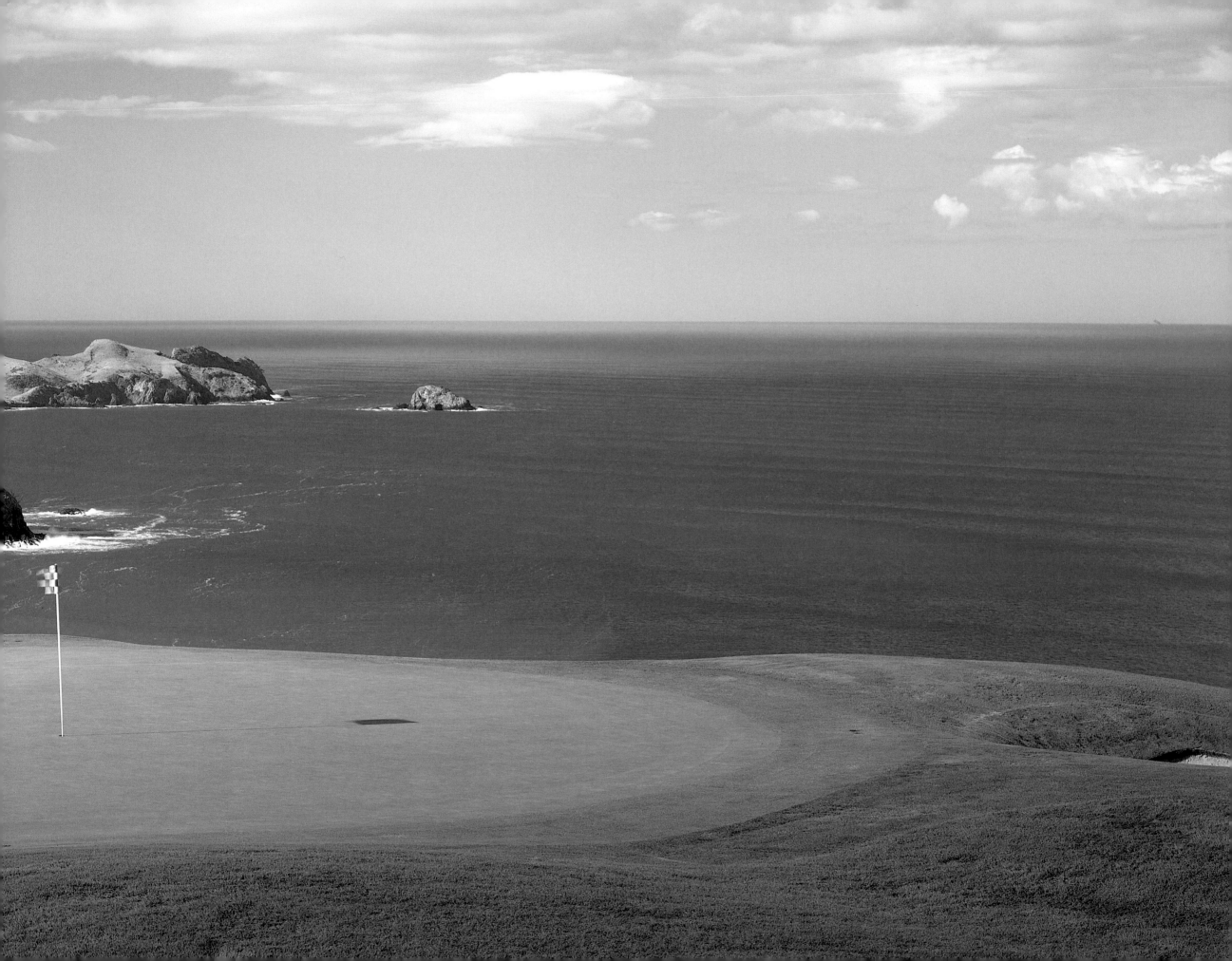

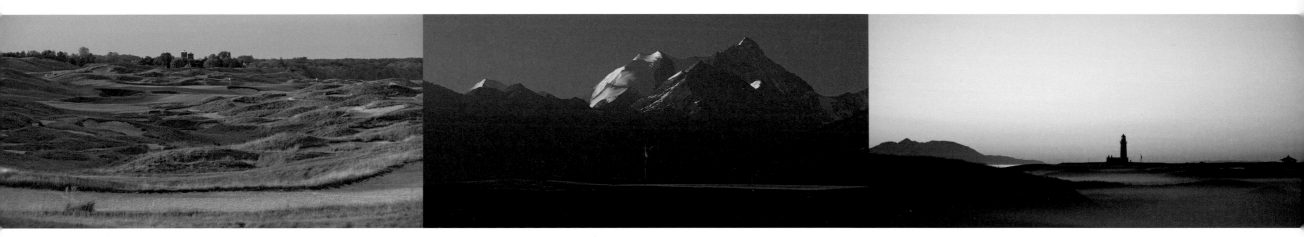

First published in the United States
of America in 2009
by RIZZOLI INTERNATIONAL
PUBLICATIONS, INC.
300 Park Avenue South
New York, NY 10010

2009 2010 2011 2012 2011 / 10 9 8 7 6 5
4 3 2 1

Design by Opto Design

Printed in China

ISBN 13: 978-0-8478-3121-0
Library of Congress Catalog Control
Number: 2008941692

Page 1: Kauri Cliffs, Matauri Bay,
Northland, New Zealand. 7th hole, par 3,
220 yd. Designer: David Harman.

Pages 2–3: Kintyre Course, Westin
Turnberry Resort, Ayrshire, Scotland. 9th
hole, par 5, 480 yd. Designer:
Donald Steel.

Pages 4–5: Championship Course,
Carnoustie Golf Links, Carnoustie, Angus,
Scotland. 3rd hole, par 4, 337 yd.
Designer: James Braid.

Pages 8–9: Isleworth Country Club,
Windemere, Florida, U.S. 9th hole, par 4,
443 yd. Designers: Arnold Palmer, Ed
Seay, with revisions by Steve Smyers.

Pages 10–11: Kauri Cliffs, Matauri Bay,
Northland, New Zealand. 16th hole, par 4,
367 yd. Designer: David Harman.

Above (L–R):

Straits Course, Whistling Straits, Kohler,
Wisconsin, U.S. 11th hole, par 5, 619 yd.
Designer: Pete Dye.

Golf-Club Crans-sur-Sierre, Crans
Montana, Switzerland. 7th hole, par 4,
317 yd. Designer: Severiano Ballesteros.

Ailsa Course, Westin Turnberry Resort,
Ayrshire, Scotland. Designer: Philip
Mackenzie Ross.

Royal Westmoreland, St. James,
Barbados. 7th hole, par 3, 161 yd.
Designer: Robert Trent Jones, Jr.

Fancourt Hotel and Country Club Estate,
George, South Africa. 15th hole, par 4,
465 yd. Designer: Gary Player.

Cape Kidnappers Golf Course, Hawkes
Bay, New Zealand. Designer: Tom Doak.

Following pages:
Pages 14–15: Seaside Course, Sea Island
Resorts, St. Simons Island, Georgia, U.S.
17th hole, par 3, 176 yd. Designers: Tom
Fazio (original Seaside Course designed
by Harry S. Colt and Charles H. Alison).
Pages 16–17: Swinley Forest Golf Club,
Ascot, England. 12th hole, par 4, 455 yd.
Designer: Harry S. Colt.

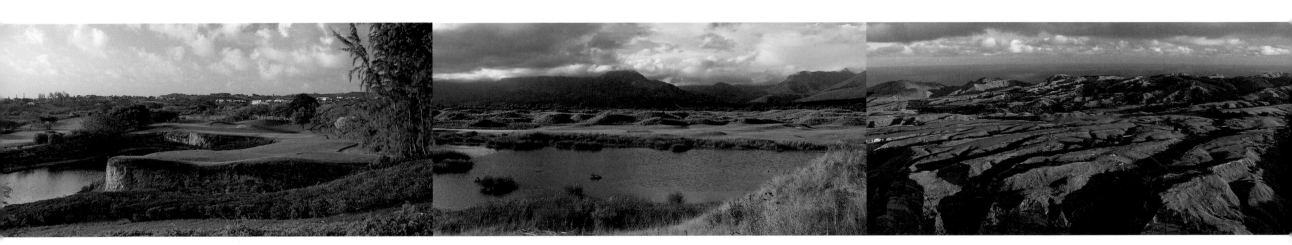

CONTENTS

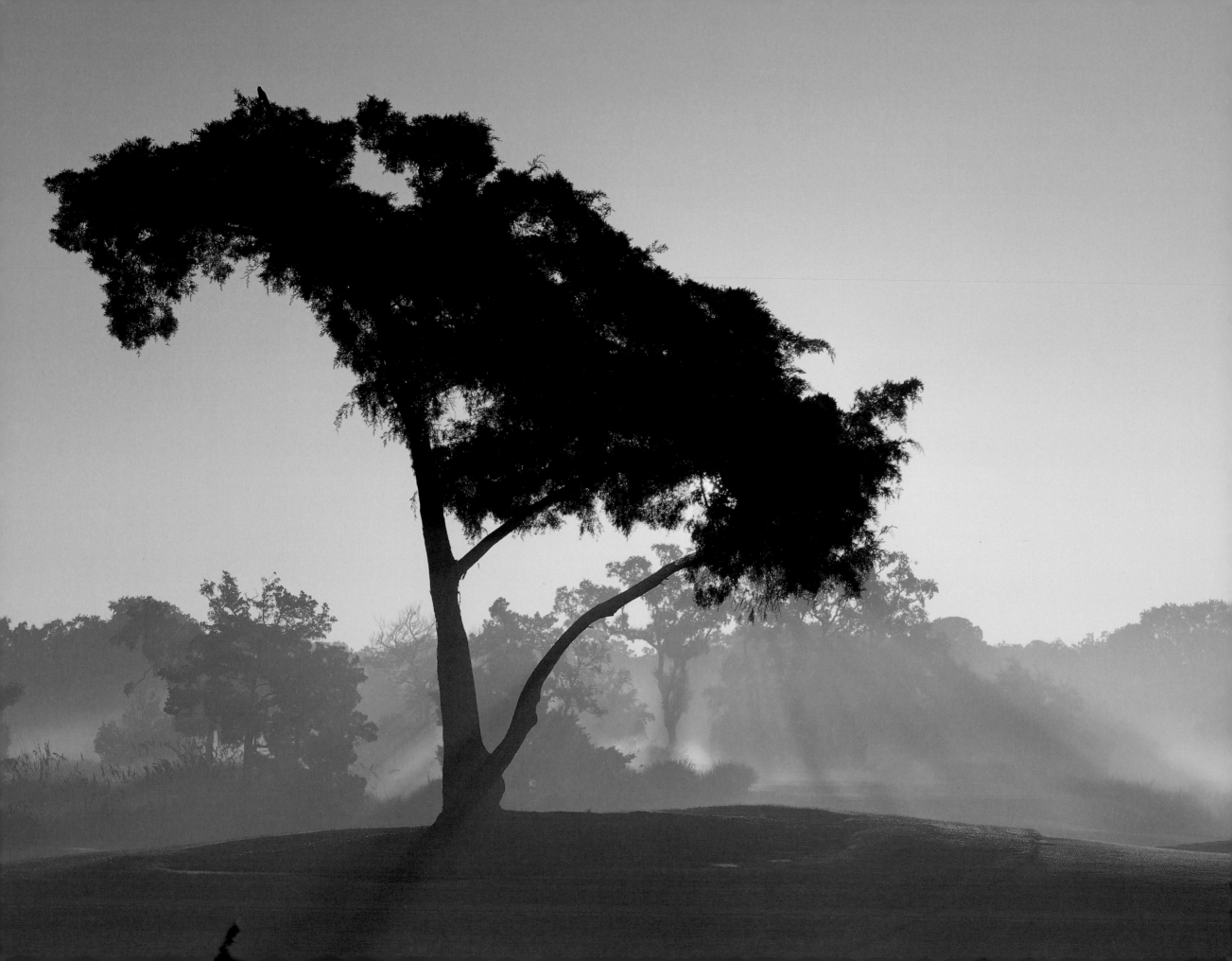

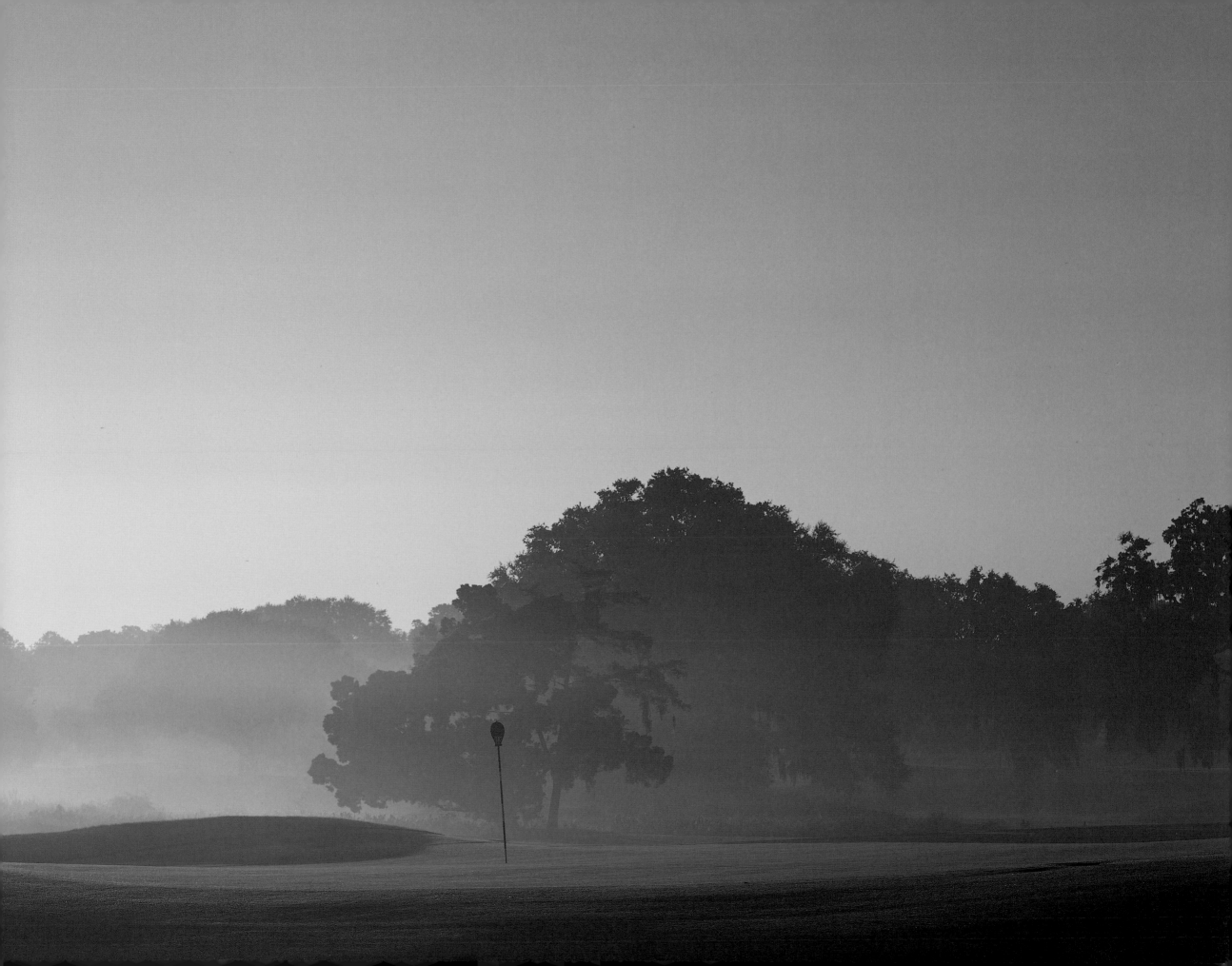

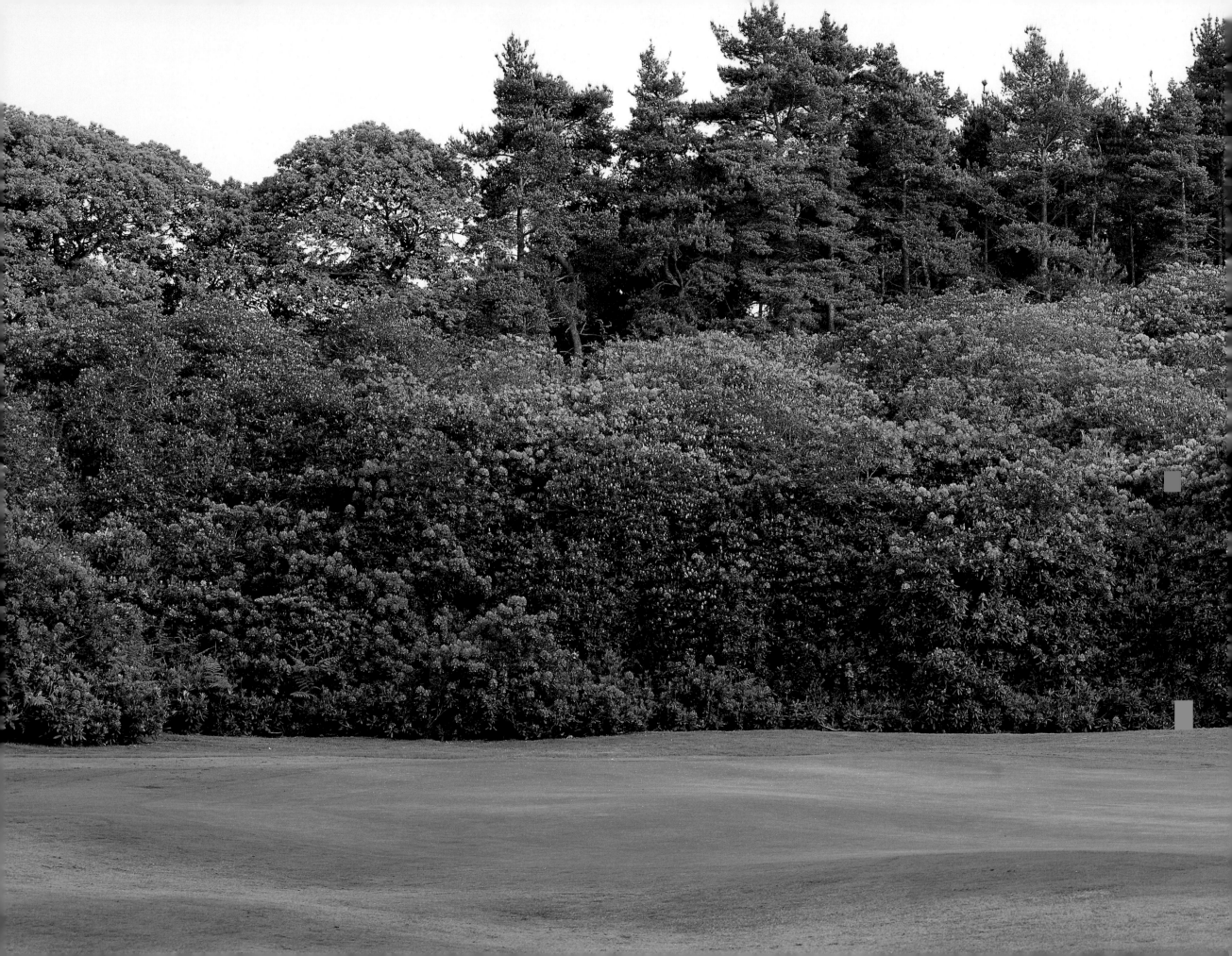

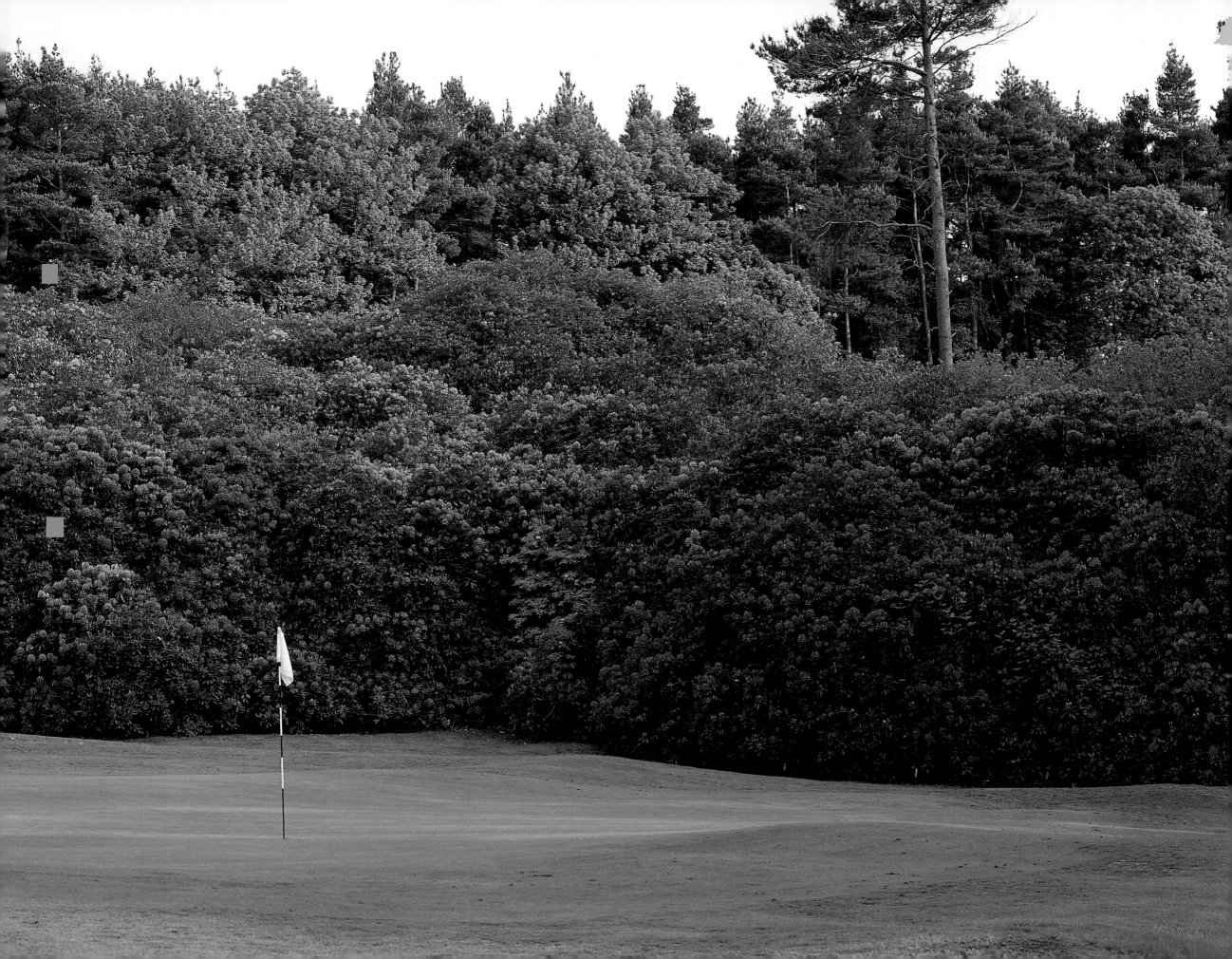

18 AS A PROFESSIONAL GOLFER I'm lucky to play some of the best golf courses in the world, and in all corners of the world. It's fair to say that I travel more than most players, but that's the way I like it. In 2004, a fairly typical season, I traveled something like 85,000 miles and that doesn't include private holidays, various sponsor commitments, and trips connected to my golf course design business and other areas of professional interest. I played tournaments in Australia, Dubai, England, Scotland, Ireland, Korea, Thailand, Germany, Switzerland, South Africa, and nine different states in America, including Hawaii. It's been quite a ride.

One of the great things about golf is that wherever you go no two courses are the same. Unlike many other sports, the golfing arena is different every time you play. This diversity is one of the great attractions of the game, as far as I'm concerned. And I think the experience of playing a global schedule and getting to experience the different styles of golf courses, the varying conditions and climates, have helped make me a more complete golfer. You face a different challenge every time you set foot on the golf course, and adapting to those challenges, learning how to play a variety of shots to suit the conditions, basically get-

ting the best score out of every round you play, can only make you a better player. I've no doubt at all that it's contributed to my success as a professional.

I've known David Cannon professionally for more than fifteen years, and obviously our paths have crossed "inside the ropes" at many a golf tournament—me hitting shots, him photographing them. There's no doubt in my mind he's one of the best photographers in the business. He did the photography for both of my instruction books; no other photographer could have done a better job. You have probably seen and admired his images in other books and golf magazines. Many of them are award winners, which is not surprising. David has also since become a good friend. He's got the trust of all the players, too, which means he can get close to the action, without ever getting in the way. That's not nearly as easy as it might sound.

David doesn't just photograph golfers, though. He takes incredible pictures of golf courses. I think the fact that he's a good golfer himself and knows the game inside out enables him to achieve shots that other photographers might not get. This book is a showcase for that talent. It features some of the best, and most famous, courses in the world. I think you'll find that his images make you want to

dive into the page and hit a shot. He seems to have this gift for bringing to your attention all that is good about a golf course or a particular hole. But then that's the power of a good photograph: it inspires you. I look at these photographs of golf courses from all over—many on which I've played lots of times over the years—and for me personally it brings back some wonderful memories. It also makes me want to go back and play the courses again. As I mentioned, that's the inspiration factor—you just want to drop everything and play golf!

I know how much effort David put into getting these photos, and it really shows; it is a beautiful book. And if it stirs you into wanting to play some of the courses that are featured, David would probably consider his job well done.

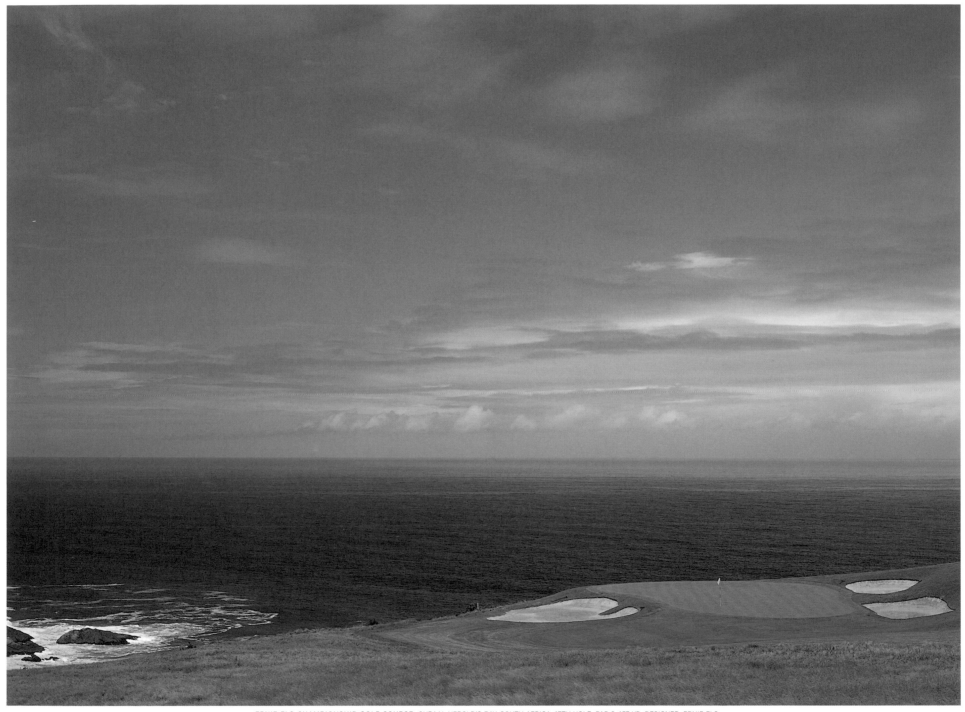

ERNIE ELS CHAMPIONSHIP GOLF COURSE, OUBAAI, HEROLD'S BAY, SOUTH AFRICA. 17TH HOLE, PAR 3, 157 YD. DESIGNER: ERNIE ELS.

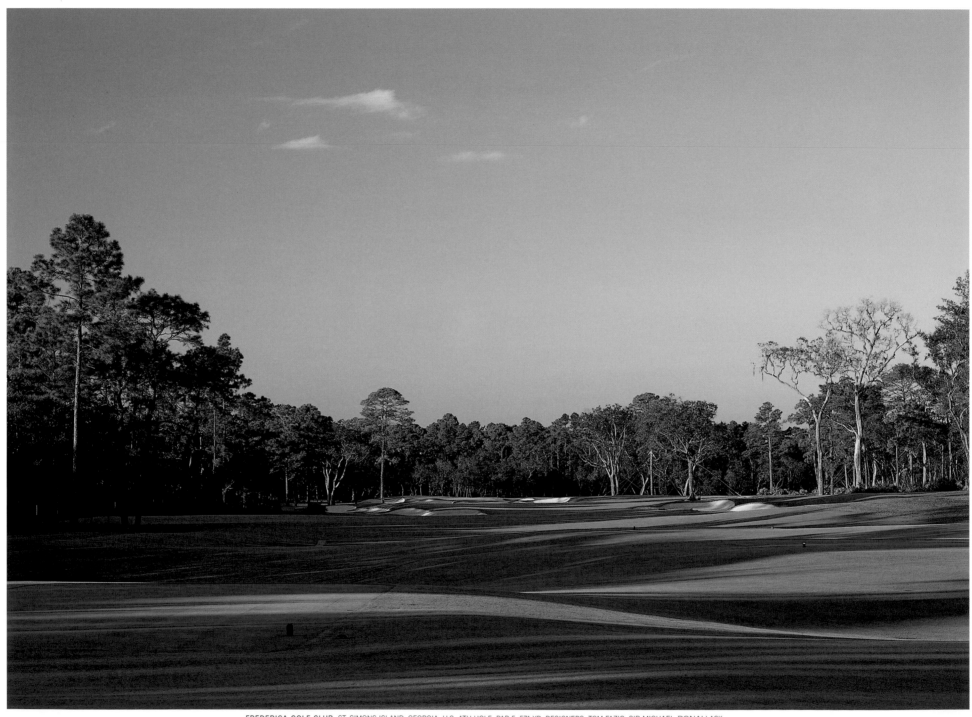

FREDERICA GOLF CLUB, ST. SIMONS ISLAND, GEORGIA, U.S. 4TH HOLE, PAR 5, 571 YD. DESIGNERS: TOM FAZIO, SIR MICHAEL BONALLACK.

THERE ARE VERY FEW SPORTS photographers who would be almost equally at home on the other side of the camera lens, but David Cannon as a young golfer showed such prowess that he may well have made a lucrative career as a professional. Happily for those who love the game and enjoy recalling the dramatic moments that occur in golf, as well as being reminded of the visual beauty of some of the world's greatest courses, he decided to turn his talents to photography.

David played amateur golf at a high level, which included playing in the qualifying rounds for the Open Championship, and it is no doubt that his knowledge of the game—including an appreciation of what is likely to happen at any given moment—has led to him being recognized as one of the world's leading golf photographers.

Unlike most other sports, golf is played on diverse and different arenas every week. Hardly any two courses are the same, and on the world's greatest courses you are very aware that your surroundings are due largely to nature rather than having been created by man. This is one of the features that makes the game so enjoyable.

It is good news for all of us that David, who has had more experience than almost anyone, has decided to make this photographic record of some of these beautiful courses that have given so much pleasure to those who have played them; but it will also remind those who have not what wonderful treats are still to be enjoyed.

22 EVERY PIECE OF PROPERTY and every golf course are different. This variety makes the game of golf—its playing grounds and course architecture—so fascinating. Words can describe a setting, place, or golf shot, but nothing can capture the feeling like photography can. One photograph can tell a story, spark the imagination, and stir emotions.

My field, golf course architecture, is about studying, understanding, and then revealing the land in such a manner as to create an interesting journey and environment in which to play golf. The features of the land are utilized and enhanced to develop stimulating, exciting, and strategic golf holes. Through design, a story unfolds: the property is unveiled, and the thrill of golf is exposed. Golf architects use photography to display their work and relay to golfers their unique art that makes the game so enticing.

David Cannon, through his intimate understanding of golf course architecture and his passion for the game, has captured in this collection the true excitement and drama of the world's great golf courses. His work reveals the beauty, mystery, and strategy of golf that can only be told through photography. I believe you will find David's book to be both relaxing and stimulating. It is sure to give you a greater understanding and appreciation of golf courses and their architects.

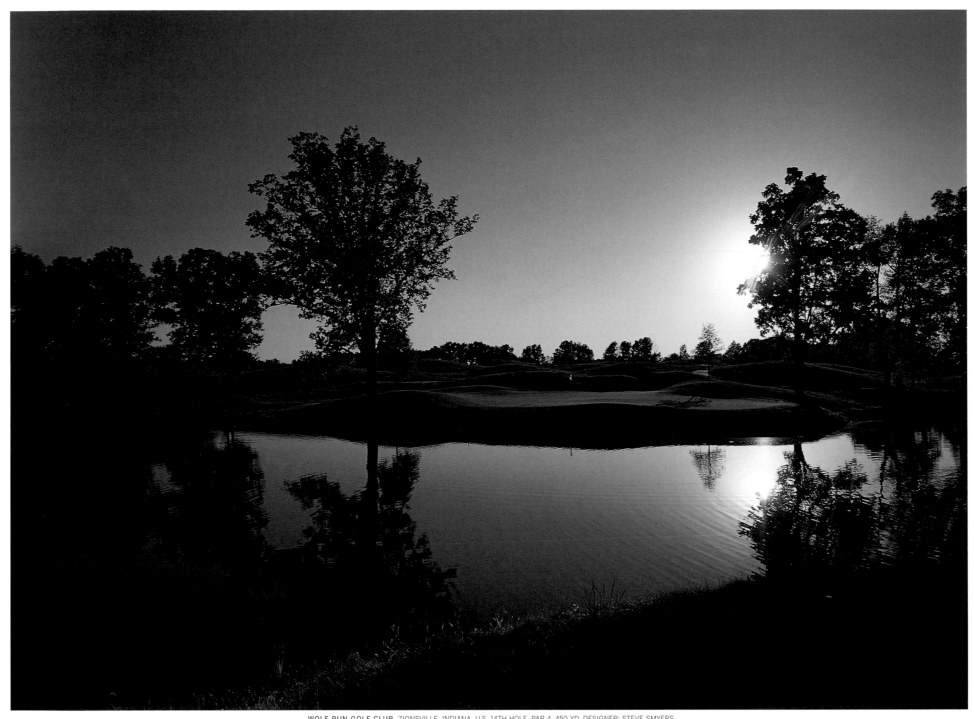

WOLF RUN GOLF CLUB, ZIONSVILLE, INDIANA, U.S. 14TH HOLE, PAR 4, 450 YD. DESIGNER: STEVE SMYERS.

1
NORTH AMERICA

AUGUSTA NATIONAL, BALTUSROL, BANDON DUNES, BETHPAGE, CHICAGO GOLF CLUB, CROOKED STICK, CYPRESS POINT CLUB, FAIRMONT BANFF SPRINGS, GREENBRIER, HOKULI'A,
ISLESWORTH, KIAWAH, KITTANSETT, LAKE NONA, MAIDSTONE, MAUNA KEA, MAUNA LANI, MCARTHUR, MERION, OAKLAND HILLS, OLD MEMORIAL,
PEBBLE BEACH, PINE VALLEY, PINEHURST, PRAIRIE DUNES, RICH HARVEST FARMS, SAN FRANCISCO GOLF CLUB, SAND HILLS, SAWGRASS, SEA ISLAND, SEMINOLE, SHADOW RIDGE, SUGARLOAF,
TIBURON, VALHALLA, WE-KO-PA, WHISPER ROCK, WHISTLING STRAITS, WINGED FOOT, WOLF RUN

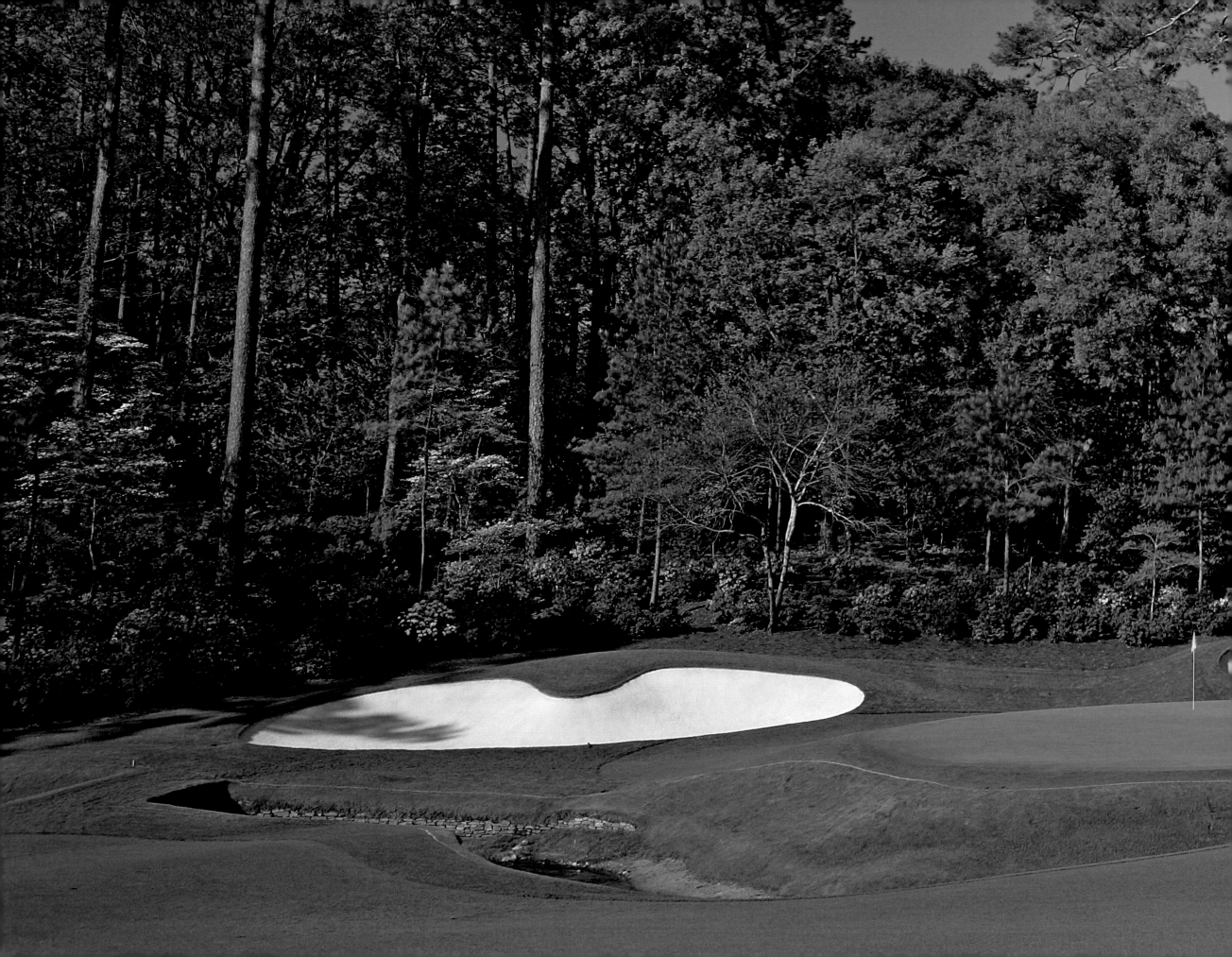

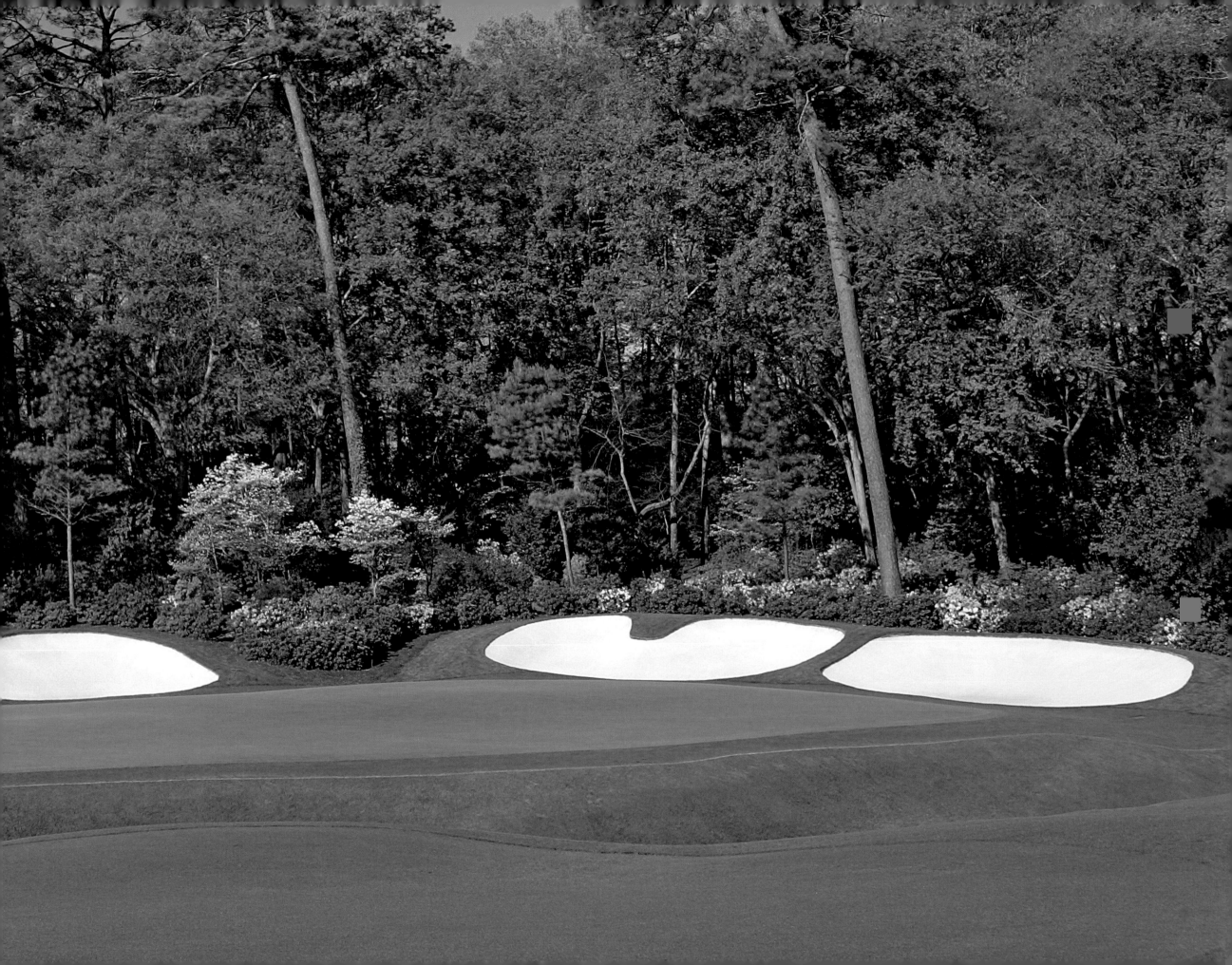

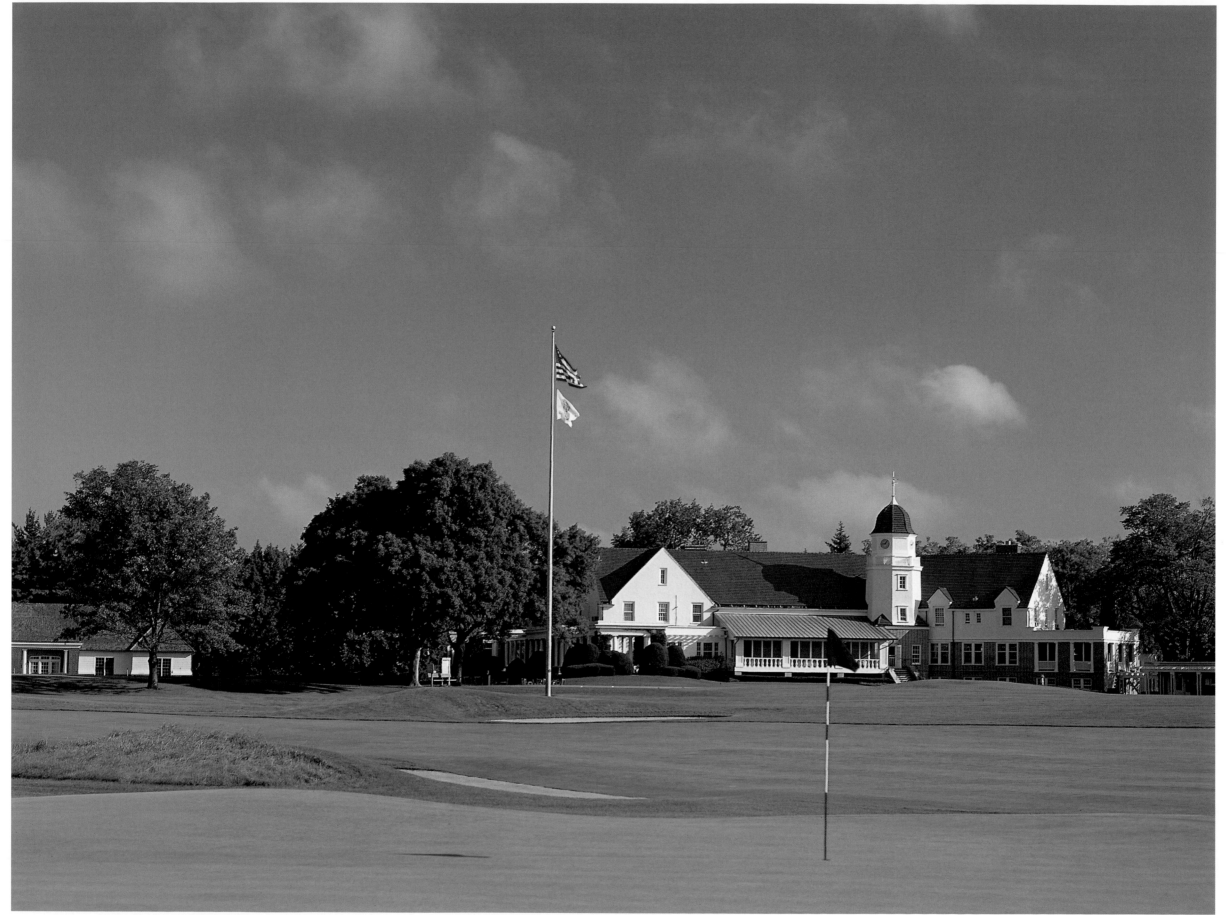

28

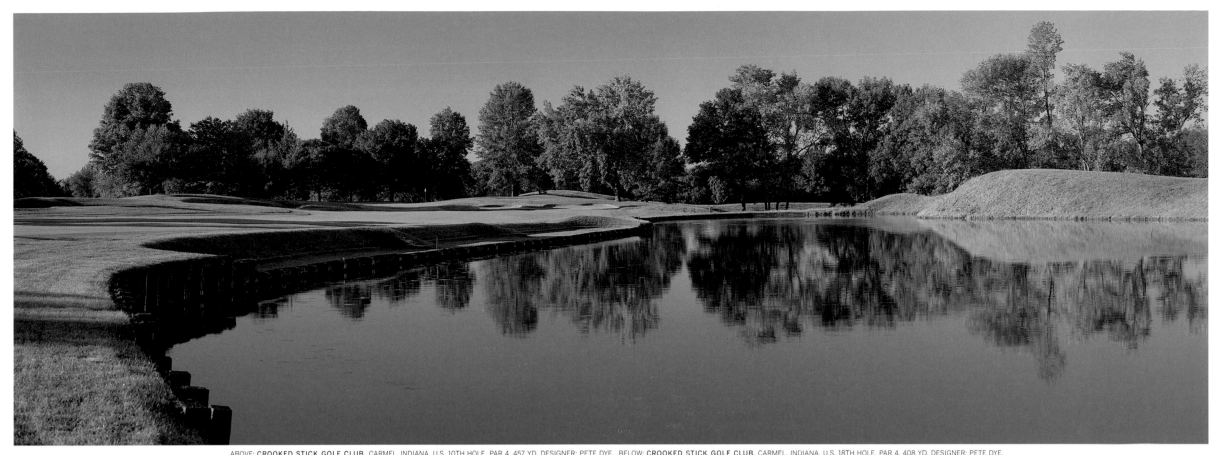

ABOVE: **CROOKED STICK GOLF CLUB,** CARMEL, INDIANA, U.S. 10TH HOLE, PAR 4, 457 YD. DESIGNER: PETE DYE. BELOW: **CROOKED STICK GOLF CLUB,** CARMEL, INDIANA, U.S. 18TH HOLE, PAR 4, 408 YD. DESIGNER: PETE DYE.

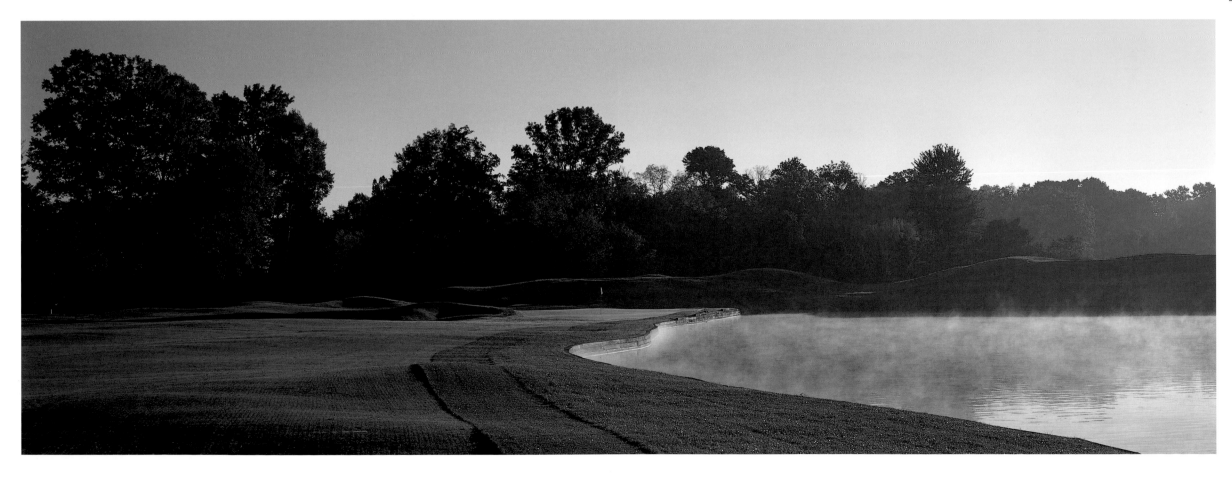

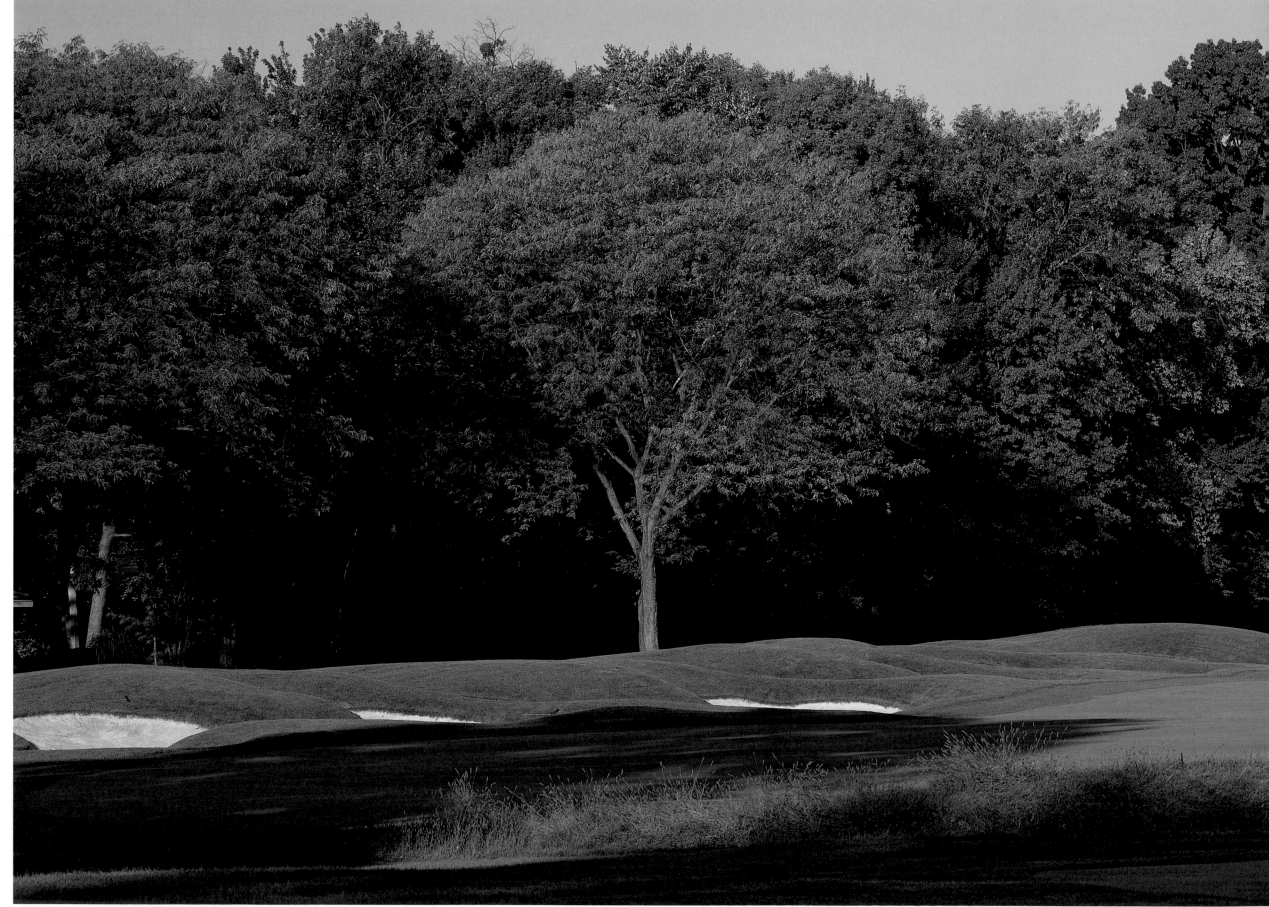

PREVIOUS PAGES, 26-27: AUGUSTA NATIONAL GOLF CLUB, AUGUSTA, GEORGIA, U.S. 13TH HOLE, PAR 5, 519 YD. DESIGNERS: BOBBY JONES, DR. ALISTER MACKENZIE. ABOVE: CHICAGO GOLF CLUB, WHEATON, ILLINOIS, U.S. 15TH HOLE, PAR 4, 393 YD. DESIGNER: CHARLES BLAIR MACDONALD.

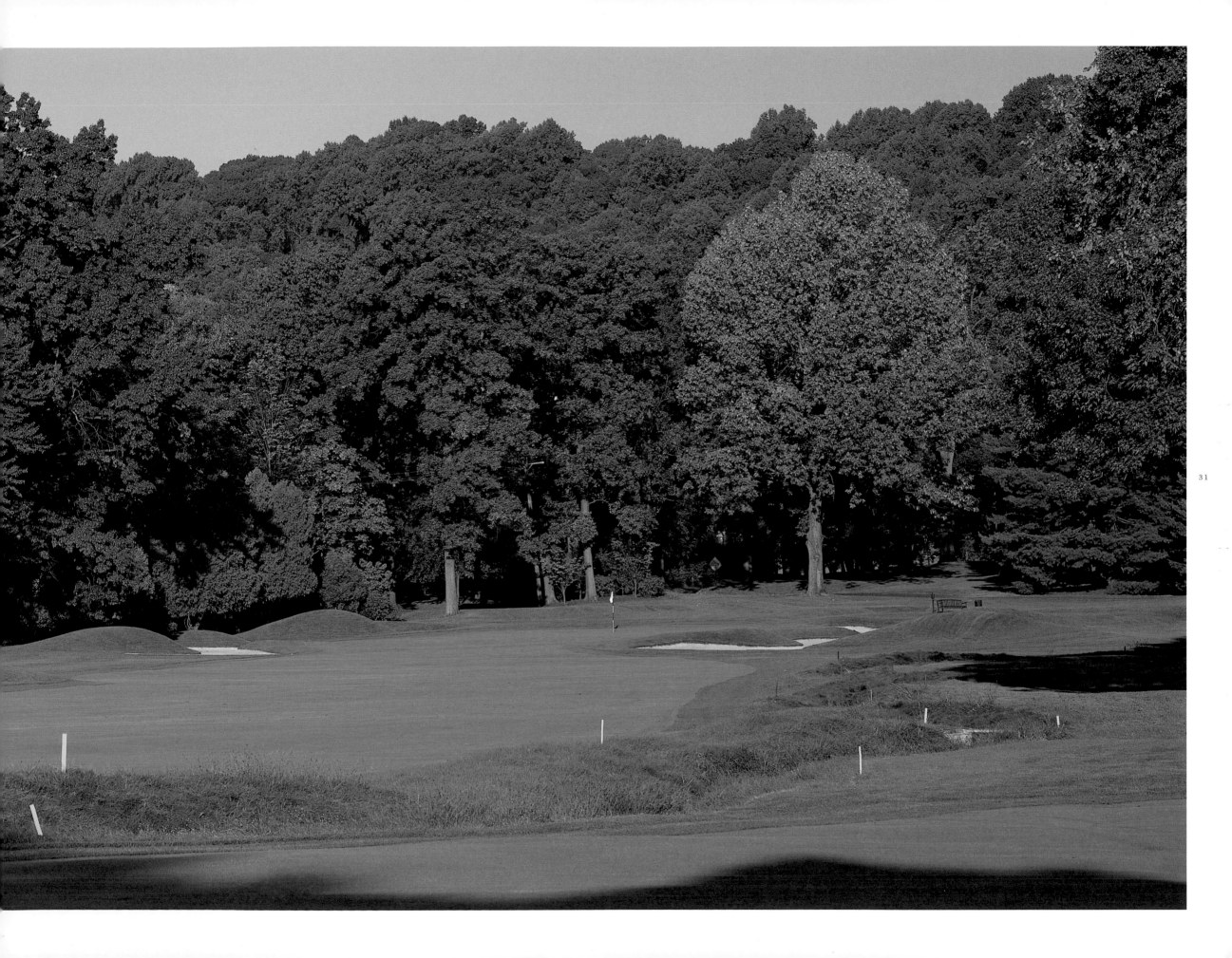

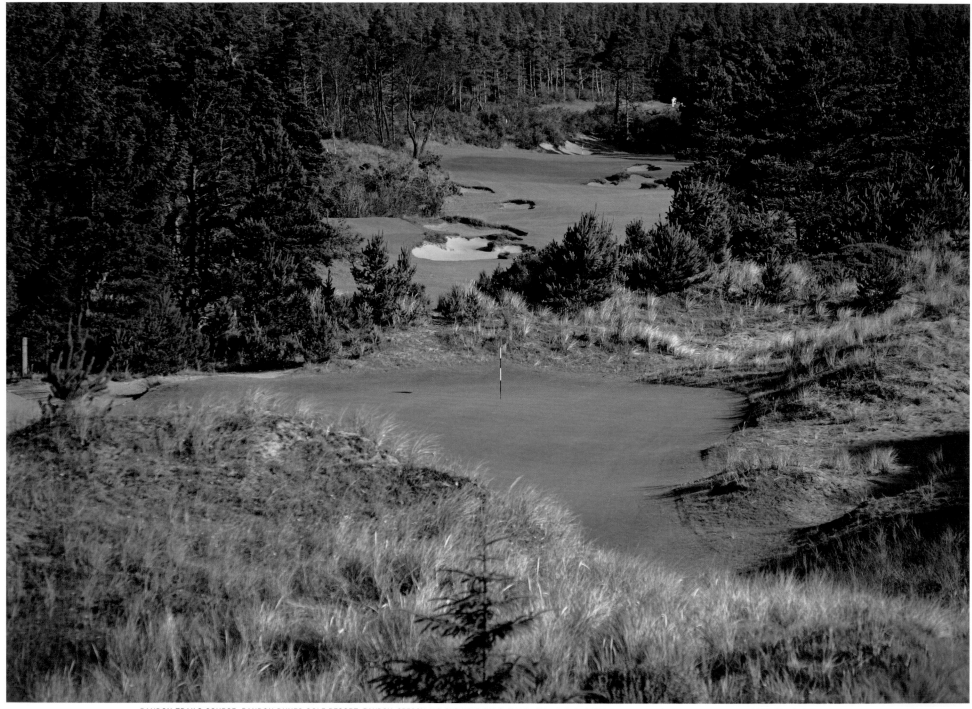

32

BANDON TRAILS COURSE, BANDON DUNES GOLF RESORT, BANDON, OREGON, U.S. 2ND HOLE, PAR 3, 214 YD.; 3RD HOLE (BACKGROUND), PAR 5, 549 YD. DESIGNERS: BILL COORE, BEN CRENSHAW.

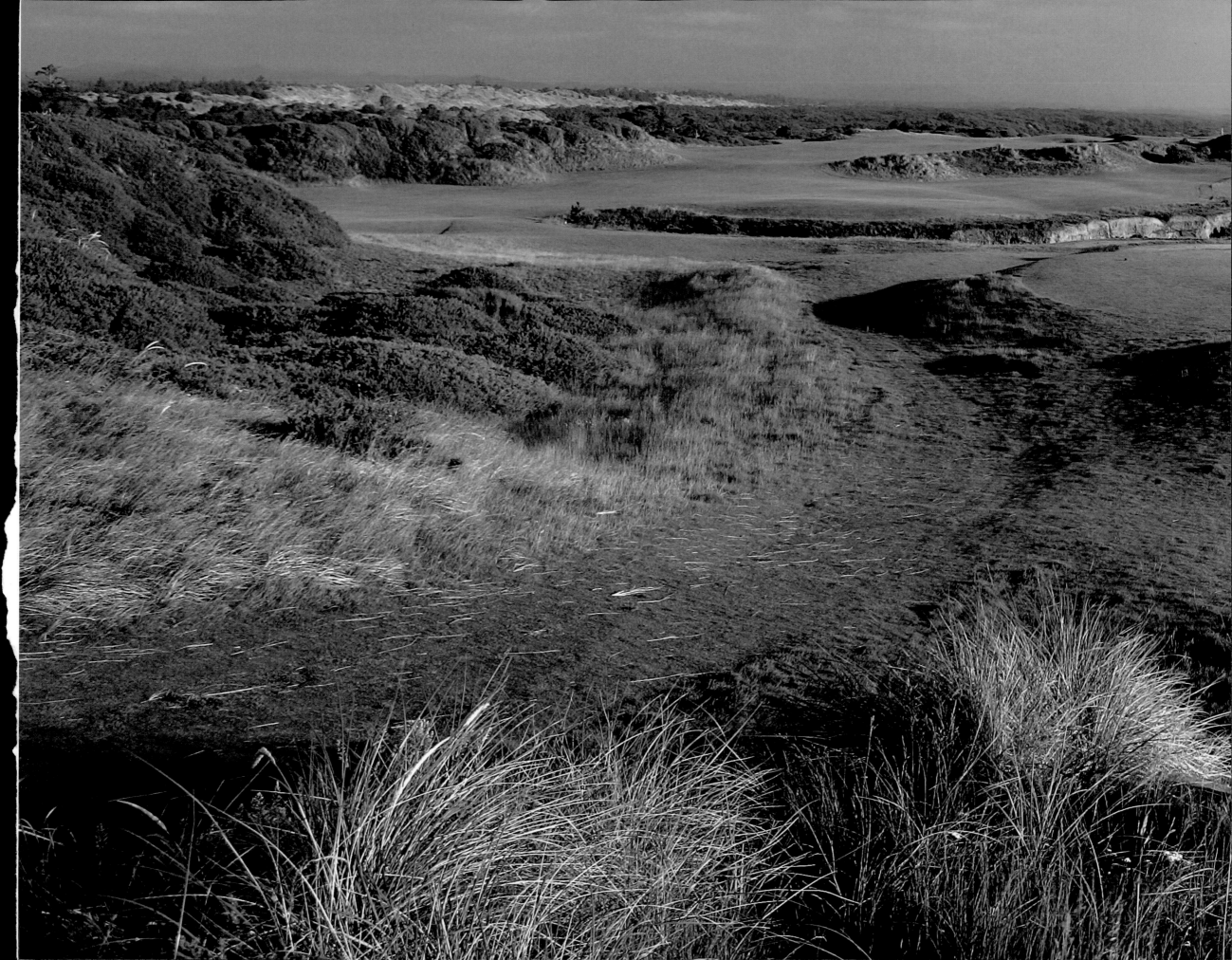

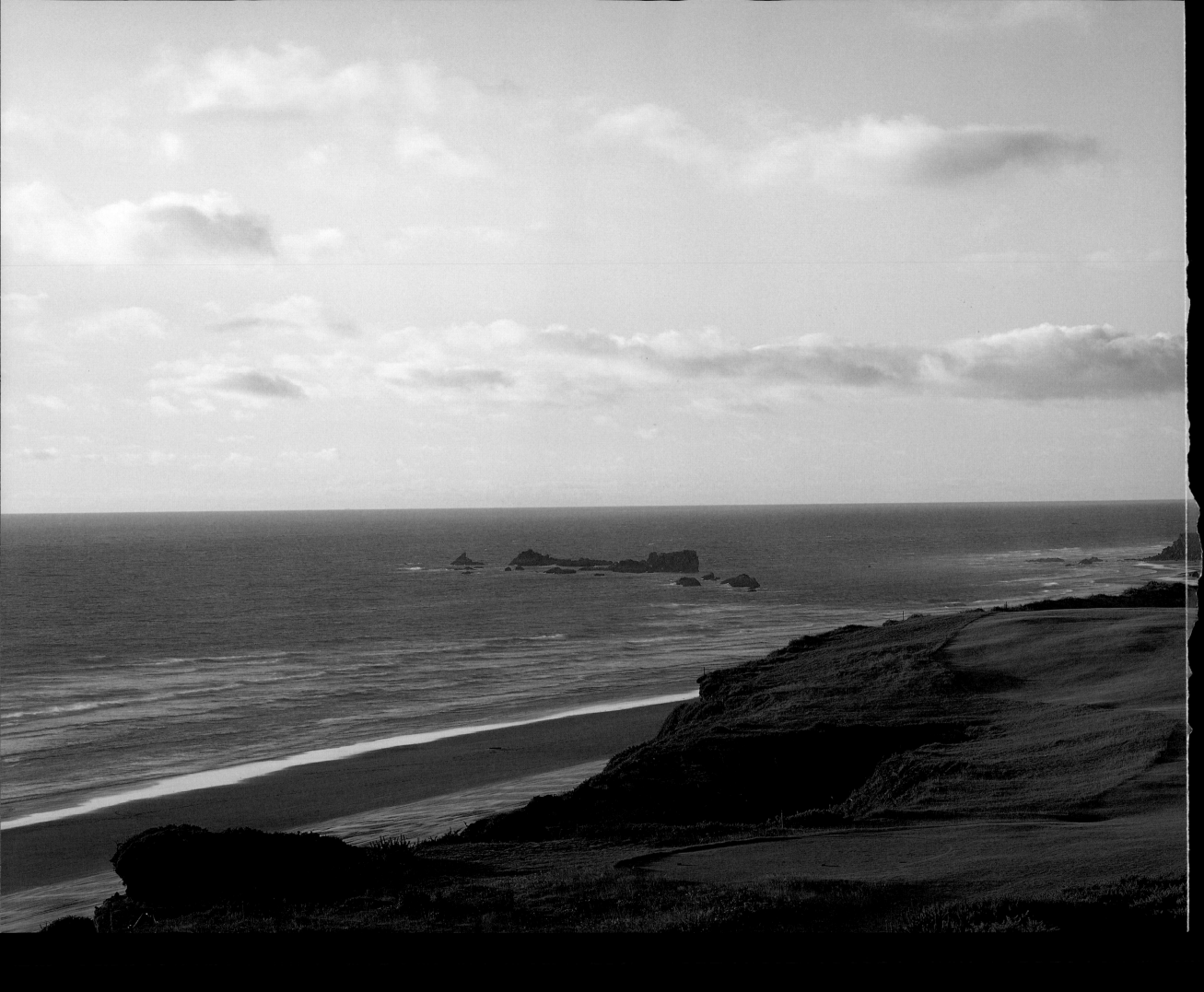

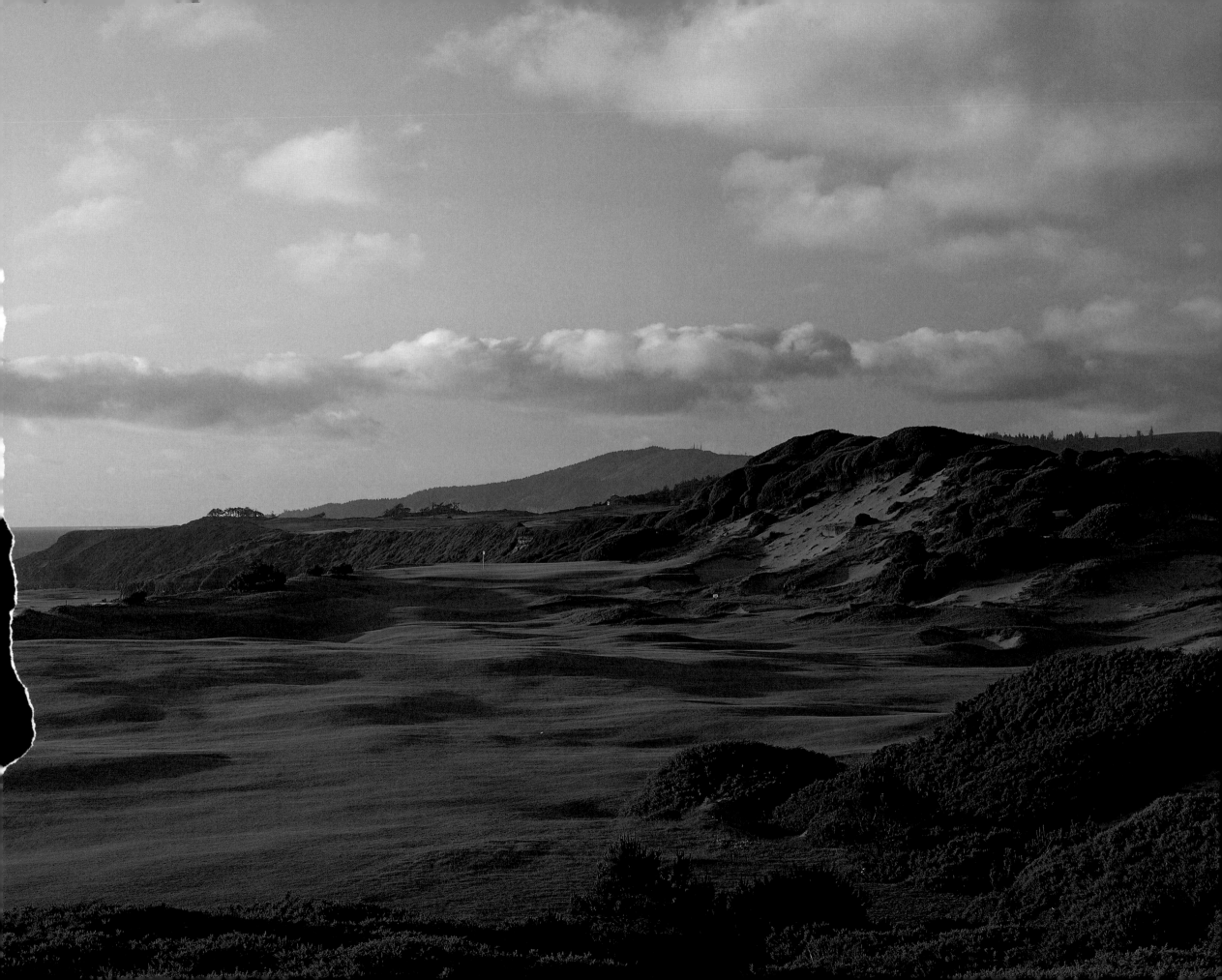

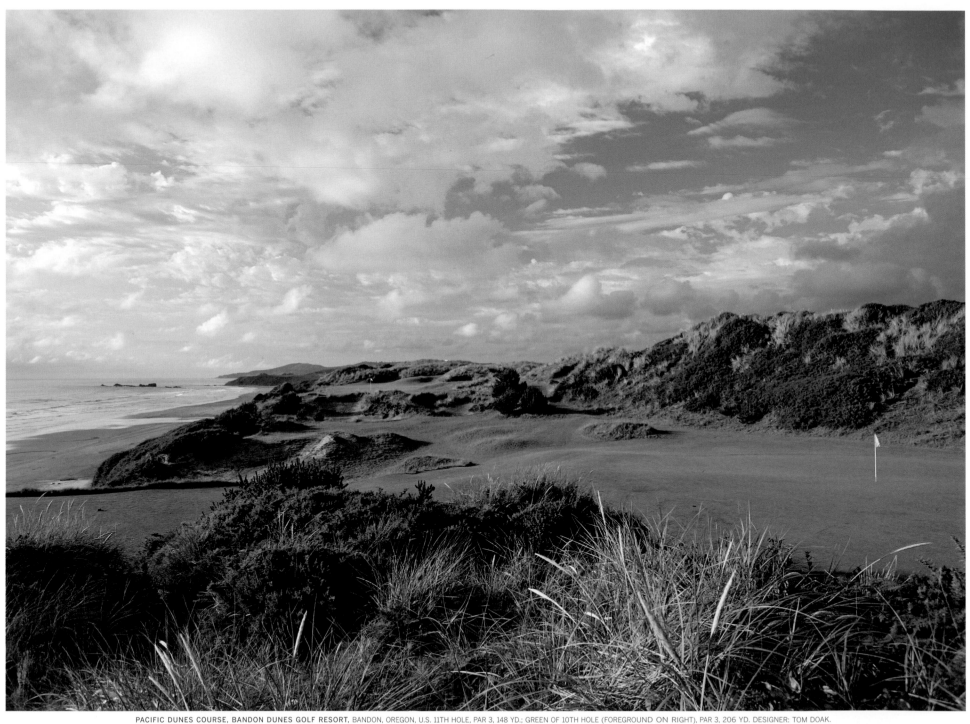

PACIFIC DUNES COURSE, BANDON DUNES GOLF RESORT, BANDON, OREGON, U.S. 11TH HOLE, PAR 3, 148 YD.; GREEN OF 10TH HOLE (FOREGROUND ON RIGHT), PAR 3, 206 YD. DESIGNER: TOM DOAK.
FOLLOWING PAGES, 34–35: **PACIFIC DUNES COURSE, BANDON DUNES GOLF RESORT,** BANDON, OREGON, U.S. 13TH HOLE, PAR 4, 444 YD. DESIGNER: TOM DOAK.

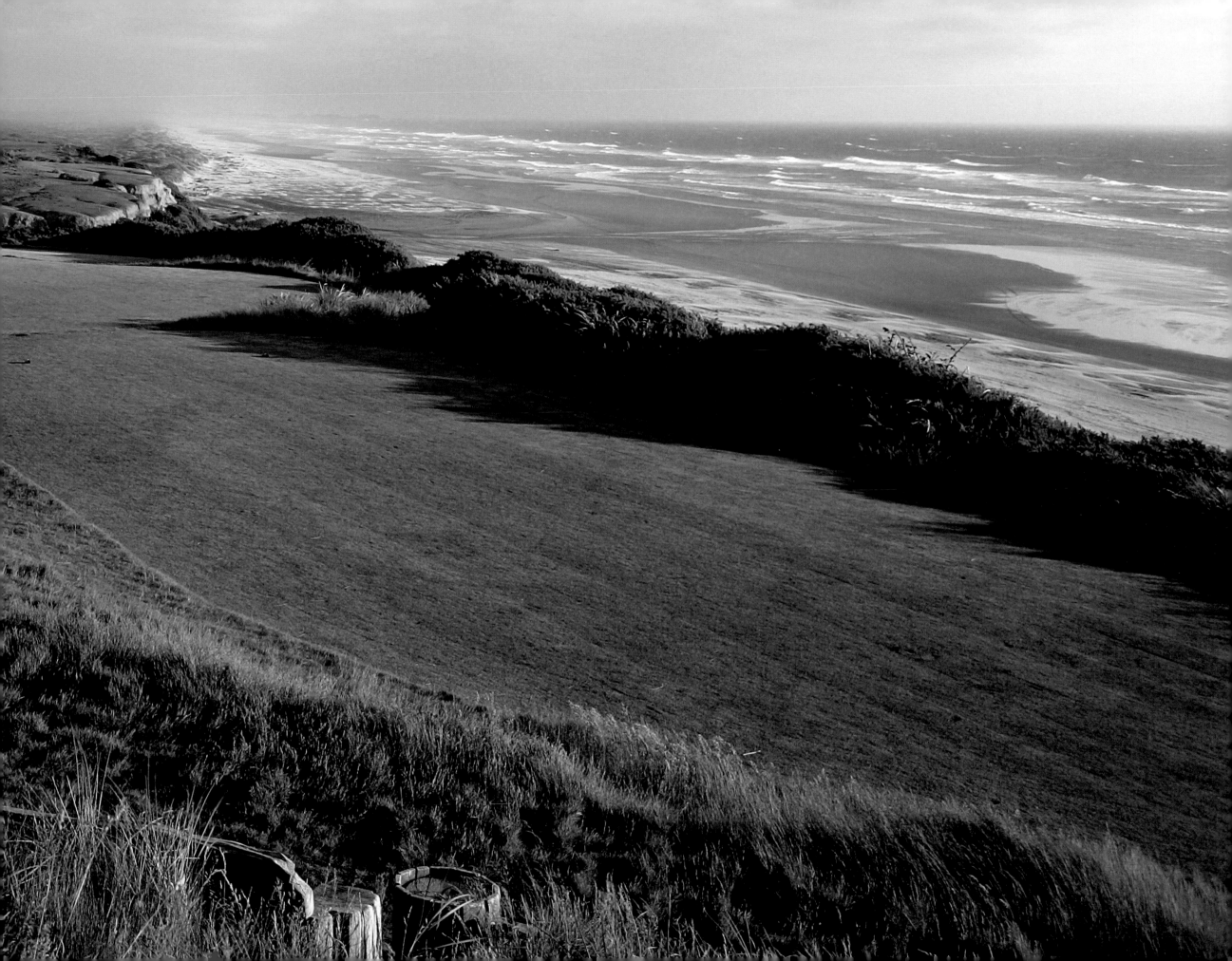

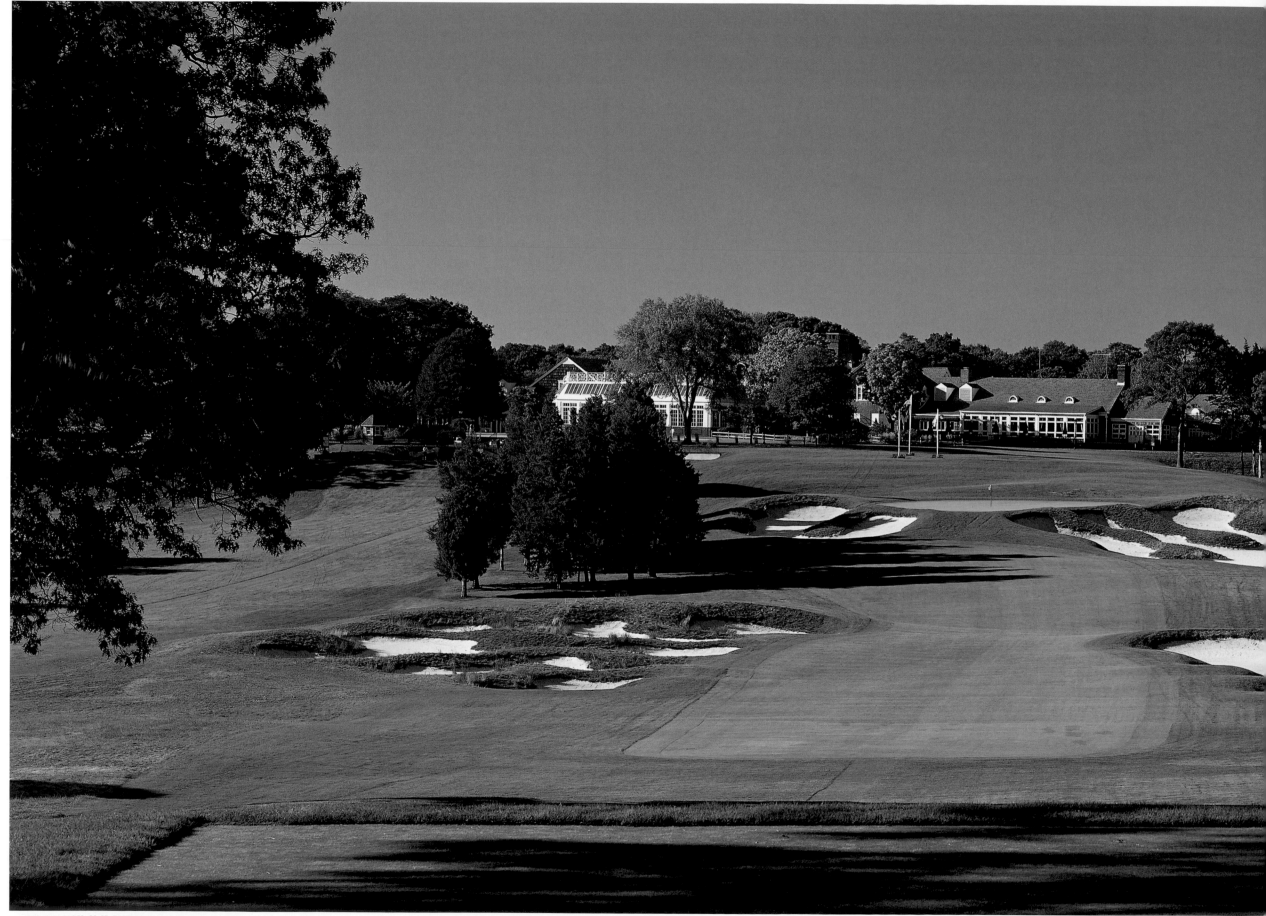

PREVIOUS PAGES, 36-37: **BANDON DUNES COURSE**, **BANDON DUNES GOLF RESORT**, BANDON, OREGON, U.S. 16TH HOLE, PAR 4, 363 YD. DESIGNER: DAVID MCLAY-KIDD. ABOVE: **BLACK COURSE**, **BETHPAGE STATE PARK**, FARMINGDALE, NEW YORK, U.S. 18TH HOLE, PAR 4, 411 YD. DESIGNERS: A. W. TILLINGHAST, JOSEPH H. BURBECK.

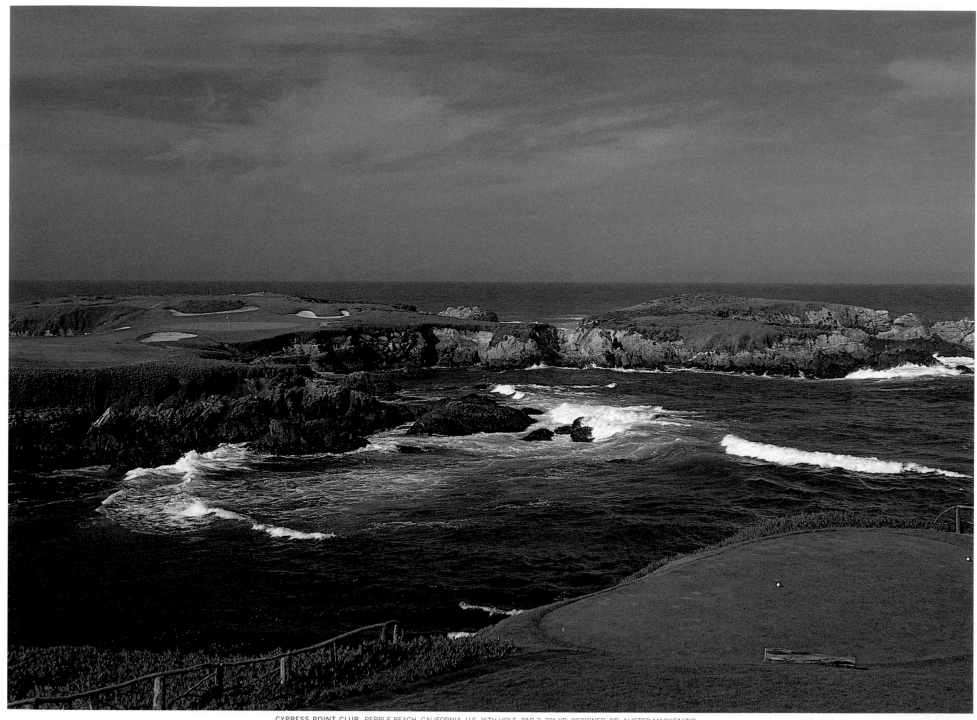

CYPRESS POINT CLUB, PEBBLE BEACH, CALIFORNIA, U.S. 16TH HOLE, PAR 3, 231 YD. DESIGNER: DR. ALISTER MACKENZIE.

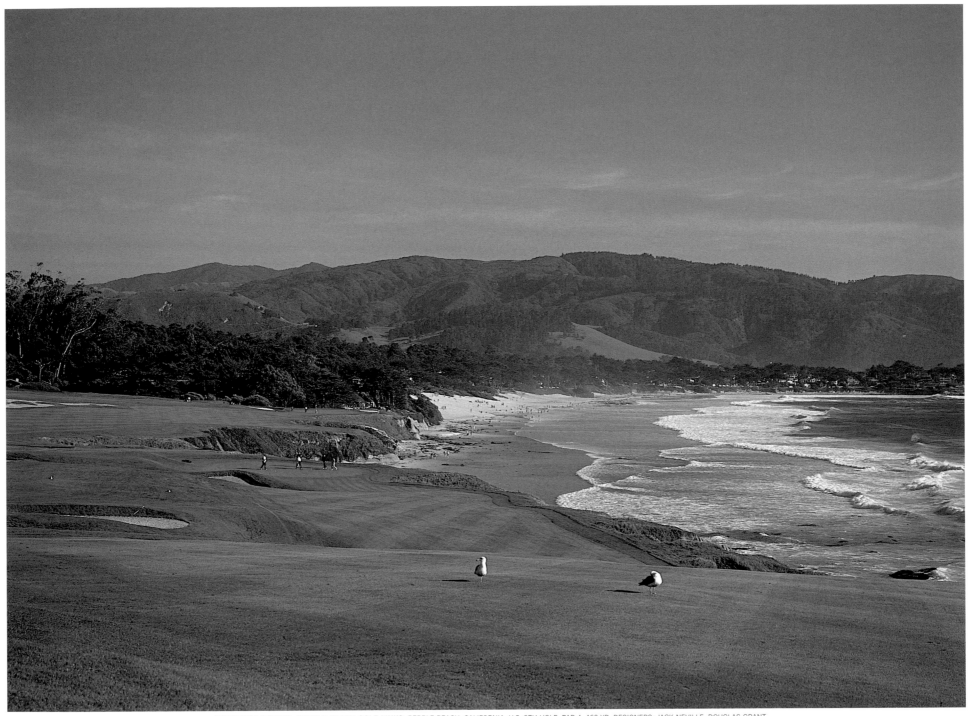

GOLF LINKS COURSE, PEBBLE BEACH GOLF LINKS, PEBBLE BEACH, CALIFORNIA, U.S. 9TH HOLE, PAR 4, 462 YD. DESIGNERS: JACK NEVILLE, DOUGLAS GRANT.

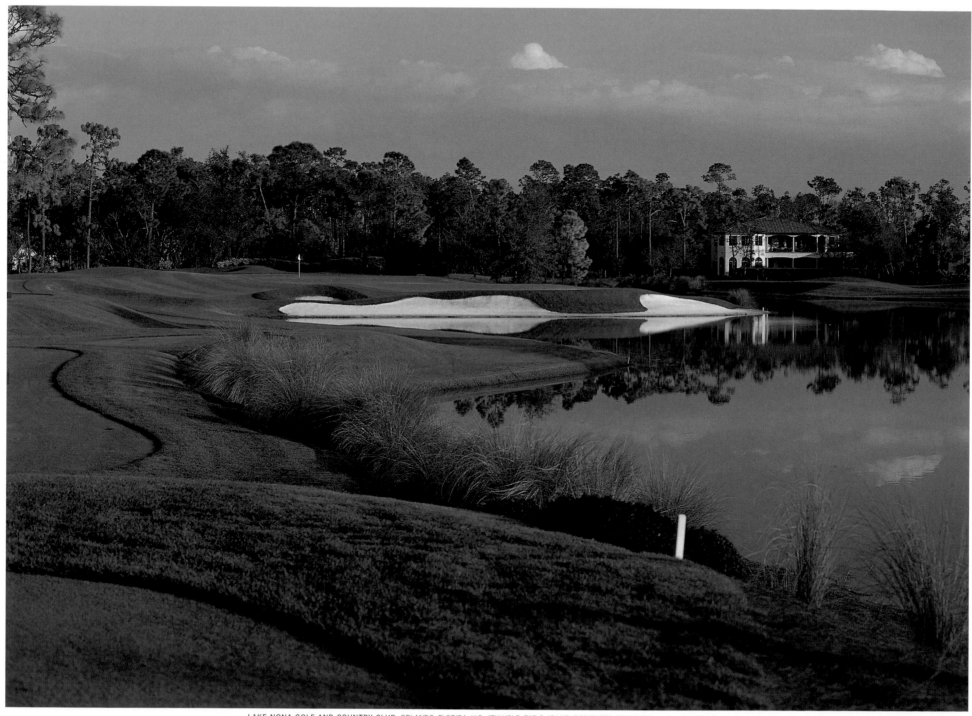

LAKE NONA GOLF AND COUNTRY CLUB, ORLANDO, FLORIDA, U.S. 4TH HOLE, PAR 3, 184 YD. DESIGNERS: TOM FAZIO, ANDY BANFIELD.

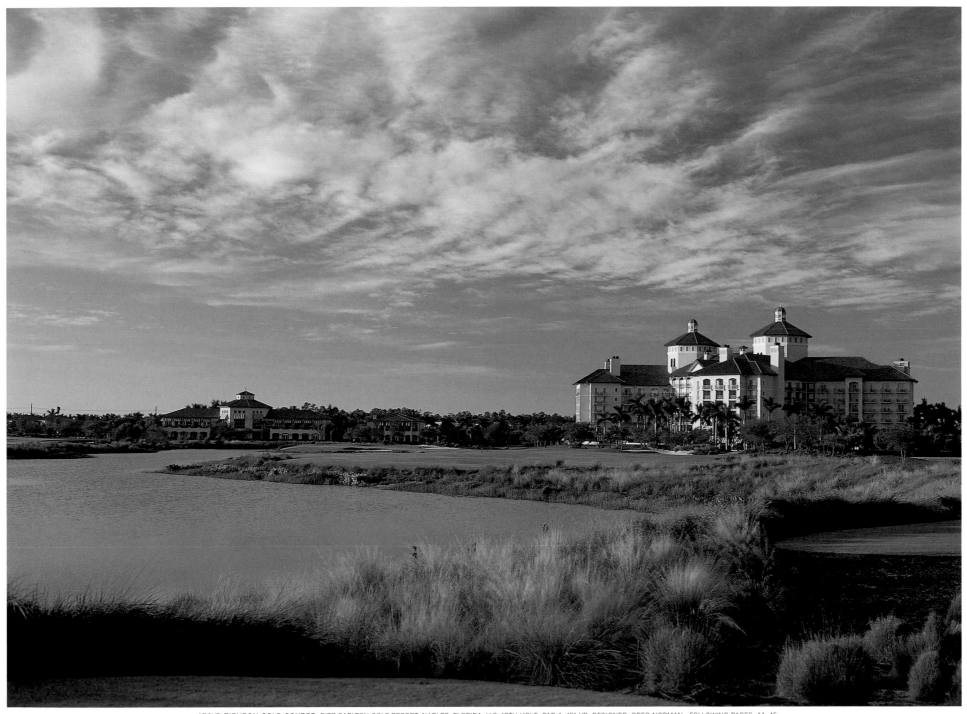

ABOVE: **TIBURON GOLD COURSE**, RITZ CARLTON GOLF RESORT, NAPLES, FLORIDA, U.S. 18TH HOLE, PAR 4, 451 YD. DESIGNER: GREG NORMAN. FOLLOWING PAGES, 44–45:
MCARTHUR GOLF CLUB, HOBE SOUND, FLORIDA, U.S. 13TH HOLE, PAR 3, 188 YD. DESIGNERS: TOM FAZIO, NICK PRICE.

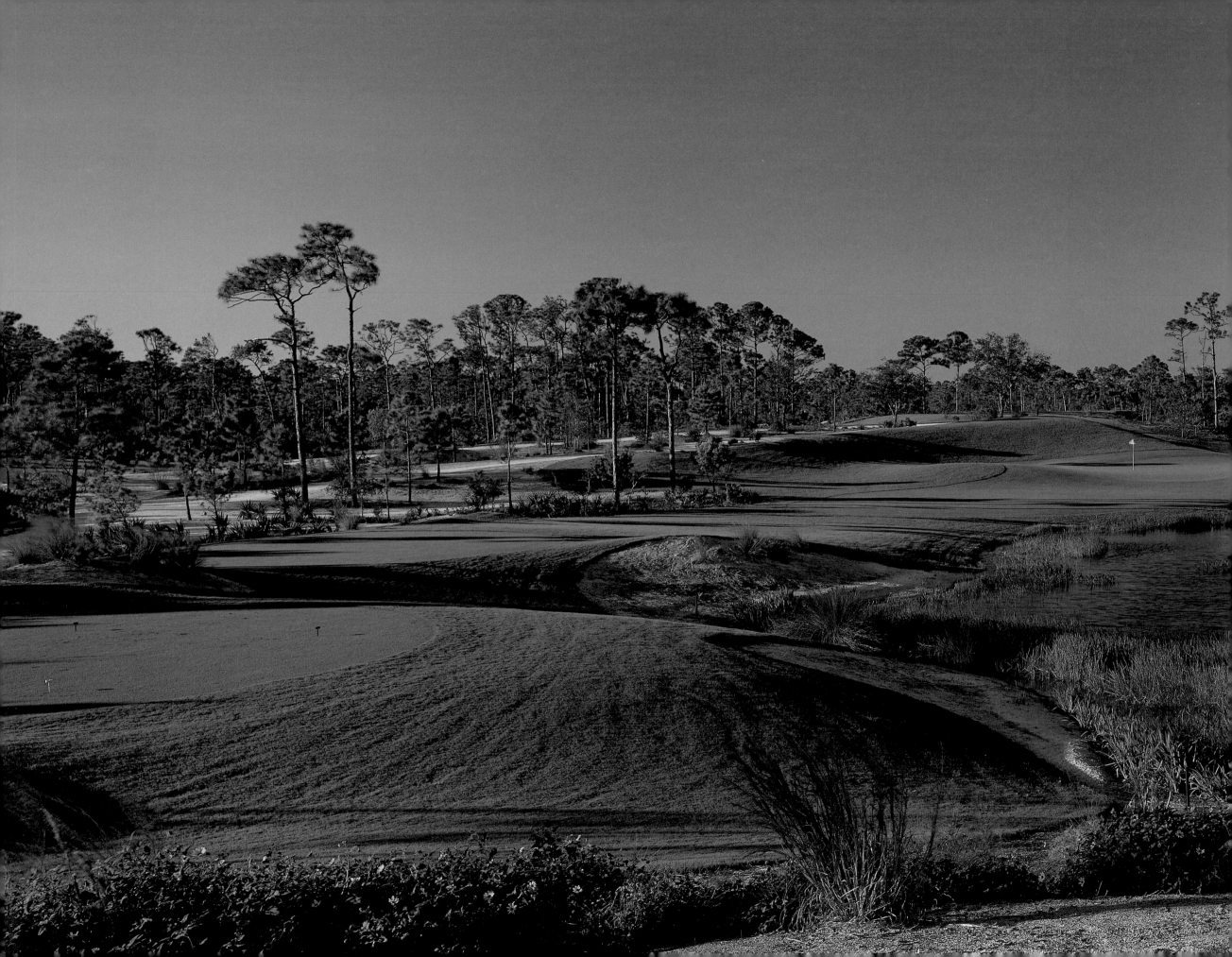

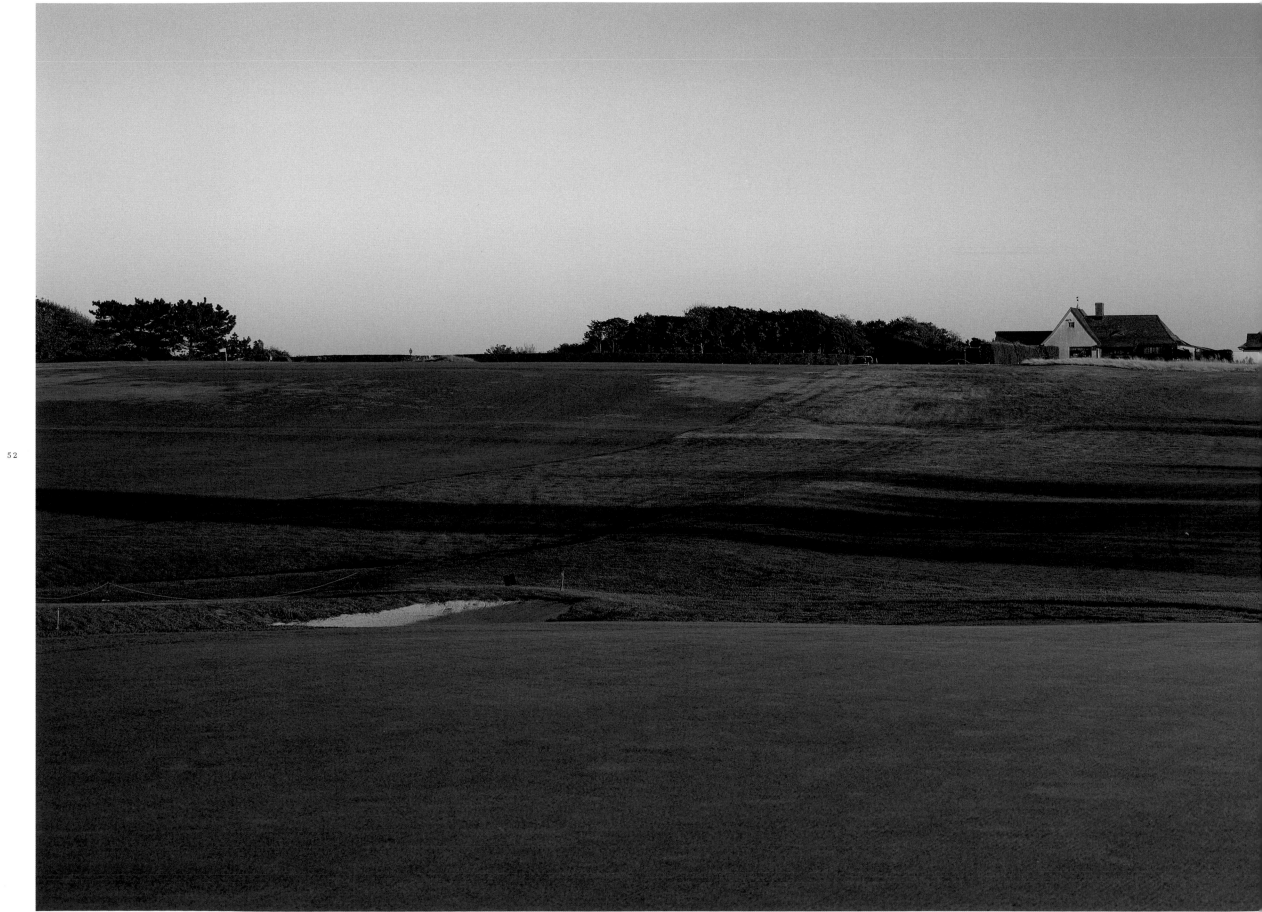

52

ABOVE: **THE MAIDSTONE CLUB**, EAST HAMPTON, NEW YORK, U.S. 1ST HOLE, PAR 4, 380 YD. DESIGNERS: WILLIE PARK, JR., JOHN PARK. FOLLOWING PAGES, 54–55: **SUGARLOAF GOLF CLUB AND RESORT**, CARRABASSETT VALLEY, MAINE, U.S. 14TH HOLE, PAR 4, 401 YD. DESIGNER: ROBERT TRENT JONES, JR.

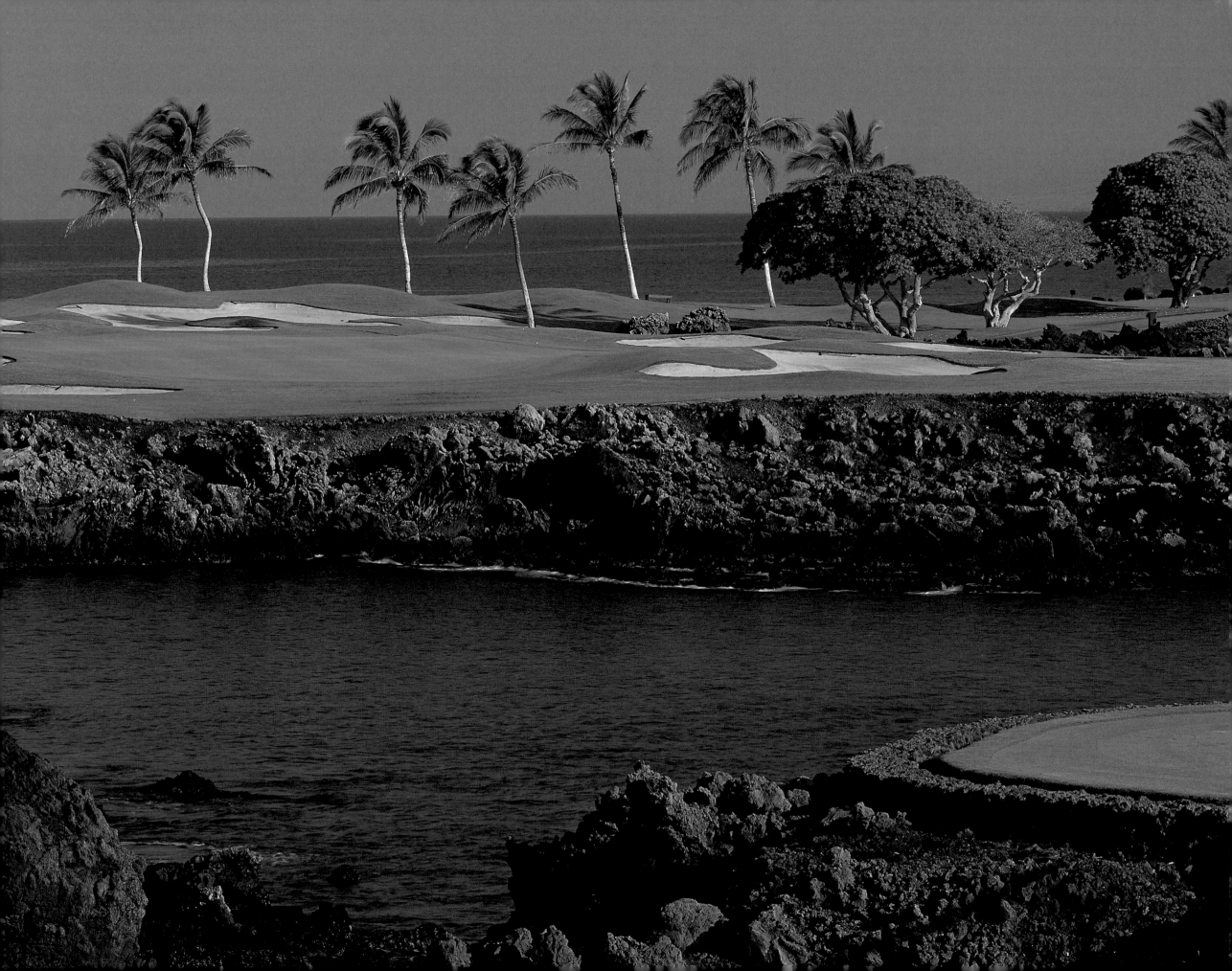

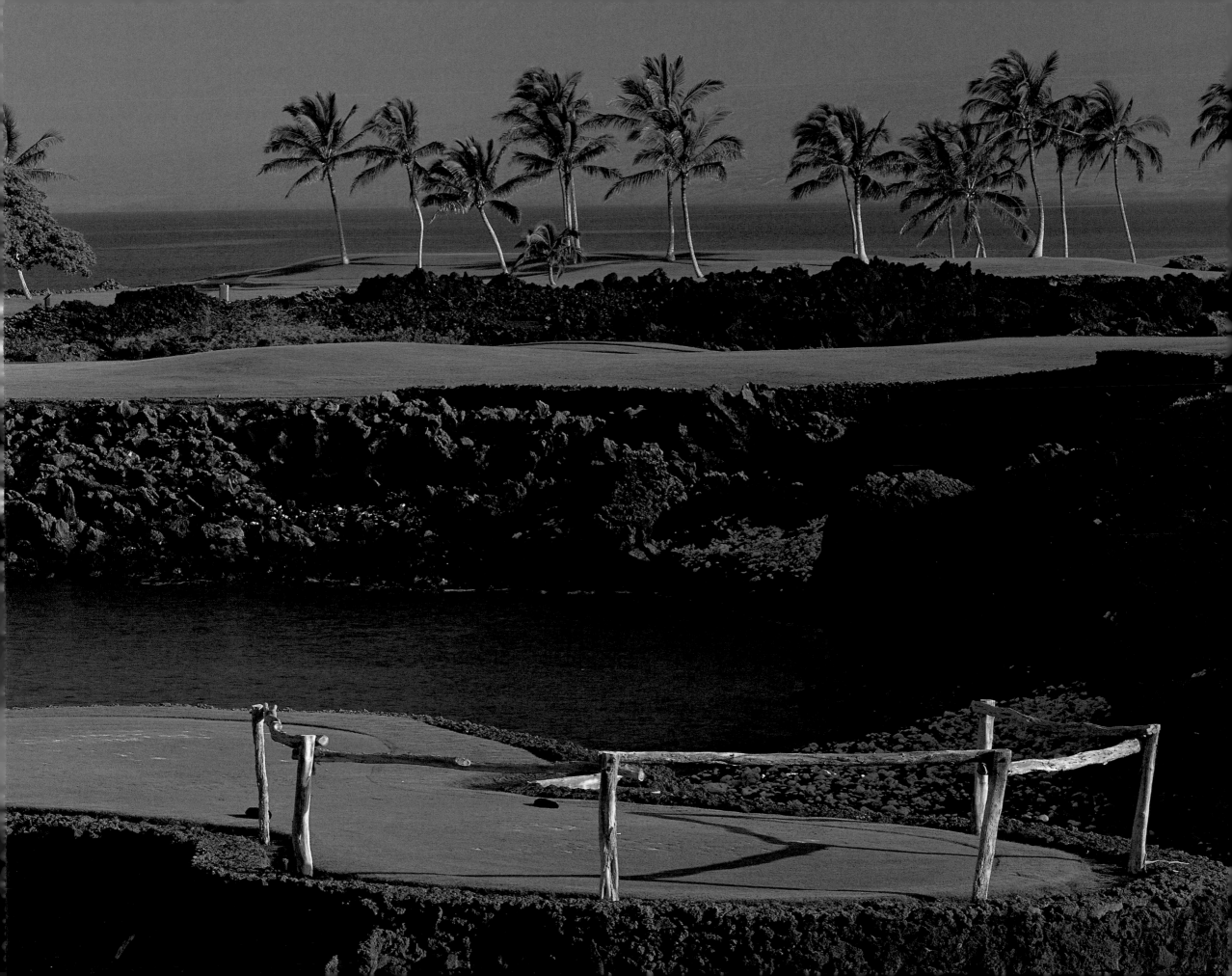

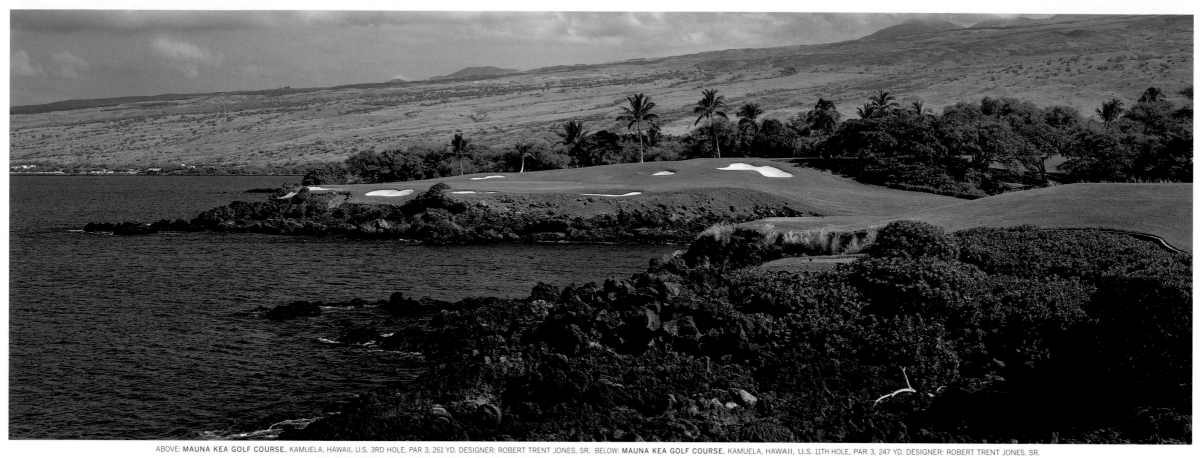

ABOVE: **MAUNA KEA GOLF COURSE**, KAMUELA, HAWAII, U.S. 3RD HOLE, PAR 3, 261 YD. DESIGNER: ROBERT TRENT JONES, SR. BELOW: **MAUNA KEA GOLF COURSE**, KAMUELA, HAWAII, U.S. 11TH HOLE, PAR 3, 247 YD. DESIGNER: ROBERT TRENT JONES, SR.
FOLLOWING PAGES, 48–51: **SOUTH COURSE, MAUNA LANI**, KOHALA COAST, HAWAII, U.S. 15TH HOLE, PAR 3, 196 YD. DESIGNERS: H. FLINT, R. F. CAIN, R. NELSON.

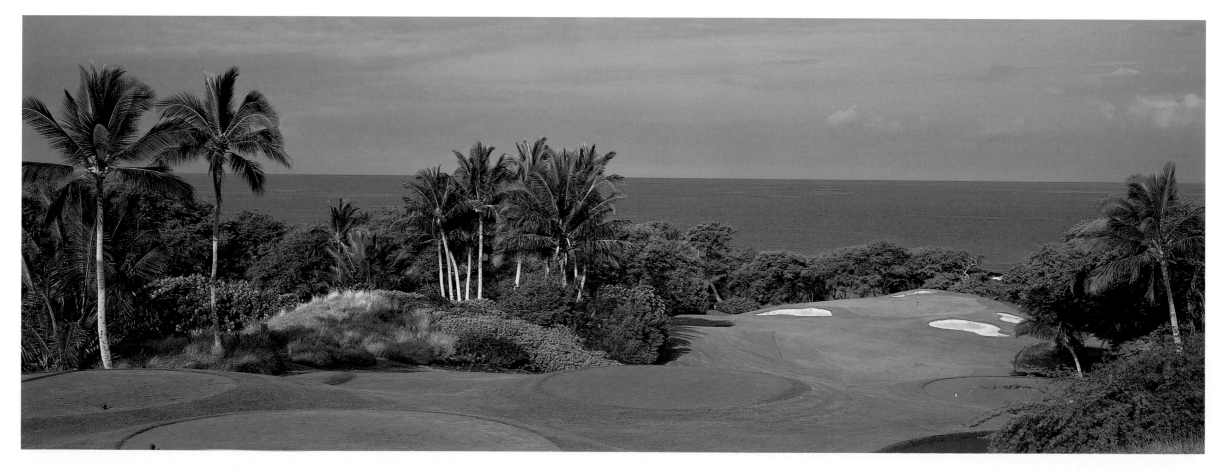

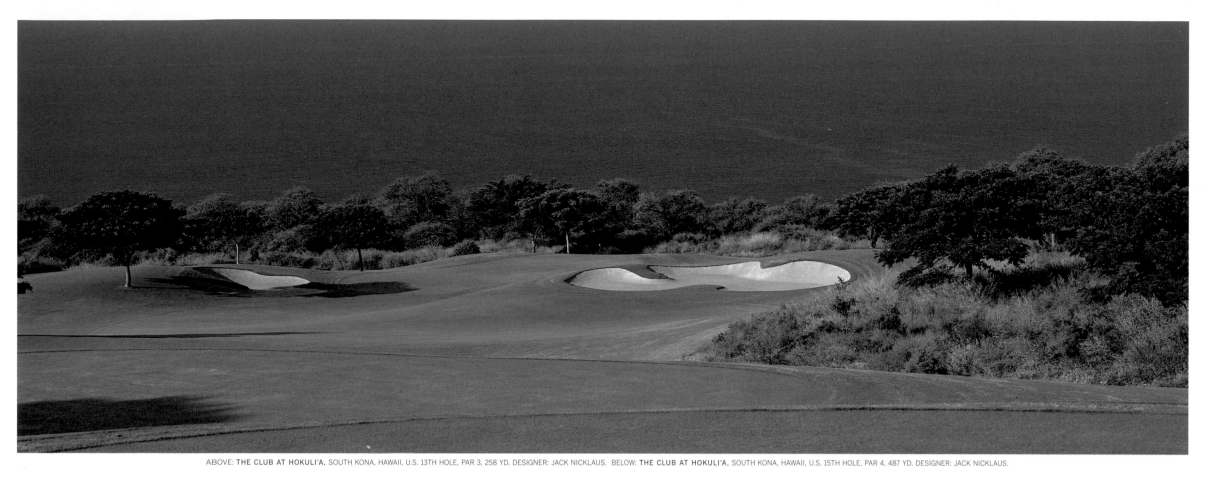

ABOVE: **THE CLUB AT HOKULI'A,** SOUTH KONA, HAWAII, U.S. 13TH HOLE, PAR 3, 258 YD. DESIGNER: JACK NICKLAUS. BELOW: **THE CLUB AT HOKULI'A,** SOUTH KONA, HAWAII, U.S. 15TH HOLE, PAR 4, 487 YD. DESIGNER: JACK NICKLAUS.

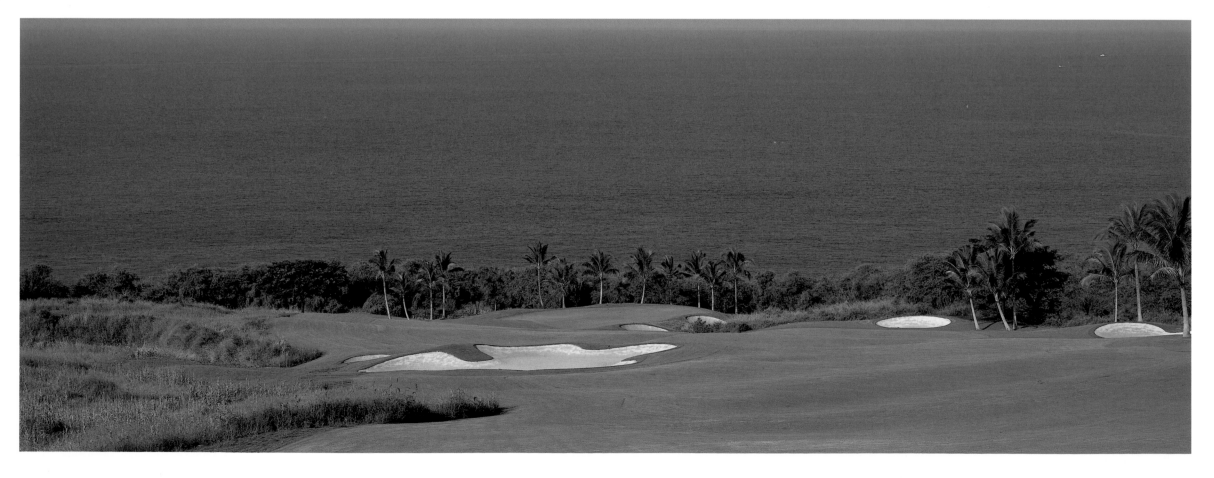

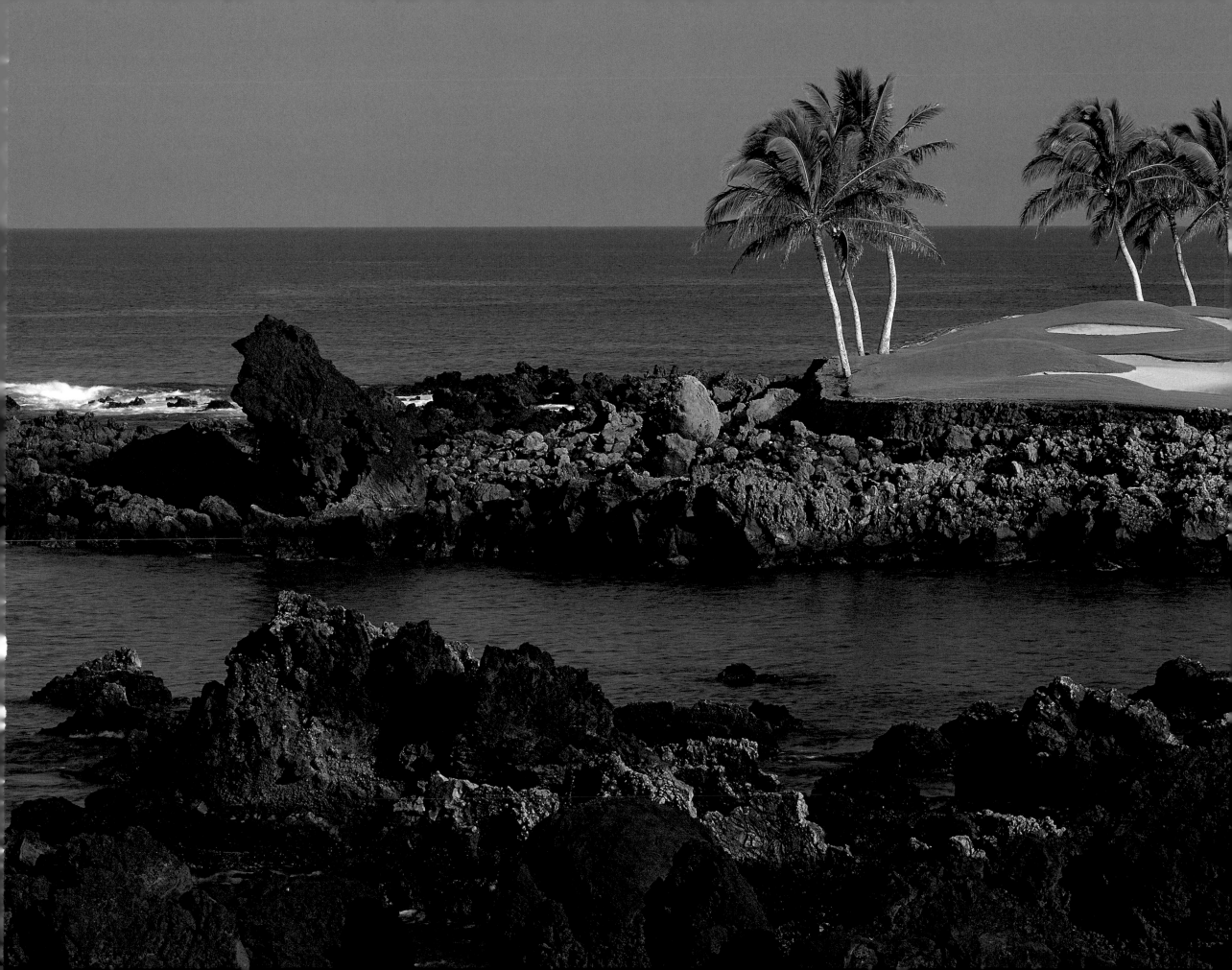

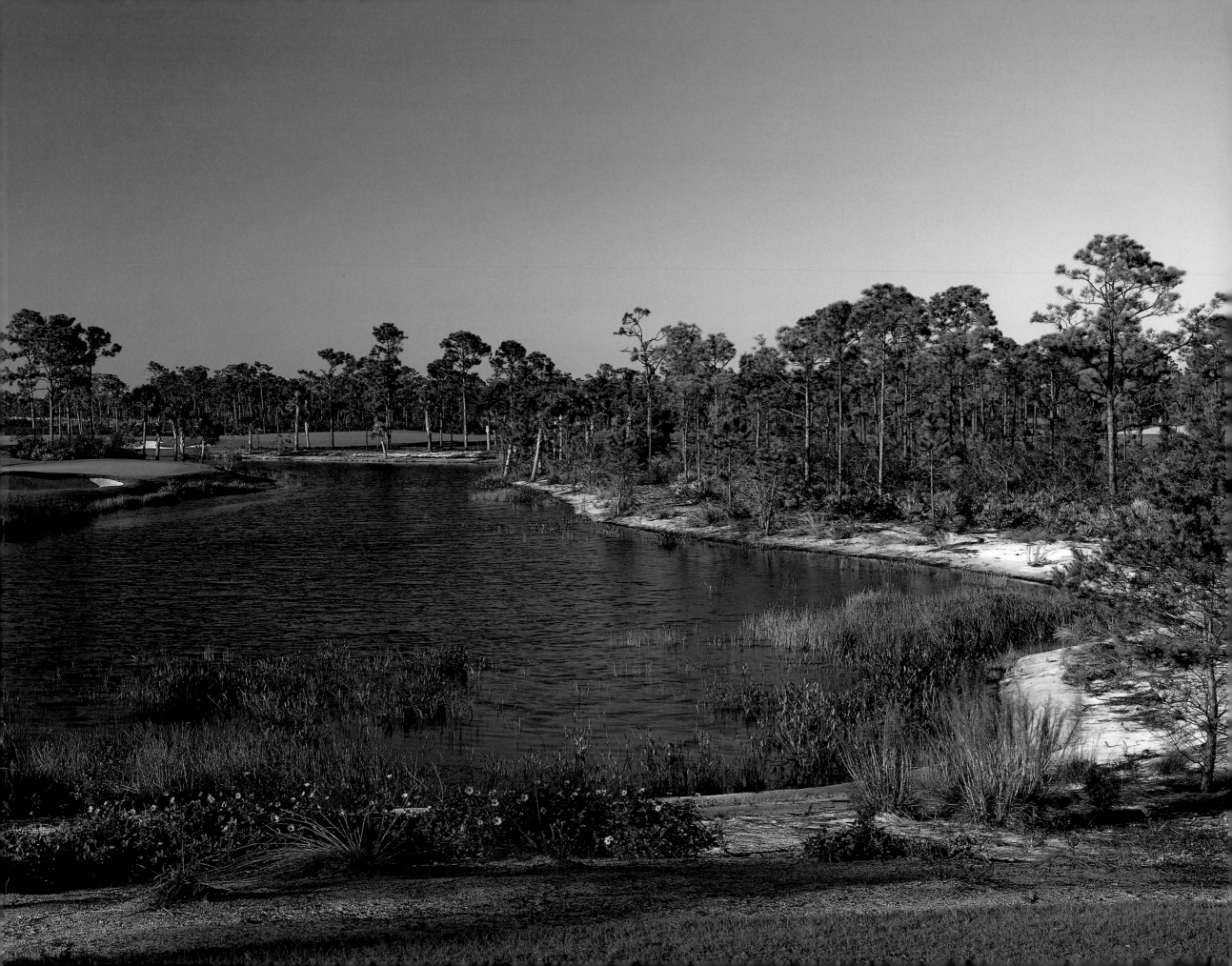

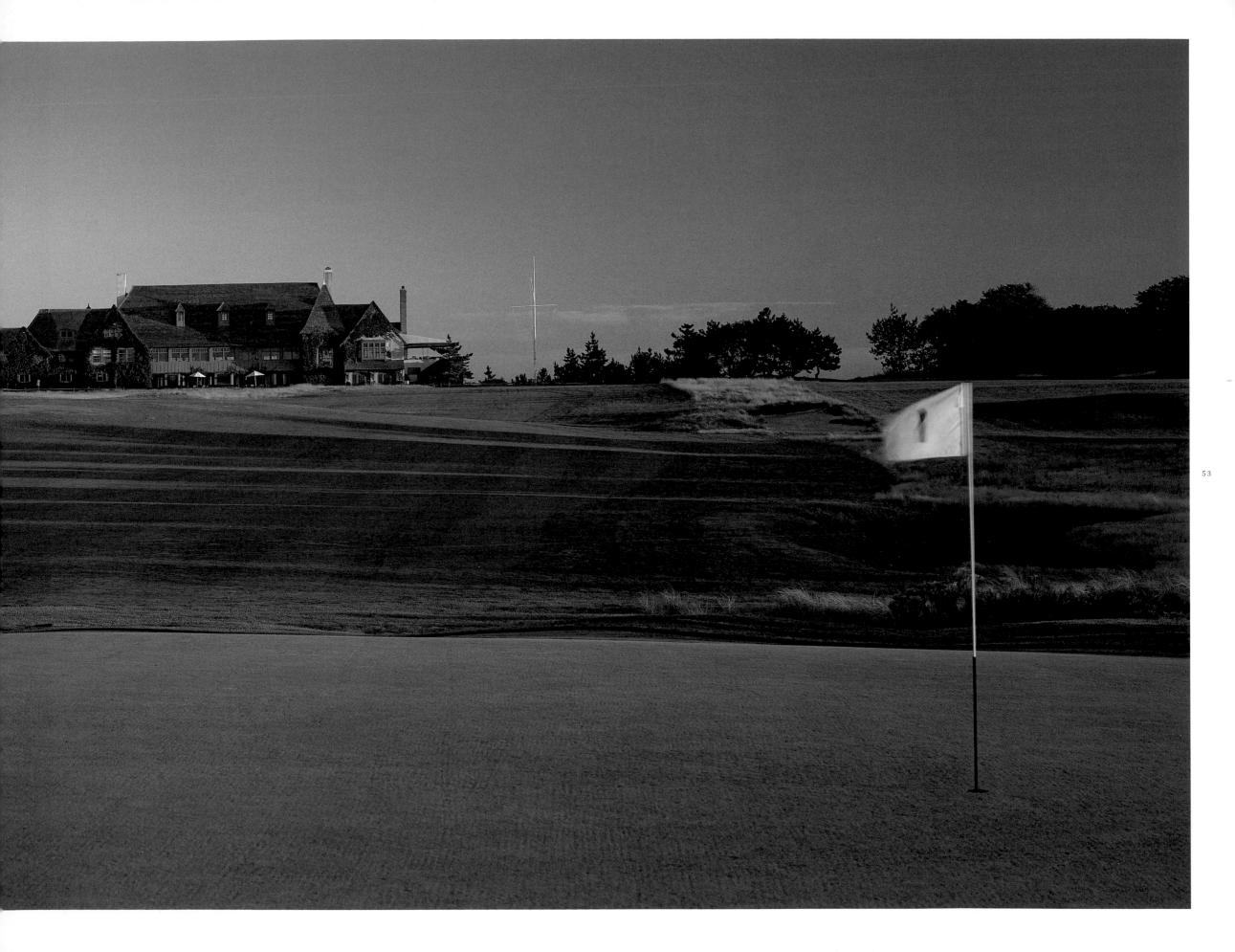

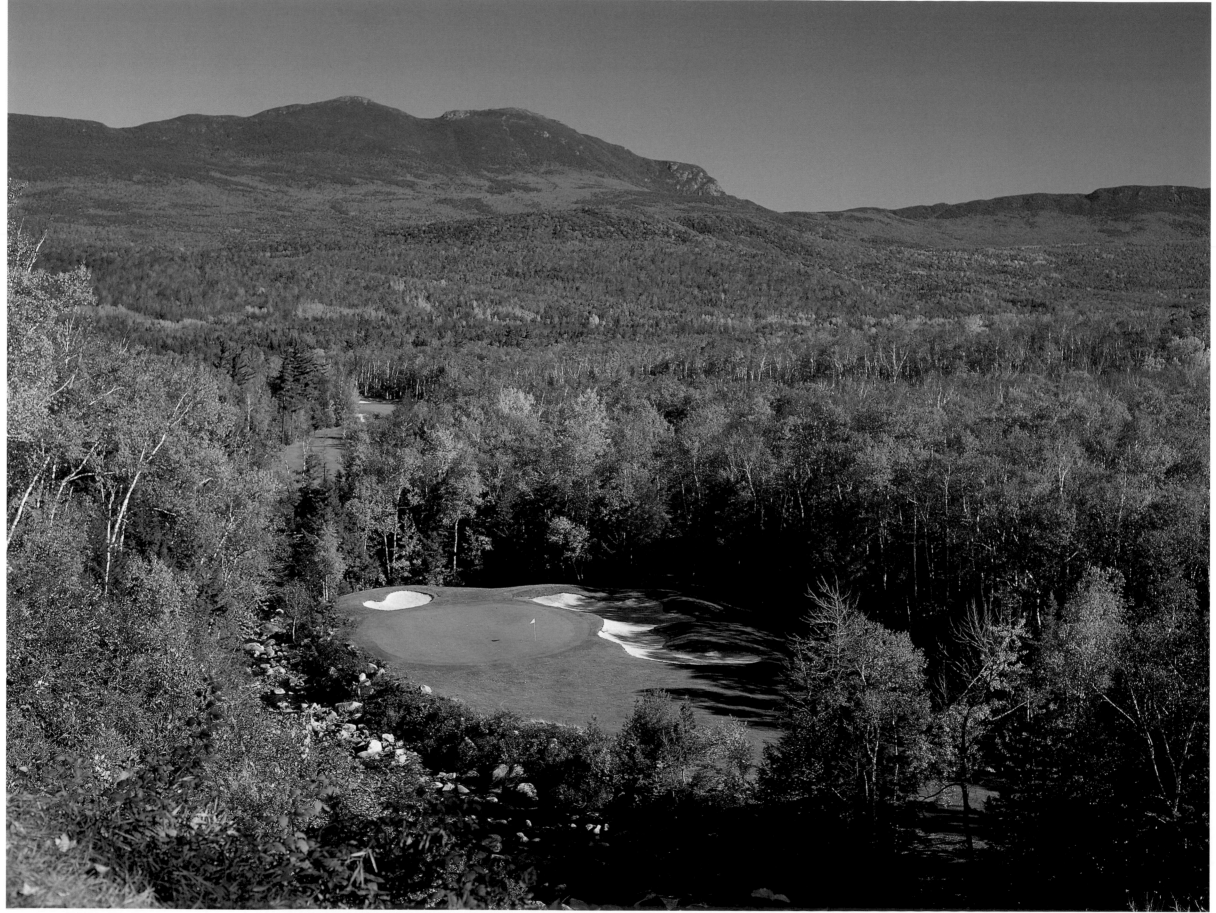

SUGARLOAF GOLF CLUB AND RESORT, CARRABASSETT VALLEY, MAINE, U.S. 11TH HOLE, PAR 3, 222 YD. DESIGNER: ROBERT TRENT JONES, JR.

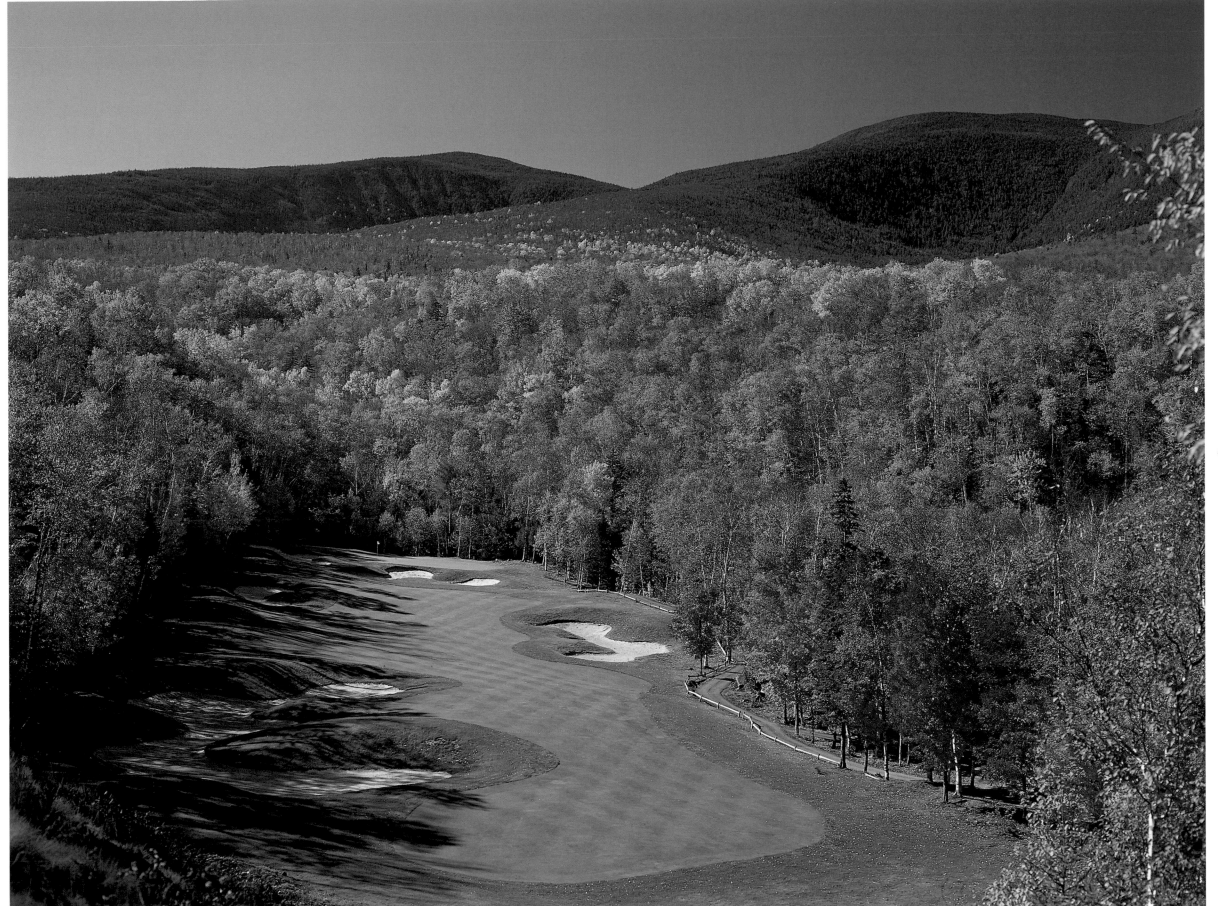

SUGARLOAF GOLF CLUB AND RESORT, CARRABASSETT VALLEY, MAINE, U.S. 10TH HOLE, PAR 4, 355 YD. DESIGNER: ROBERT TRENT JONES, JR.

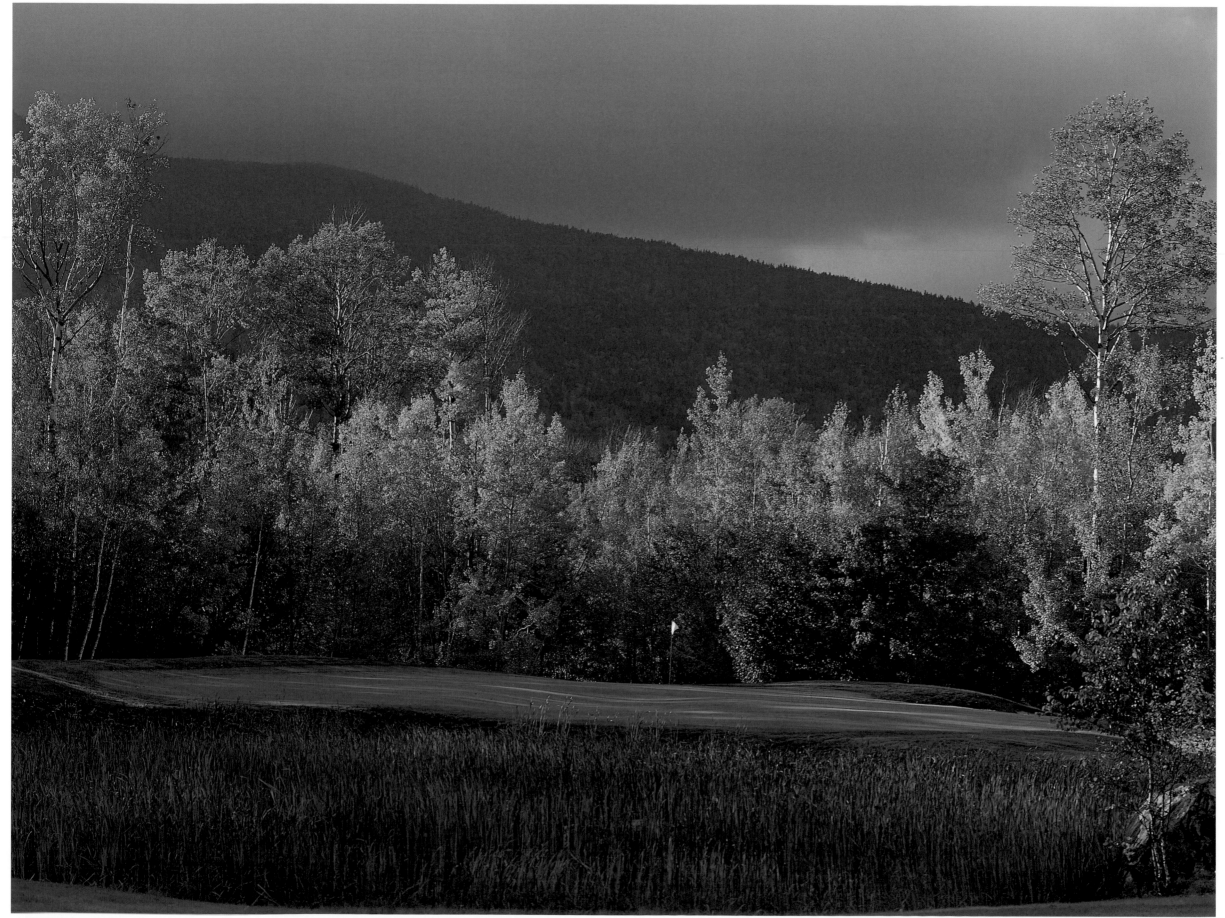

58

SUGARLOAF GOLF CLUB AND RESORT, CARRABASSETT VALLEY, MAINE, U.S. 8TH HOLE, PAR 3, 187 YD. DESIGNER: ROBERT TRENT JONES, JR.

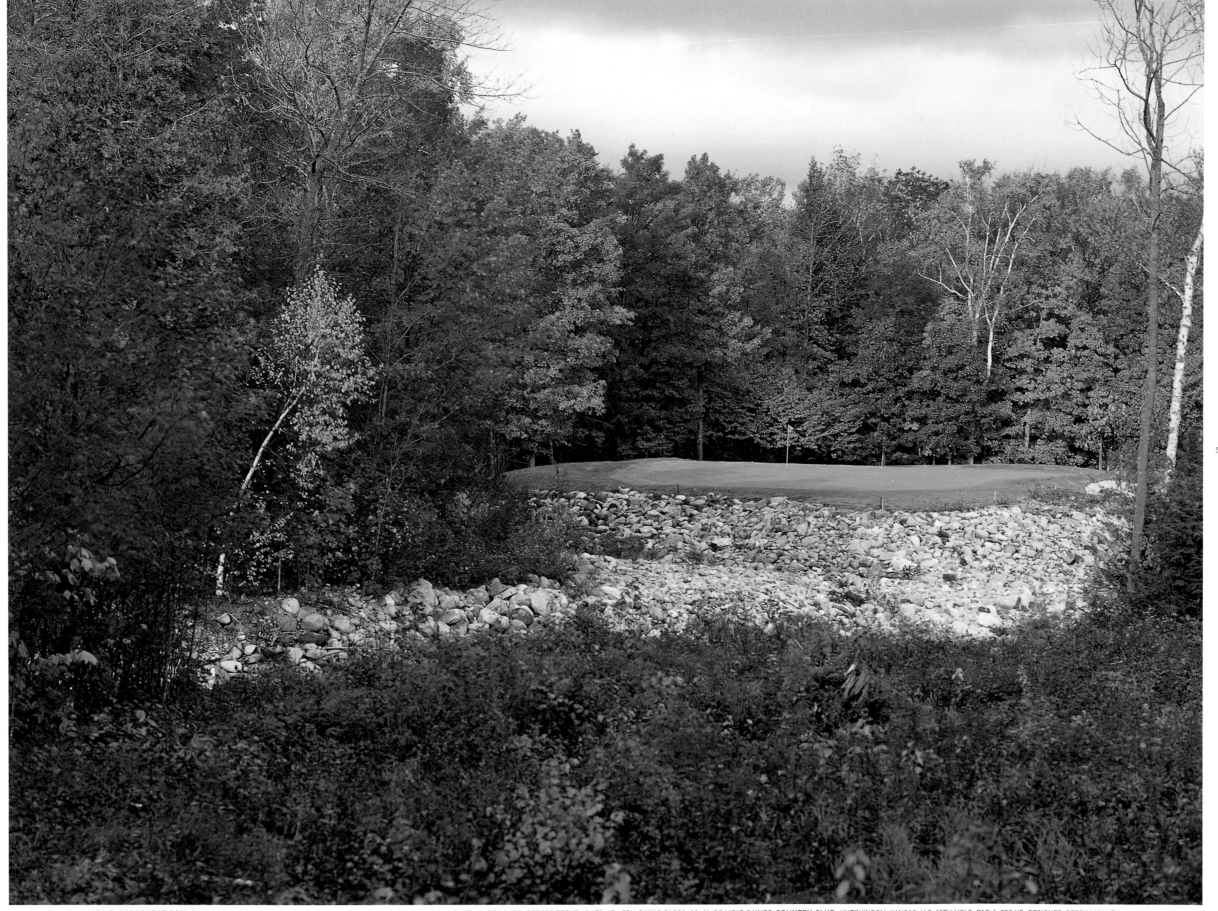

ABOVE: **SUGARLOAF GOLF CLUB AND RESORT,** CARRABASSETT VALLEY, MAINE, U.S. 15TH HOLE, PAR 3, 178 YD. DESIGNER: ROBERT TRENT JONES, JR. FOLLOWING PAGES, 60–61: **PRAIRIE DUNES COUNTRY CLUB,** HUTCHINSON, KANSAS, U.S. 12TH HOLE, PAR 4, 390 YD. DESIGNER: PERRY MAXWELL.

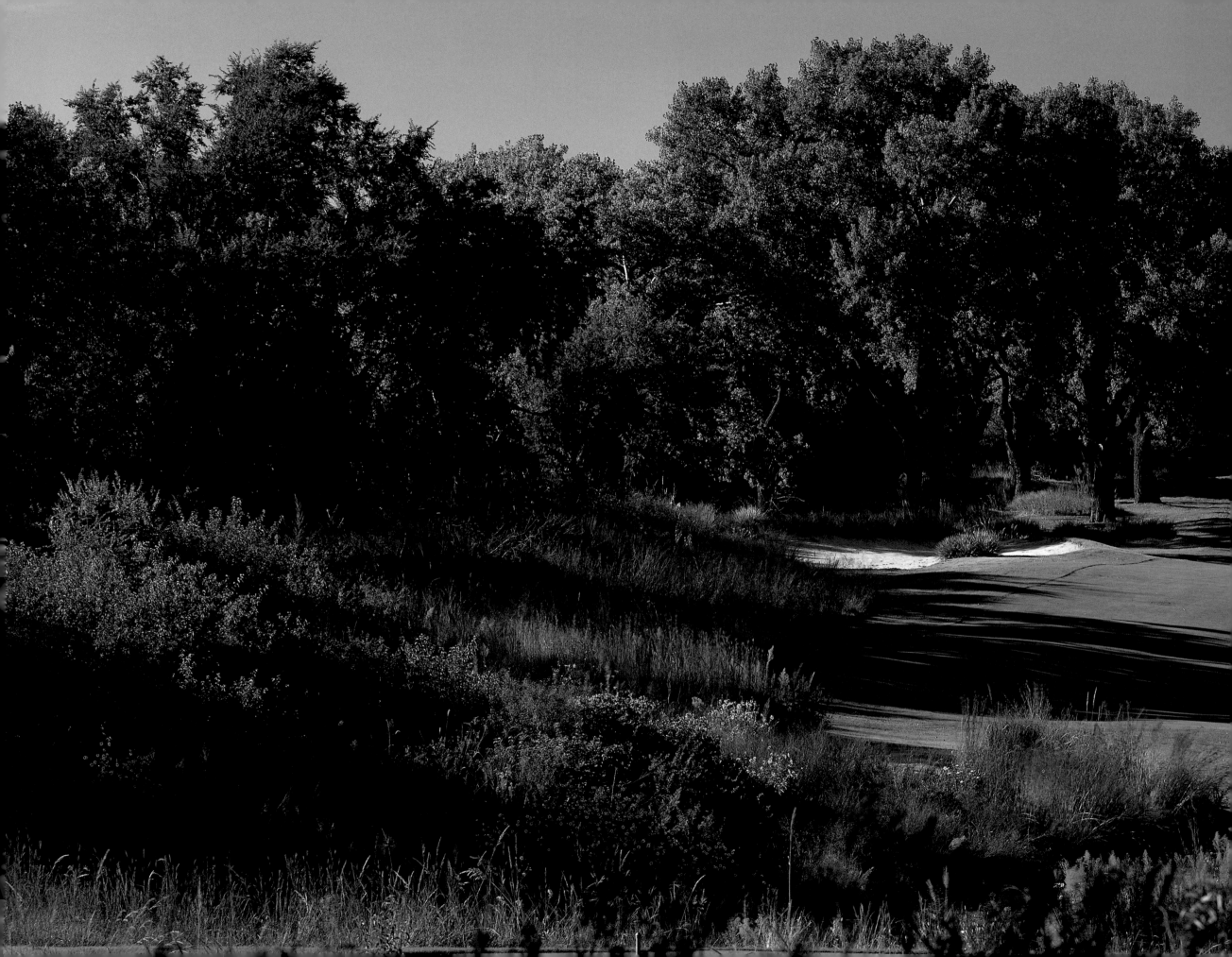

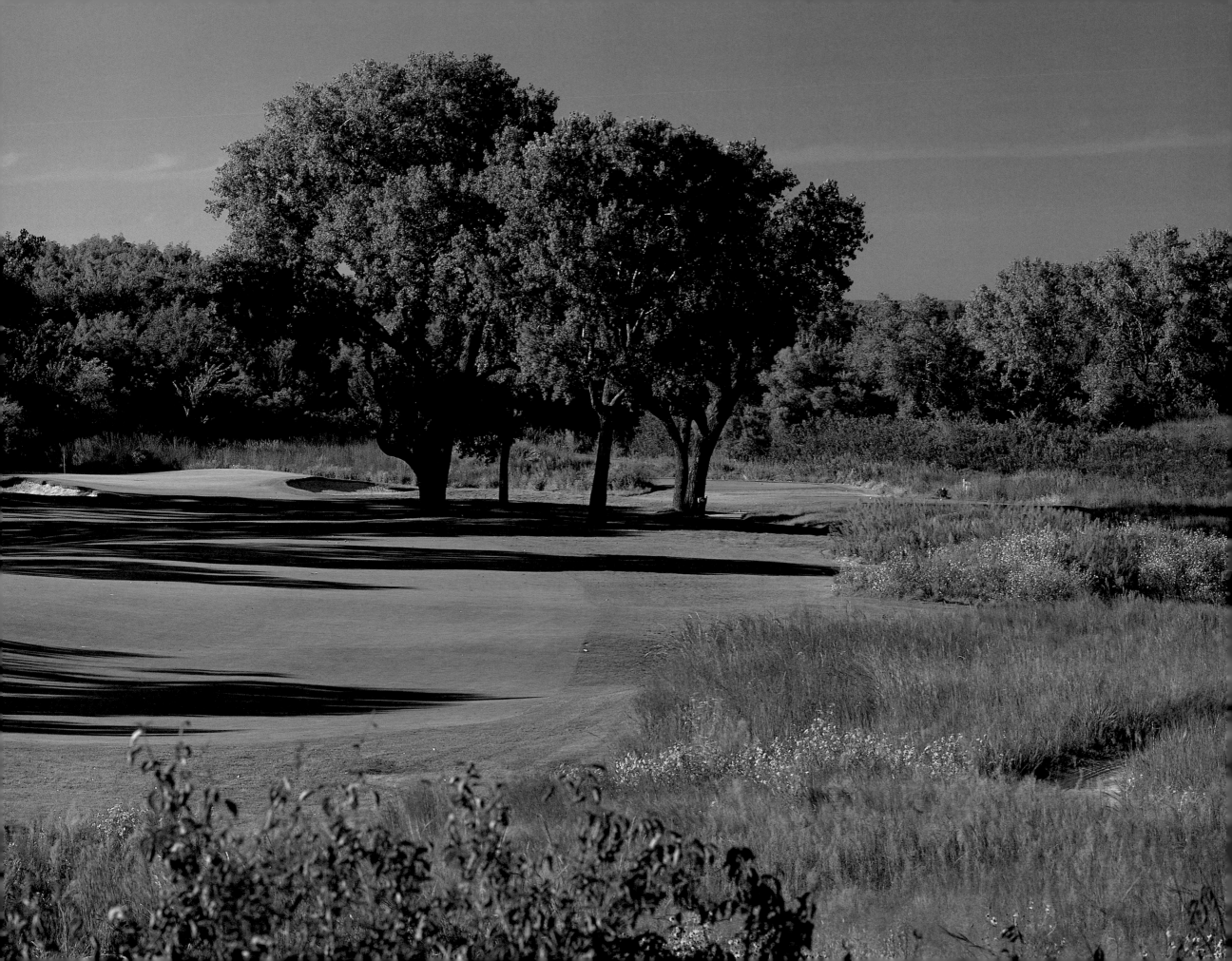

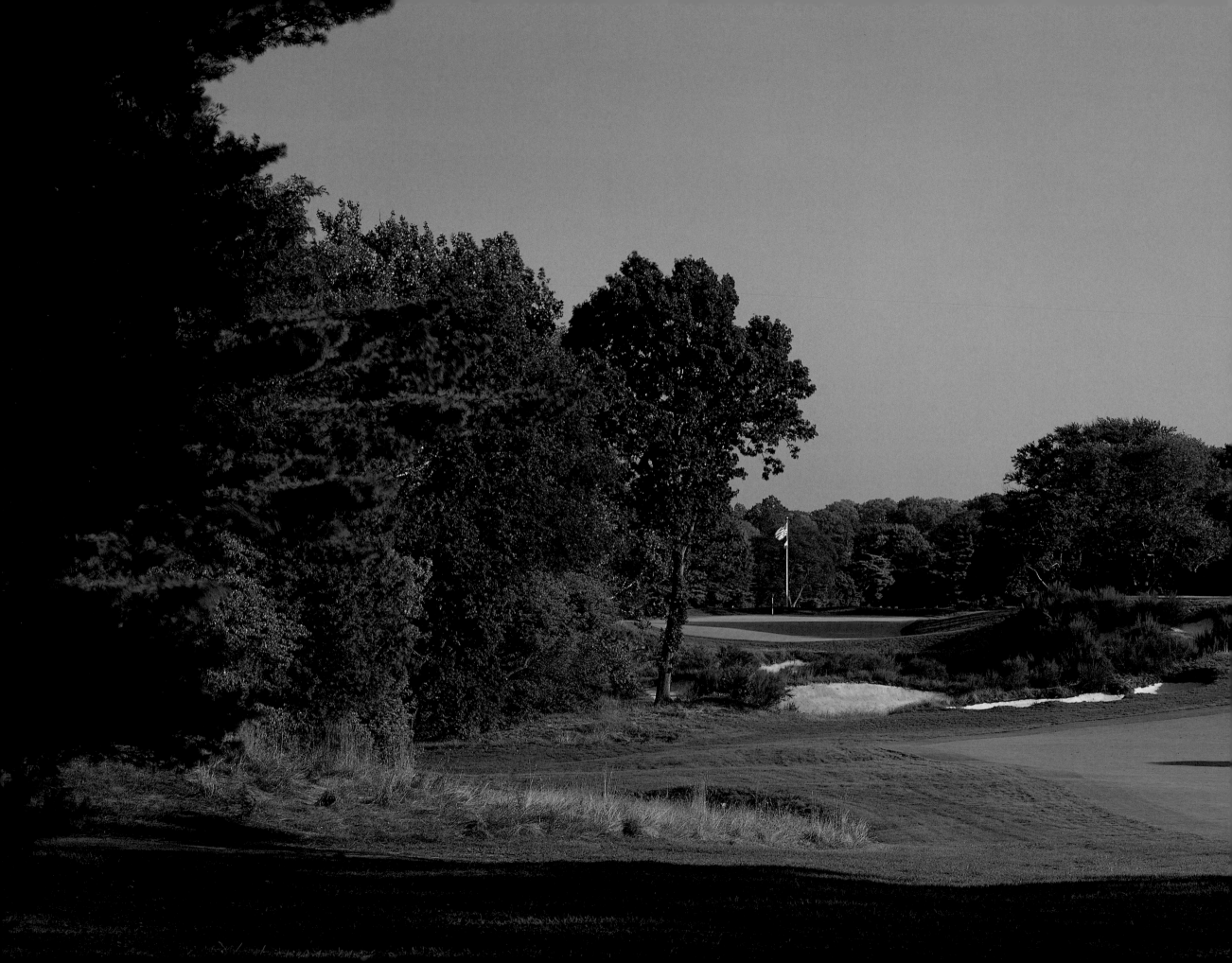

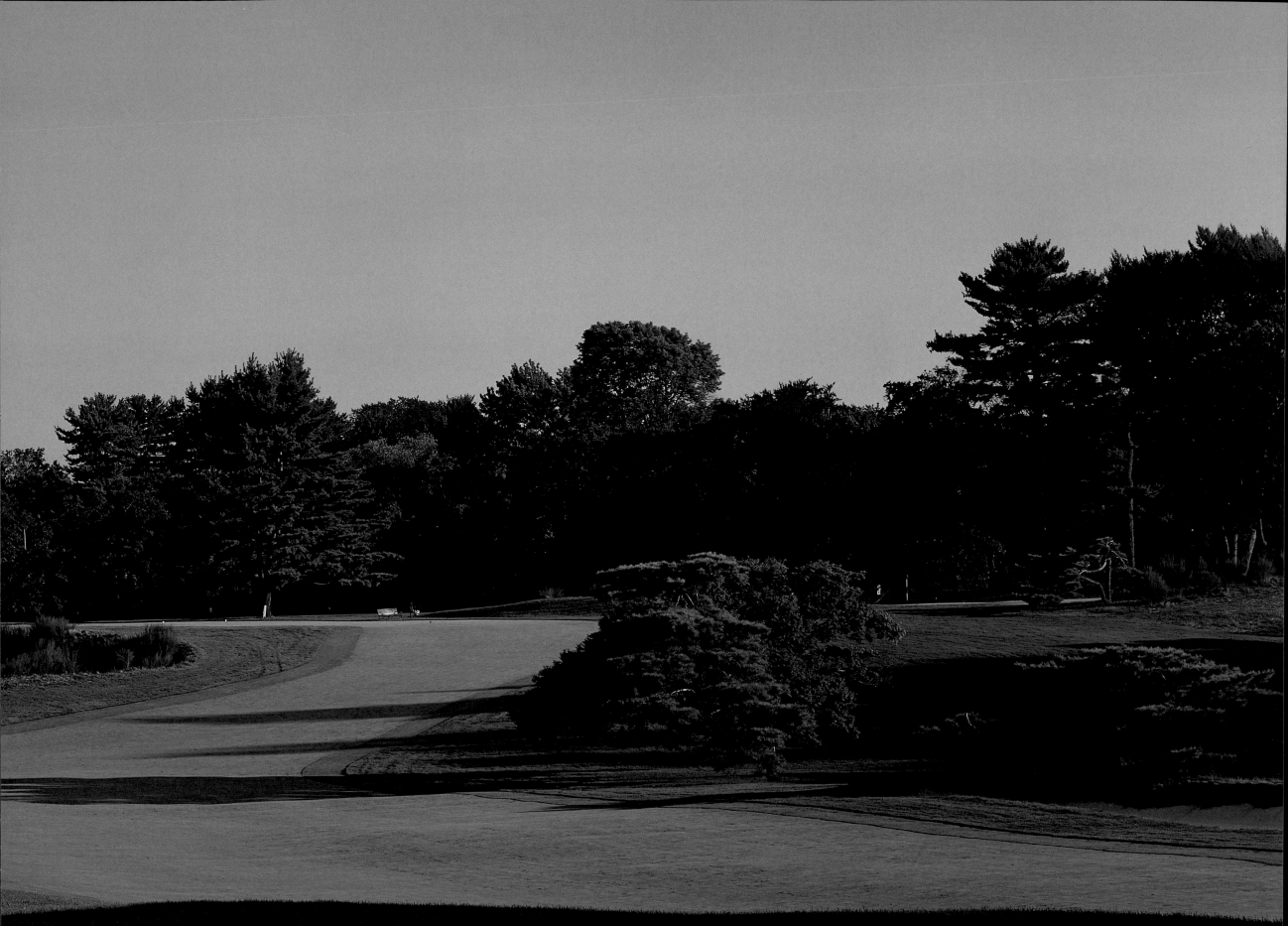

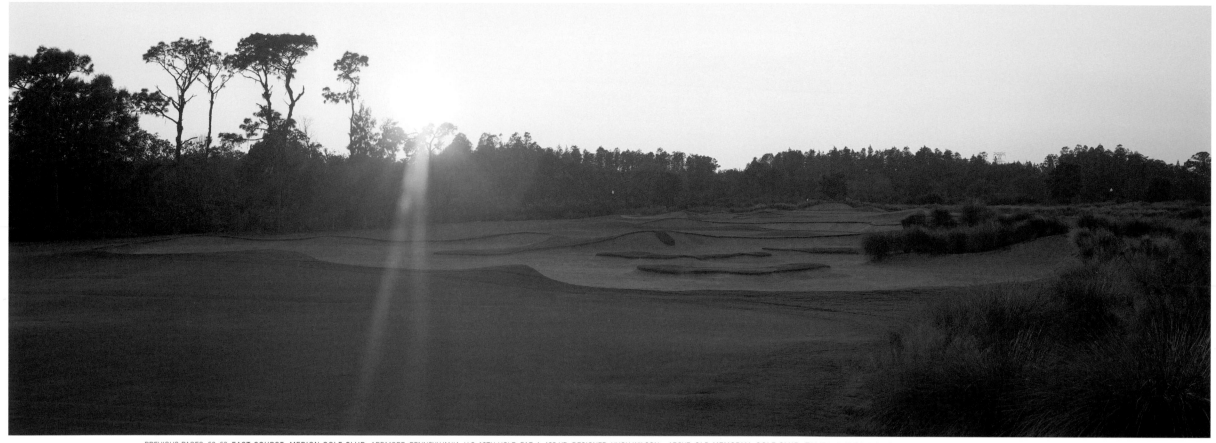

PREVIOUS PAGES, 62–63: **EAST COURSE, MERION GOLF CLUB**, ARDMORE, PENNSYLVANIA, U.S. 16TH HOLE, PAR 4, 428 YD. DESIGNER: HUGH WILSON. ABOVE: **OLD MEMORIAL GOLF CLUB**, TAMPA, FLORIDA, U.S. 9TH HOLE, PAR 5, 562 YD. DESIGNER: STEVE SMYERS.

64

BELOW LEFT: **OLD MEMORIAL GOLF CLUB**, TAMPA, FLORIDA, U.S. 9TH HOLE, PAR 5, 562 YD. DESIGNER: STEVE SMYERS. BELOW RIGHT: **OLD MEMORIAL GOLF CLUB**, TAMPA, FLORIDA, U.S. 11TH HOLE, PAR 3, 211 YD. DESIGNER: STEVE SMYERS.

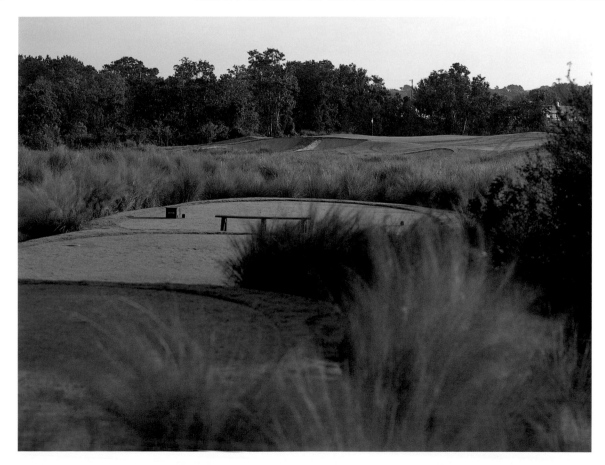

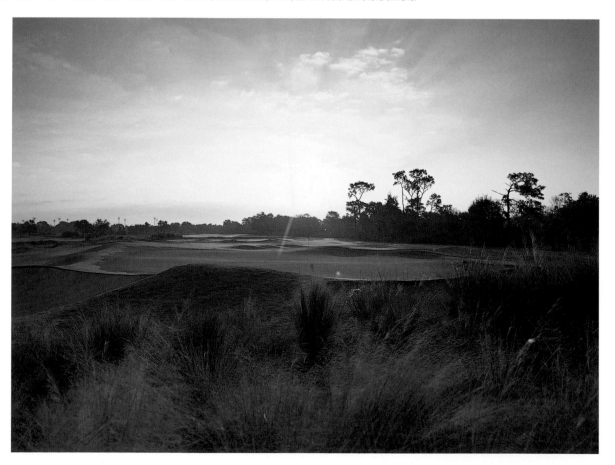

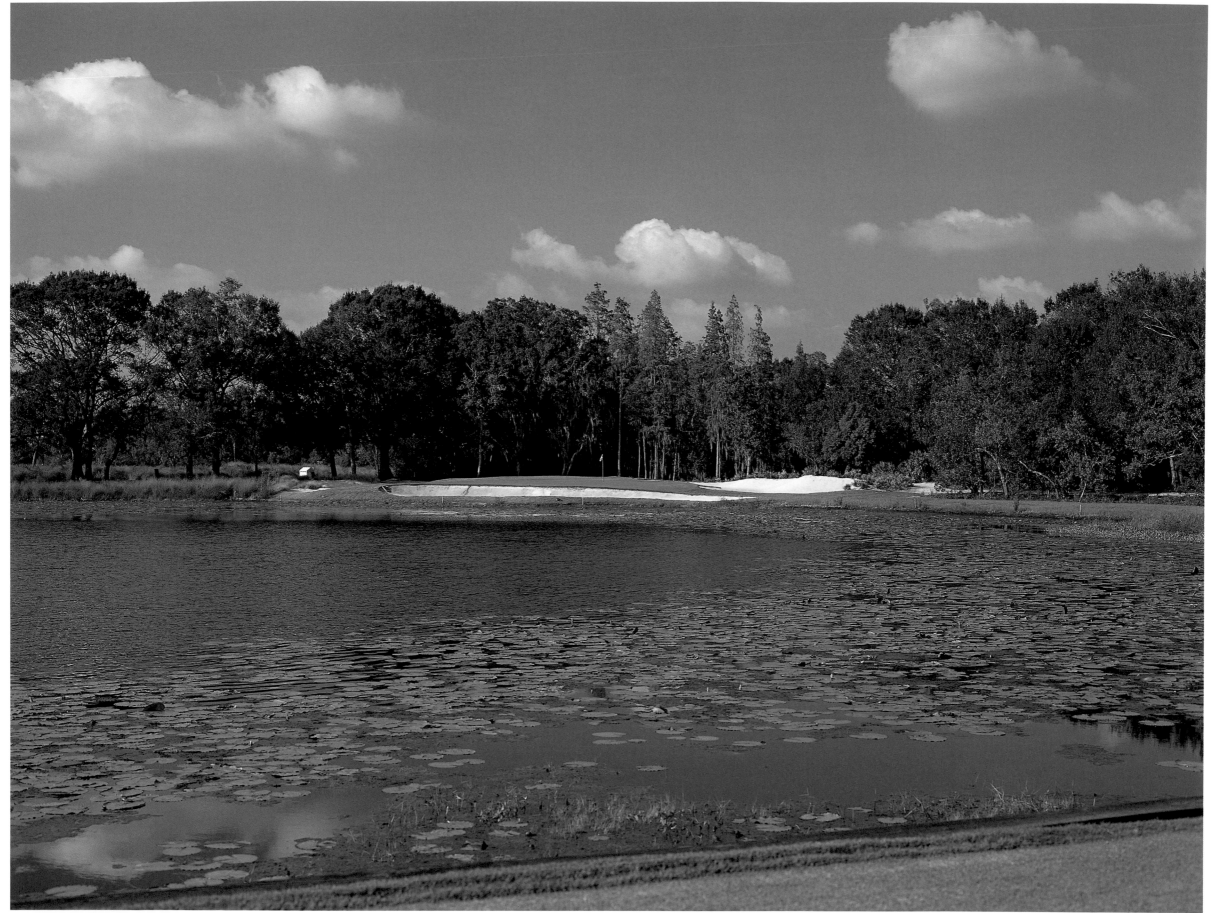

OLD MEMORIAL GOLF CLUB, TAMPA, FLORIDA, U.S. 6TH HOLE, PAR 3, 164 YD. DESIGNER: STEVE SMYERS.

66

OLD WHITE COURSE, THE GREENBRIER, WHITE SULPHUR SPRINGS, WEST VIRGINIA, U.S. 1ST HOLE, PAR 4, 449 YD. DESIGNERS: CHARLES BLAIR MACDONALD, SETH RAYNOR.

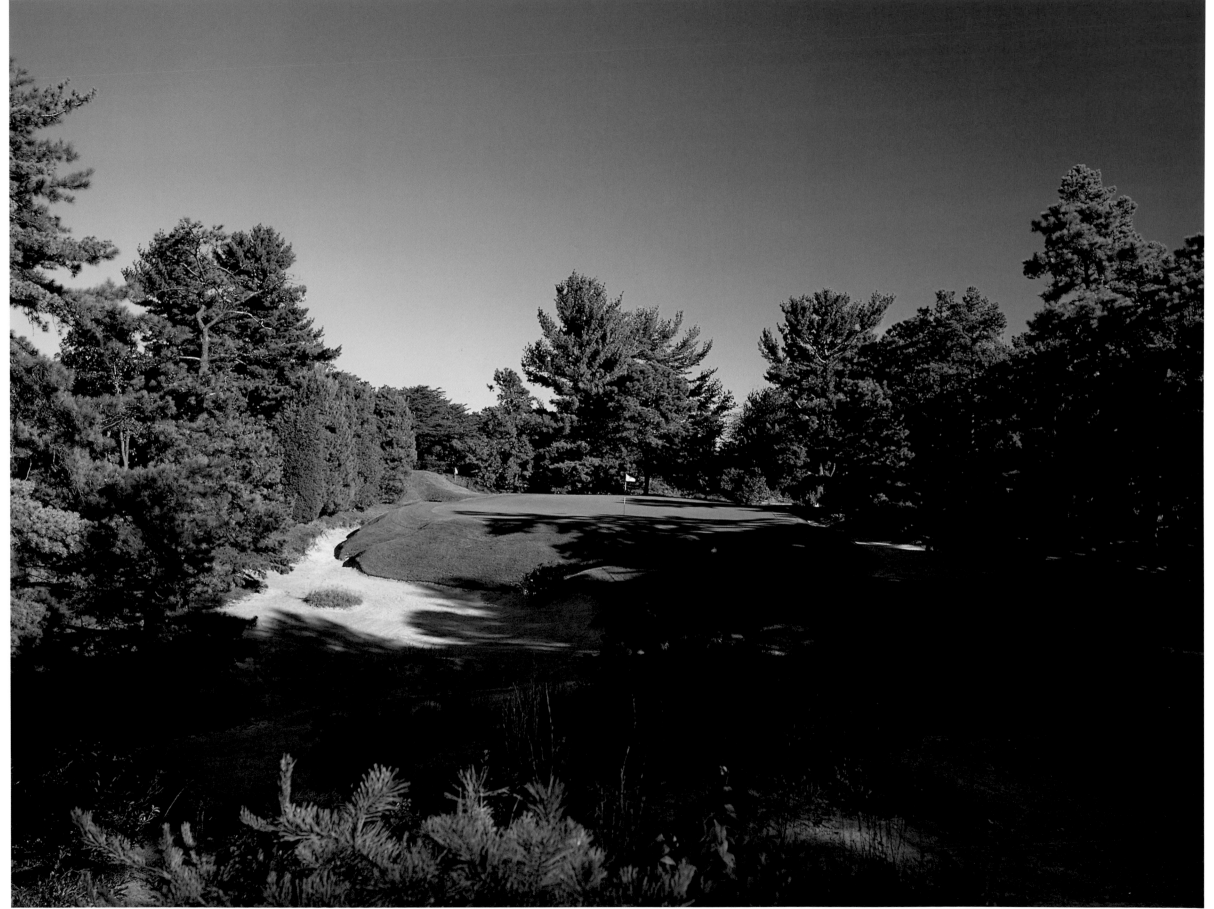

PINE VALLEY COURSE, PINE VALLEY GOLF CLUB, PINE VALLEY, NEW JERSEY, U.S. 10TH HOLE, PAR 3, 145 YD. DESIGNERS: GEORGE CRUMP, HARRY S. COLT, C. H. ALISON, AND OTHERS.

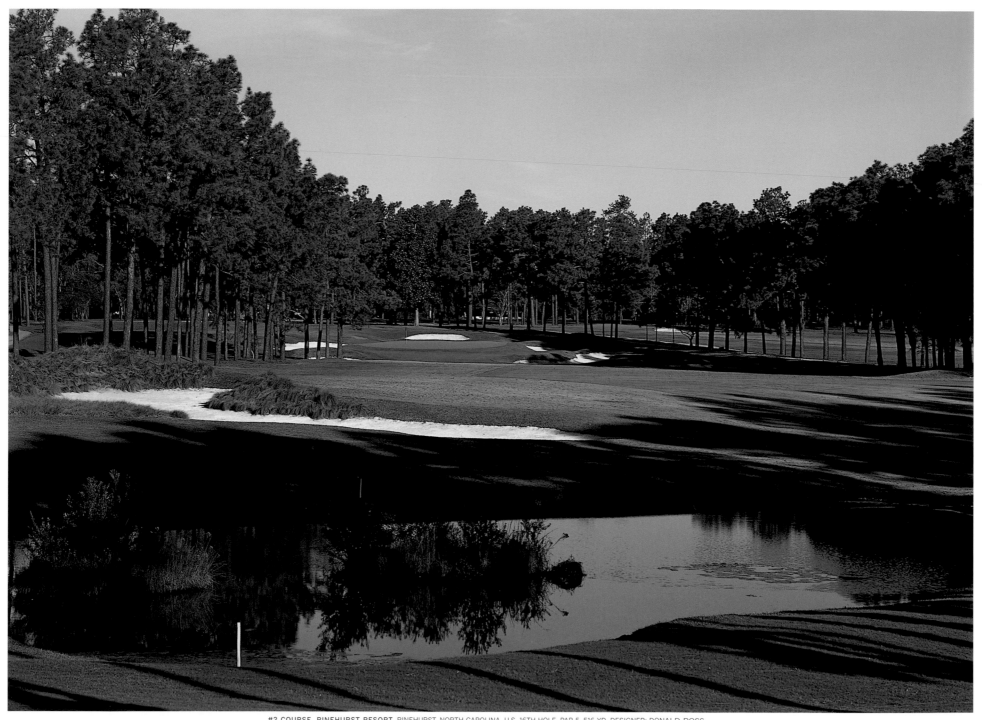

#2 COURSE, PINEHURST RESORT, PINEHURST, NORTH CAROLINA, U.S. 16TH HOLE, PAR 5, 516 YD. DESIGNER: DONALD ROSS.

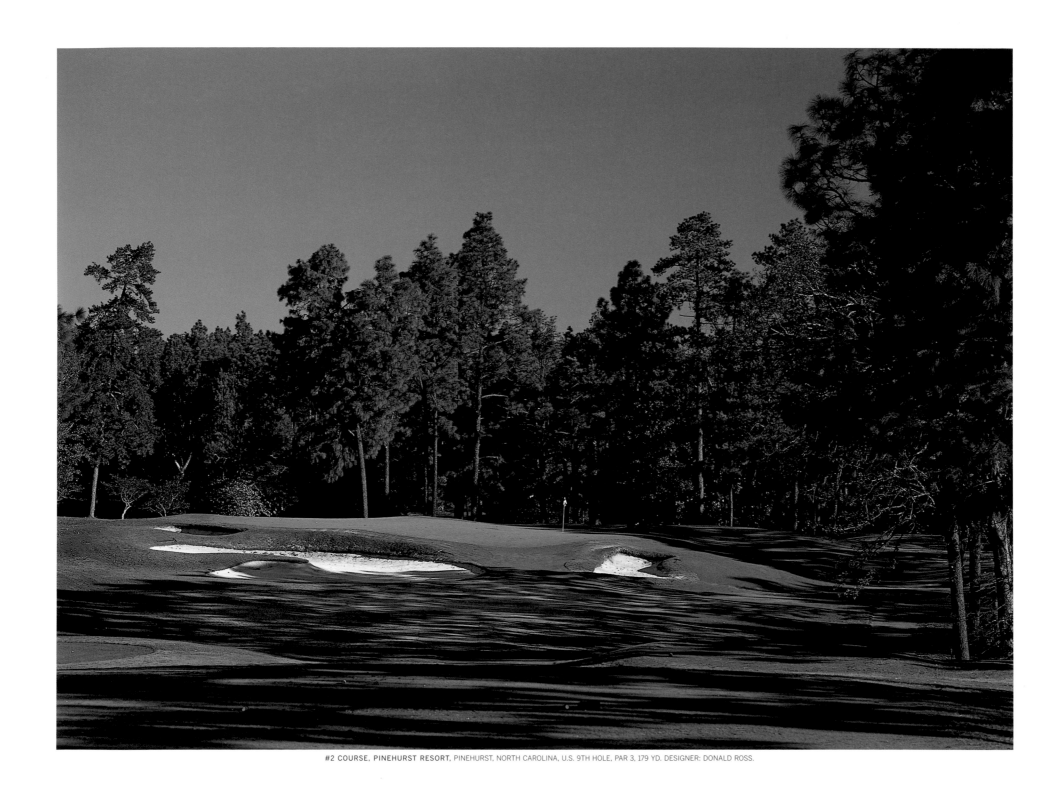

#2 COURSE, PINEHURST RESORT, PINEHURST, NORTH CAROLINA, U.S. 9TH HOLE, PAR 3, 179 YD. DESIGNER: DONALD ROSS.

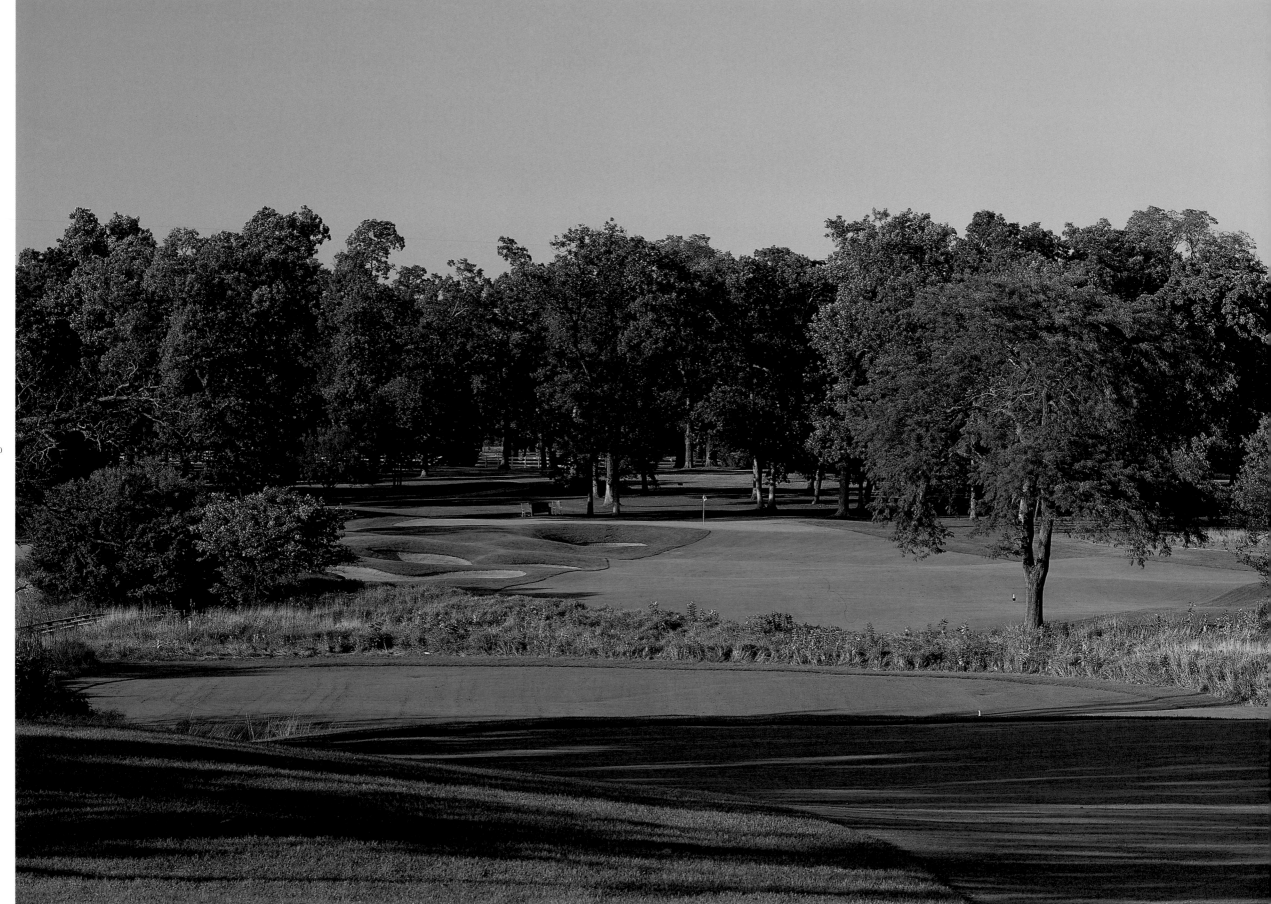

70

RICH HARVEST LINKS COURSE, THE PLANTATION AT RICH HARVEST FARMS, SUGAR GROVE, ILLINOIS, U.S. 9TH HOLE, PAR 5, 532 YD. DESIGNER: JERRY RICH.

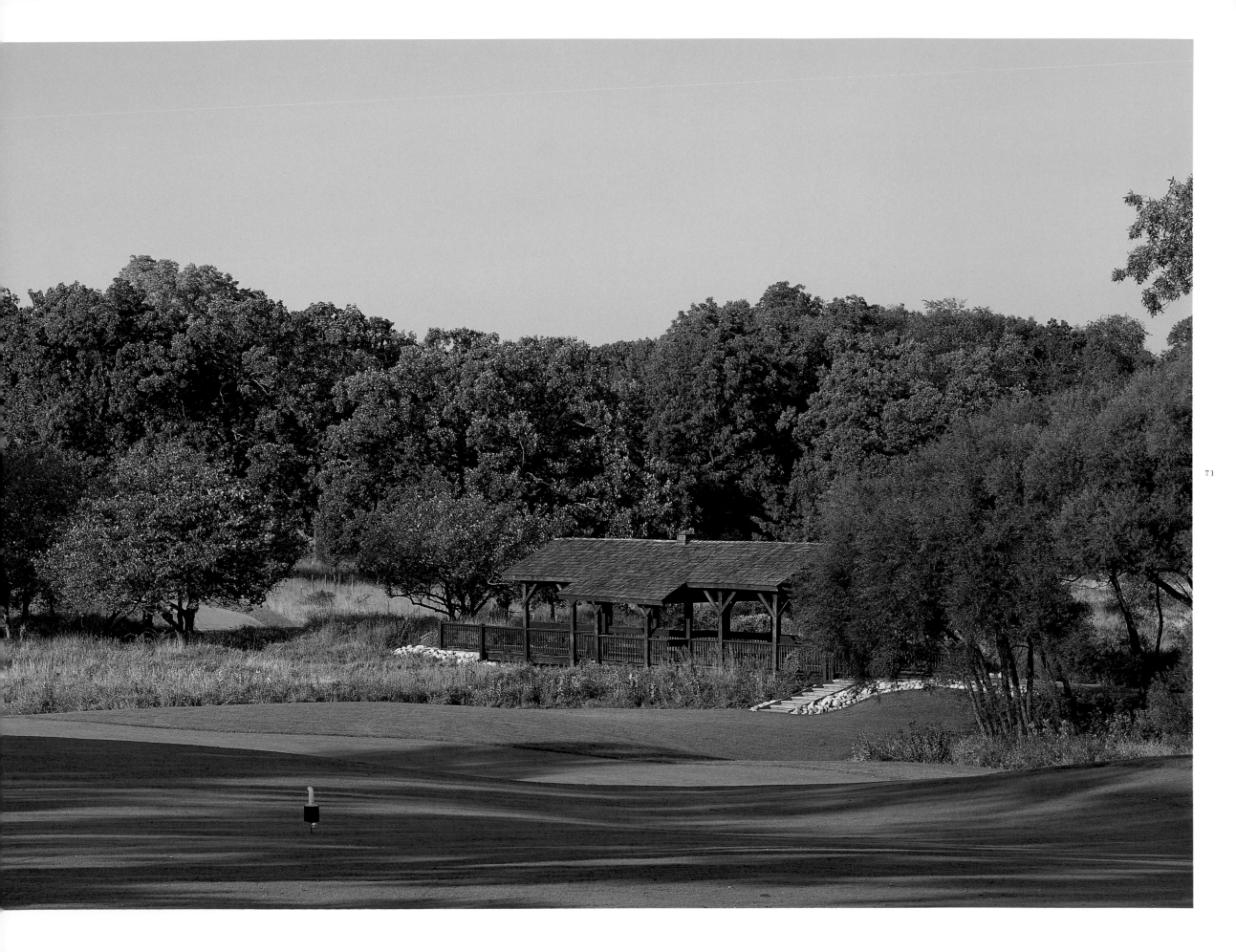

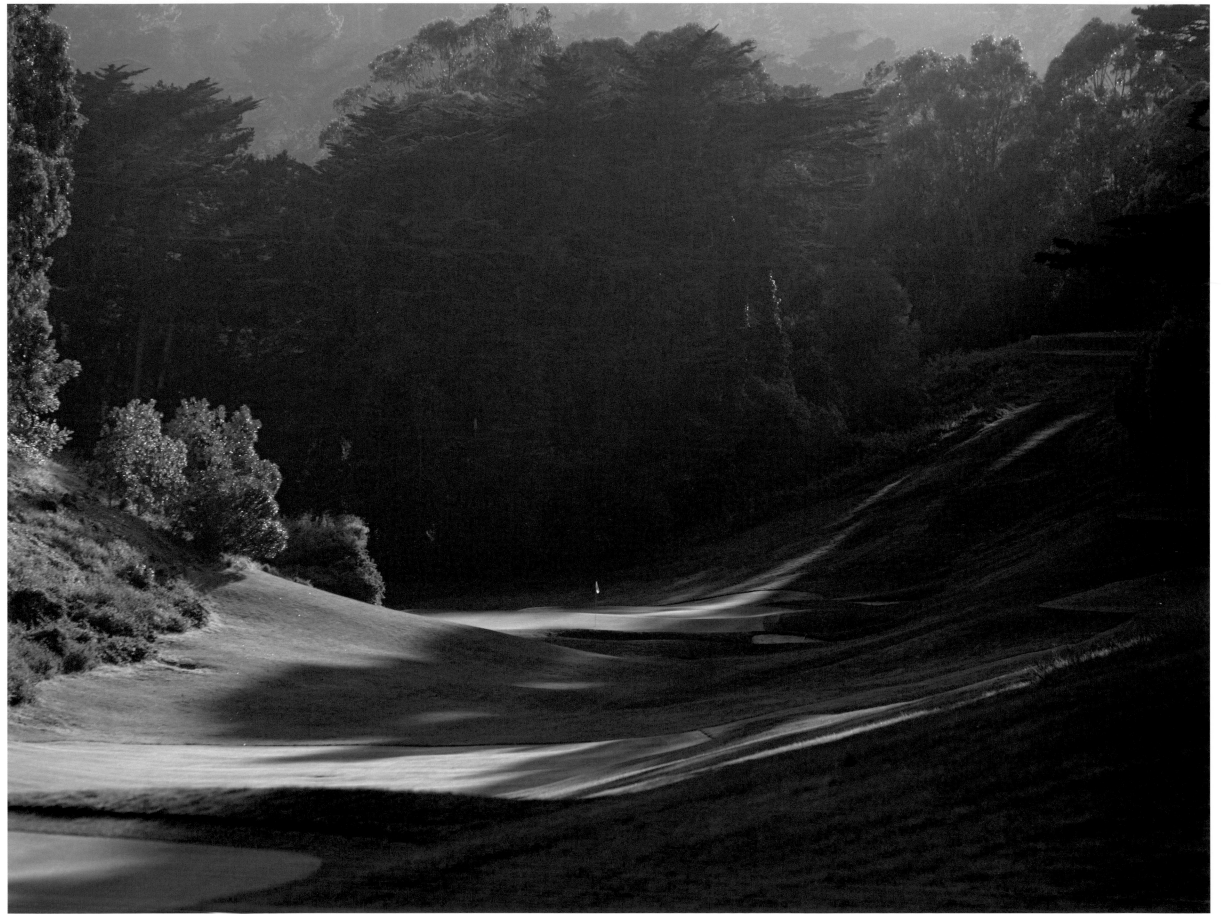

72

SAN FRANCISCO GOLF CLUB, SAN FRANCISCO, CALIFORNIA, U.S. 7TH HOLE (8TH HOLE IN FOREGROUND), PAR 3, 189 YD. DESIGNER: A. W. TILLINGHAST.

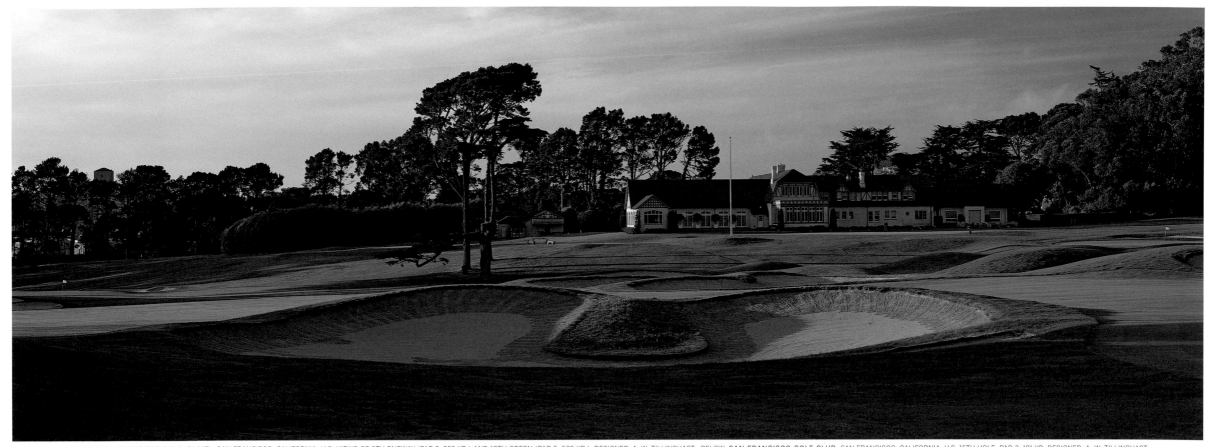

ABOVE: **SAN FRANCISCO GOLF CLUB,** SAN FRANCISCO, CALIFORNIA, U.S. VIEWS OF 9TH FAIRWAY (PAR 5, 582 YD.) AND 18TH GREEN (PAR 5, 530 YD.). DESIGNER: A. W. TILLINGHAST. BELOW: **SAN FRANCISCO GOLF CLUB,** SAN FRANCISCO, CALIFORNIA, U.S. 15TH HOLE, PAR 3, 181 YD. DESIGNER: A. W. TILLINGHAST.

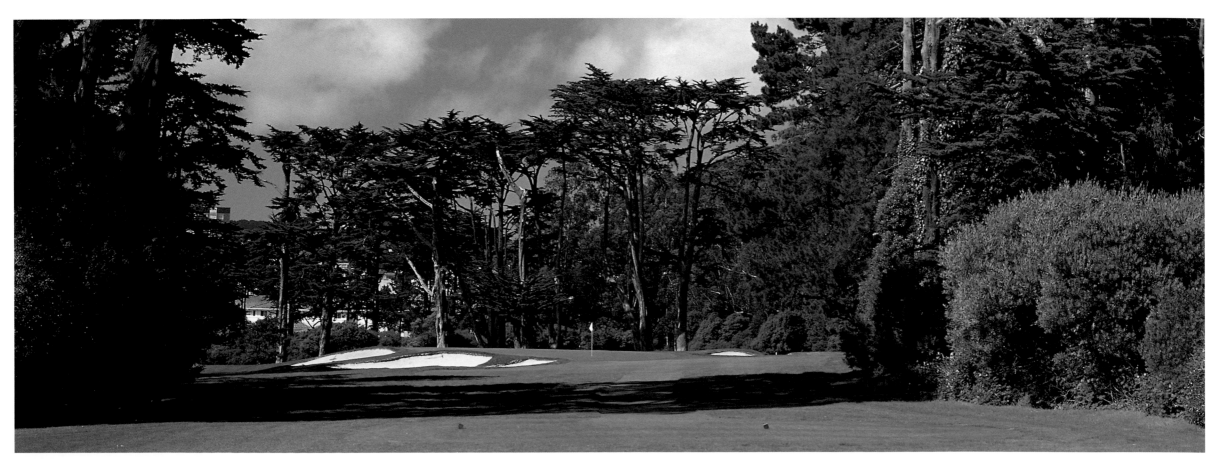

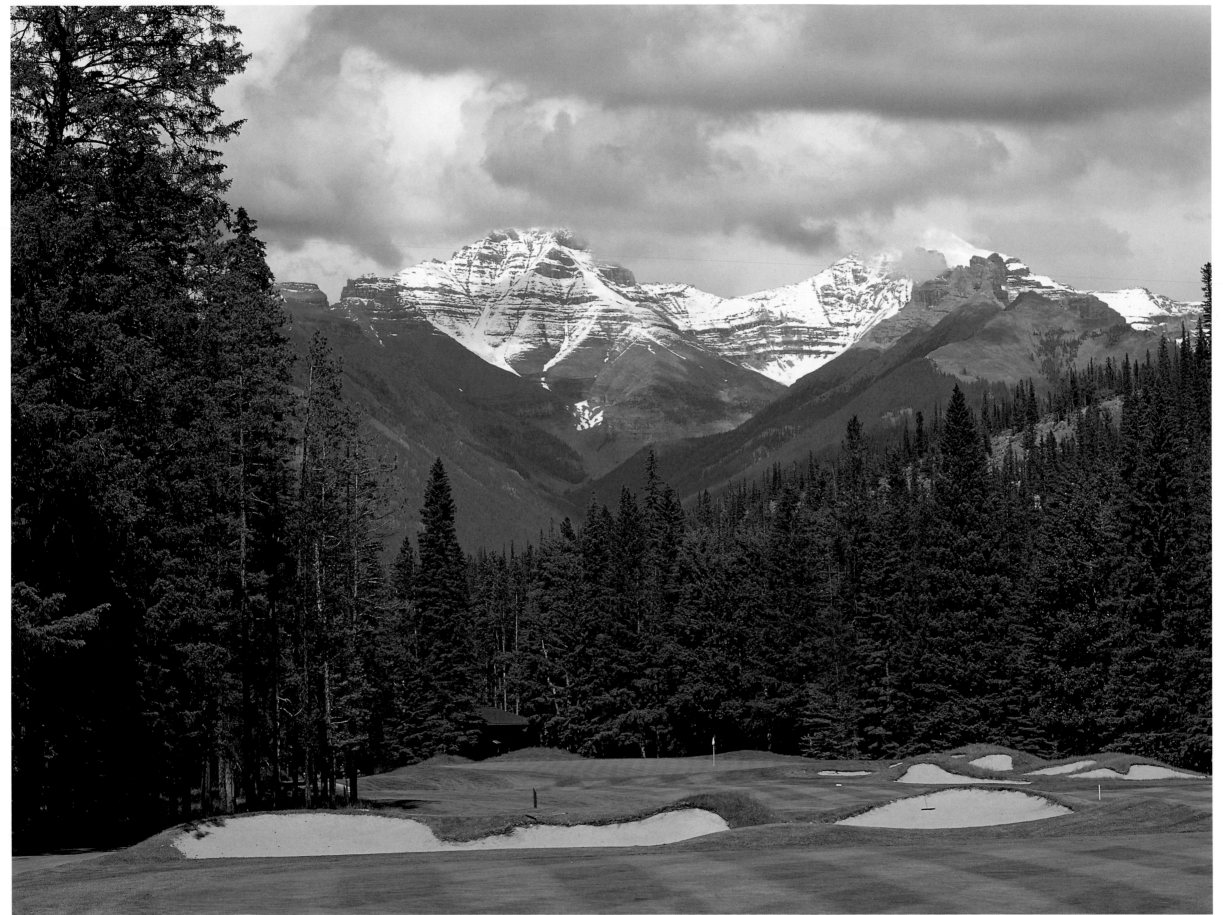

74

STANLEY THOMPSON COURSE, FAIRMONT BANFF SPRINGS RESORT, BANFF, ALBERTA, CANADA. 16TH HOLE, PAR 4, 421 YD. DESIGNER: STANLEY THOMPSON.

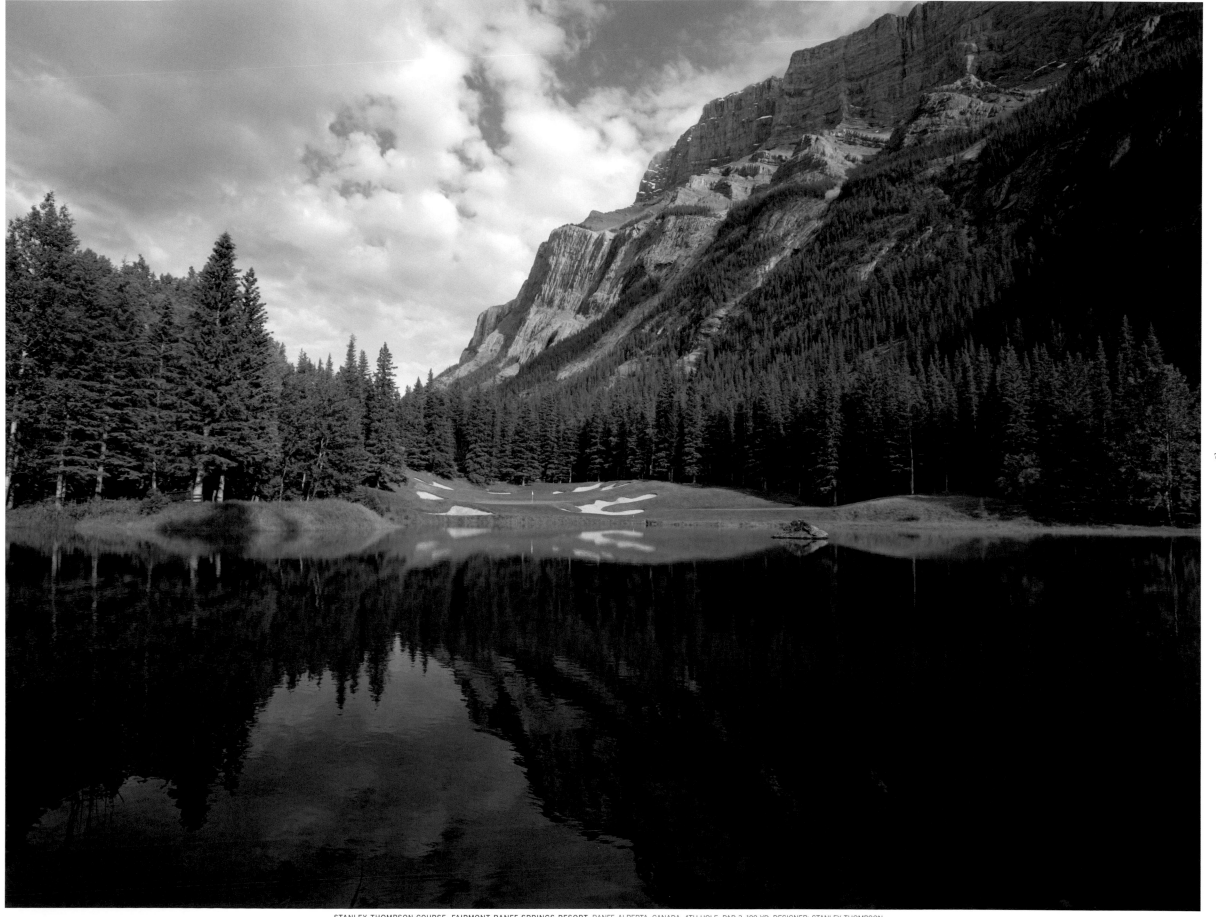

STANLEY THOMPSON COURSE, FAIRMONT BANFF SPRINGS RESORT, BANFF, ALBERTA, CANADA. 4TH HOLE, PAR 3, 199 YD. DESIGNER: STANLEY THOMPSON.

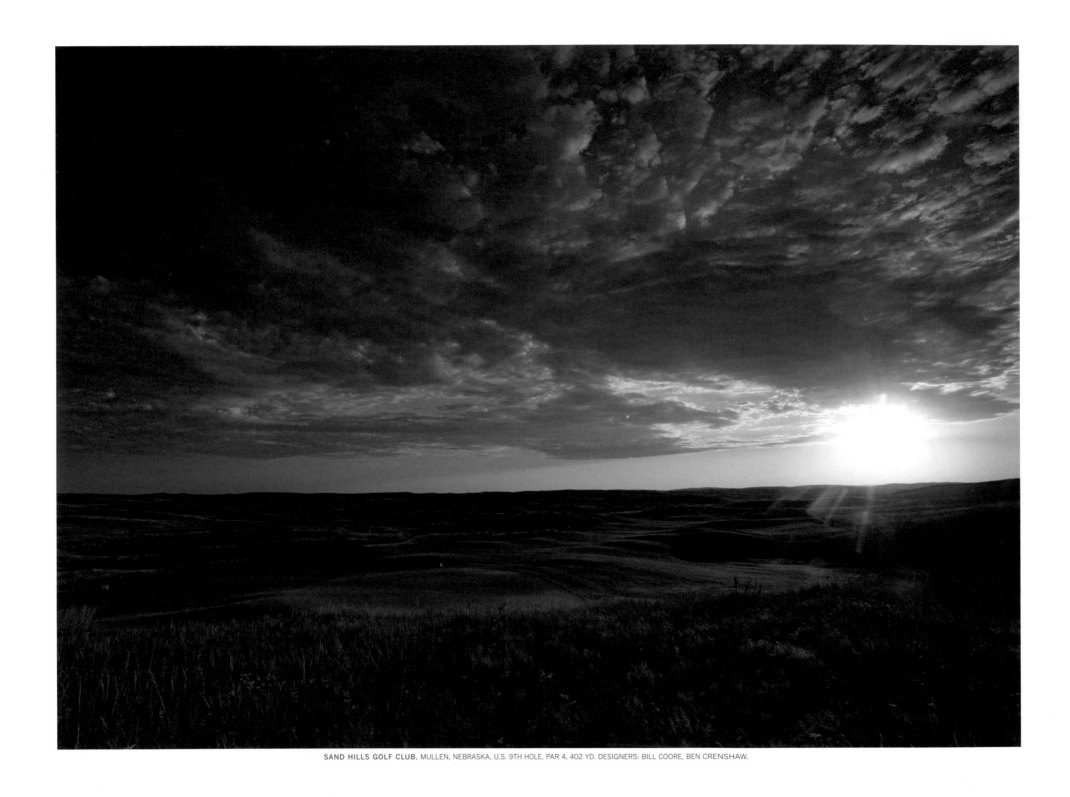

SAND HILLS GOLF CLUB, MULLEN, NEBRASKA, U.S. 9TH HOLE, PAR 4, 402 YD. DESIGNERS: BILL COORE, BEN CRENSHAW.

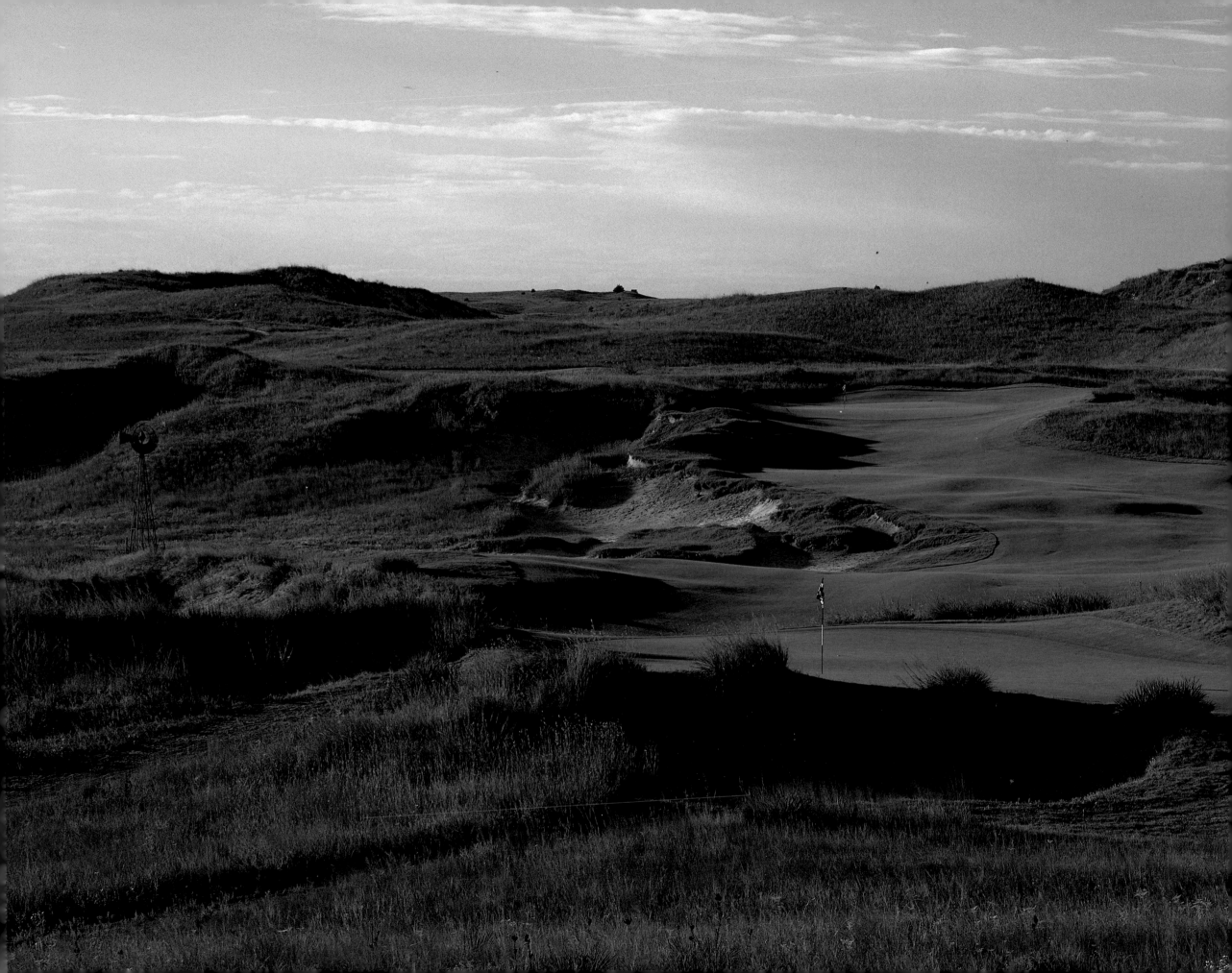

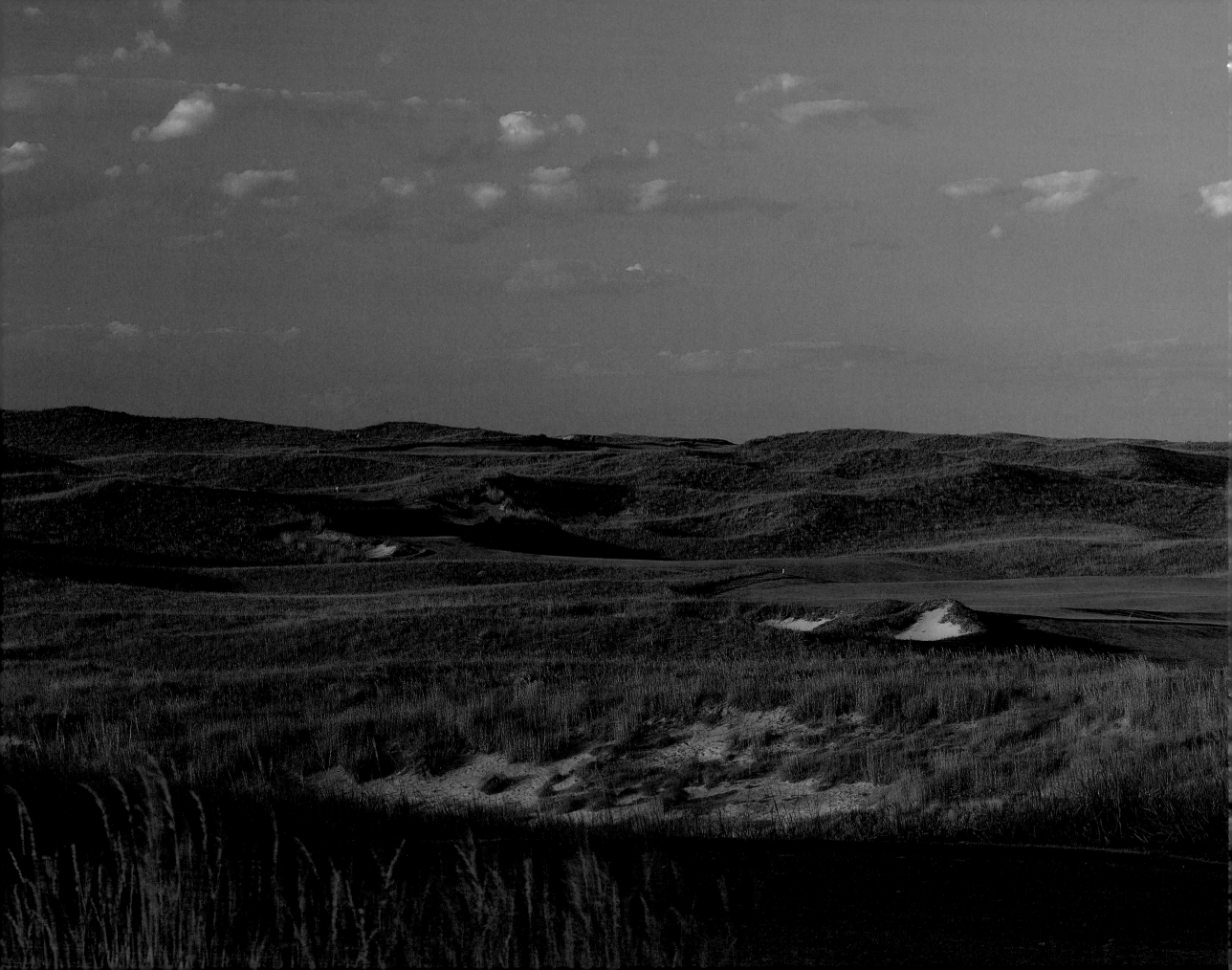

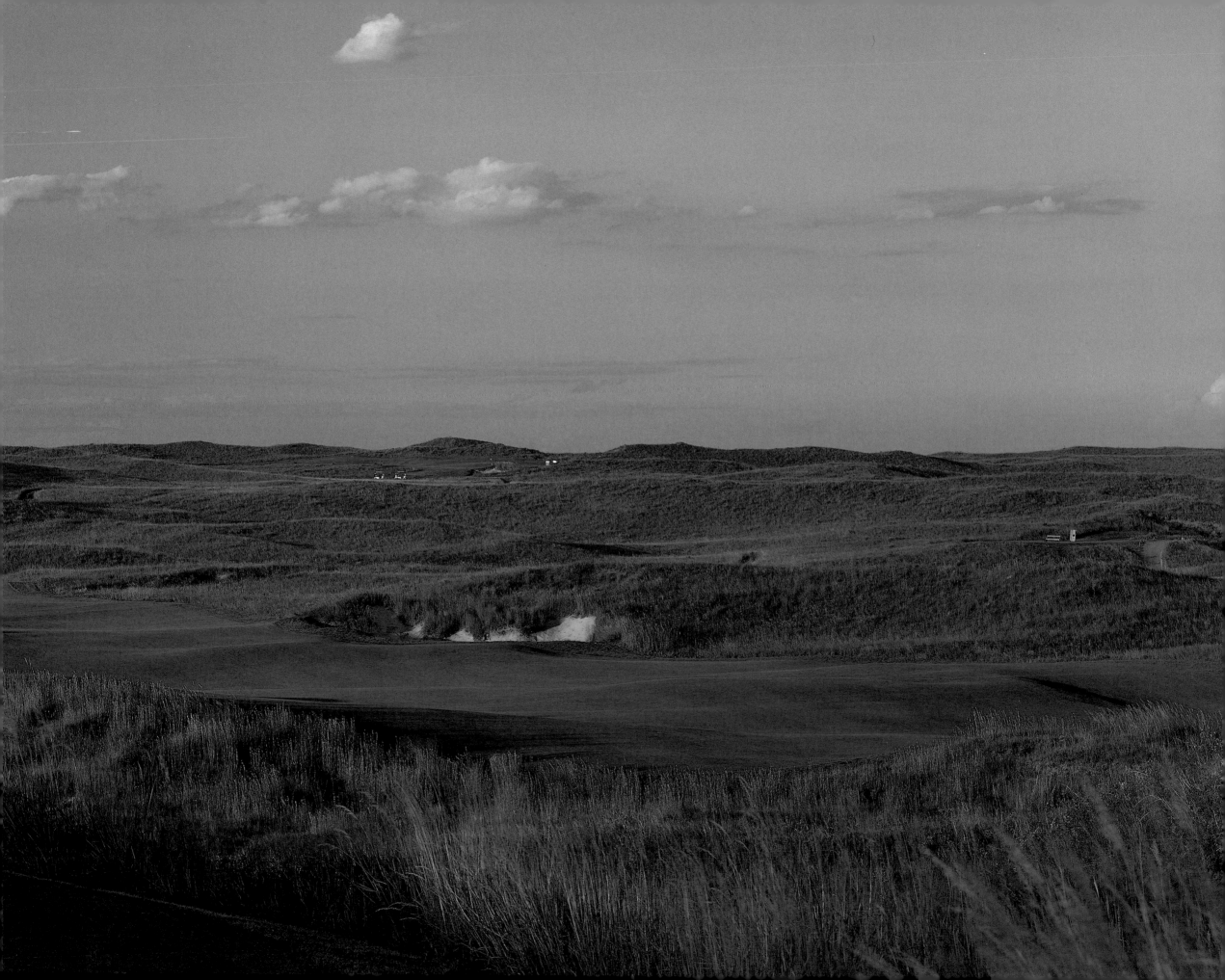

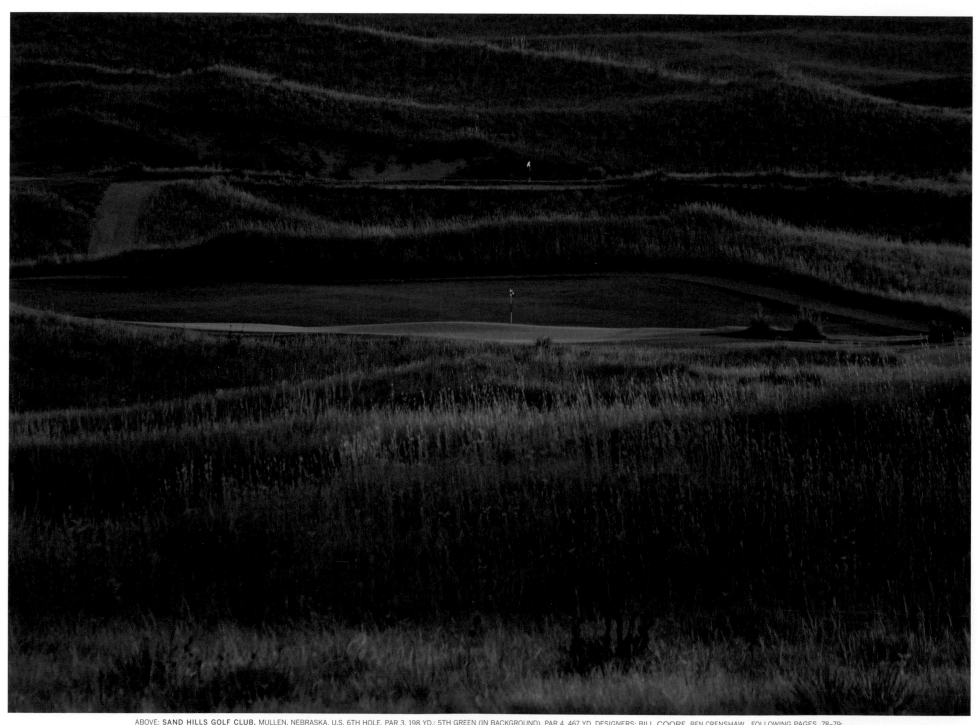

77

ABOVE: **SAND HILLS GOLF CLUB,** MULLEN, NEBRASKA, U.S. 6TH HOLE, PAR 3, 198 YD.; 5TH GREEN (IN BACKGROUND), PAR 4, 467 YD. DESIGNERS: BILL COORE, BEN CRENSHAW. FOLLOWING PAGES, 78–79:
SAND HILLS GOLF CLUB, MULLEN, NEBRASKA, U.S. 1ST HOLE, PAR 5, 549 YD. DESIGNERS: BILL COORE, BEN CRENSHAW.

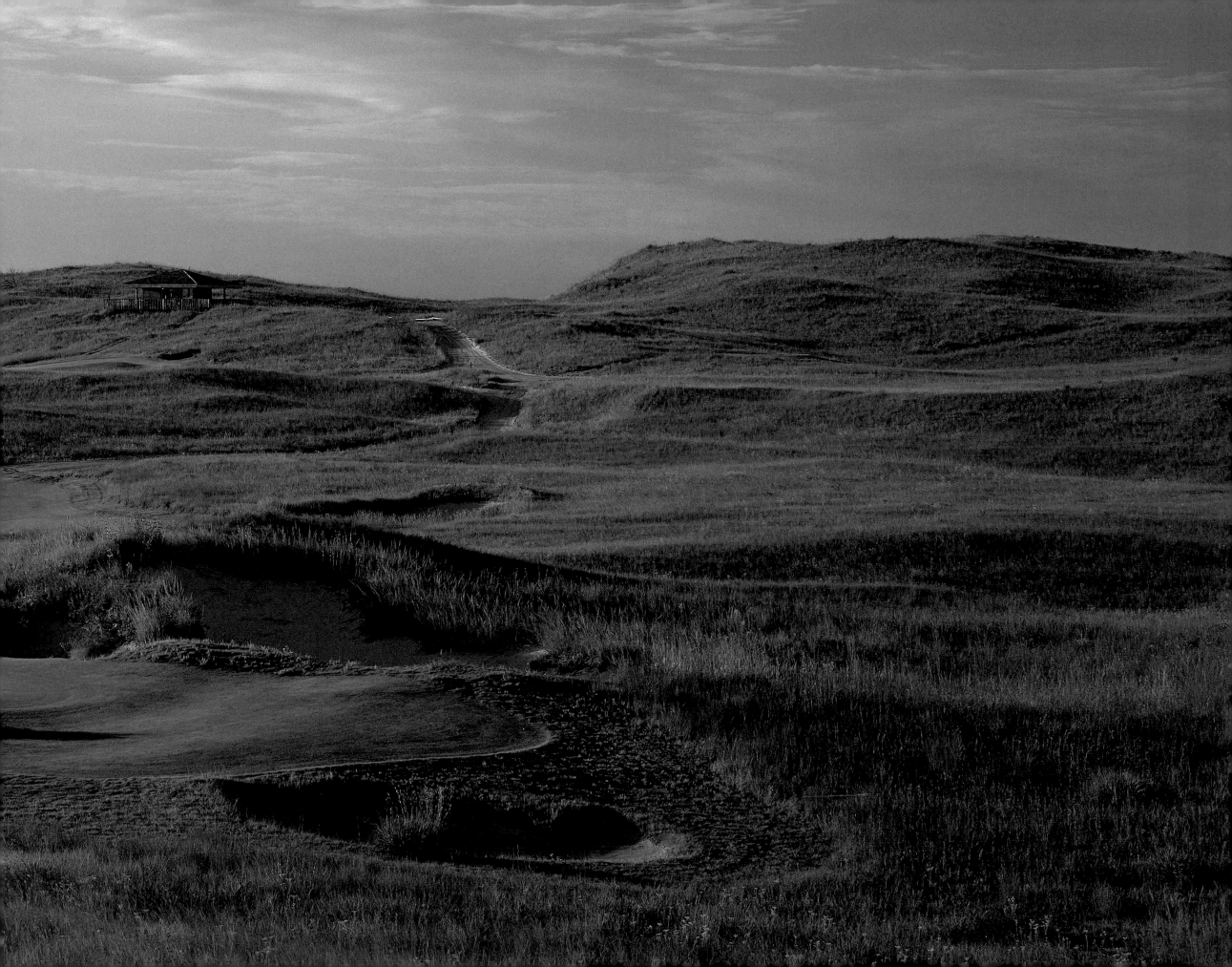

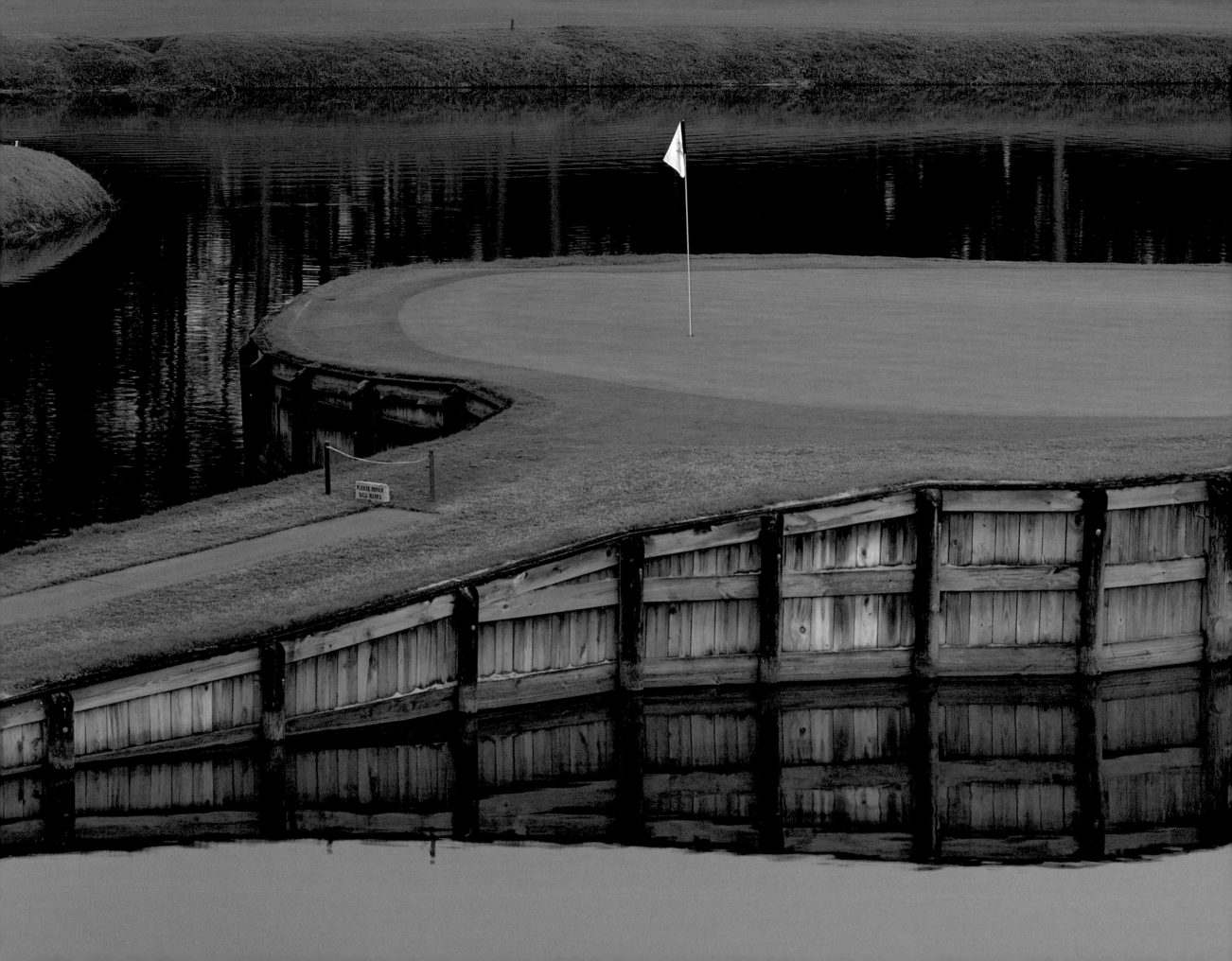

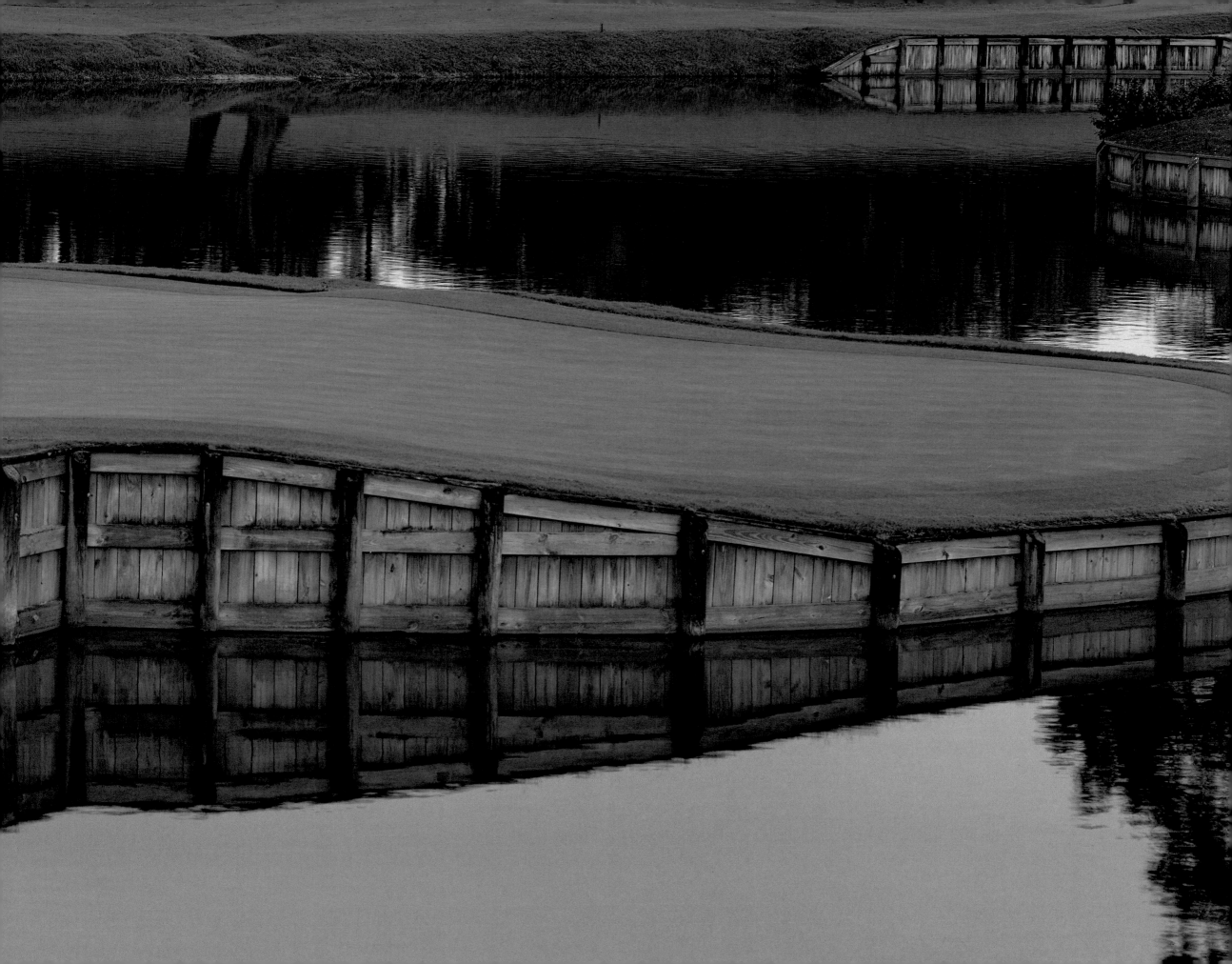

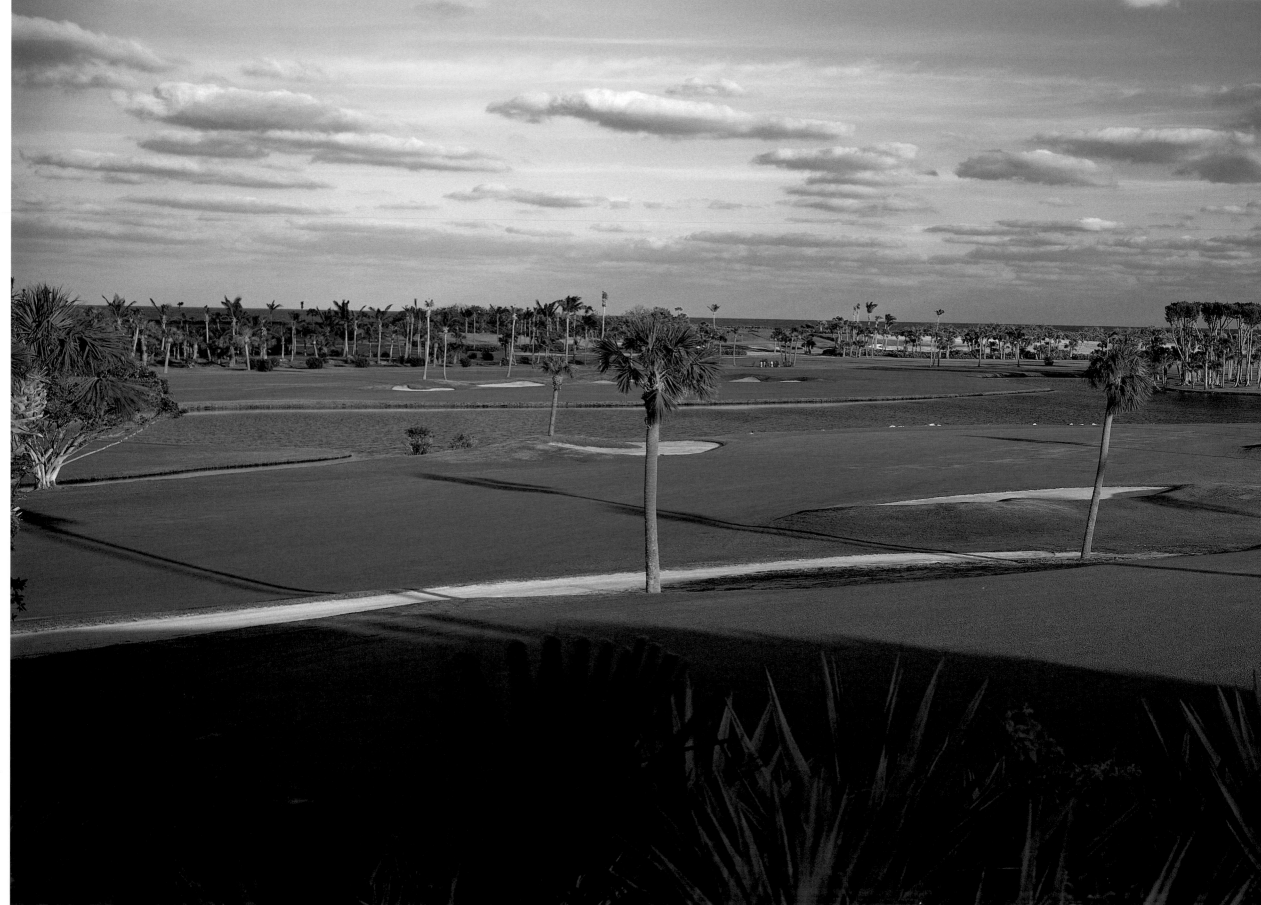

PREVIOUS PAGES, 80-81: **SAND HILLS GOLF CLUB**, MULLEN, NEBRASKA, U.S. 17TH HOLE, PAR 3, 150 YD.; 18TH HOLE (IN BACKGROUND), PAR 4, 467 YD. DESIGNERS: BILL COORE, BEN CRENSHAW. PREVIOUS PAGES, 82-83: **STADIUM COURSE, TPC AT SAWGRASS**, PONTE VEDRA BEACH, FLORIDA, U.S. 17TH HOLE, PAR 3, 132 YD. DESIGNER: PETE DYE.

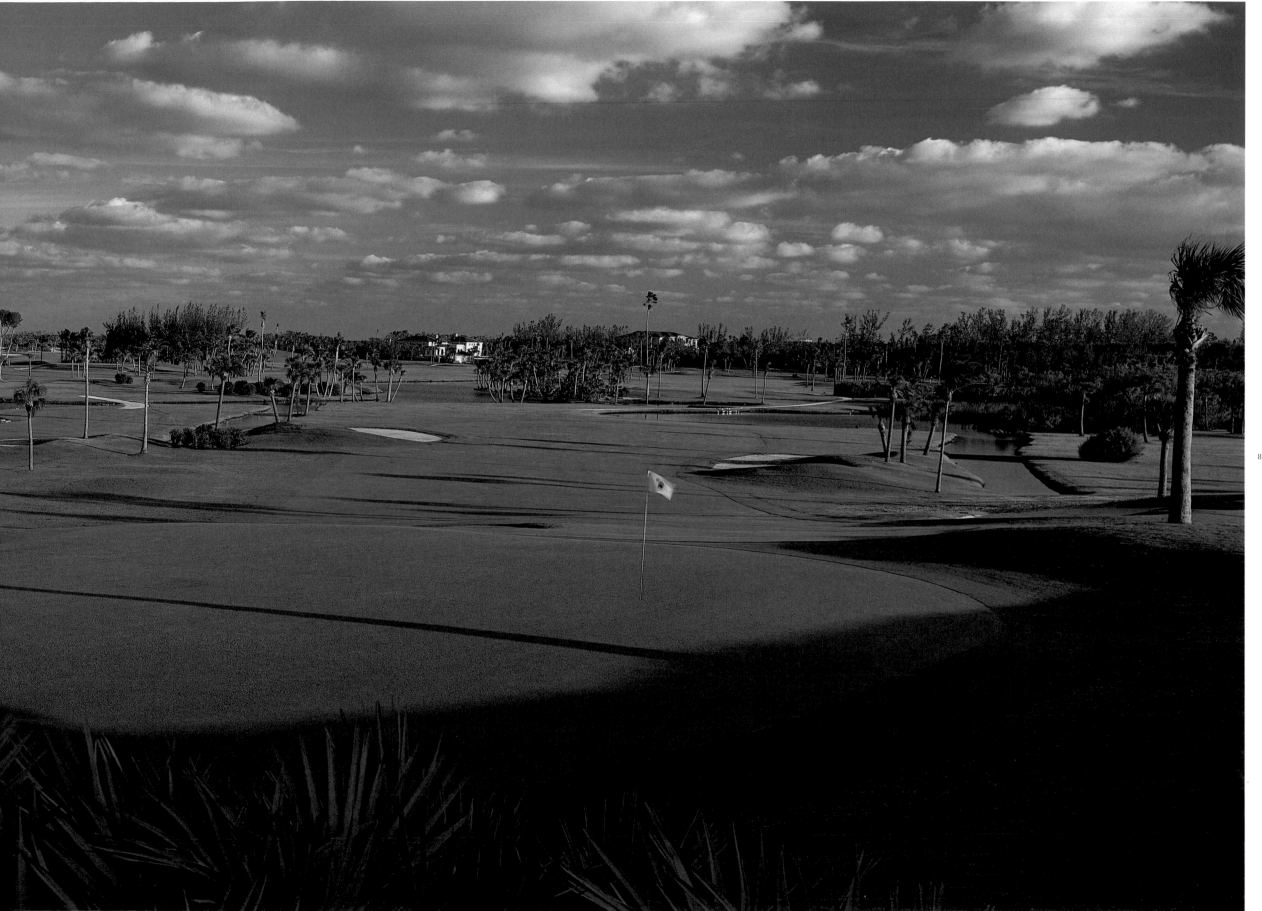

ABOVE: **SEMINOLE GOLF CLUB**, JUNO BEACH, FLORIDA, U.S. 2ND HOLE, PAR 4, 387 YD. DESIGNER: DONALD ROSS.

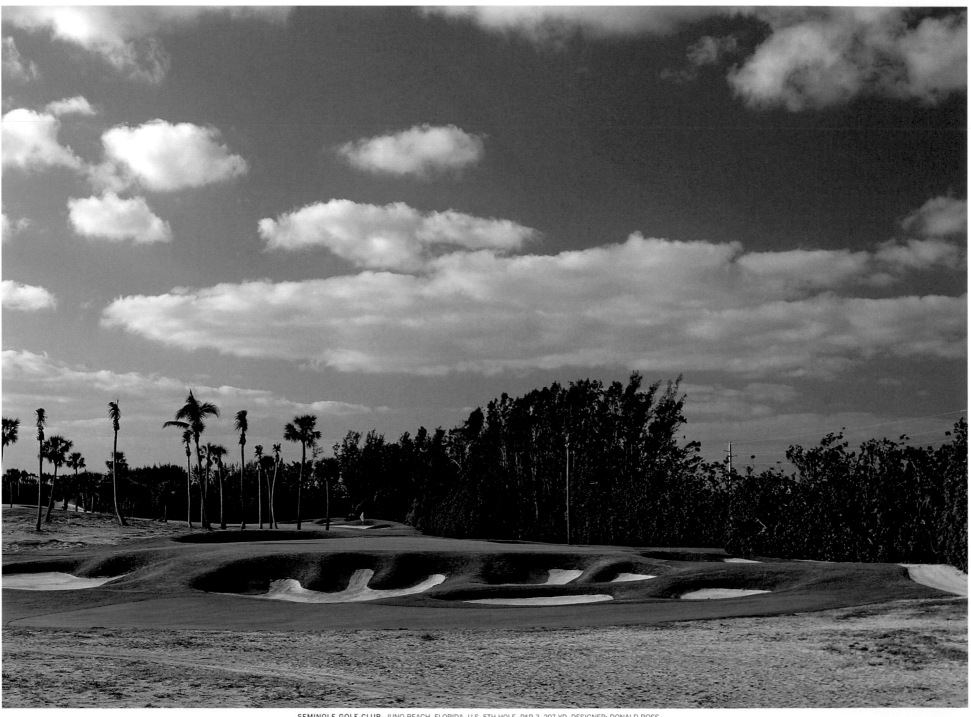

SEMINOLE GOLF CLUB, JUNO BEACH, FLORIDA, U.S. 5TH HOLE, PAR 3, 207 YD. DESIGNER: DONALD ROSS.

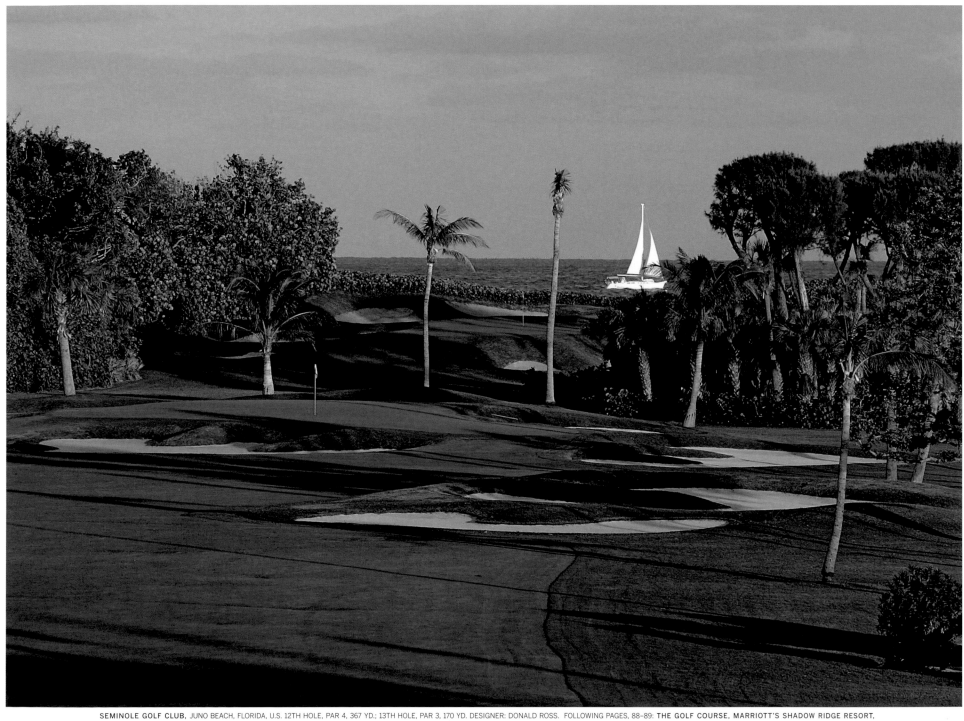

SEMINOLE GOLF CLUB, JUNO BEACH, FLORIDA, U.S. 12TH HOLE, PAR 4, 367 YD.; 13TH HOLE, PAR 3, 170 YD. DESIGNER: DONALD ROSS. FOLLOWING PAGES, 88–89: THE GOLF COURSE, MARRIOTT'S SHADOW RIDGE RESORT, PALM DESERT, CALIFORNIA, U.S. 3RD HOLE, PAR 4, 324 YD. DESIGNER: NICK FALDO.

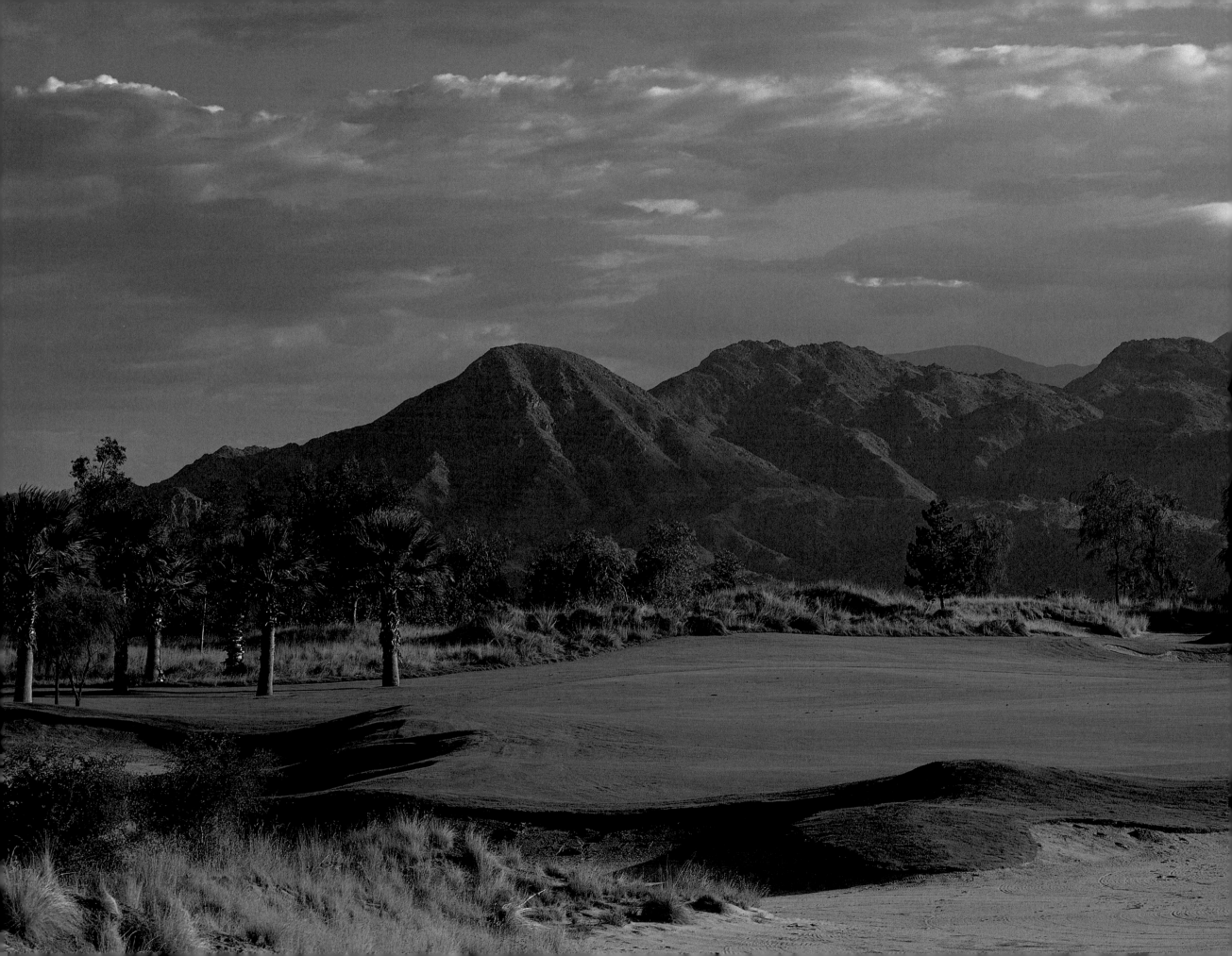

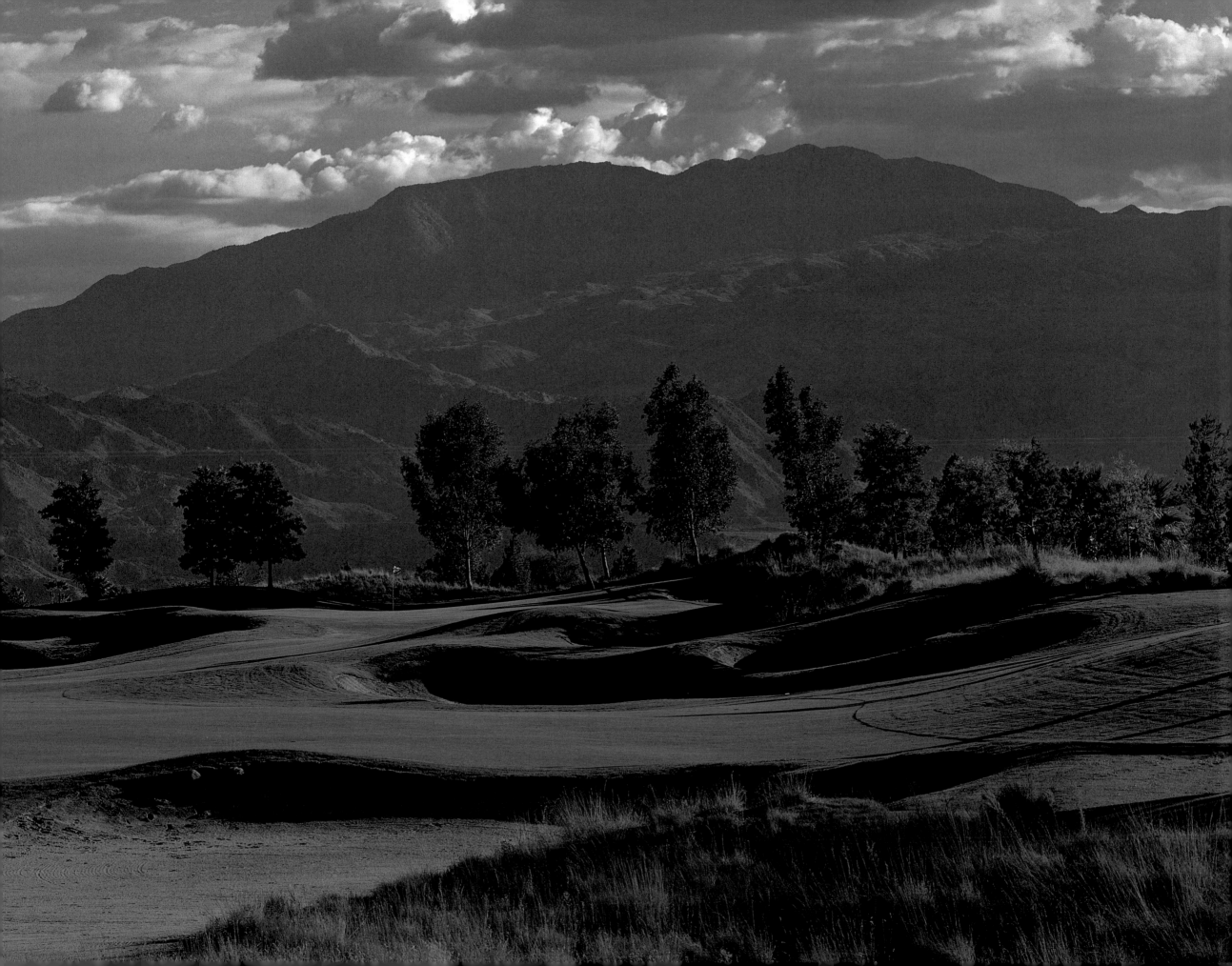

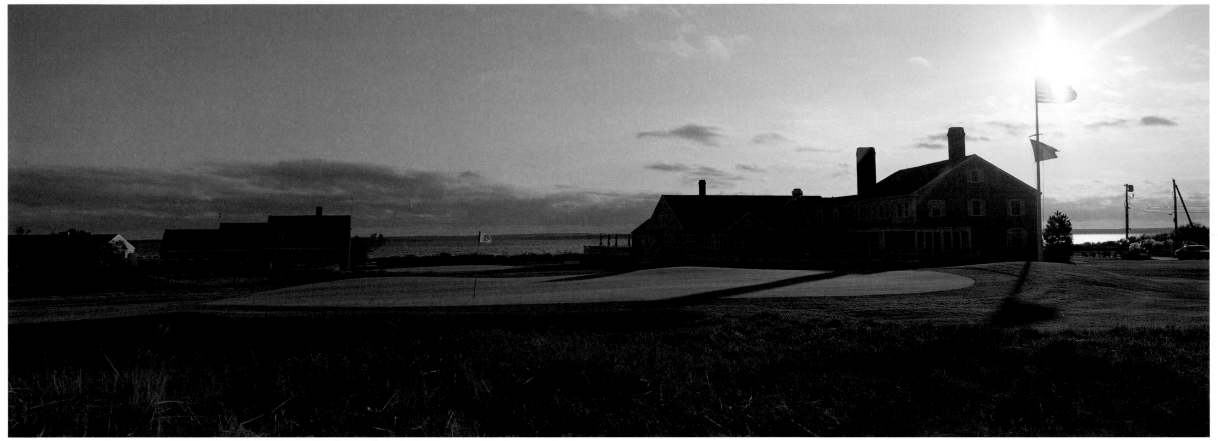

ABOVE: **THE KITTANSETT CLUB**, MARION, MASSACHUSETTS, U.S. 18TH HOLE, PAR 5, 491 YD. DESIGNER: FREDRICK C. HOOD. BELOW: **THE KITTANSETT CLUB**, MARION, MASSACHUSETTS, U.S. 2ND HOLE, PAR 4, 438 YD. DESIGNER: FREDRICK C. HOOD.

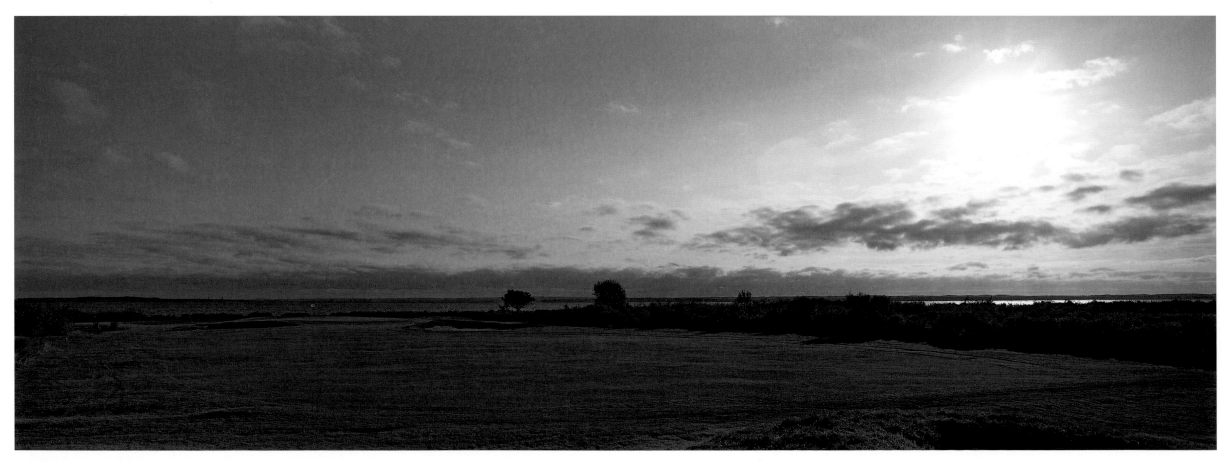

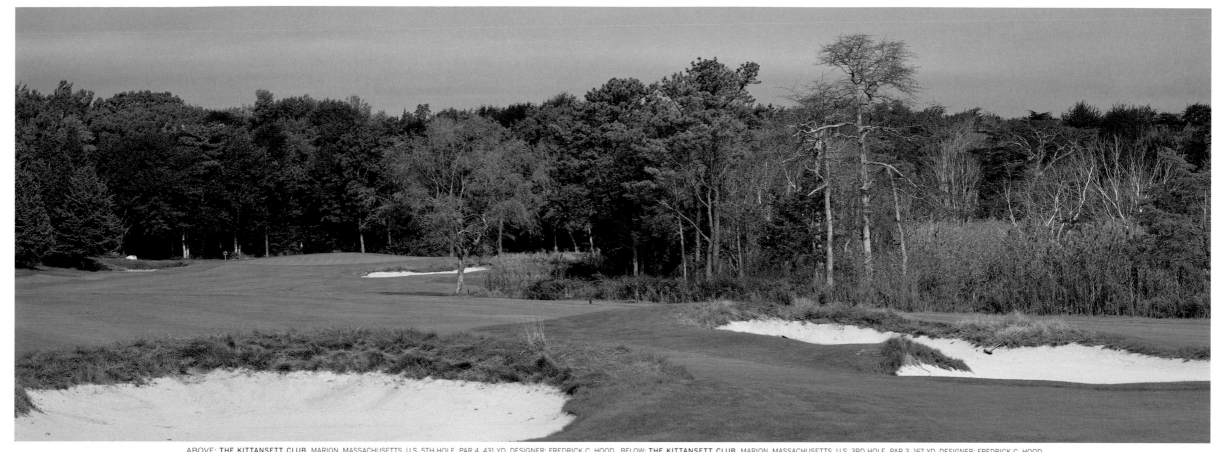

ABOVE: **THE KITTANSETT CLUB,** MARION, MASSACHUSETTS, U.S. 5TH HOLE, PAR 4, 431 YD. DESIGNER: FREDRICK C. HOOD. BELOW: **THE KITTANSETT CLUB,** MARION, MASSACHUSETTS, U.S. 3RD HOLE, PAR 3, 167 YD. DESIGNER: FREDRICK C. HOOD.

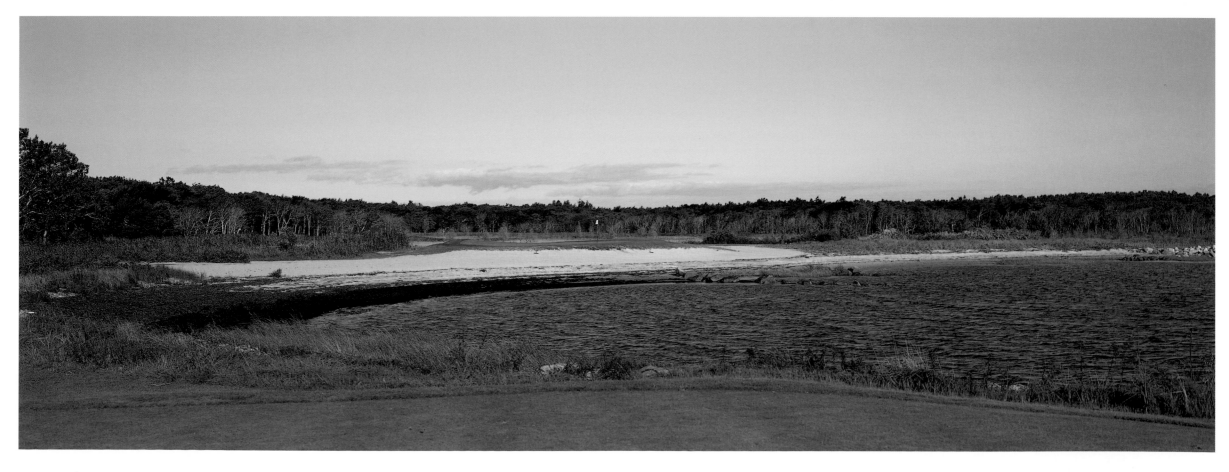

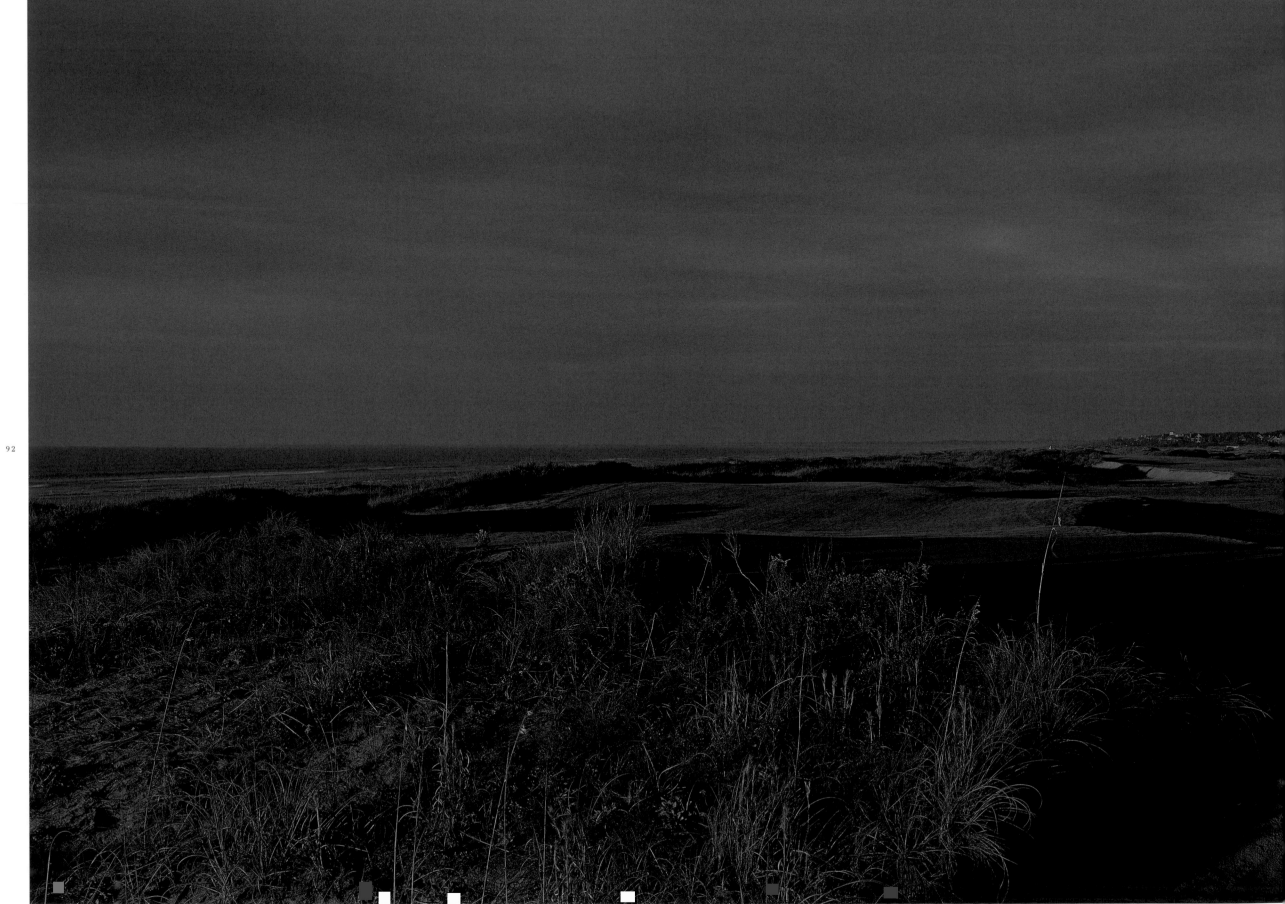

THE OCEAN COURSE, KIAWAH ISLAND RESORT, KIAWAH ISLAND, SOUTH CAROLINA, U.S. 16TH GREEN, PAR 5, 579 YD. DESIGNER: PETE DYE.

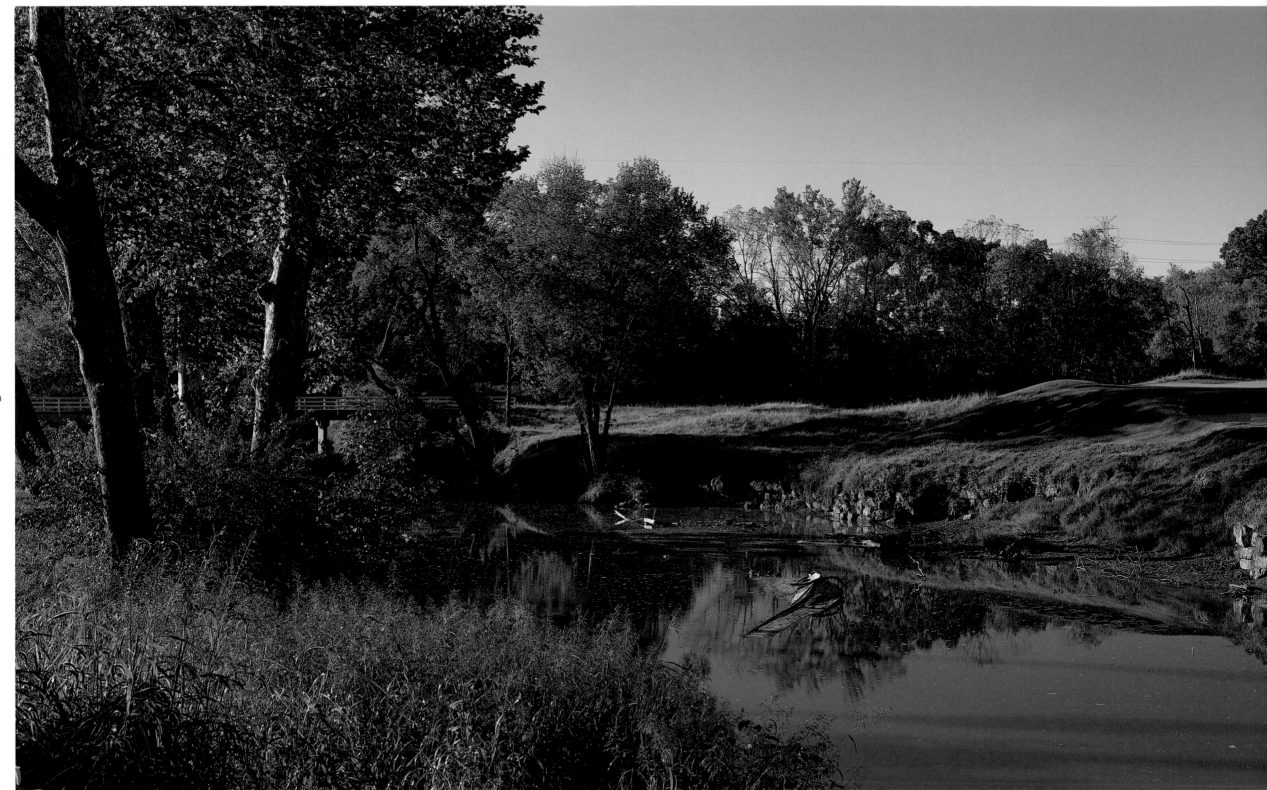

ABOVE: **VALHALLA GOLF CLUB**, LOUISVILLE, KENTUCKY, U.S. 6TH GREEN, PAR 4, 420 YD. DESIGNER: JACK NICKLAUS. FOLLOWING PAGES, 96–97: **VALHALLA GOLF CLUB**, LOUISVILLE, KENTUCKY, U.S. 5TH GREEN, PAR 4, 465 YD. DESIGNER: JACK NICKLAUS.

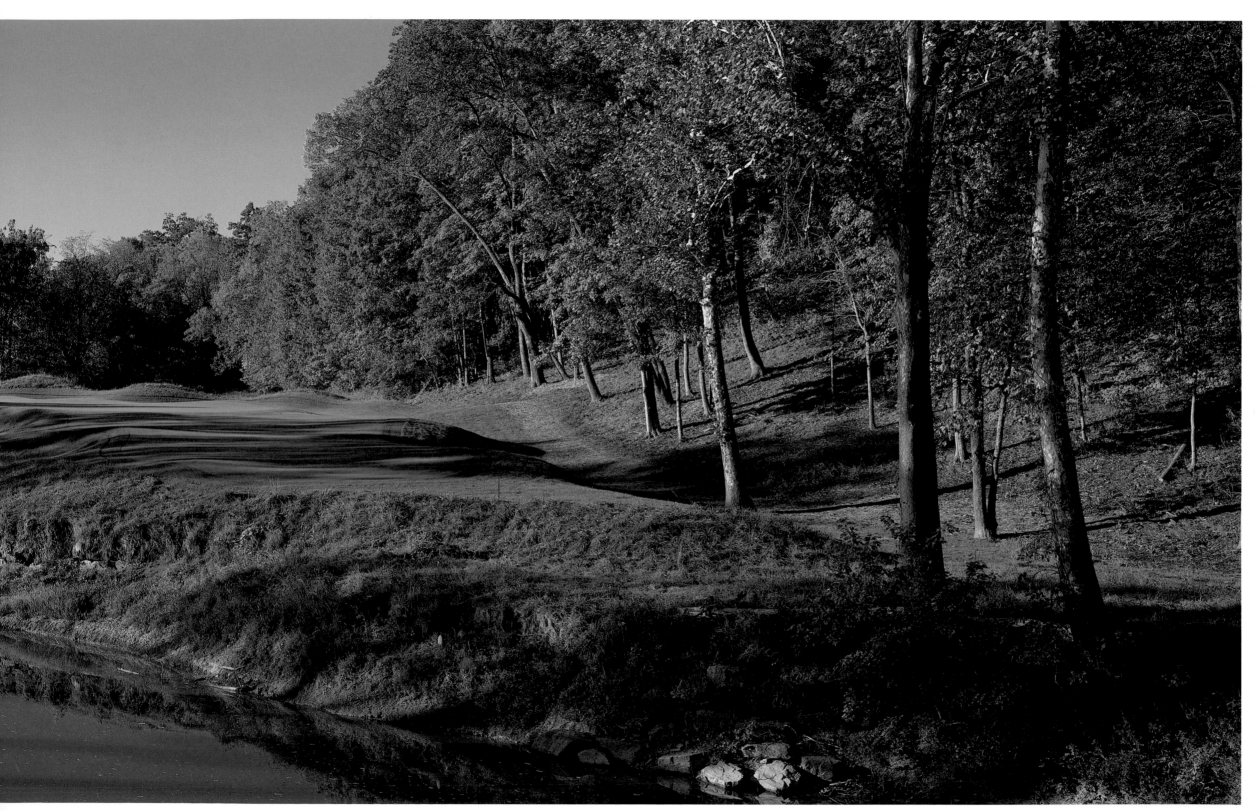

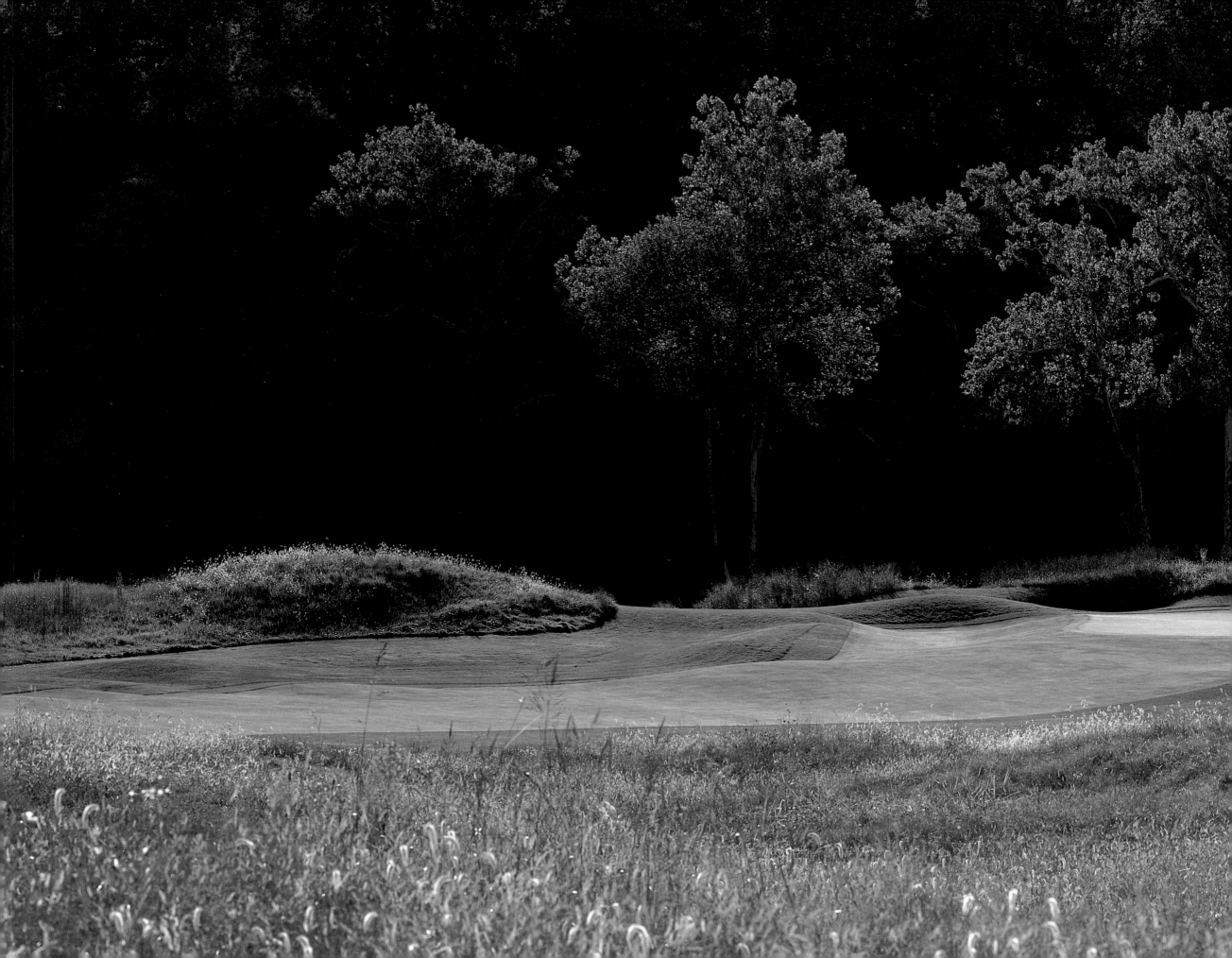

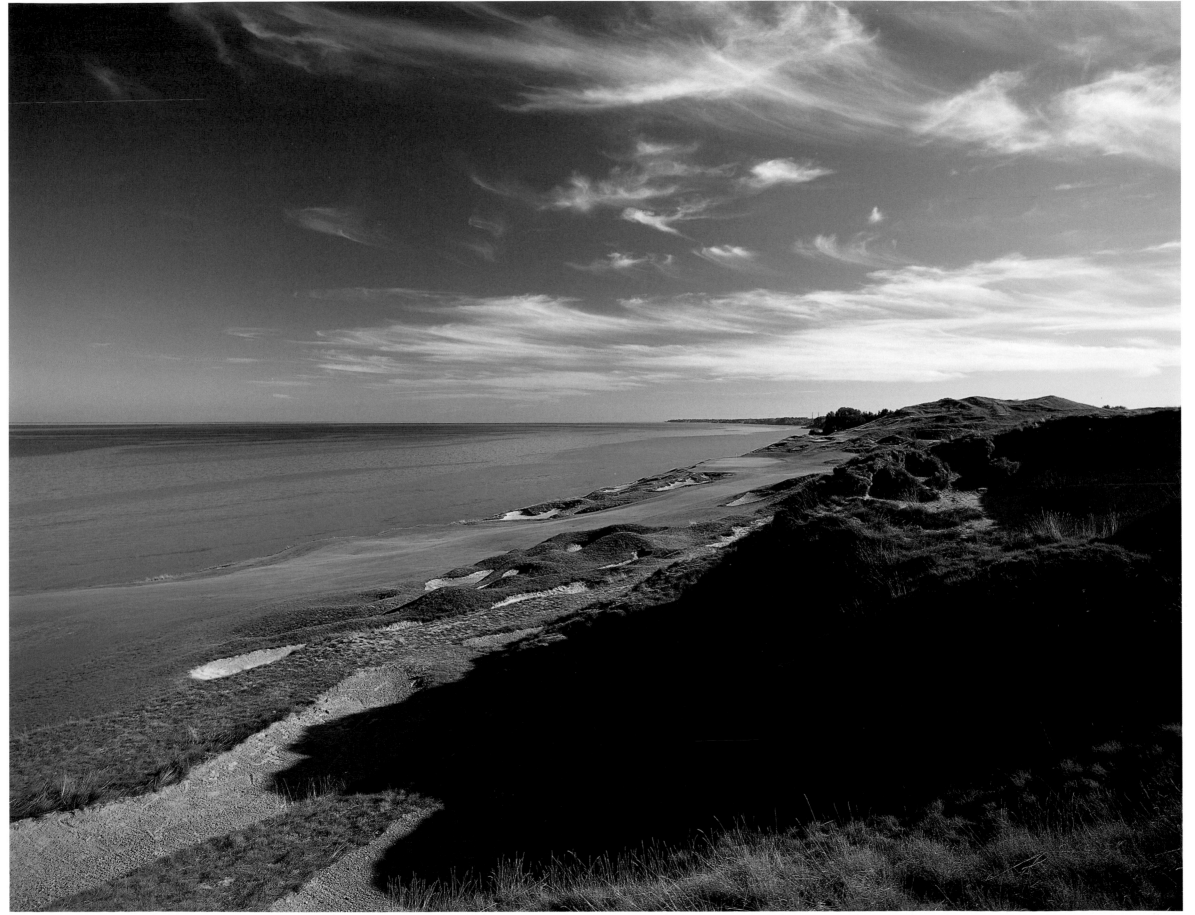

STRAITS COURSE, WHISTLING STRAITS, KOHLER, WISCONSIN, U.S. 4TH HOLE, PAR 4, 455 YD. DESIGNER: PETE DYE.

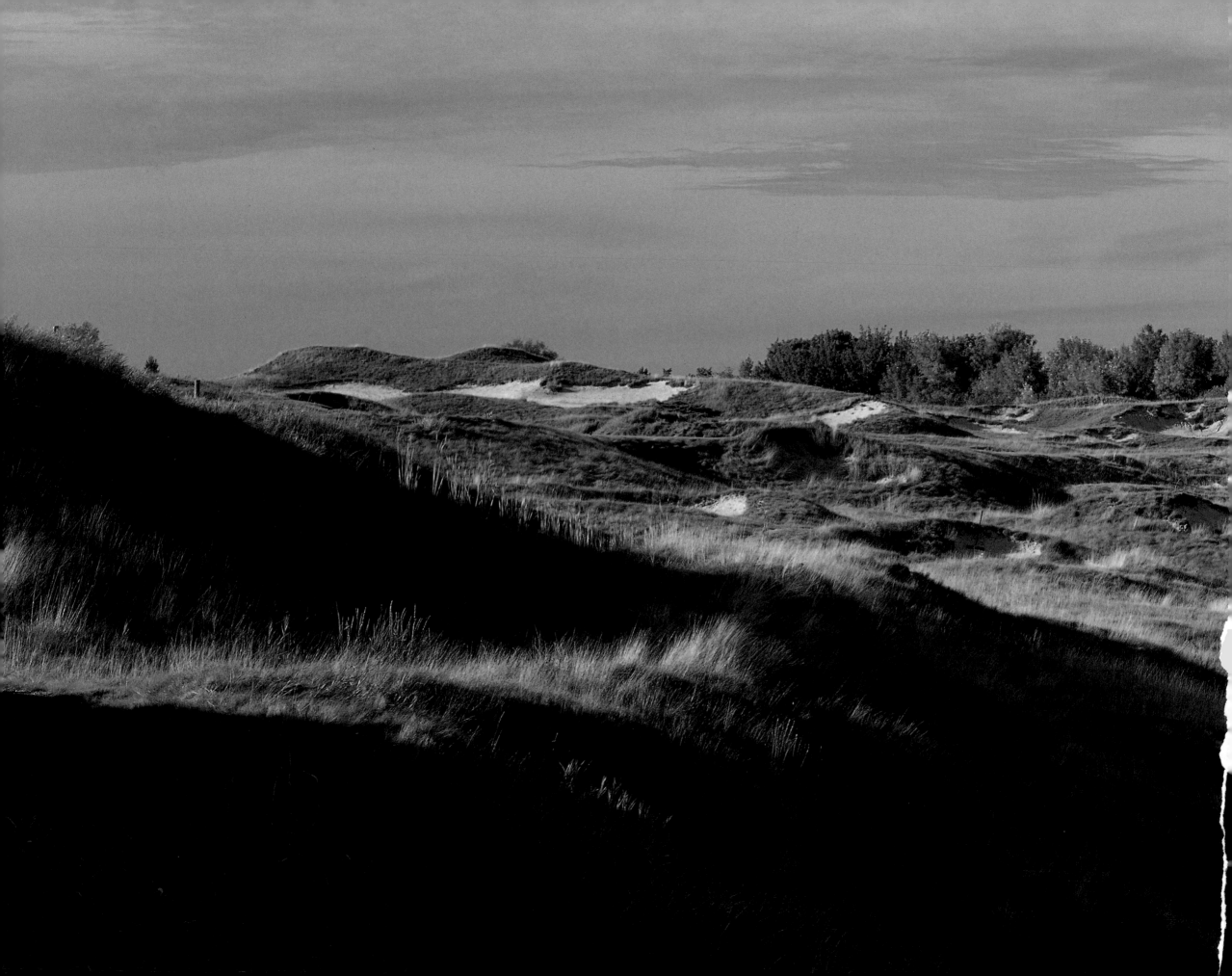

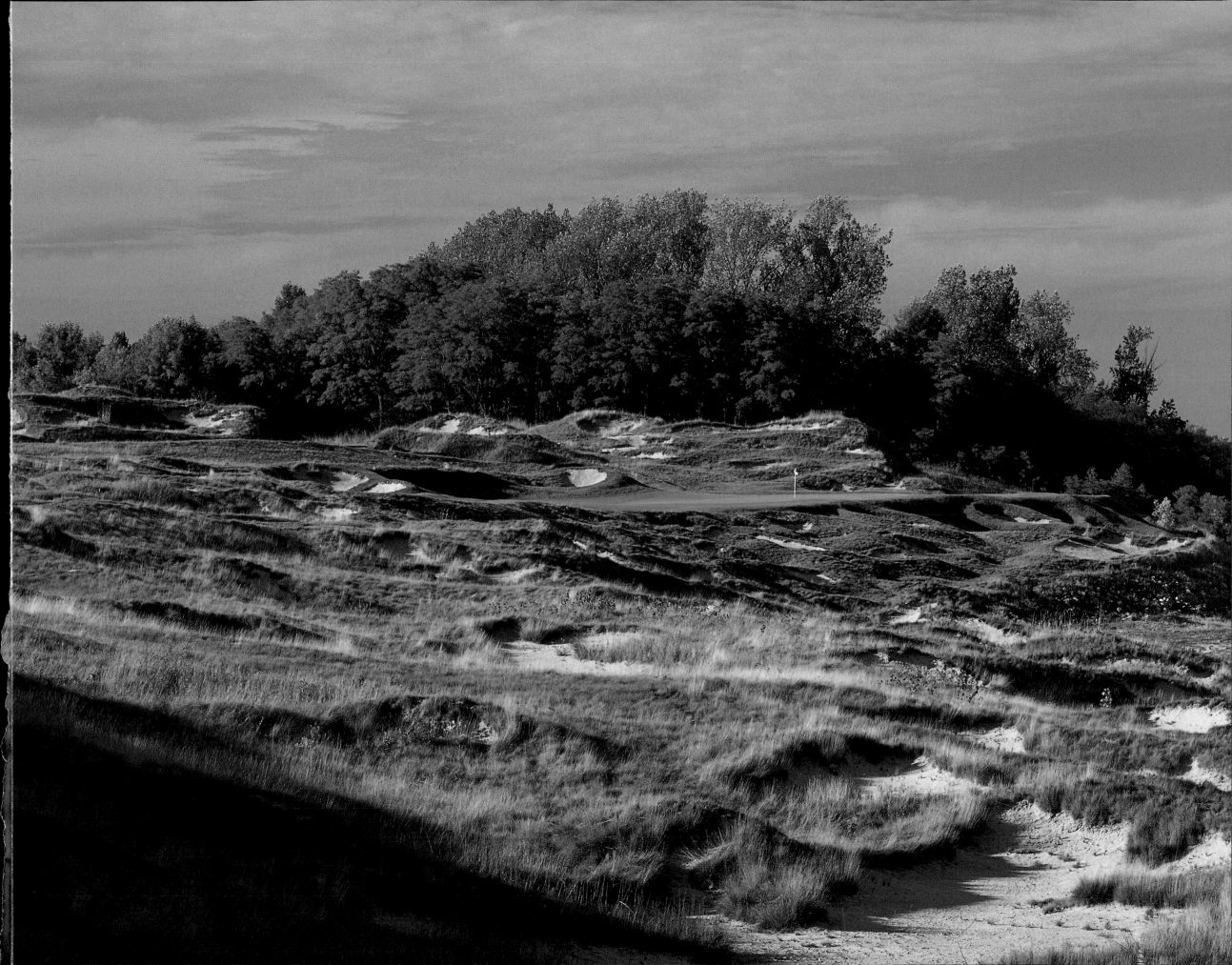

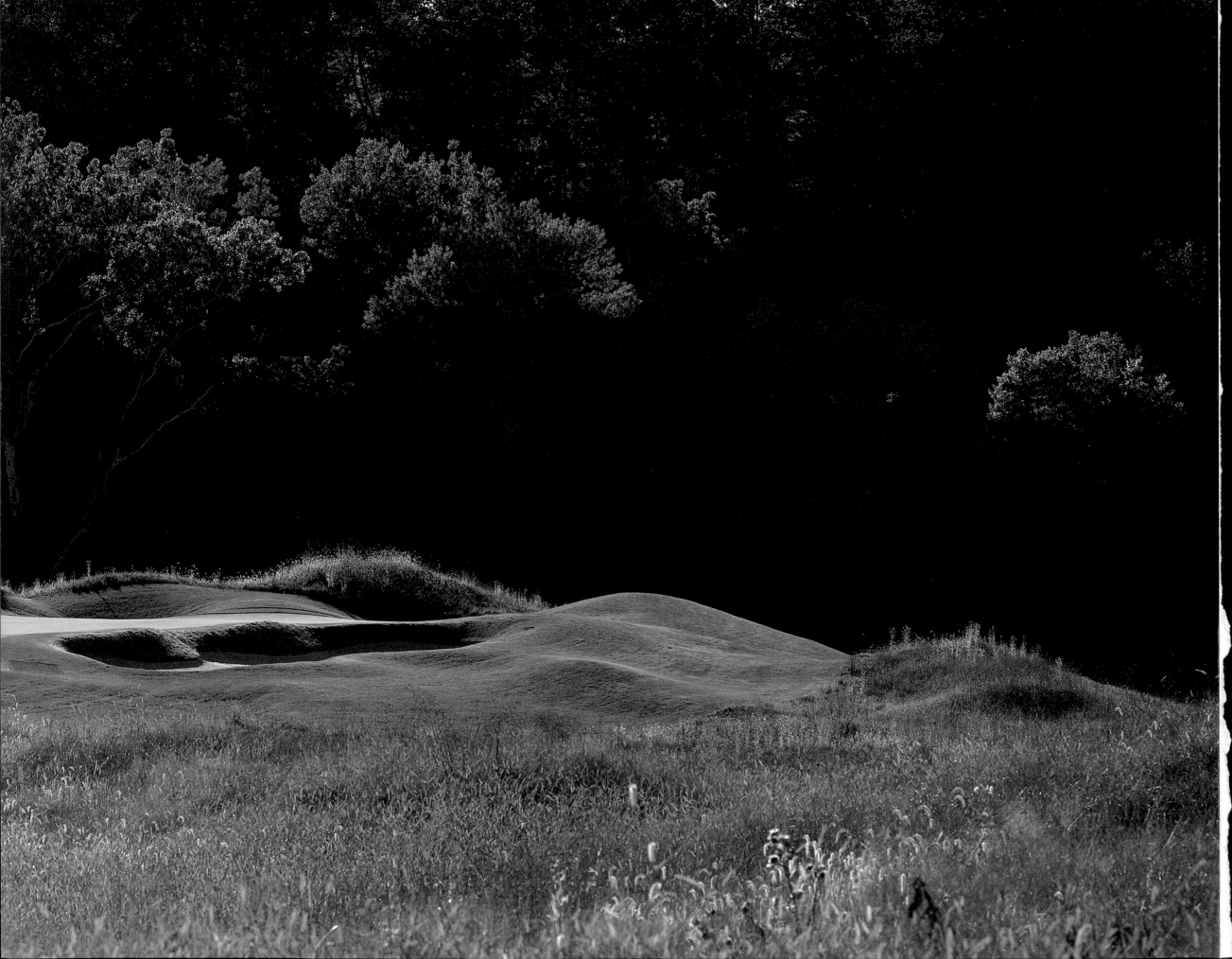

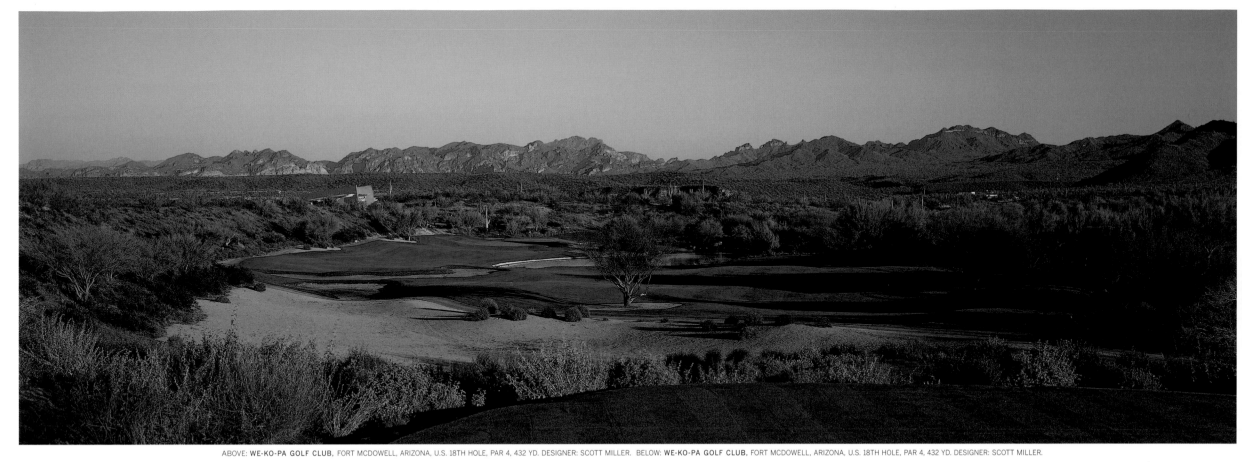

ABOVE: **WE-KO-PA GOLF CLUB,** FORT MCDOWELL, ARIZONA, U.S. 18TH HOLE, PAR 4, 432 YD. DESIGNER: SCOTT MILLER. BELOW: **WE-KO-PA GOLF CLUB,** FORT MCDOWELL, ARIZONA, U.S. 18TH HOLE, PAR 4, 432 YD. DESIGNER: SCOTT MILLER.

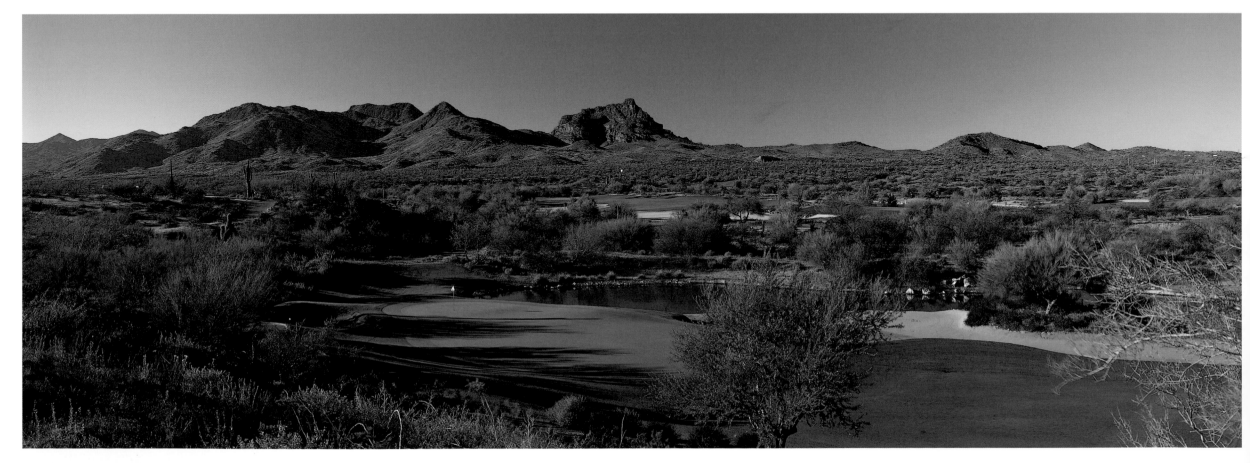

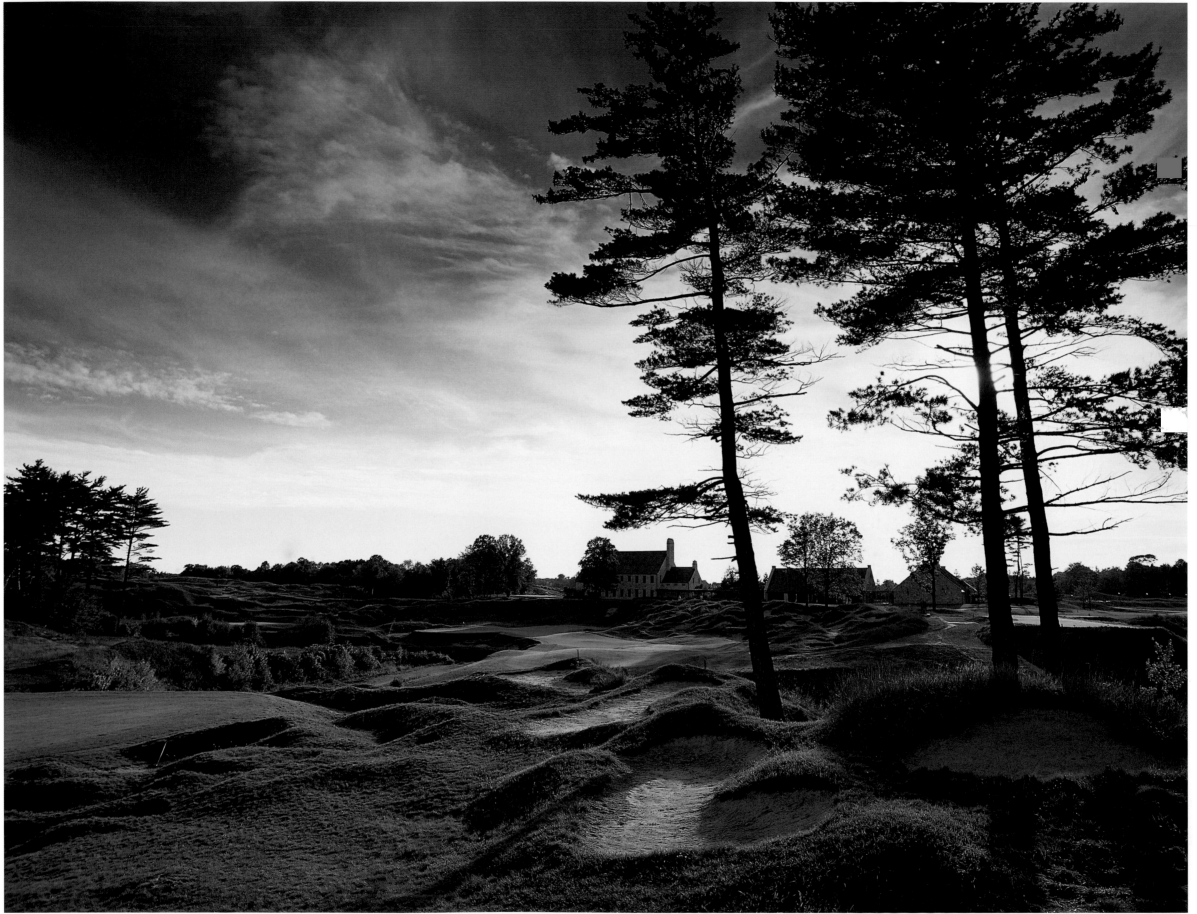

ABOVE: **STRAITS COURSE, WHISTLING STRAITS,** KOHLER, WISCONSIN, U.S. 18TH HOLE, PAR 4, 489 YD. DESIGNER: PETE DYE. FOLLOWING PAGES, 100–103: **STRAITS COURSE, WHISTLING STRAITS,** KOHLER, WISCONSIN, U.S. 8TH HOLE, PAR 4, 462 YD. DESIGNER: PETE DYE.

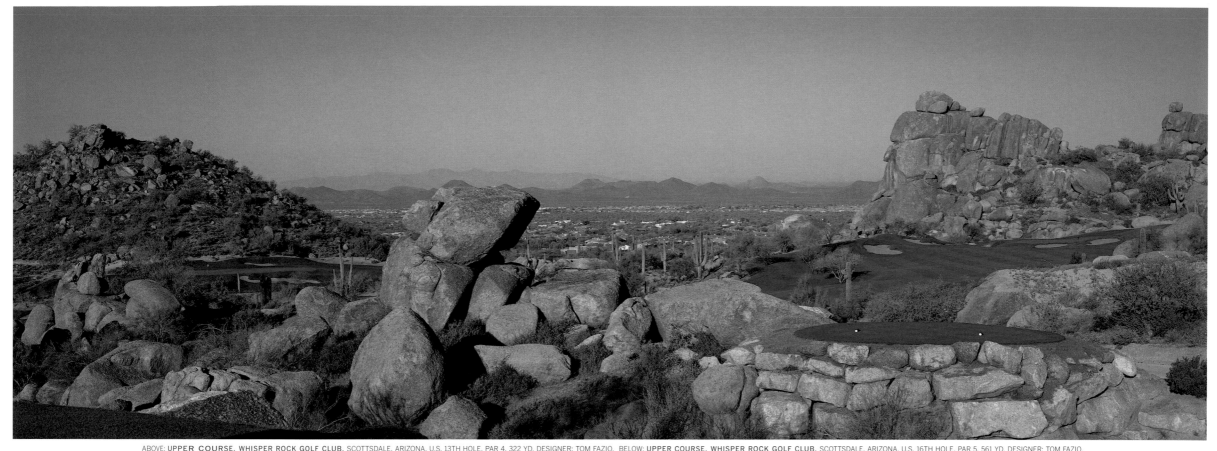

ABOVE: **UPPER COURSE, WHISPER ROCK GOLF CLUB**, SCOTTSDALE, ARIZONA, U.S. 13TH HOLE, PAR 4, 322 YD. DESIGNER: TOM FAZIO. BELOW: **UPPER COURSE, WHISPER ROCK GOLF CLUB**, SCOTTSDALE, ARIZONA, U.S. 16TH HOLE, PAR 5, 561 YD. DESIGNER: TOM FAZIO.

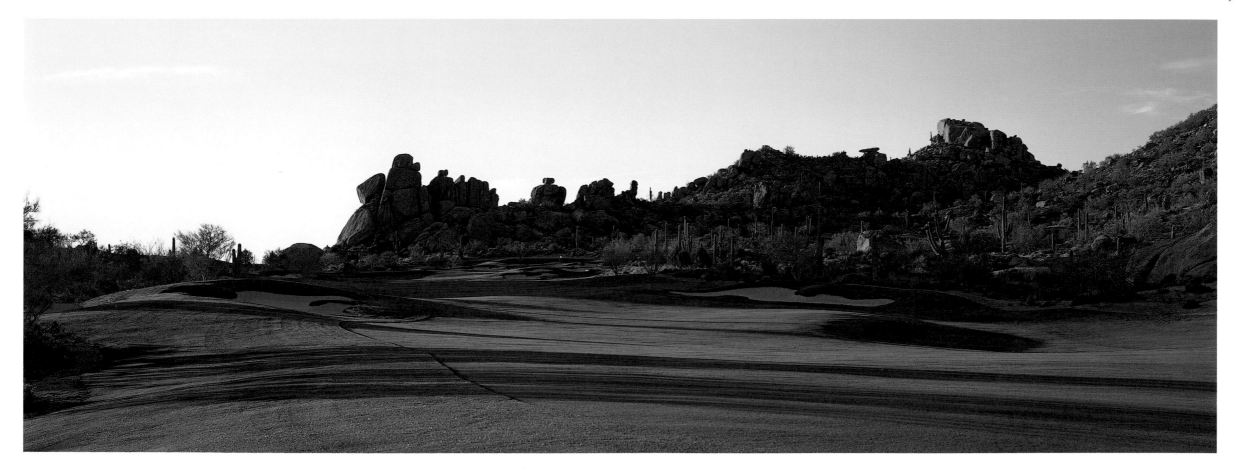

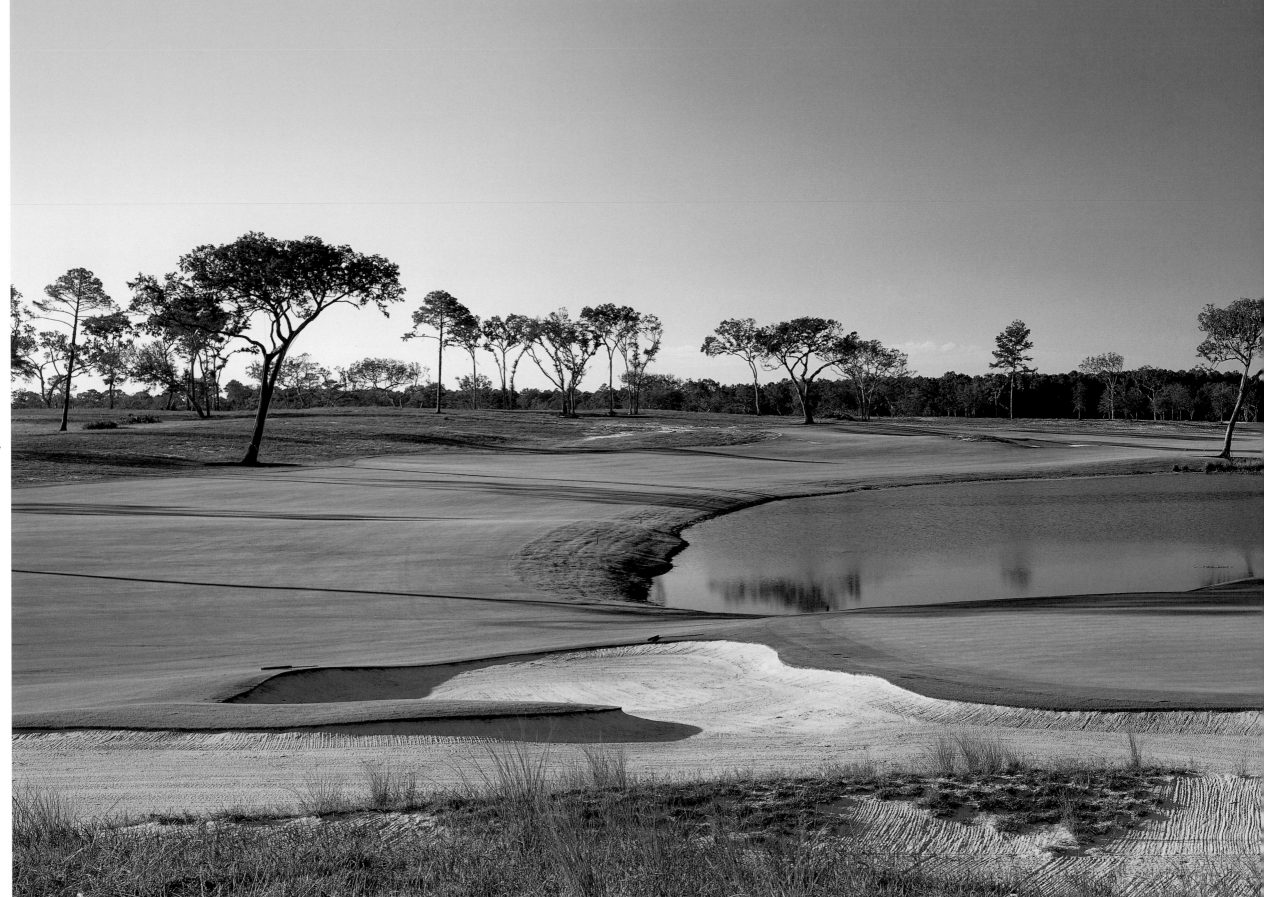

106

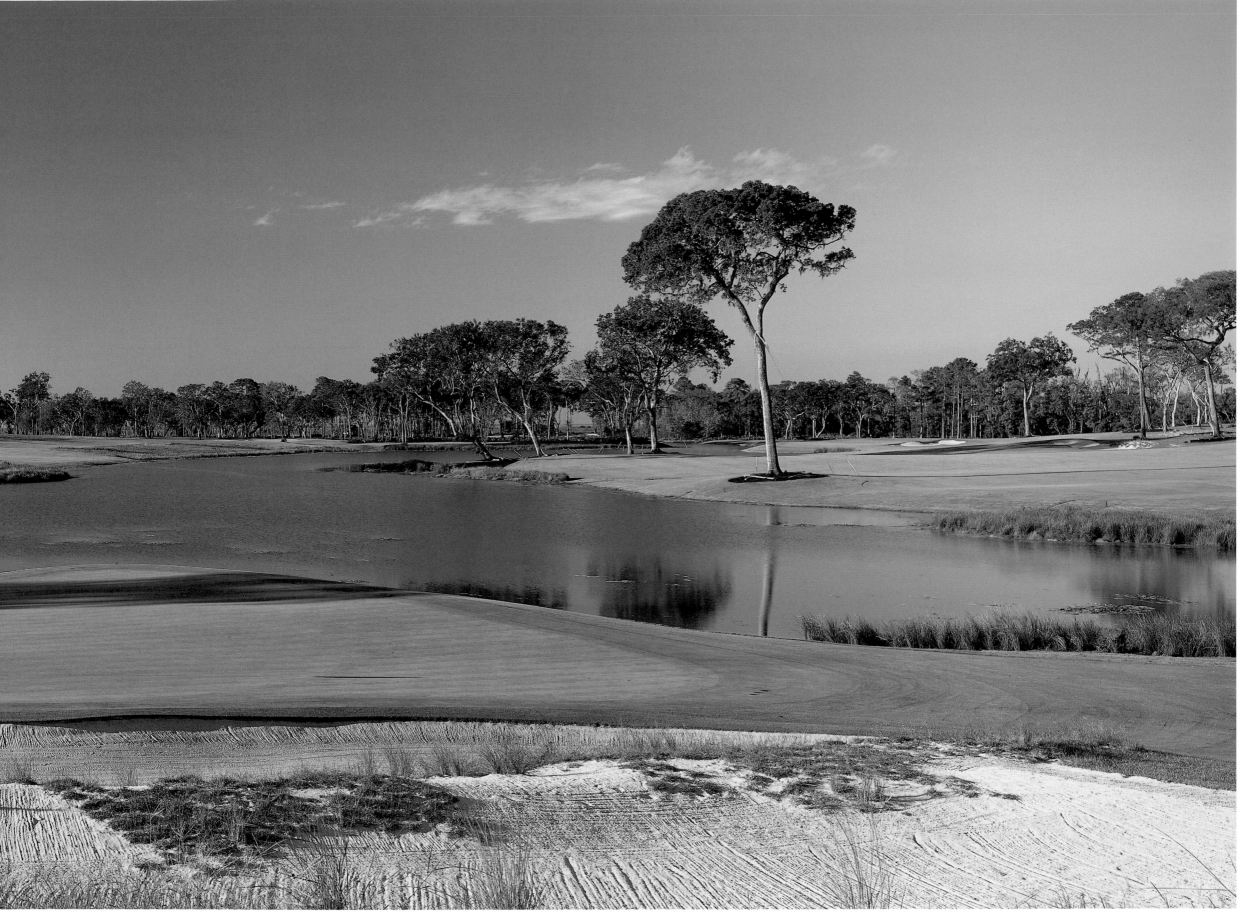

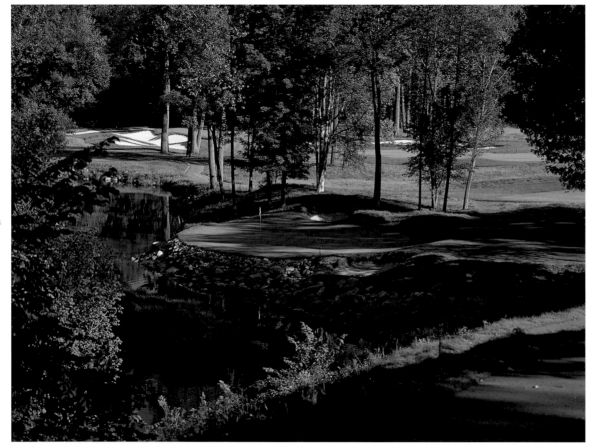

ABOVE LEFT: **WOLF RUN GOLF CLUB**, ZIONSVILLE, INDIANA, U.S. 16TH HOLE, PAR 3, 130 YD. DESIGNER: STEVE SMYERS.

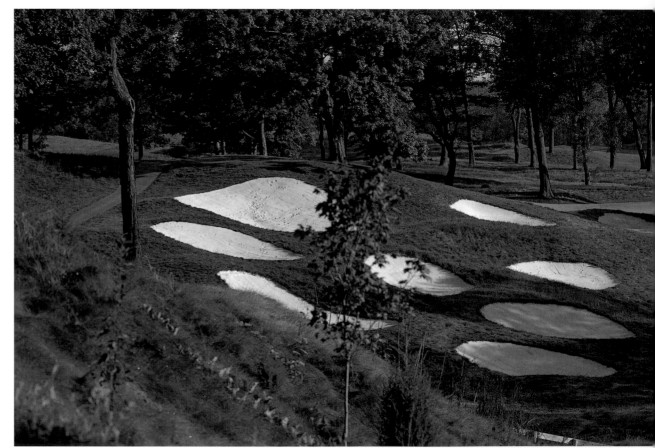

ABOVE CENTER: **WOLF RUN GOLF CLUB**, ZIONSVILLE, INDIANA, U.S. 13TH HOLE, PAR 3, 245 YD. DESIGNER: STEVE SMYERS.

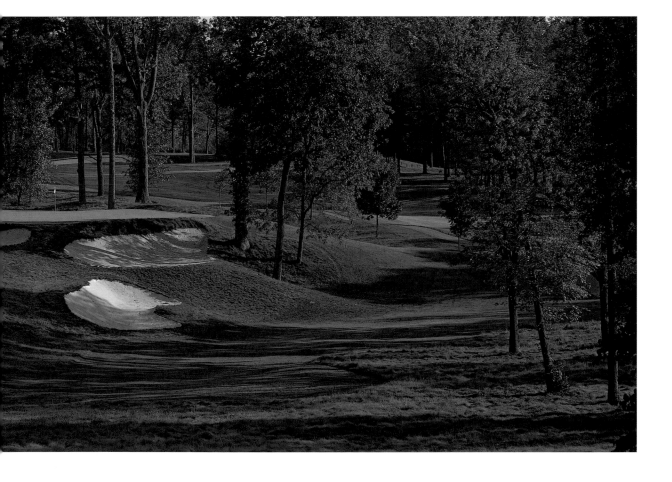

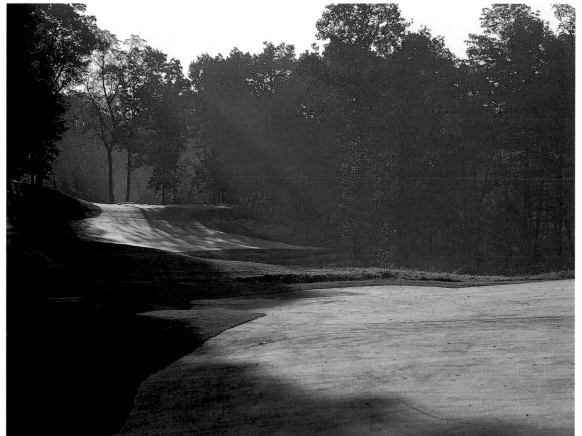

ABOVE RIGHT: **WOLF RUN GOLF CLUB**, ZIONSVILLE, INDIANA, U.S. 15TH HOLE, PAR 4, 465 YD. DESIGNER: STEVE SMYERS.

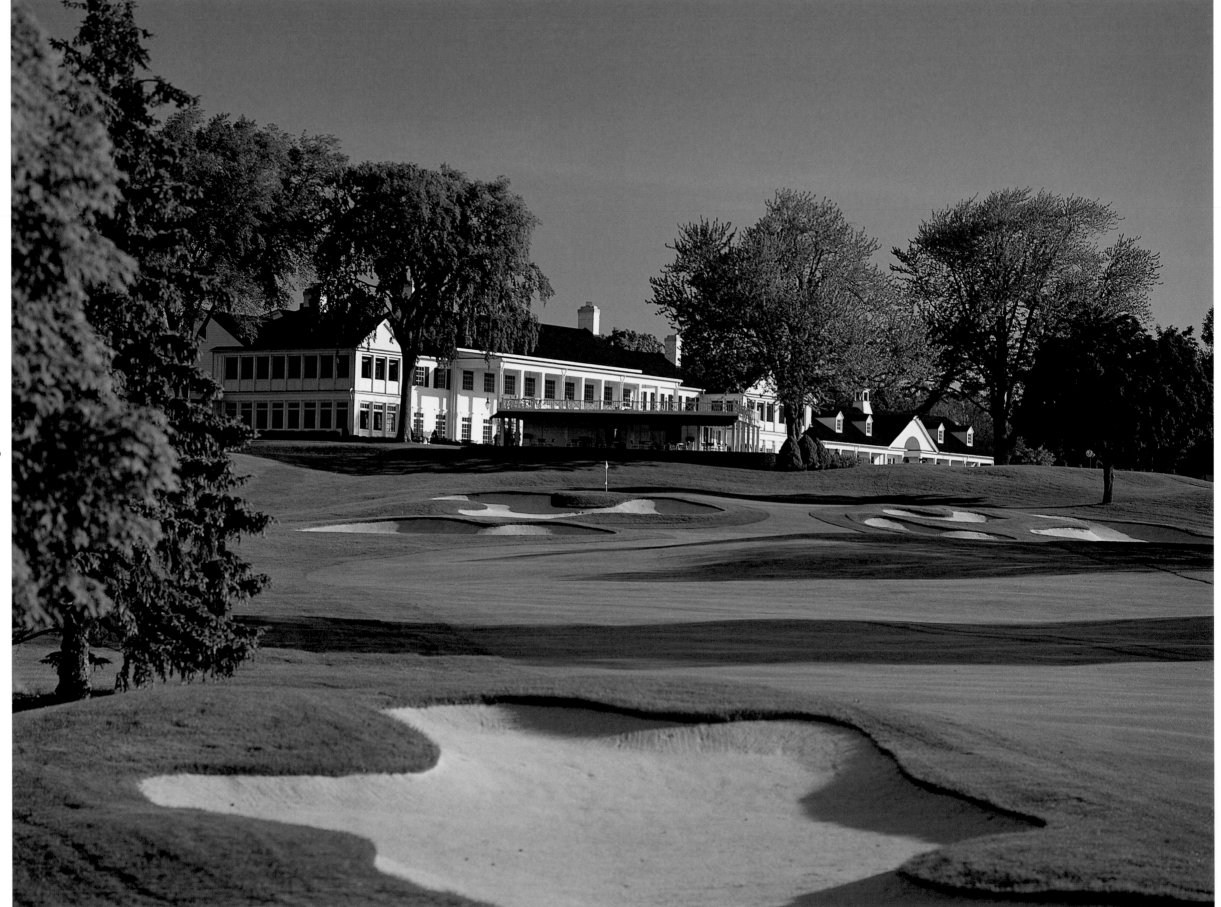

110

SOUTH COURSE, OAKLAND HILLS COUNTRY CLUB, BLOOMFIELD HILLS, MICHIGAN, U.S. 18TH HOLE, PAR 5, 492 YD. DESIGNERS: DONALD ROSS, WITH REVISIONS BY ROBERT TRENT JONES, SR.

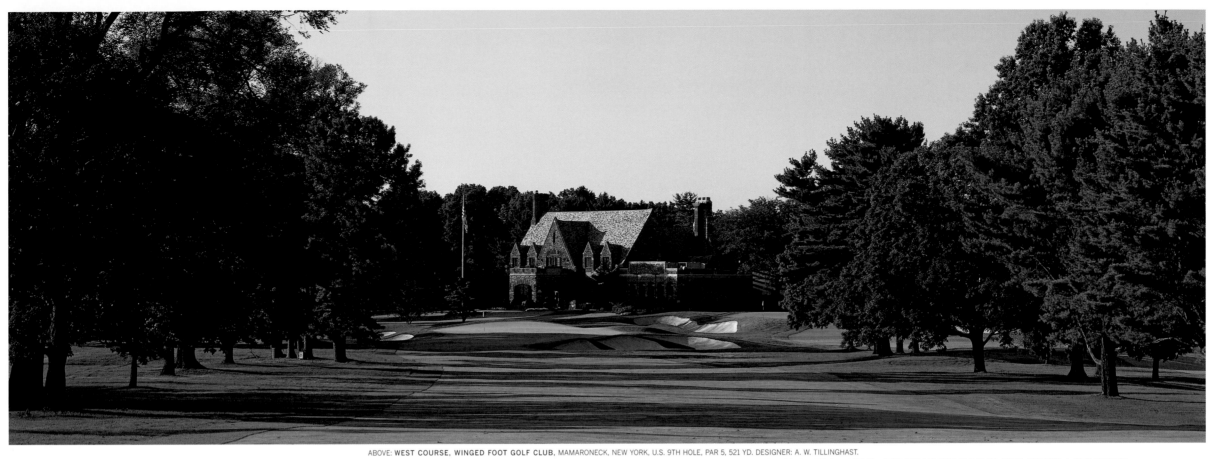

ABOVE: **WEST COURSE, WINGED FOOT GOLF CLUB**, MAMARONECK, NEW YORK, U.S. 9TH HOLE, PAR 5, 521 YD. DESIGNER: A. W. TILLINGHAST.
BELOW LEFT: **WEST COURSE, WINGED FOOT GOLF CLUB**, MAMARONECK, NEW YORK, U.S. 14TH HOLE, PAR 4, 450 YD. DESIGNER: A. W. TILLINGHAST. BELOW RIGHT: **WEST COURSE, WINGED FOOT GOLF CLUB**, MAMARONECK, NEW YORK, U.S. 7TH HOLE, PAR 3, 162 YD. DESIGNER: A. W. TILLINGHAST.

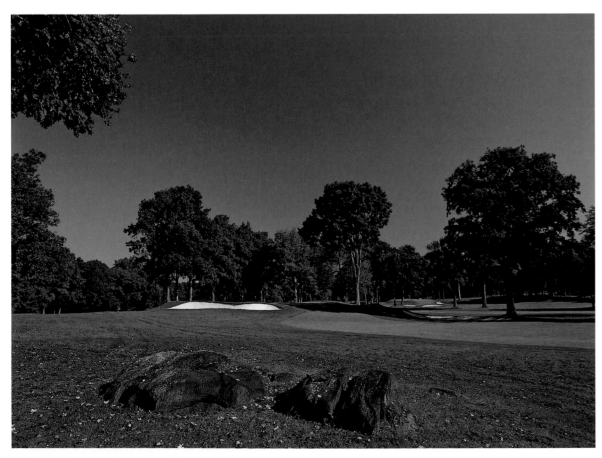

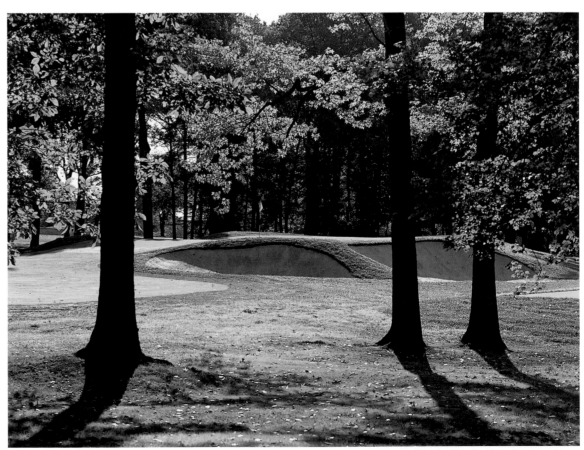

2

EUROPE

CRANS SUR SIERRE, FALSTERBO, KENNEMER, LES BORDES GOLF INTERNATIONAL, GOLF NATIONAL,
PEVERO, PRAIA D'EL REY, SPORTING CLUB BERLIN, VALDERRAMA

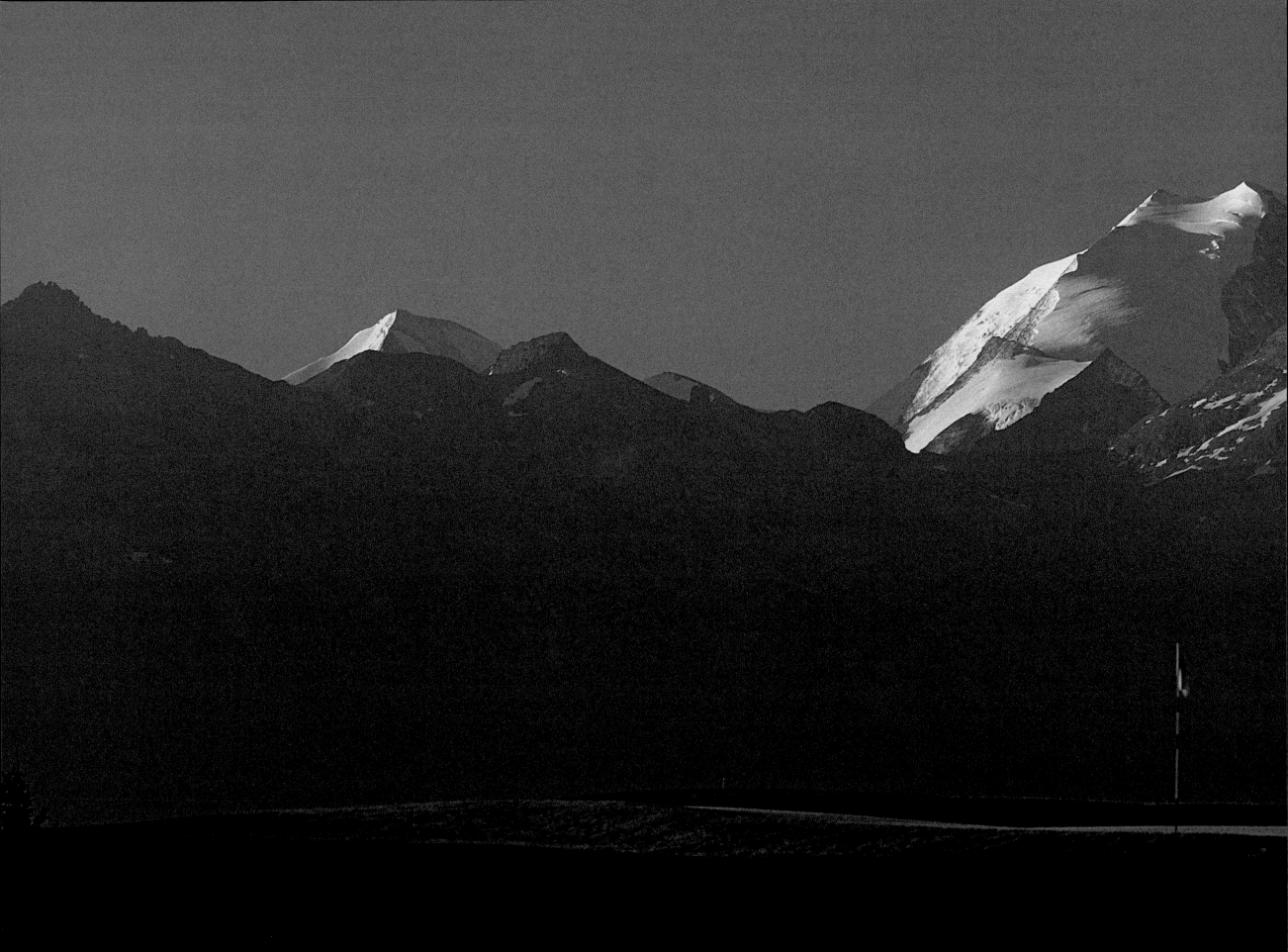

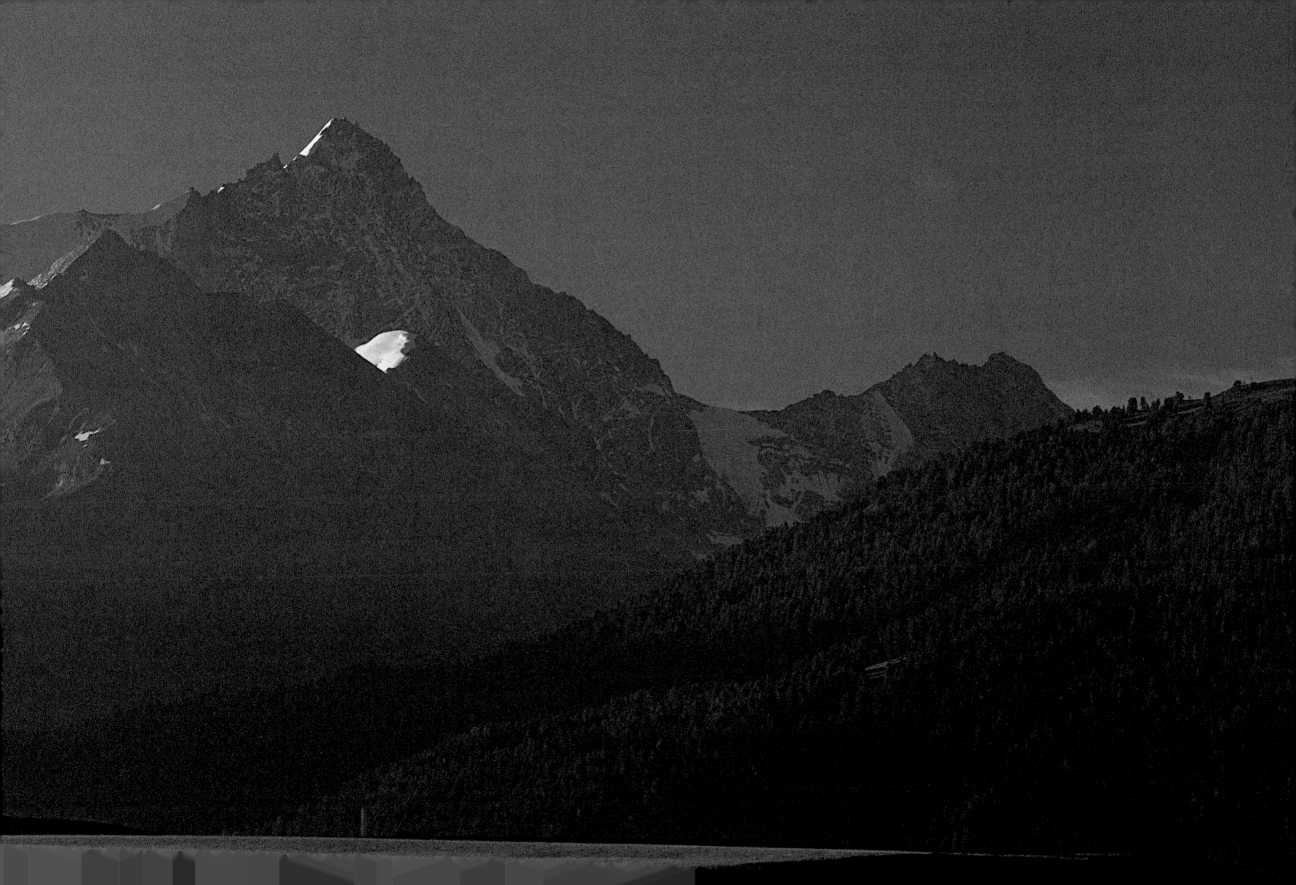

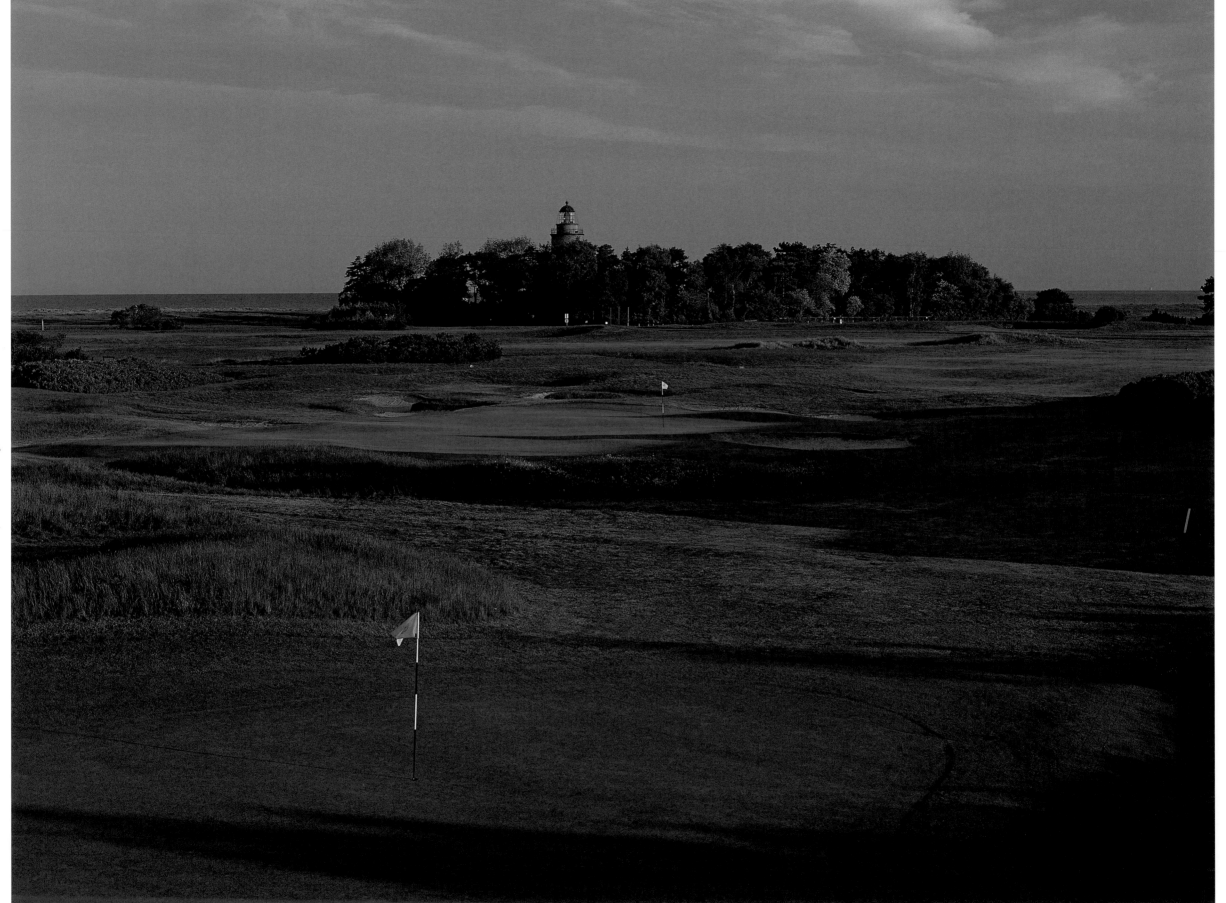

116

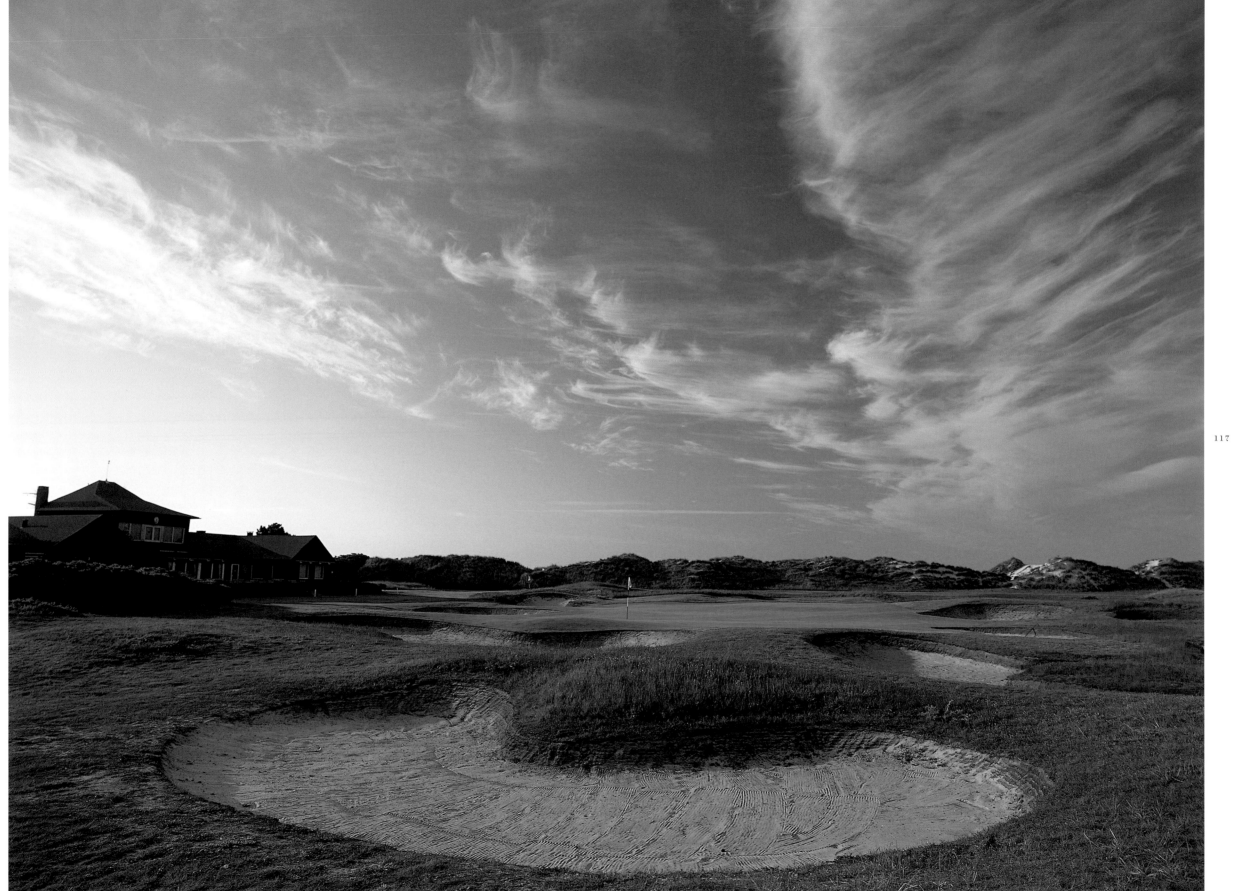

FALSTERBO GOLFKLUBB, FALSTERBO, SWEDEN. 7TH HOLE, PAR 4, 317 YD. DESIGNER: GUNNAR BAUER.

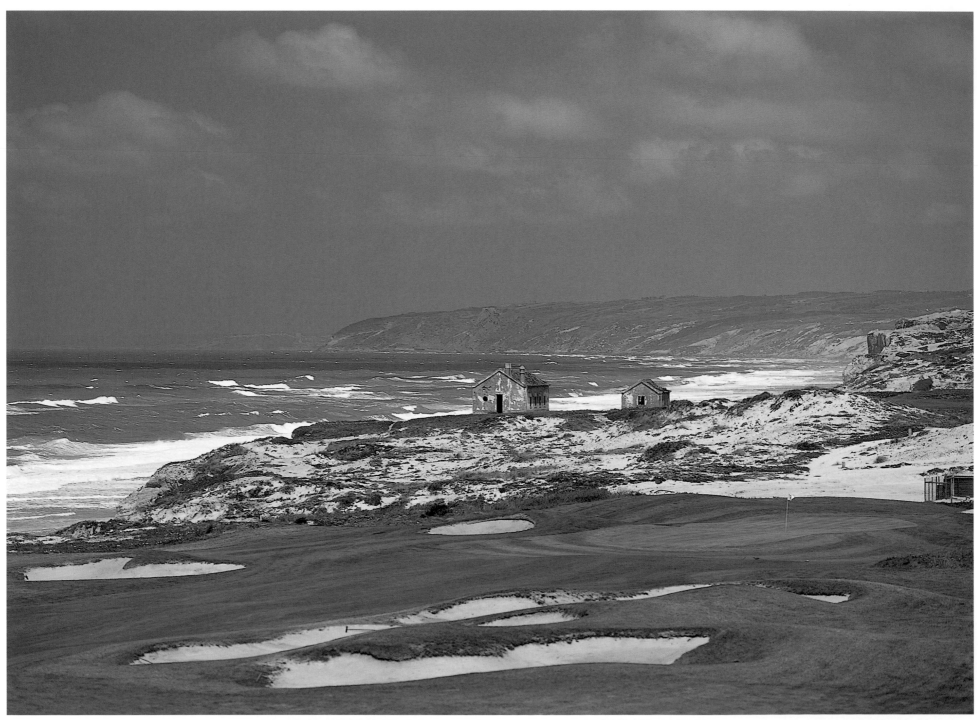

PRAIA D'EL REY GOLF AND COUNTRY CLUB, OBIDOS, PORTUGAL. 13TH HOLE, PAR 4, 328 YD. DESIGNER: CABELL B. ROBINSON.

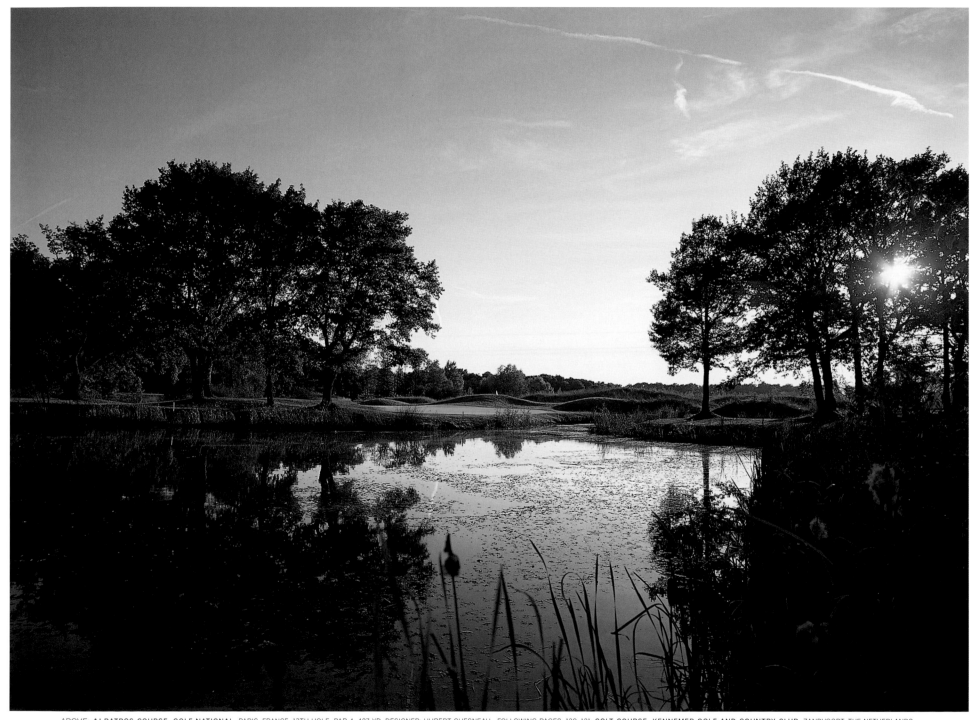

ABOVE: **ALBATROS COURSE, GOLF NATIONAL**, PARIS, FRANCE. 13TH HOLE, PAR 4, 427 YD. DESIGNER: HUBERT CHESNEAU. FOLLOWING PAGES, 120–121: **COLT COURSE, KENNEMER GOLF AND COUNTRY CLUB**, ZANDVOORT, THE NETHERLANDS. 14TH HOLE, PAR 4, 367 YD.; 15TH HOLE (IN BACKGROUND), PAR 3, 150 YD. DESIGNERS: HARRY S. COLT, JOHN S. F. MORRISON.

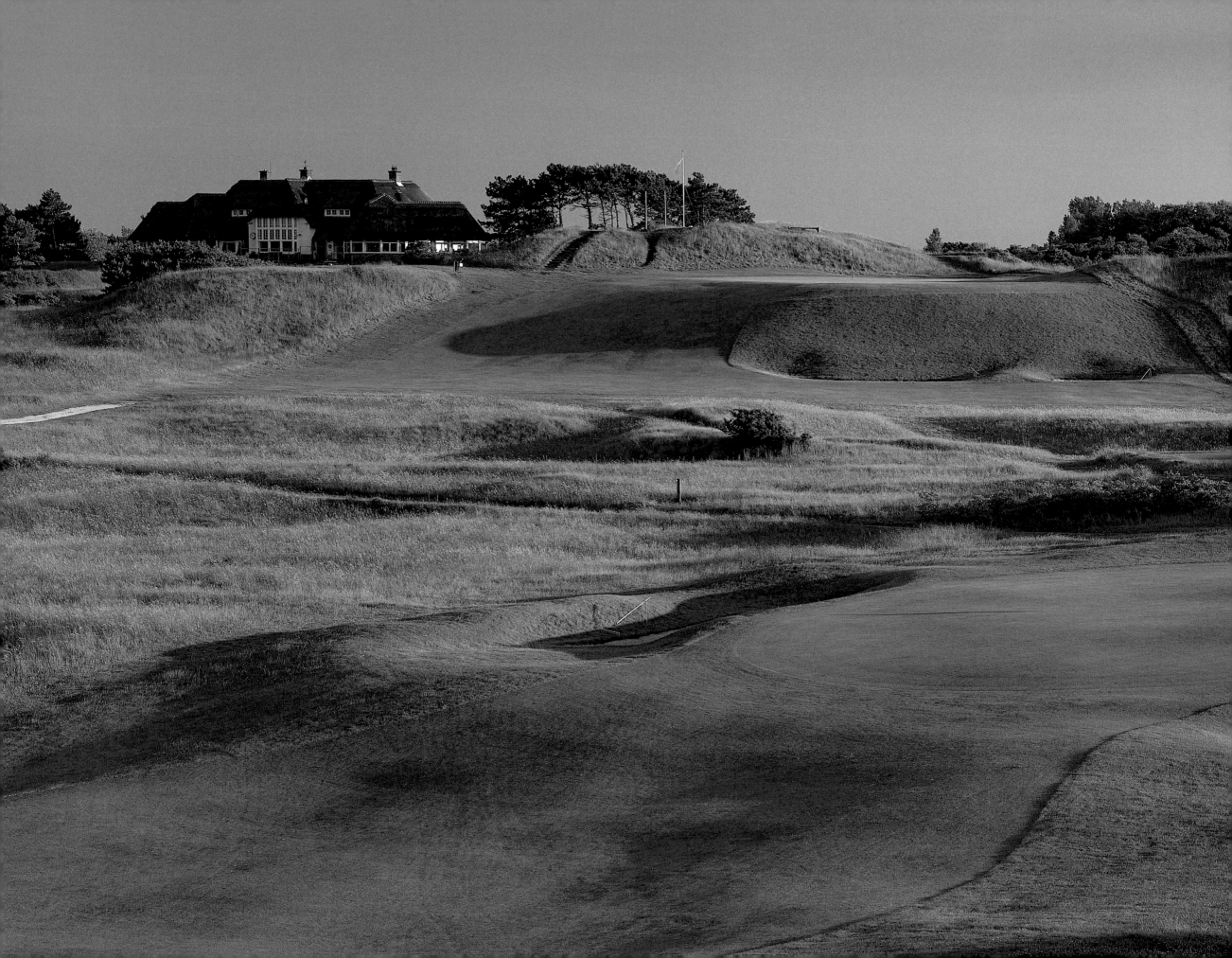

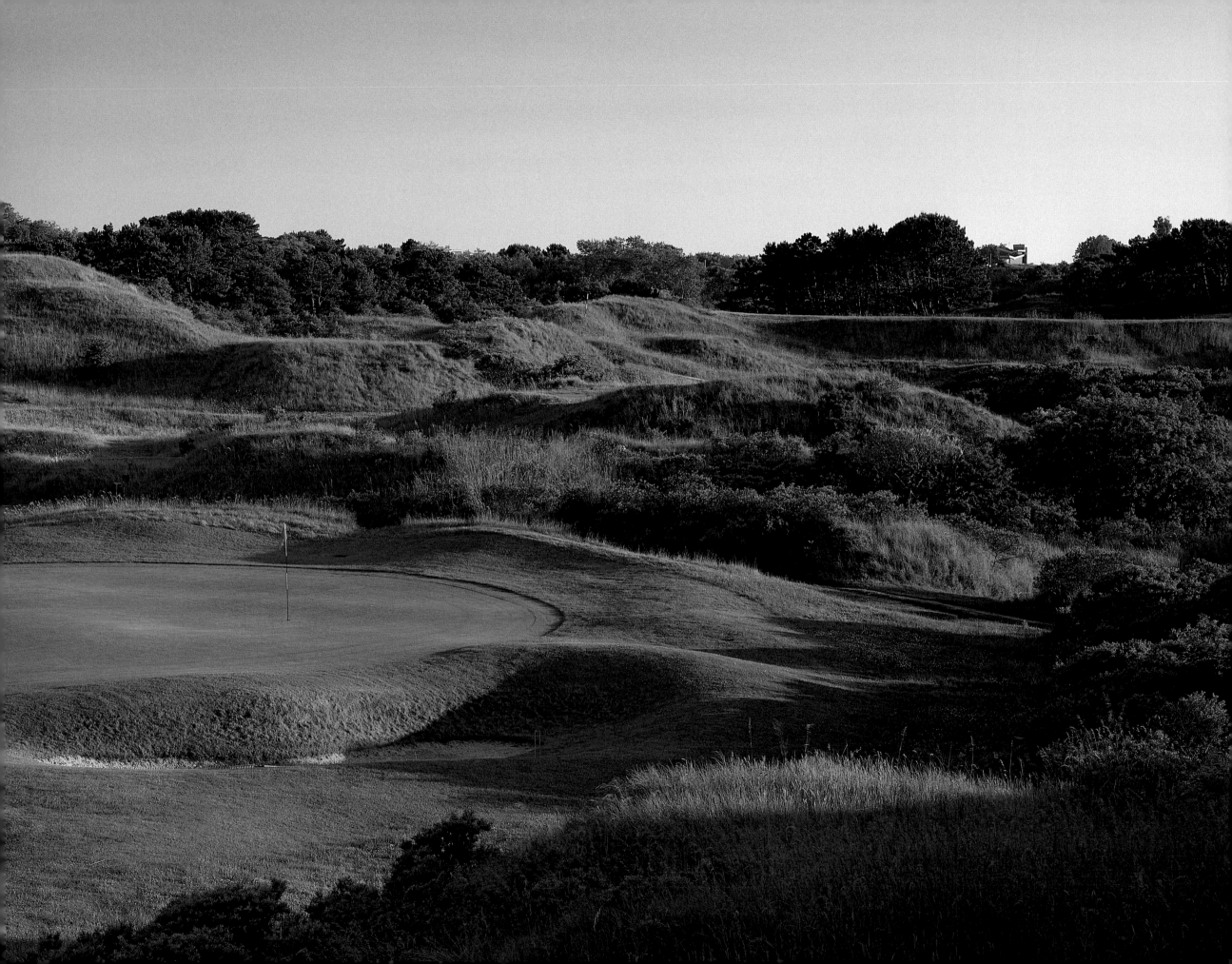

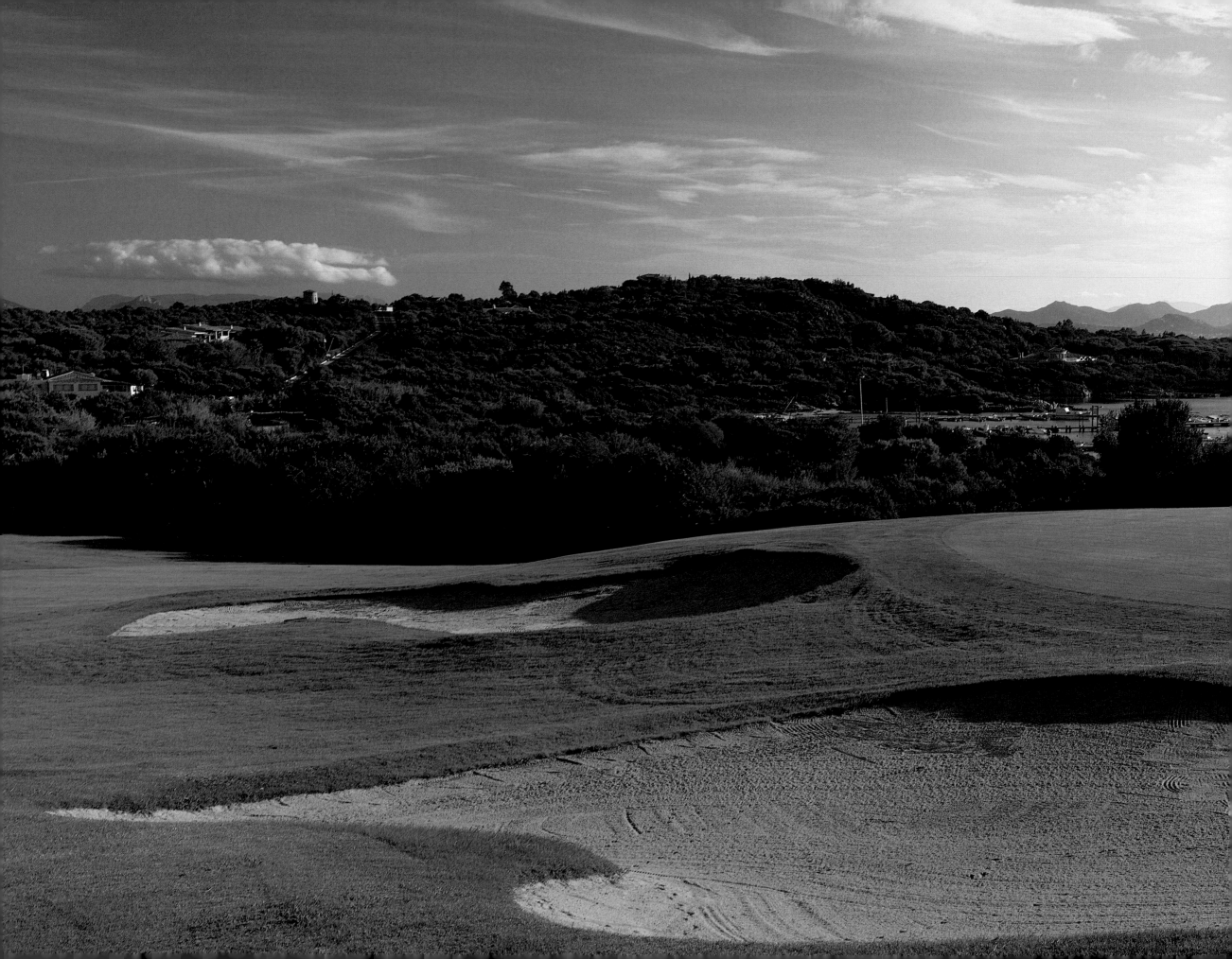

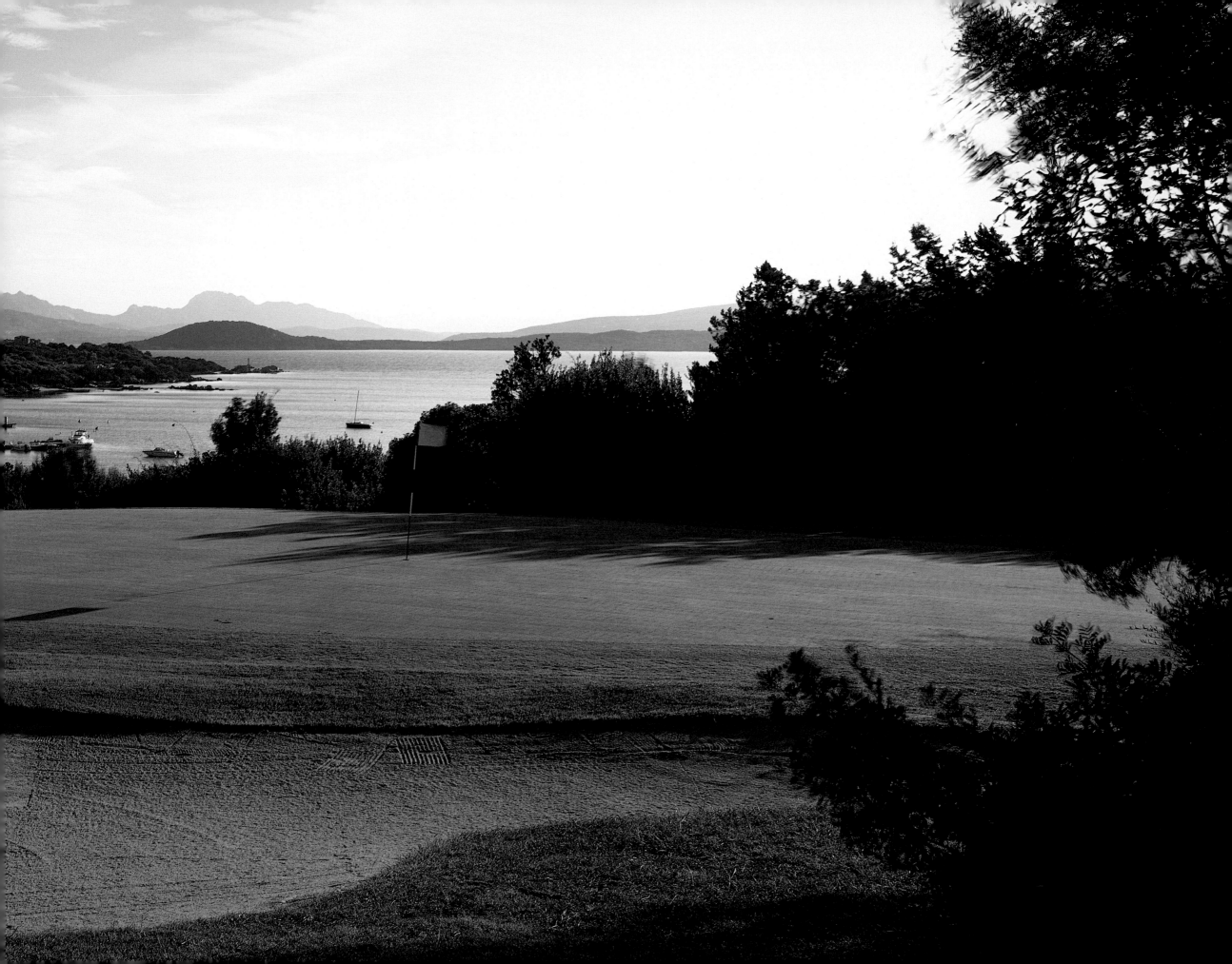

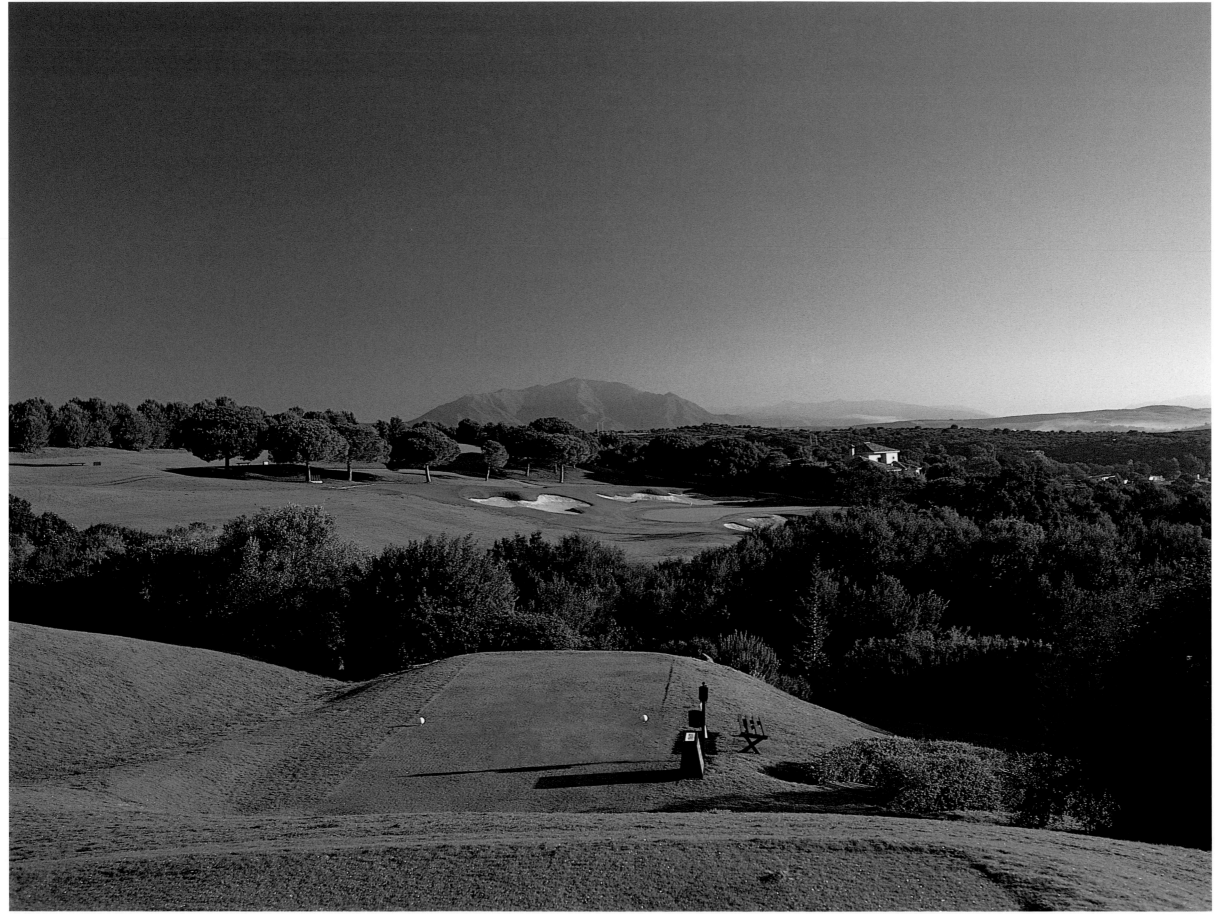

124

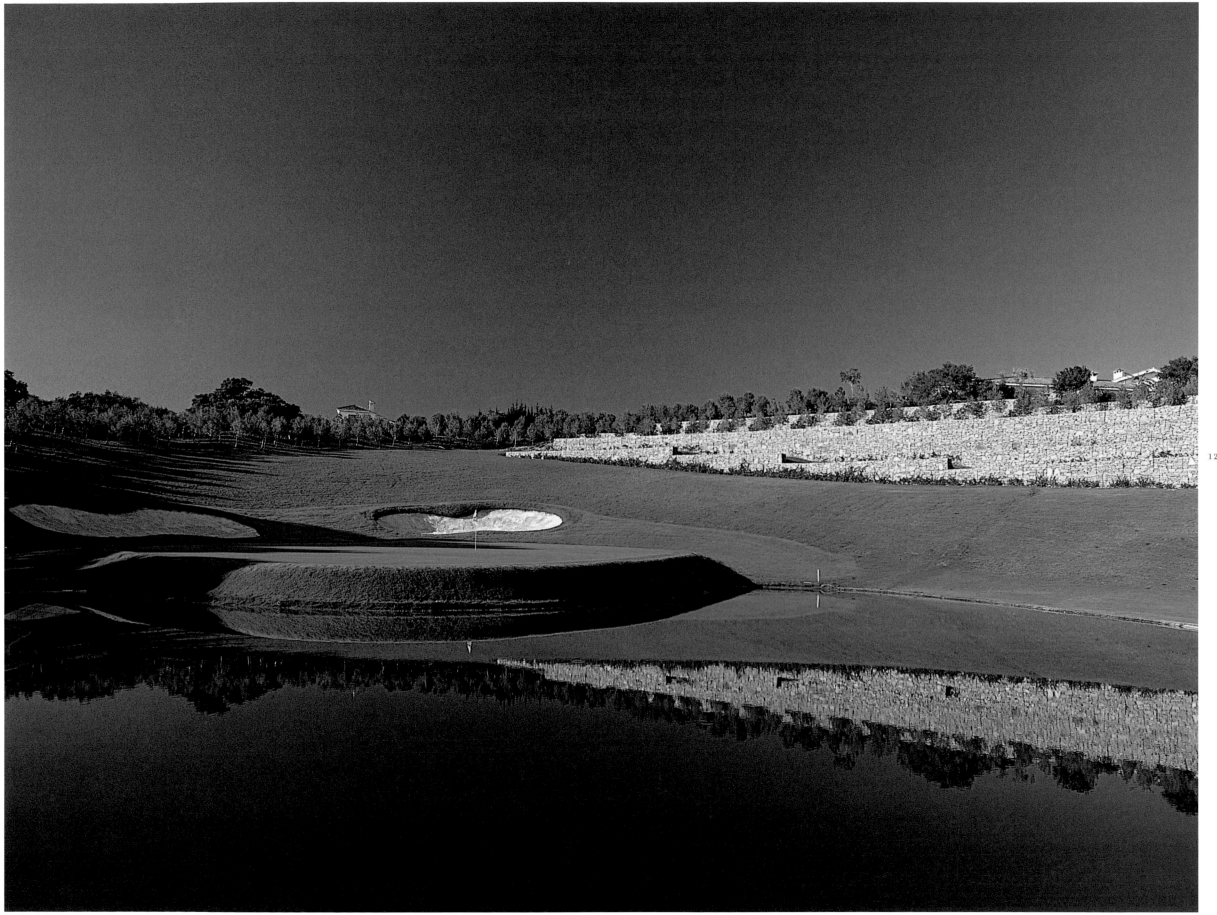

VALDERRAMA, CLUB DE GOLF, SOTOGRANDE, CADÍZ, SPAIN. 17TH HOLE, PAR 5, 536 YD. DESIGNER: ROBERT TRENT JONES, SR., WITH REVISIONS BY SEVERIANO BALLESTEROS

126

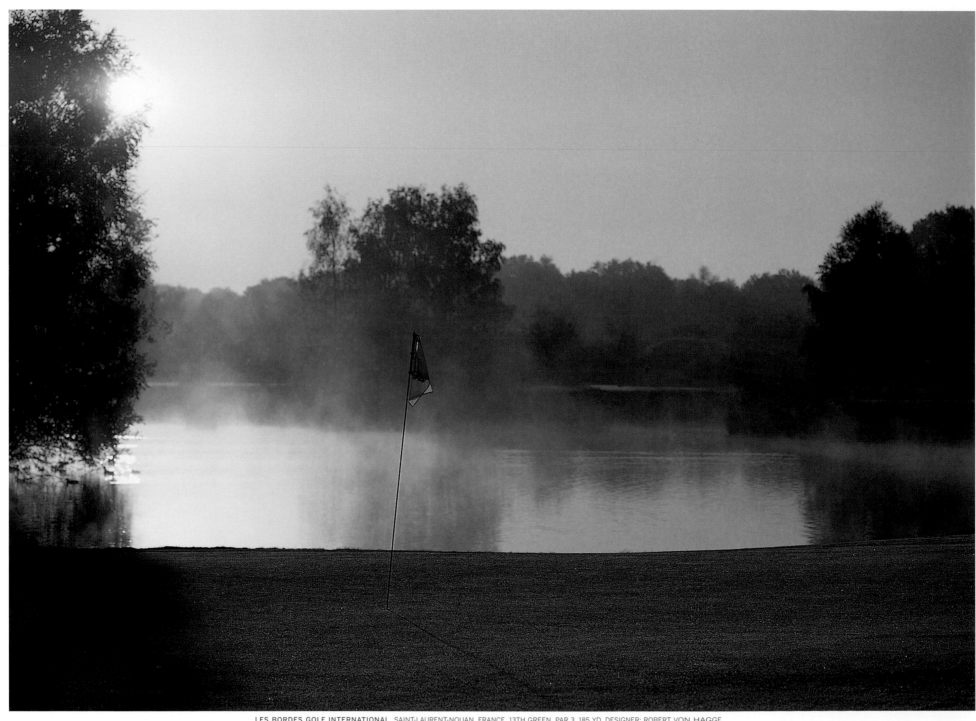

LES BORDES GOLF INTERNATIONAL, SAINT-LAURENT-NOUAN, FRANCE. 13TH GREEN, PAR 3, 185 YD. DESIGNER: ROBERT VON HAGGE.

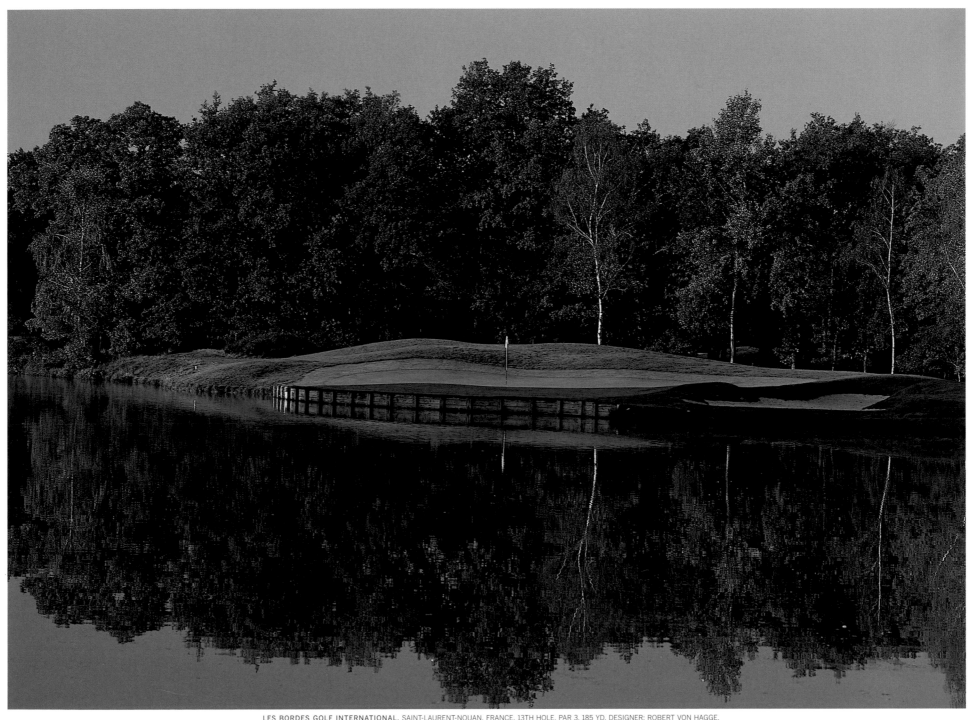

LES BORDES GOLF INTERNATIONAL, SAINT-LAURENT-NOUAN, FRANCE. 13TH HOLE, PAR 3, 185 YD. DESIGNER: ROBERT VON HAGGE.

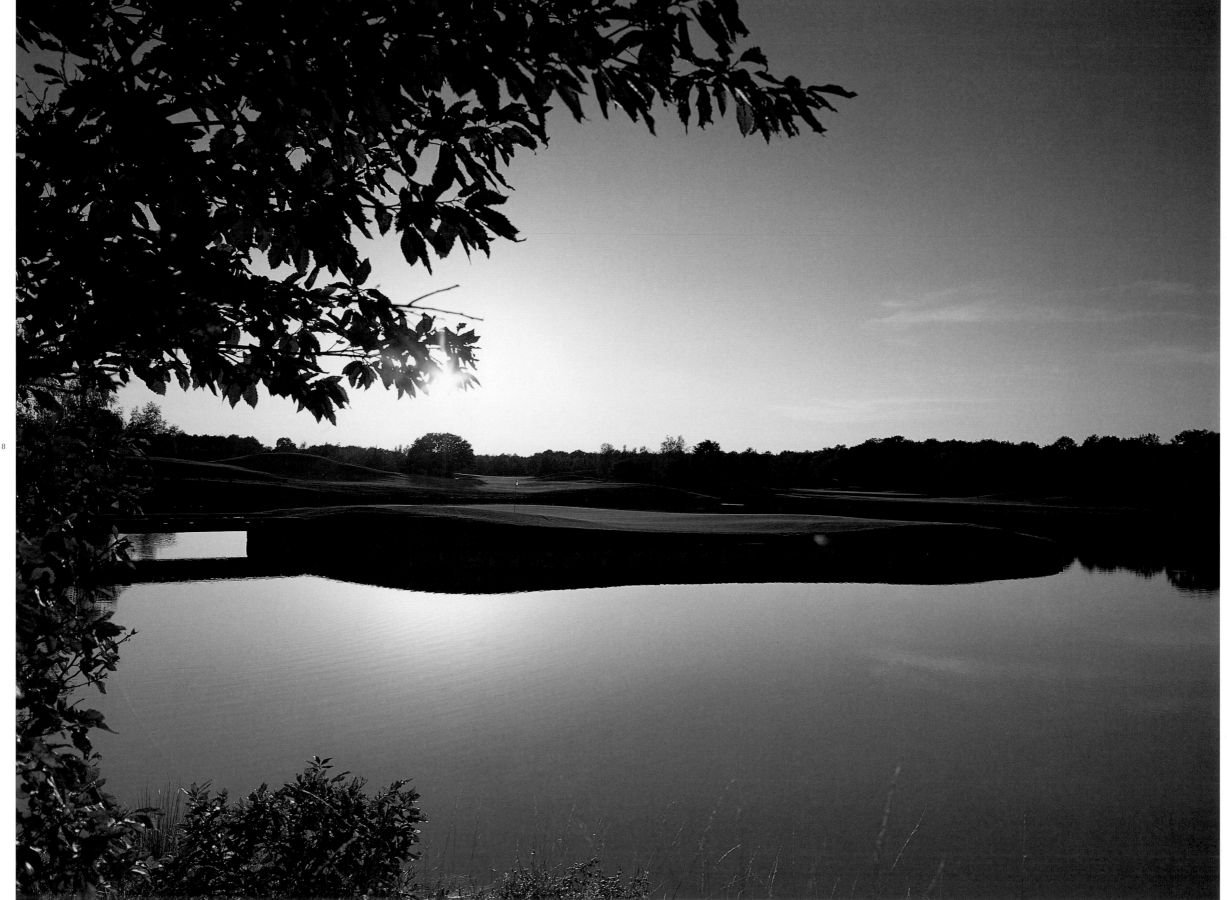

128

LES BORDES GOLF INTERNATIONAL, SAINT-LAURENT-NOUAN, FRANCE. 14TH GREEN, PAR 5, 558 YD. DESIGNER: ROBERT VON HAGGE.

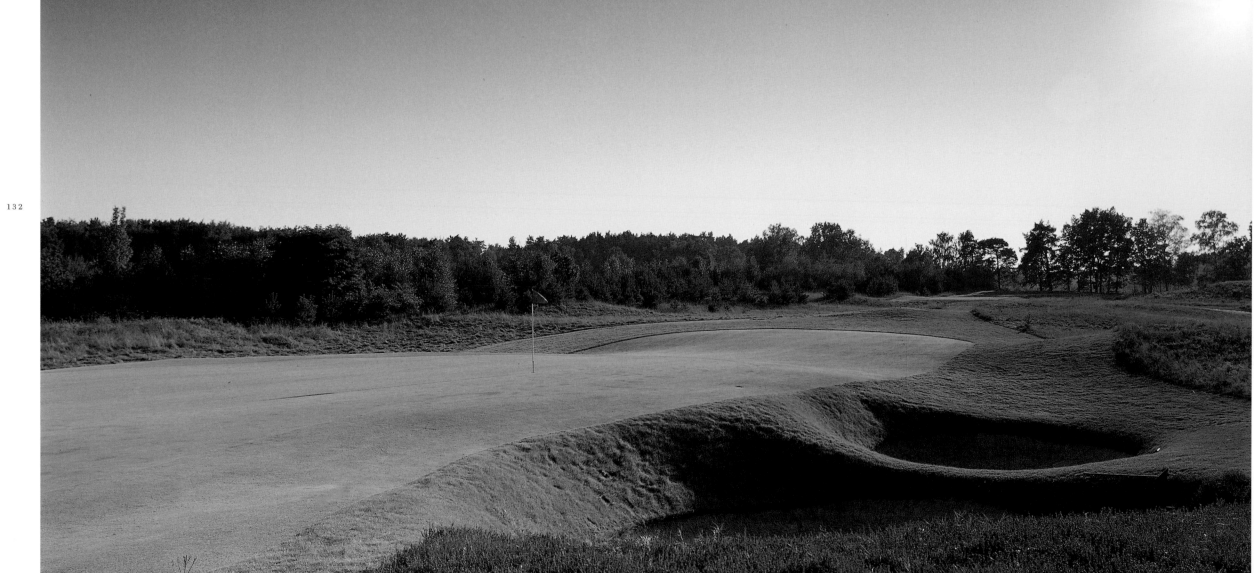

NICK FALDO COURSE, SPORTING CLUB BERLIN, BAD SAAROW, GERMANY. 17TH HOLE, PAR 3, 192 YD. DESIGNER: NICK FALDO.

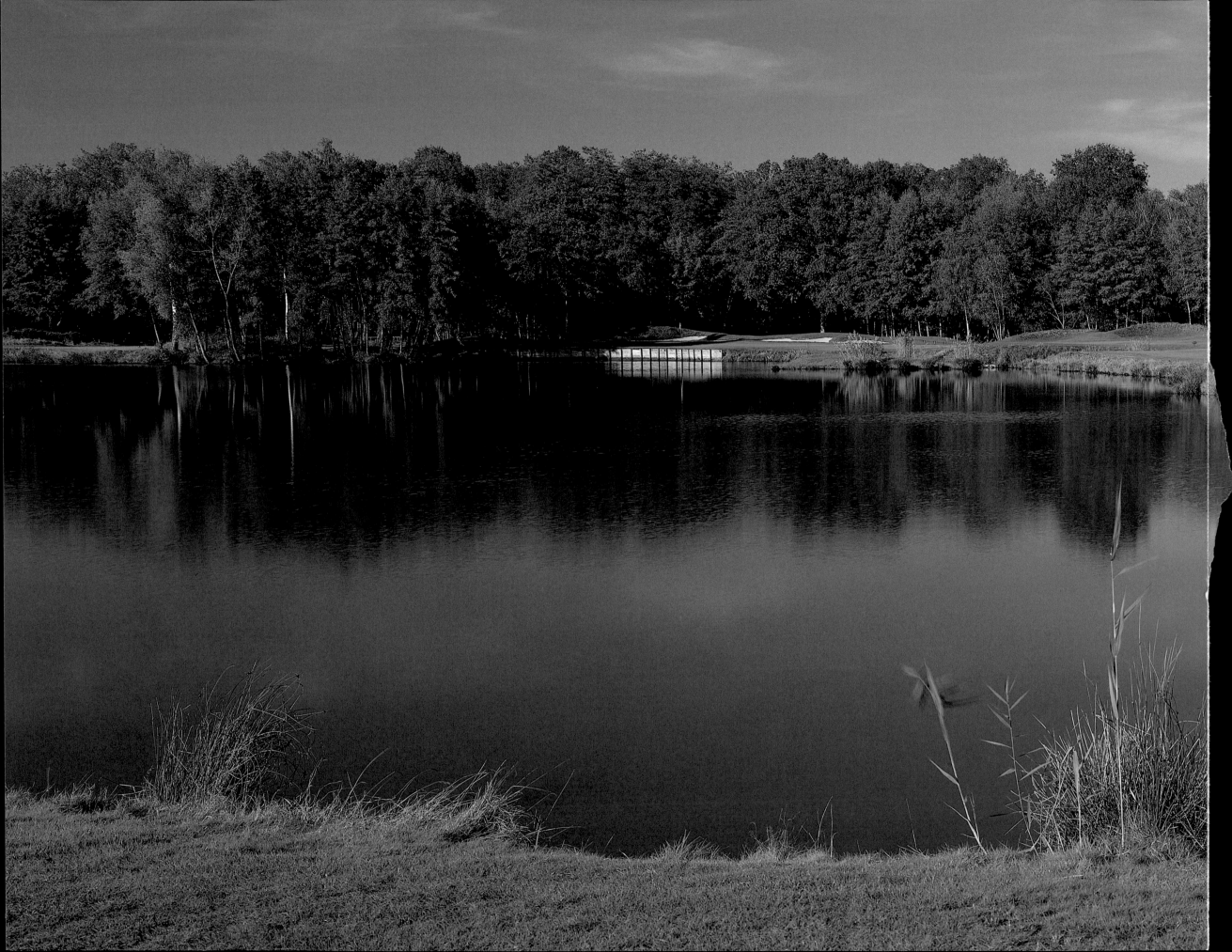

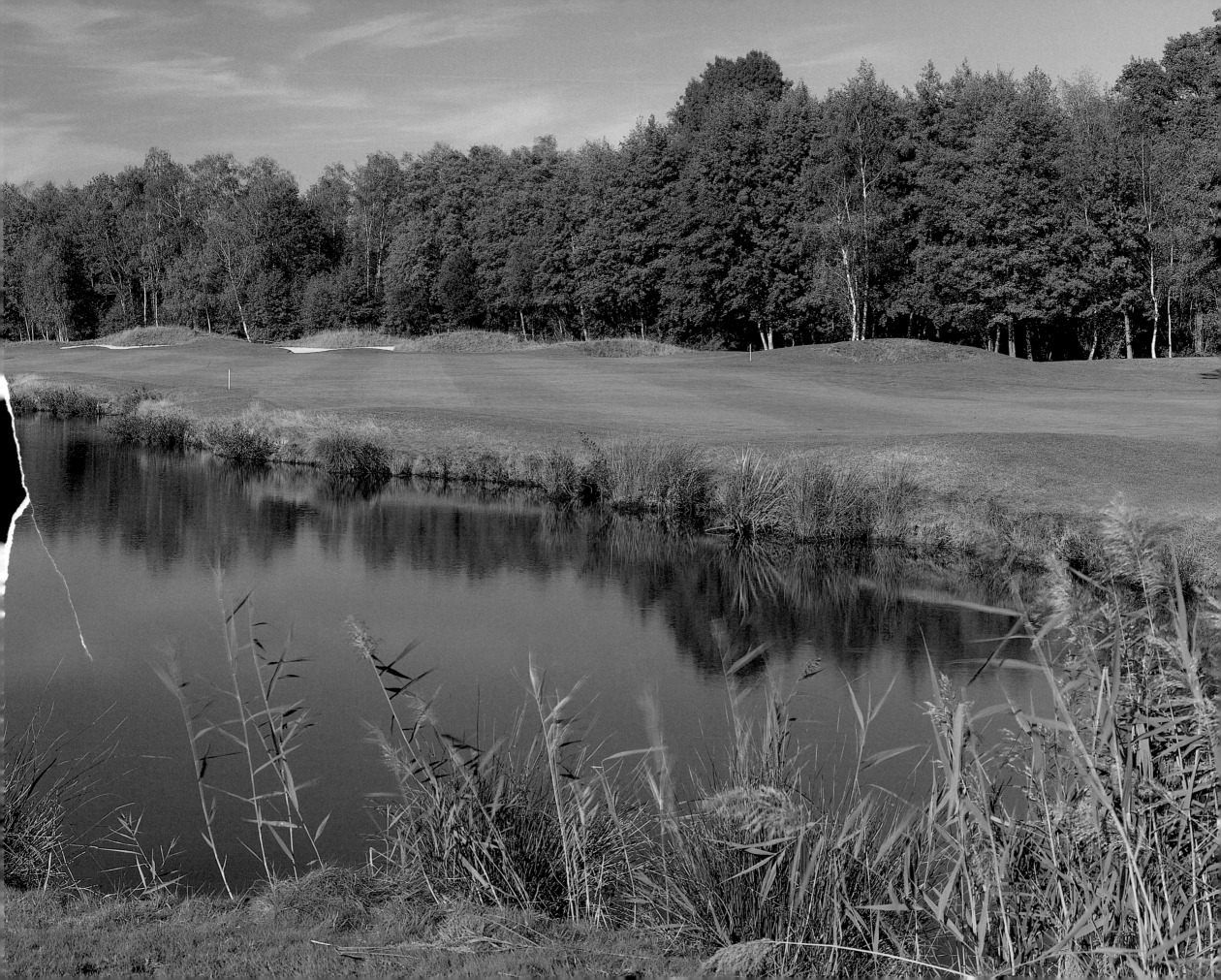

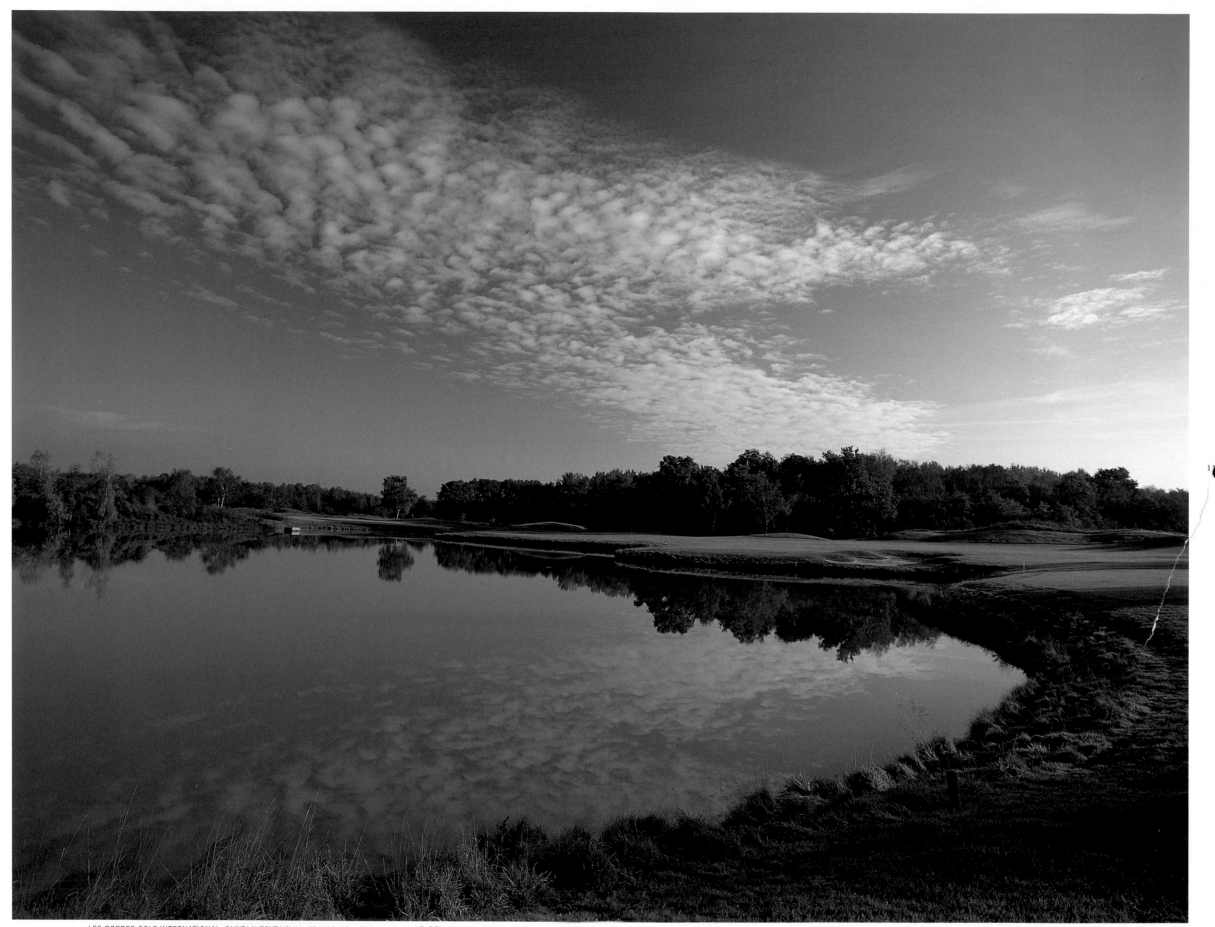

LES BORDES GOLF INTERNATIONAL, SAINT-LAURENT-NOUAN, FRANCE. 11TH HOLE, PAR 4, 401 YD. DESIGNER: ROBERT VON HAGGE. FOLLOWING PAGES, 130–131: LES BORDES GOLF INTERNATIONAL, SAINT-LAURENT-NOUAN, FRANCE. 7TH HOLE, PAR 5, 507 YD. DESIGNER: ROBERT VON HAGGE.

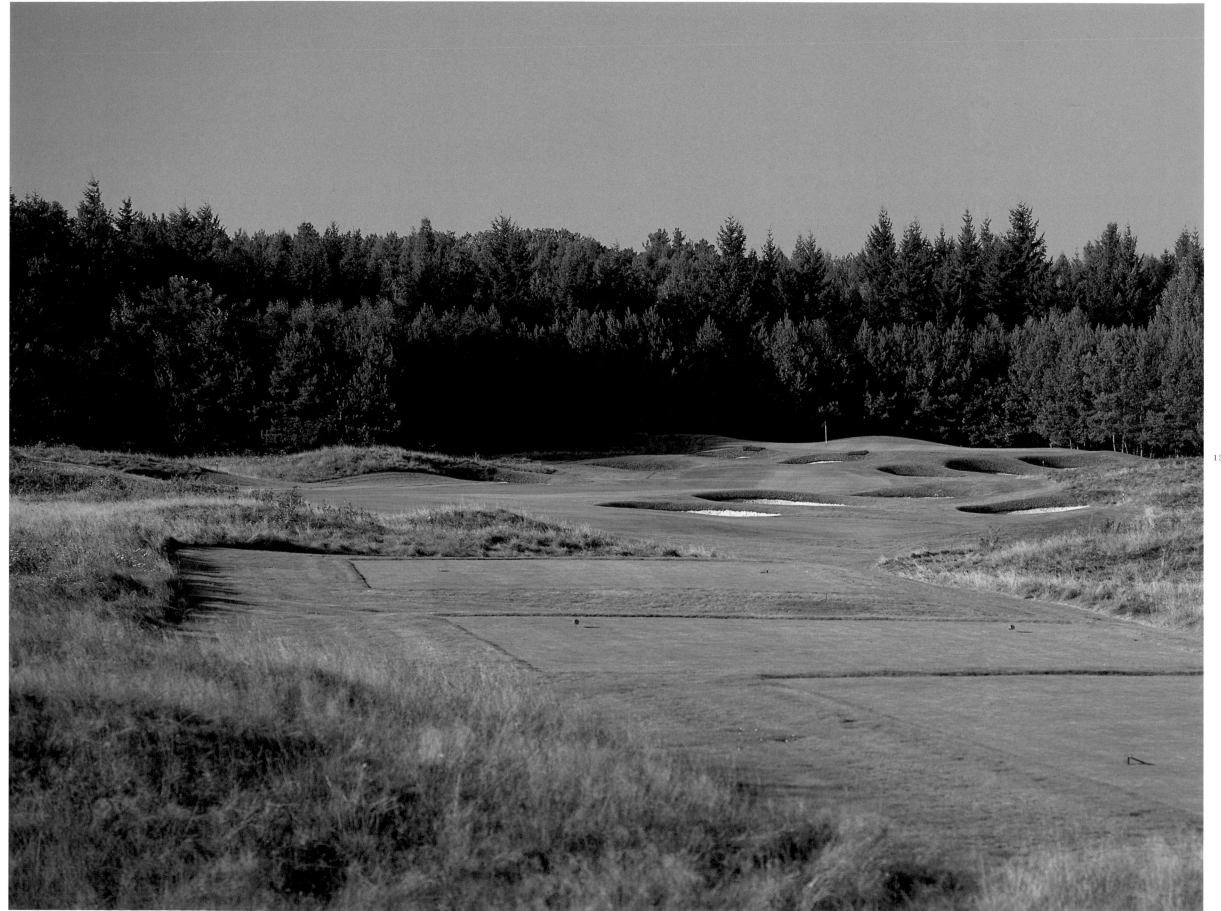

NICK FALDO COURSE, SPORTING CLUB BERLIN, BAD SAAROW, GERMANY. 15TH HOLE, PAR 4, 390 YD. DESIGNER: NICK FALDO.

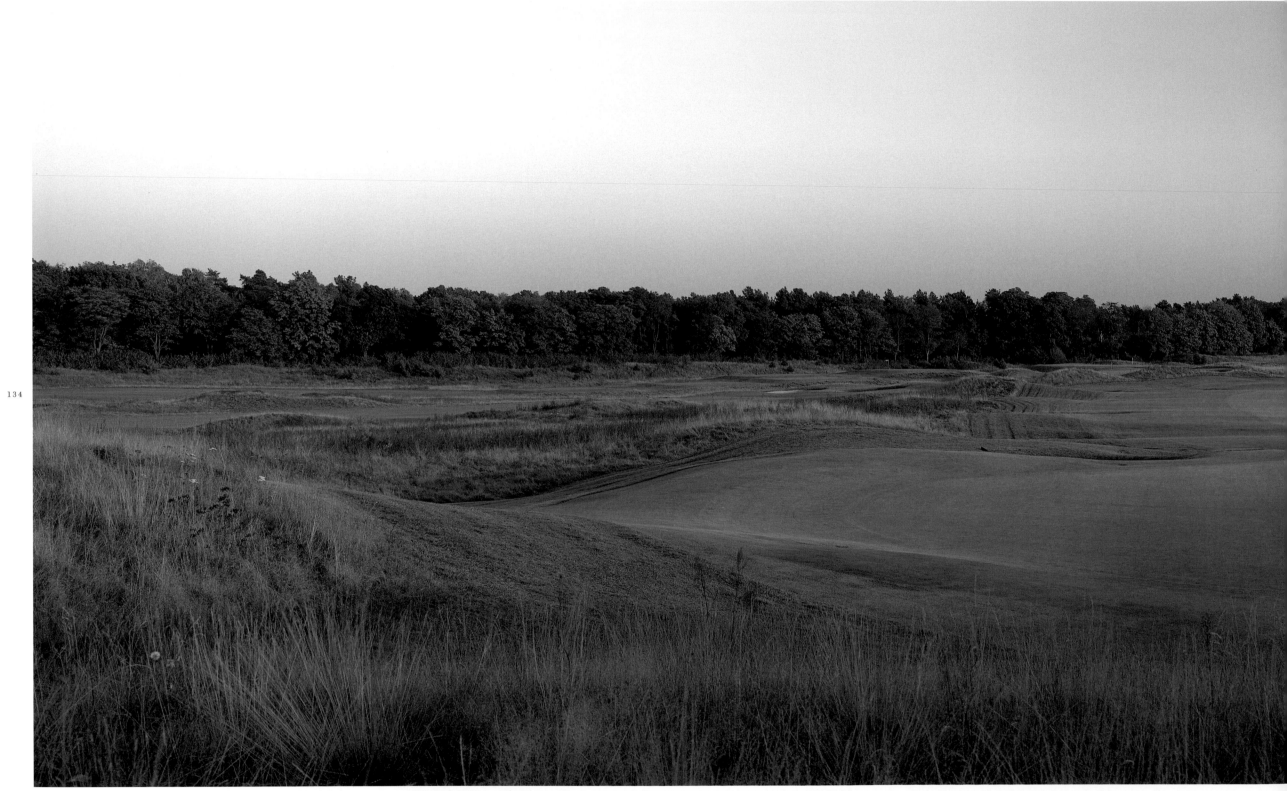

NICK FALDO COURSE, SPORTING CLUB BERLIN, BAD SAAROW, GERMANY. 7TH HOLE, PAR 4, 439 YD. DESIGNER: NICK FALDO.

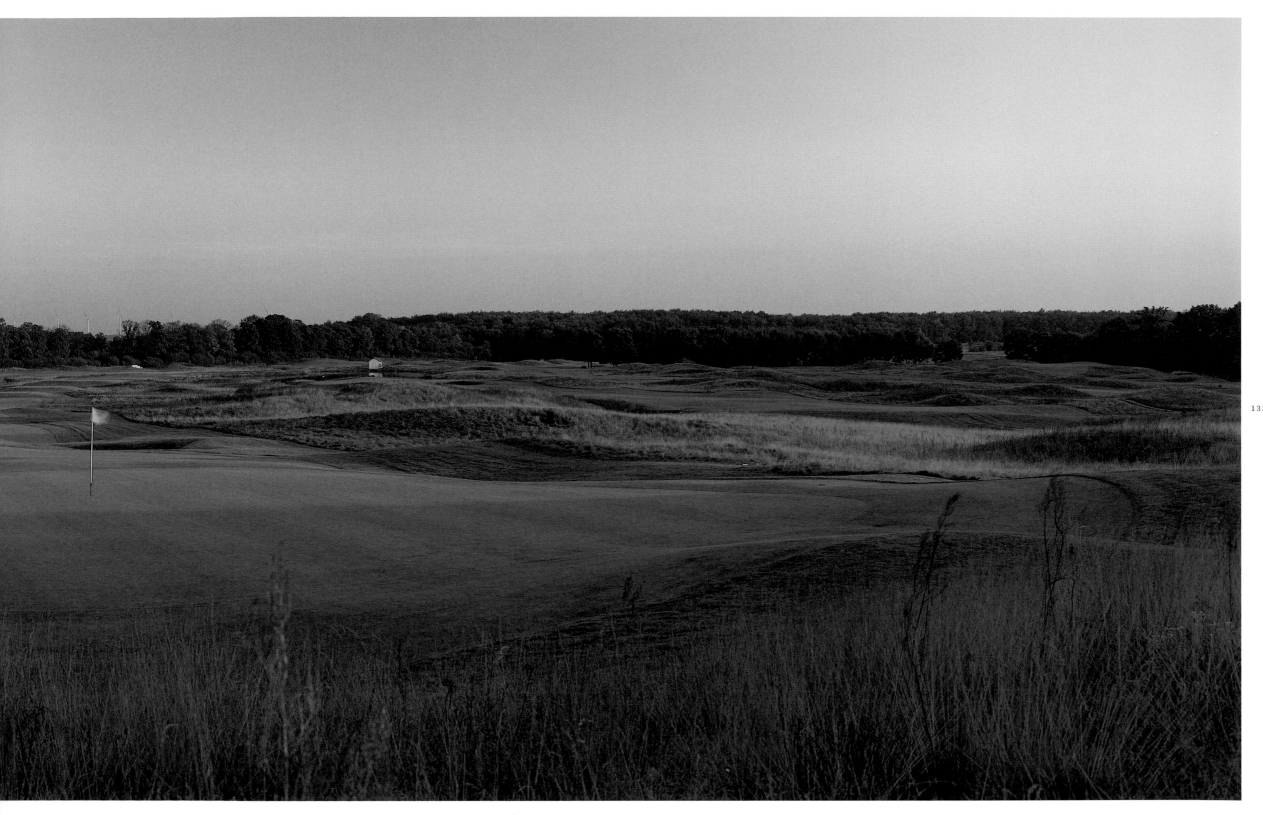

3

GREAT BRITAIN AND IRELAND

BALLYBUNION, CARNOUSTIE, CELTIC MANOR RESORT, EUROPEAN CLUB, GLENEAGLES HOTEL, HUNSTANTON, K CLUB, KINGSBARNS, LAHINCH, MUIRFIELD, PRESTWICK, ROYAL BIRKDALE, ROYAL COUNTY DOWN, ROYAL DORNOCH, ROYAL LIVERPOOL, ROYAL NORTH DEVON, ROYAL PORTRUSH, ROYAL WEST NORFOLK, ST. ANDREWS, SUNNINGDALE, SWINLEY FOREST, TURNBERRY, WALTON HEATH, WENTWORTH, WOODHALL SPA

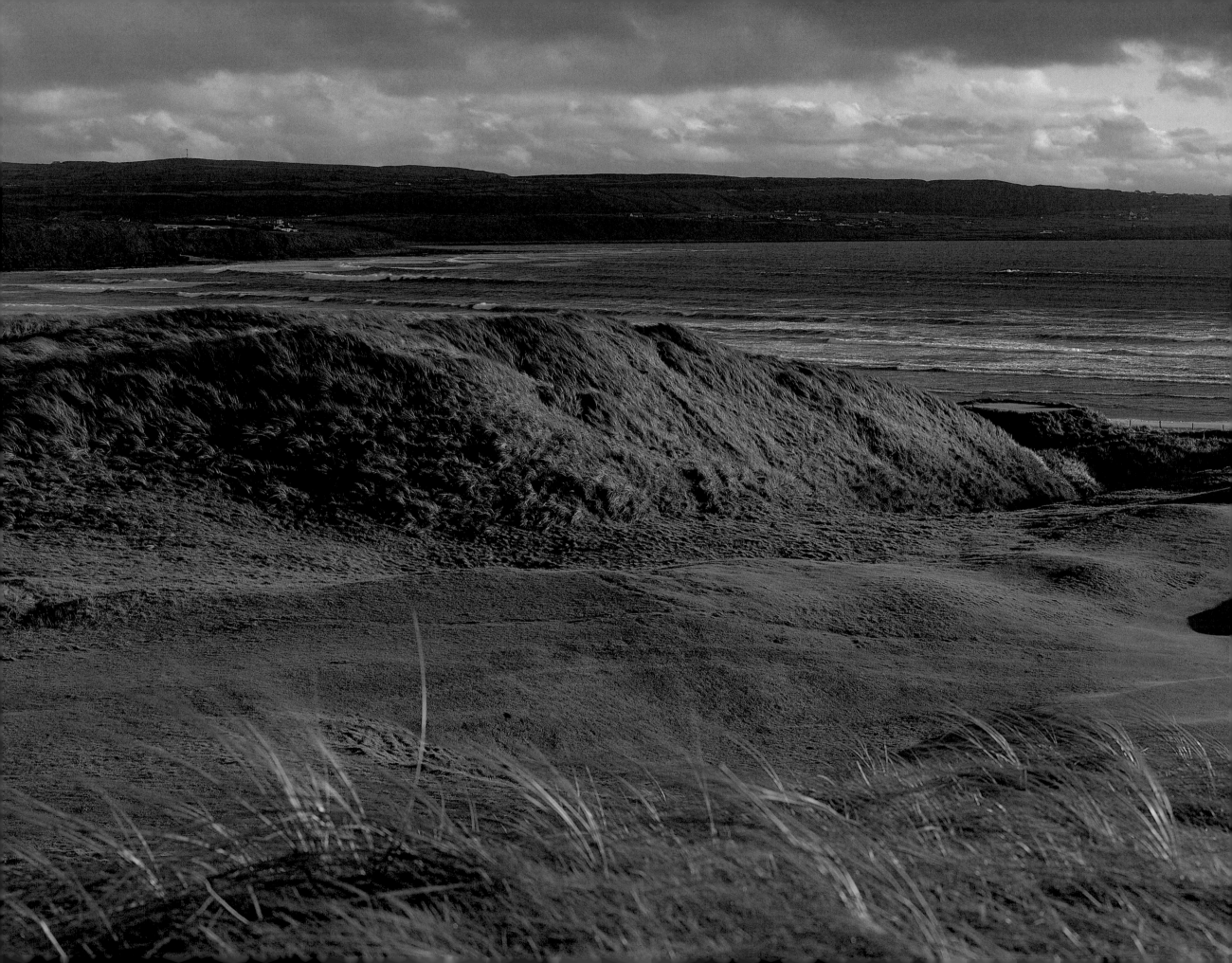

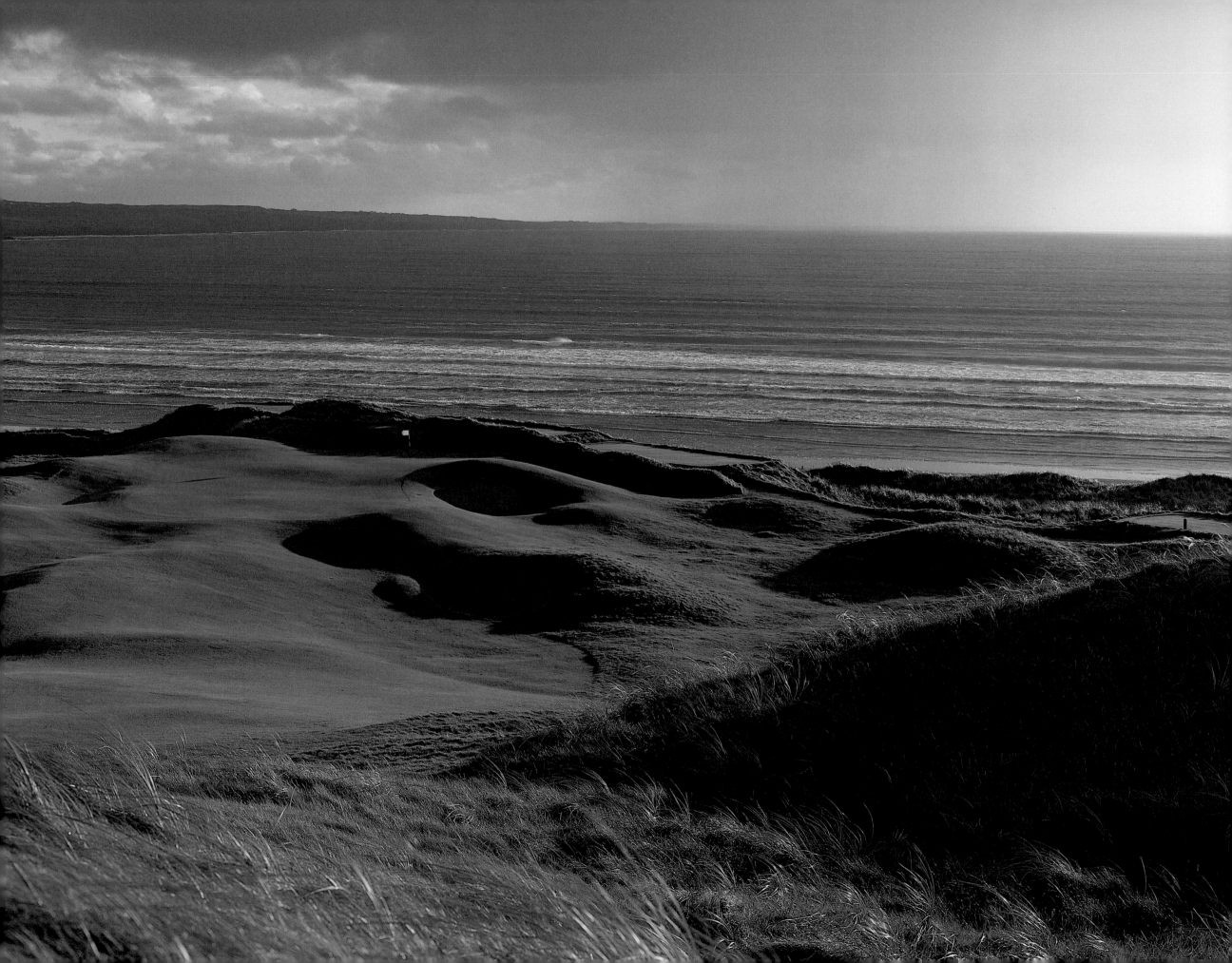

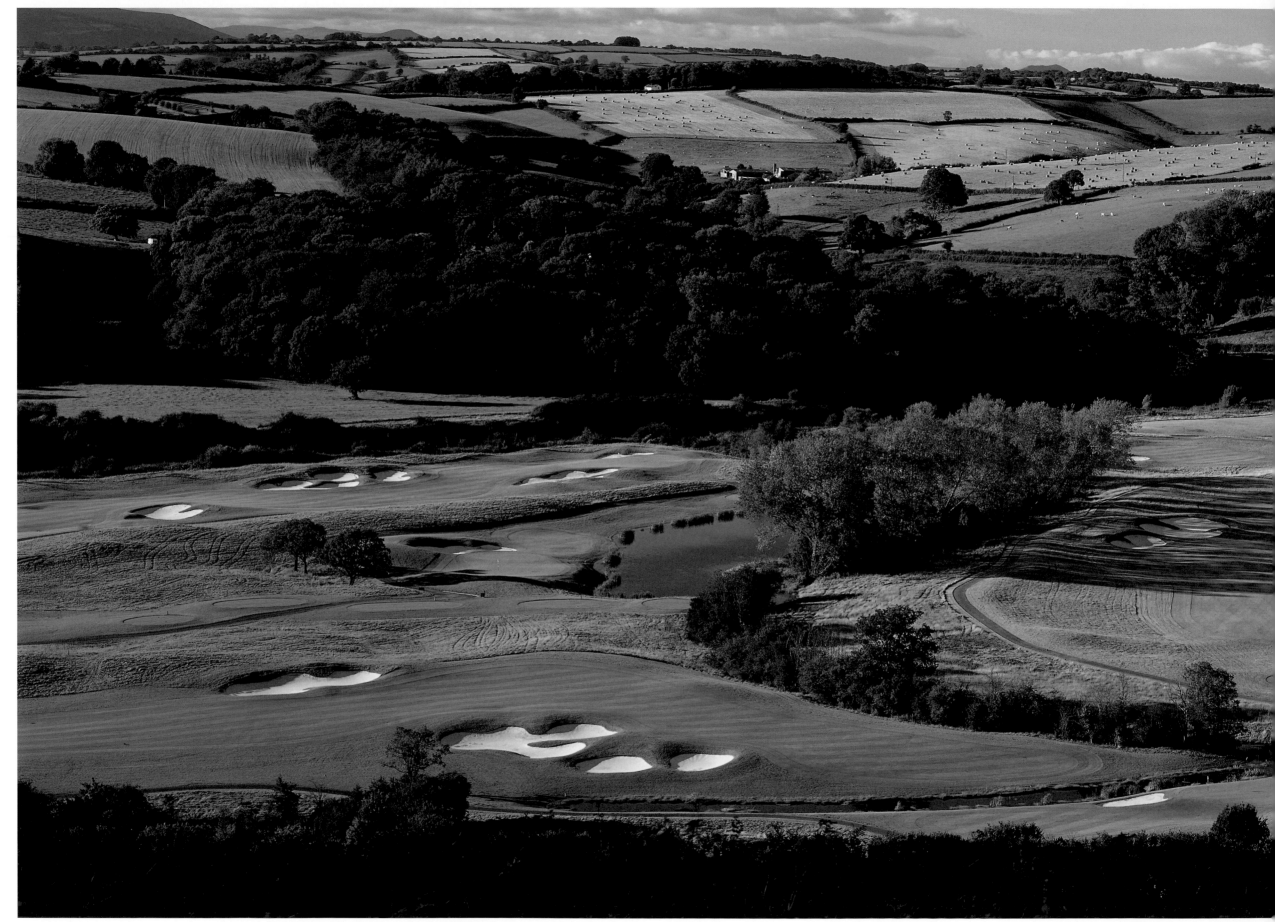

PREVIOUS PAGES, 138-139: **THE OLD COURSE, LAHINCH GOLF CLUB,** CO. CLARE, IRELAND. 6TH HOLE, PAR 4, 424 YD. DESIGNERS: OLD TOM MORRIS, DR. ALISTER MACKENZIE, MARTIN HAWTREE.

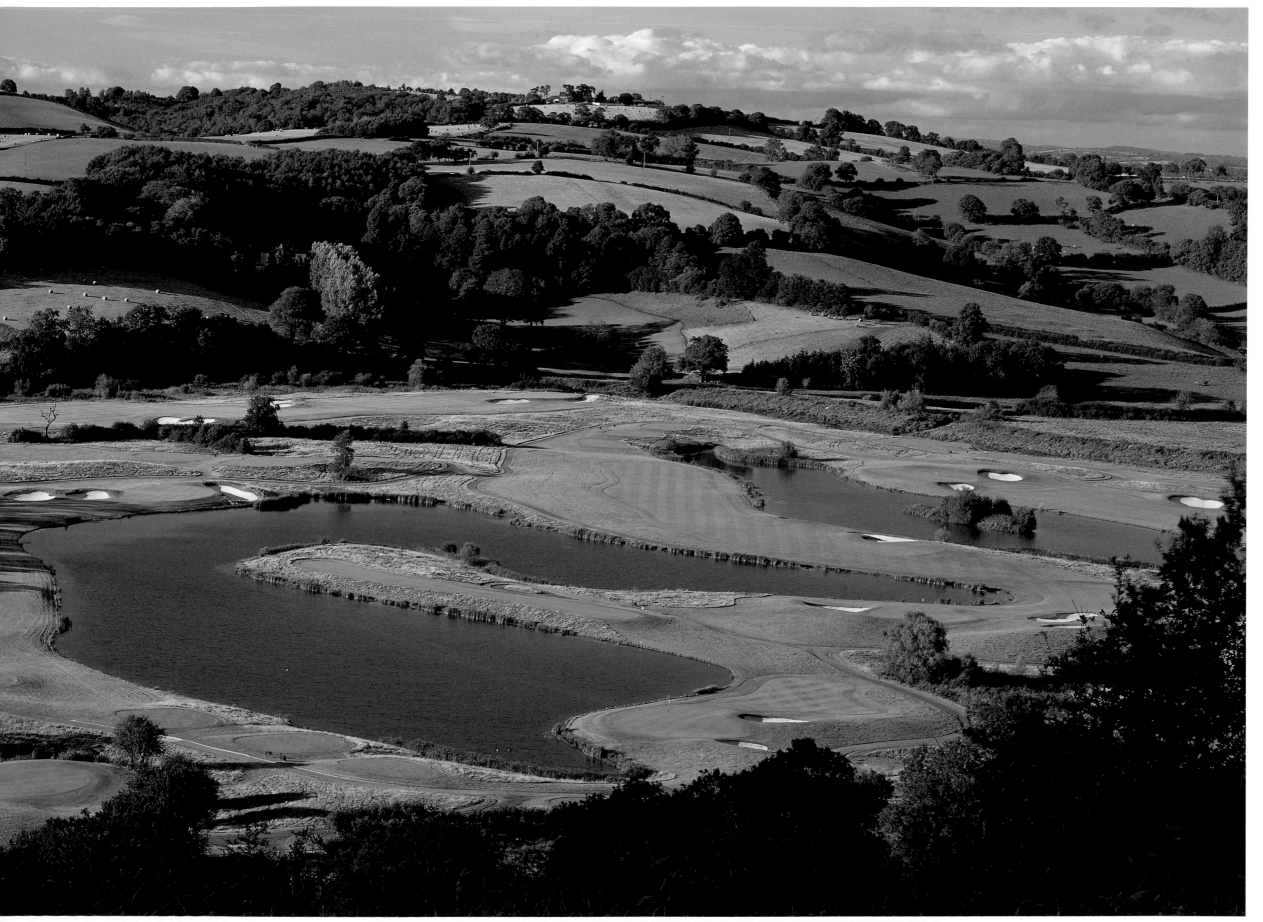

THE TWENTY TEN COURSE, THE CELTIC MANOR RESORT, NEWPORT, WALES. DESIGNERS: ROSS MCMURRAY, DESIGN CONSULTATION BY ROBERT TRENT JONES, JR.

142

THE WEST COURSE, THE WENTWORTH CLUB, VIRGINIA WATER, SURREY, ENGLAND. 8TH HOLE, PAR 4, 400 YD. DESIGNER: HARRY S. COLT.

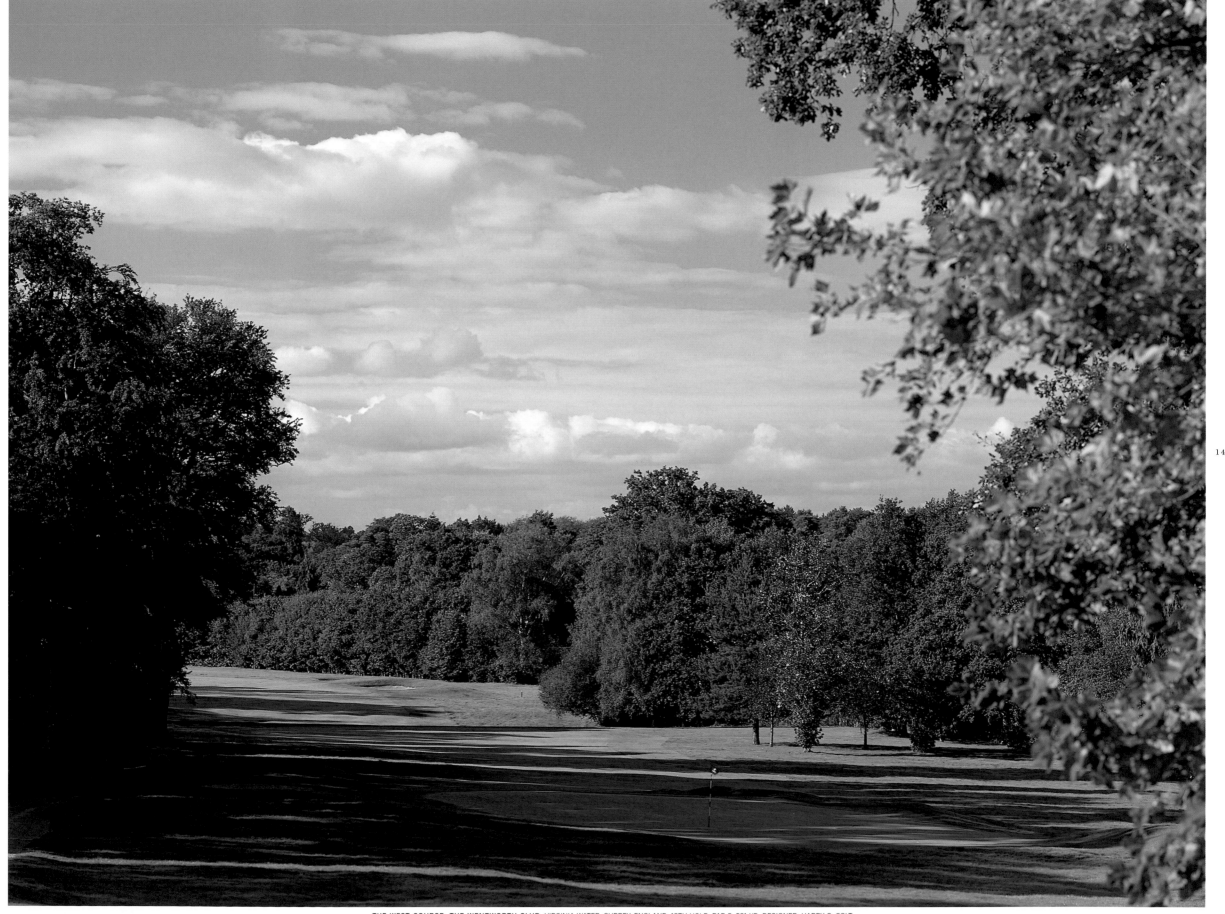

THE WEST COURSE, THE WENTWORTH CLUB, VIRGINIA WATER, SURREY, ENGLAND. 18TH HOLE, PAR 5, 531 YD. DESIGNER: HARRY S. COLT.

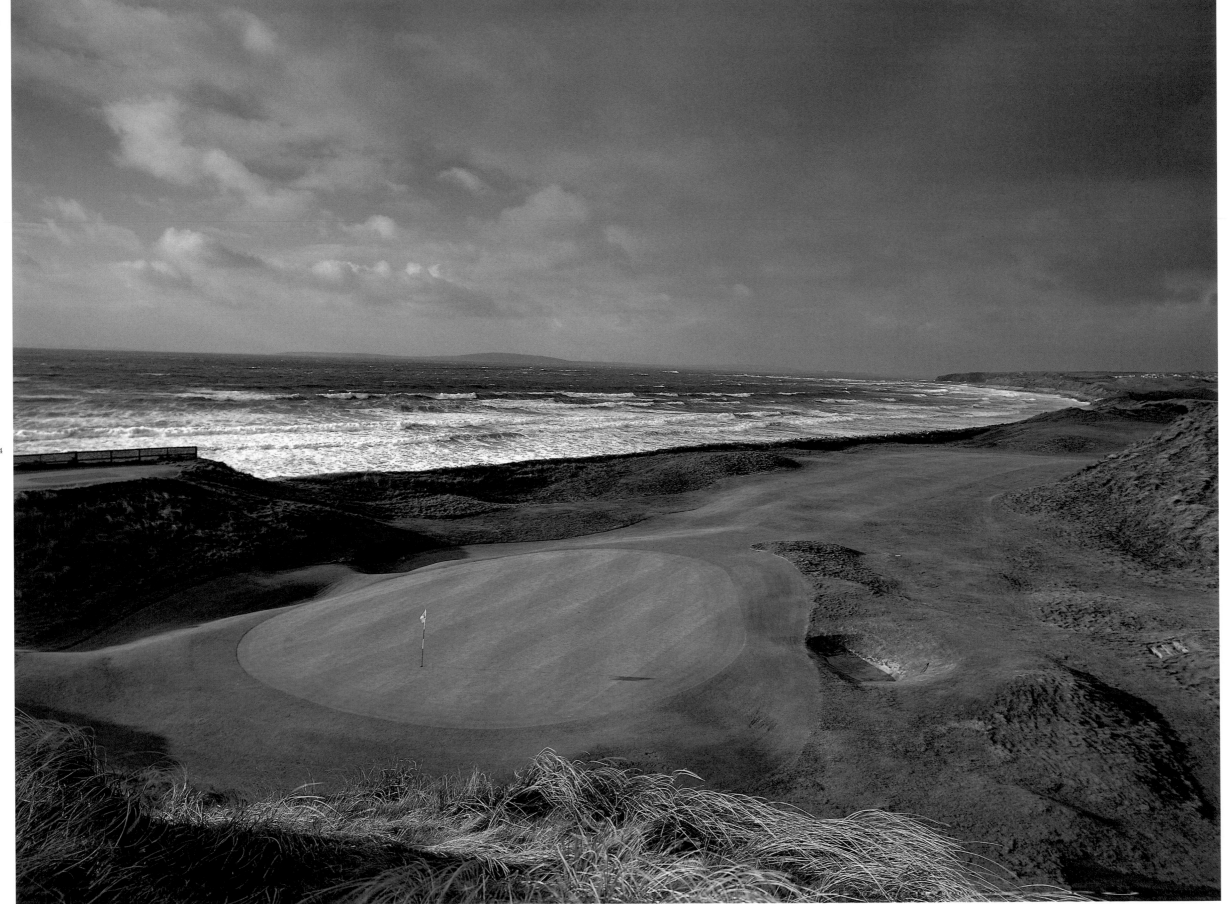

144

OLD COURSE, BALLYBUNION GOLF CLUB, BALLYBUNION, CO. KERRY, IRELAND. 17TH HOLE, PAR 4, 385 YD. DESIGNERS: TOM SIMPSON, CAPTAIN L. L. HEWSON, JAMES MCKENNA.

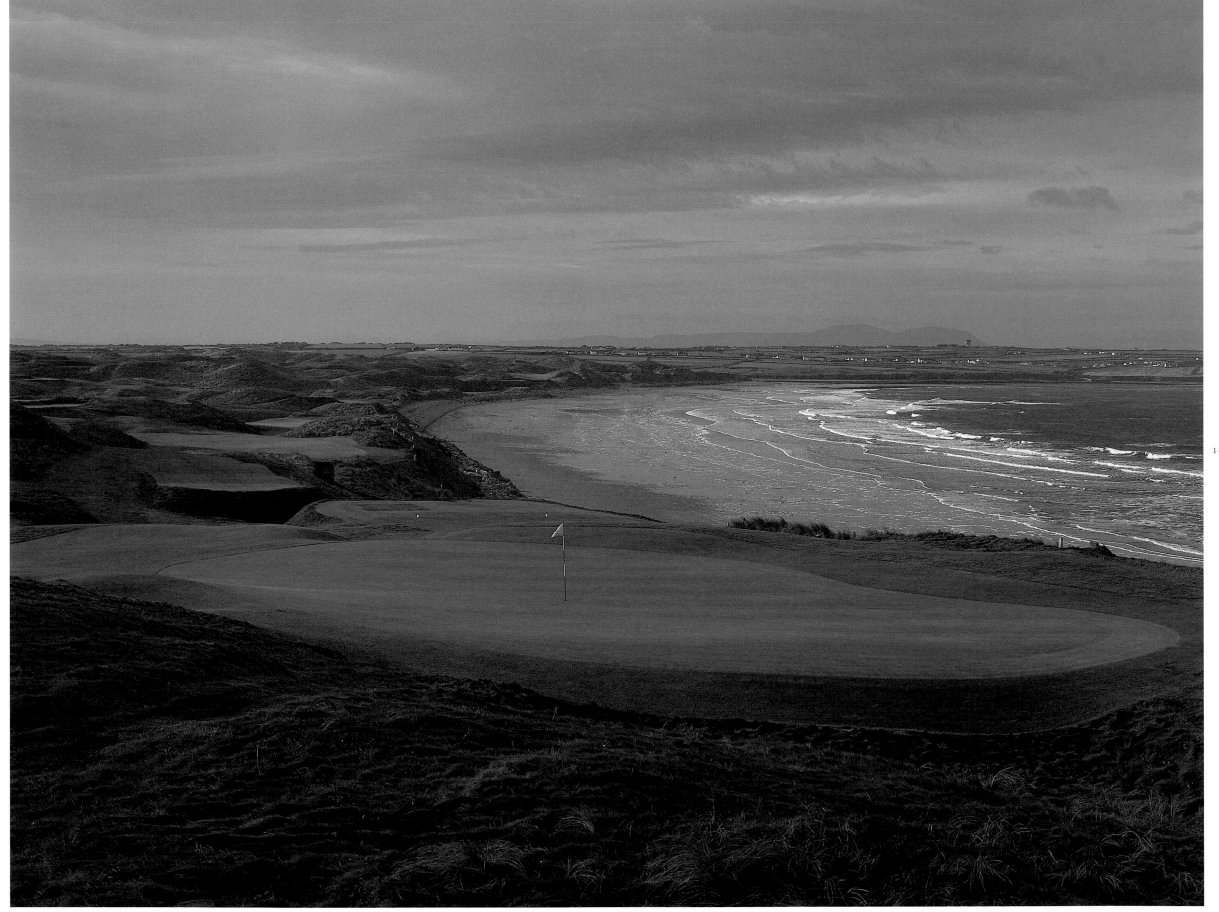

145

OLD COURSE, BALLYBUNION GOLF CLUB, BALLYBUNION, CO. KERRY, IRELAND. 10TH GREEN, PAR 4, 359 YD.; 11TH HOLE (IN BACKGROUND), PAR 4, 453 YD. DESIGNERS: TOM SIMPSON, CAPTAIN L. L. HEWSON, JAMES MCKENNA

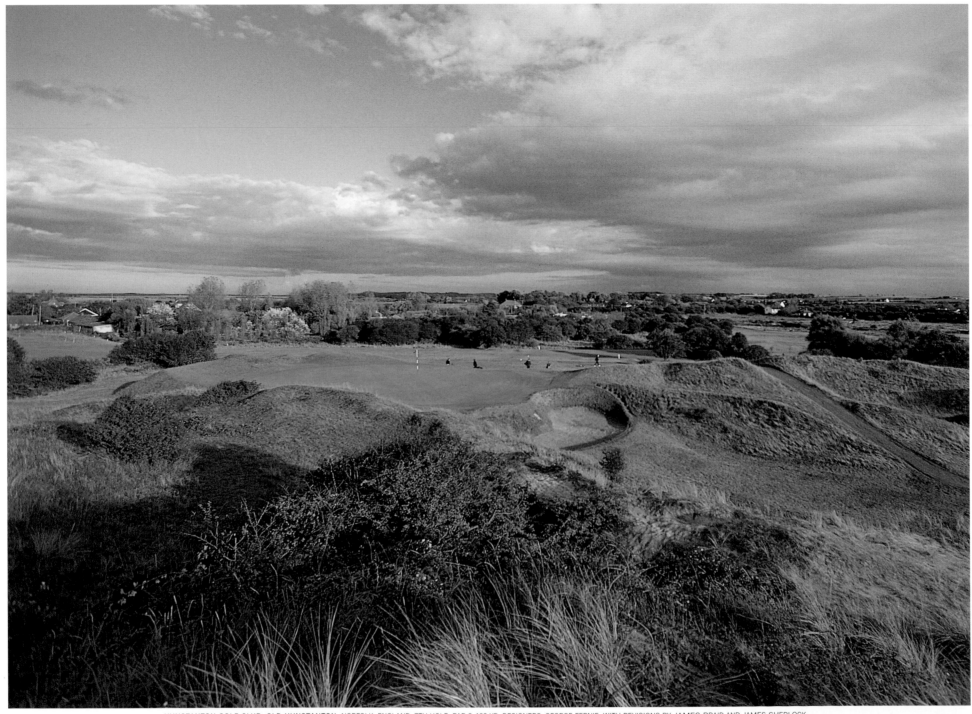

HUNSTANTON GOLF CLUB, OLD HUNSTANTON, NORFOLK, ENGLAND. 7TH HOLE, PAR 3, 162 YD. DESIGNERS: GEORGE FERNIE, WITH REVISIONS BY JAMES BRAID AND JAMES SHERLOCK.

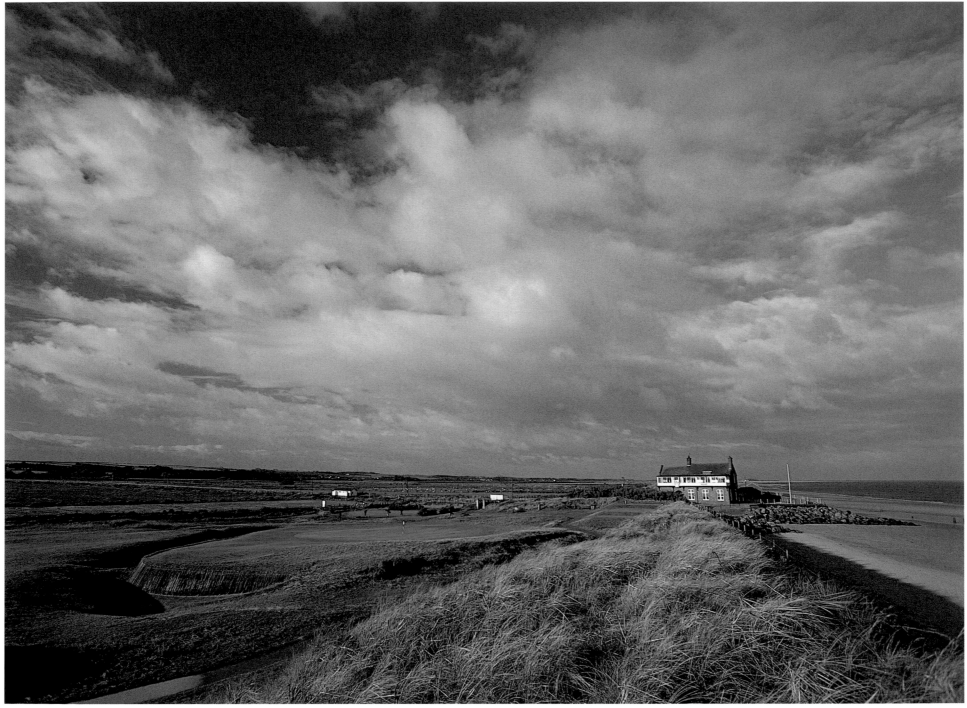

ROYAL WEST NORFOLK GOLF CLUB, BRANCASTER, NORFOLK, ENGLAND. 18TH HOLE, PAR 4, 381 YD. DESIGNERS: HOLCOMBE INGLEBY, HORACE HUTCHINSON, C. K. HUTCHINSON.

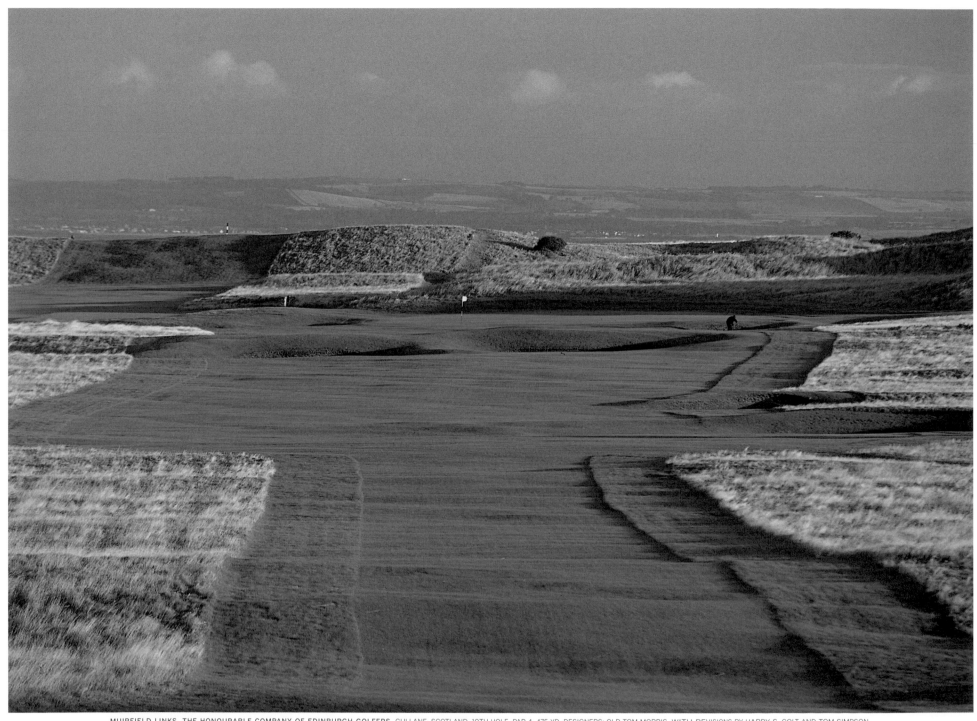

148

MUIRFIELD LINKS, THE HONOURABLE COMPANY OF EDINBURGH GOLFERS, GULLANE, SCOTLAND. 10TH HOLE, PAR 4, 475 YD. DESIGNERS: OLD TOM MORRIS, WITH REVISIONS BY HARRY S. COLT AND TOM SIMPSON.

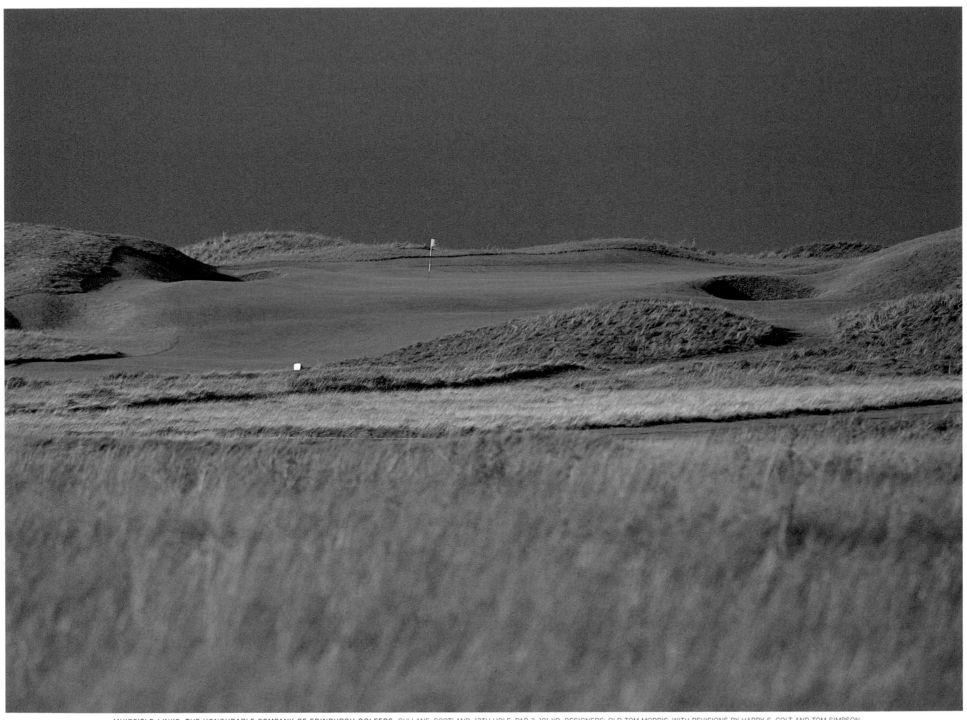

149

MUIRFIELD LINKS, THE HONOURABLE COMPANY OF EDINBURGH GOLFERS, GULLANE, SCOTLAND. 13TH HOLE, PAR 3, 191 YD. DESIGNERS: OLD TOM MORRIS, WITH REVISIONS BY HARRY S. COLT AND TOM SIMPSON.
FOLLOWING PAGES, 150–151: KINGSBARNS GOLF LINKS, KINGSBARNS, SCOTLAND. 6TH GREEN, PAR 4, 337 YD.; 16TH GREEN, PAR 5, 565 YD.; 17TH HOLE (IN BACKGROUND), PAR 4, 474 YD. DESIGNER: KYLE PHILLIPS.

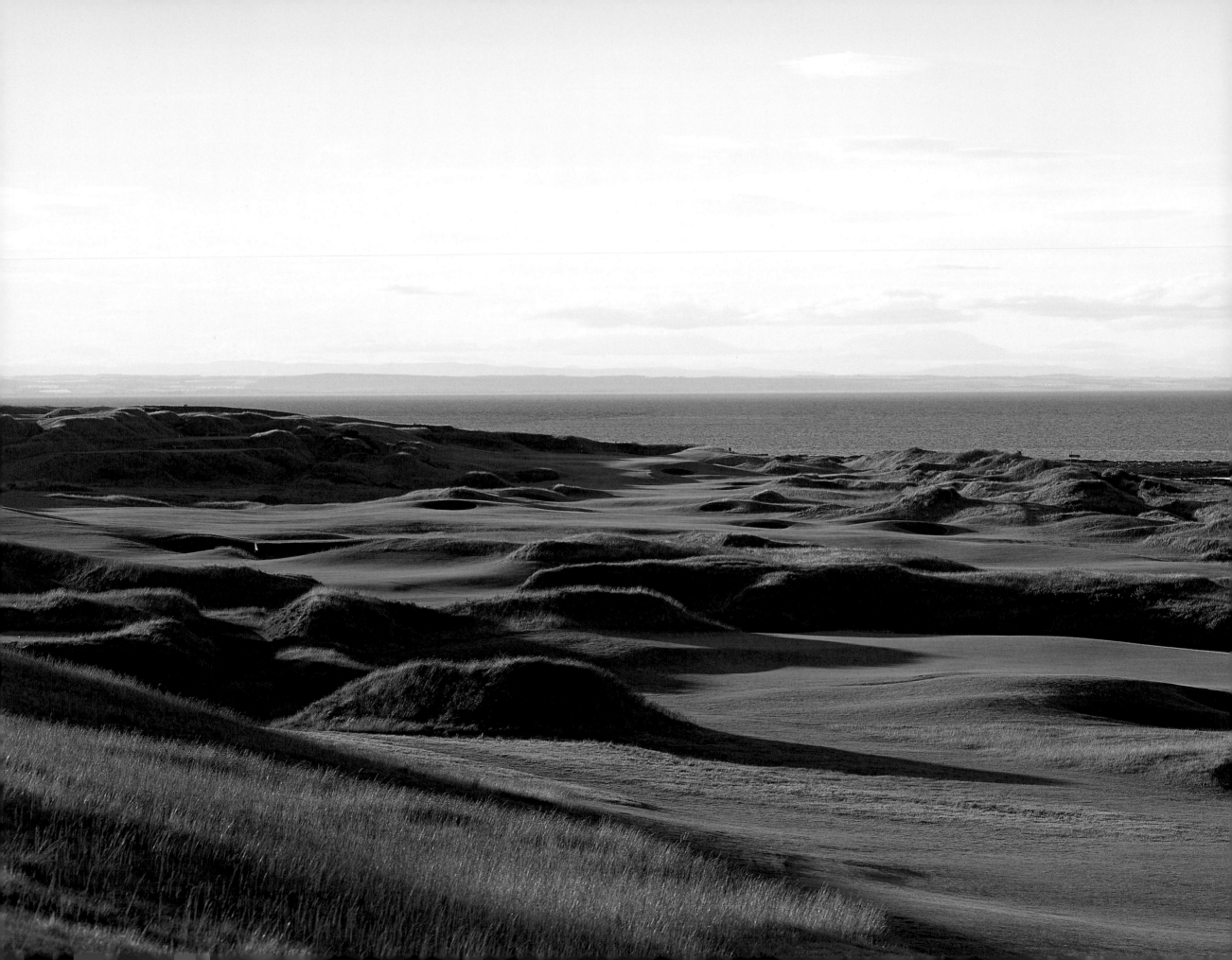

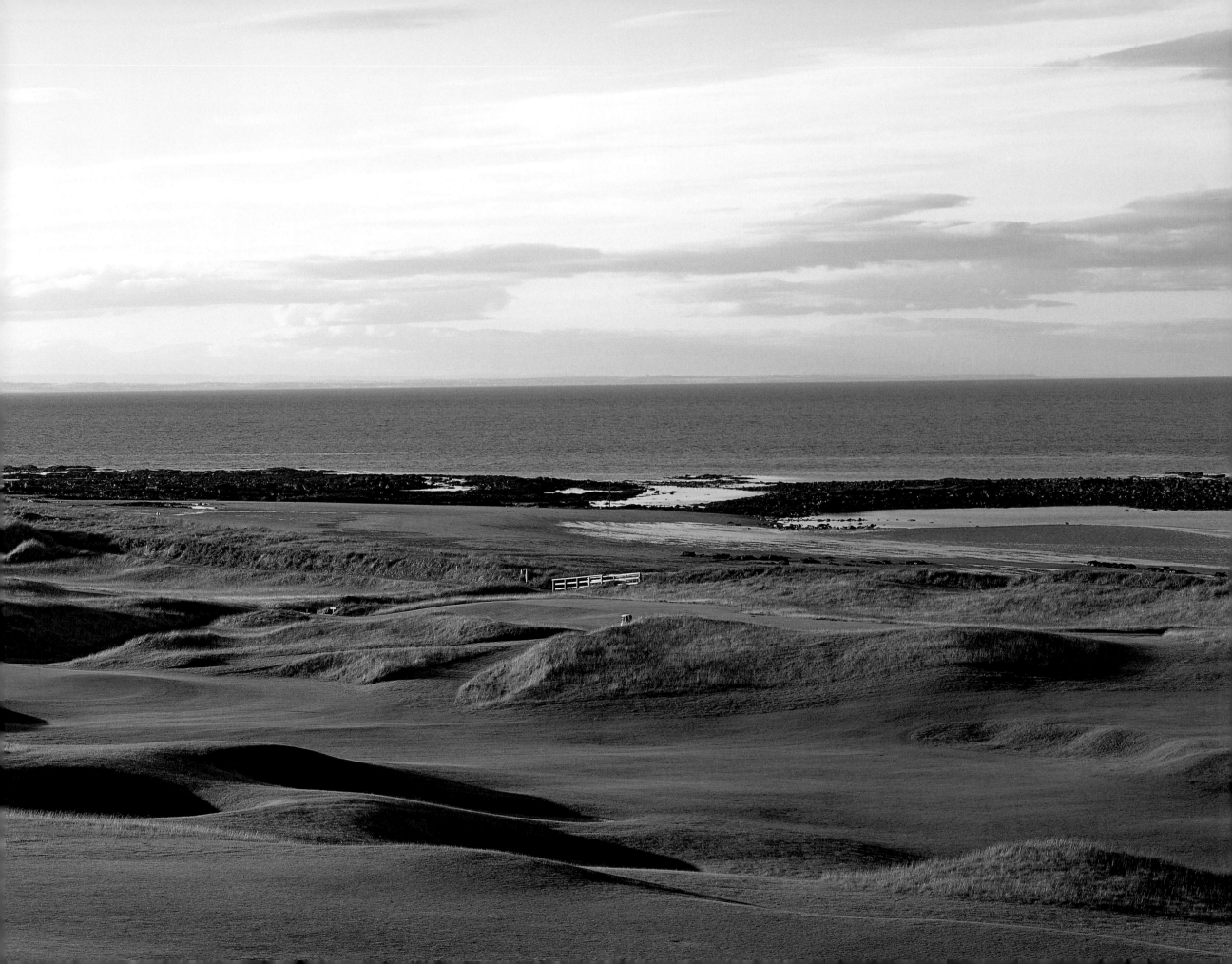

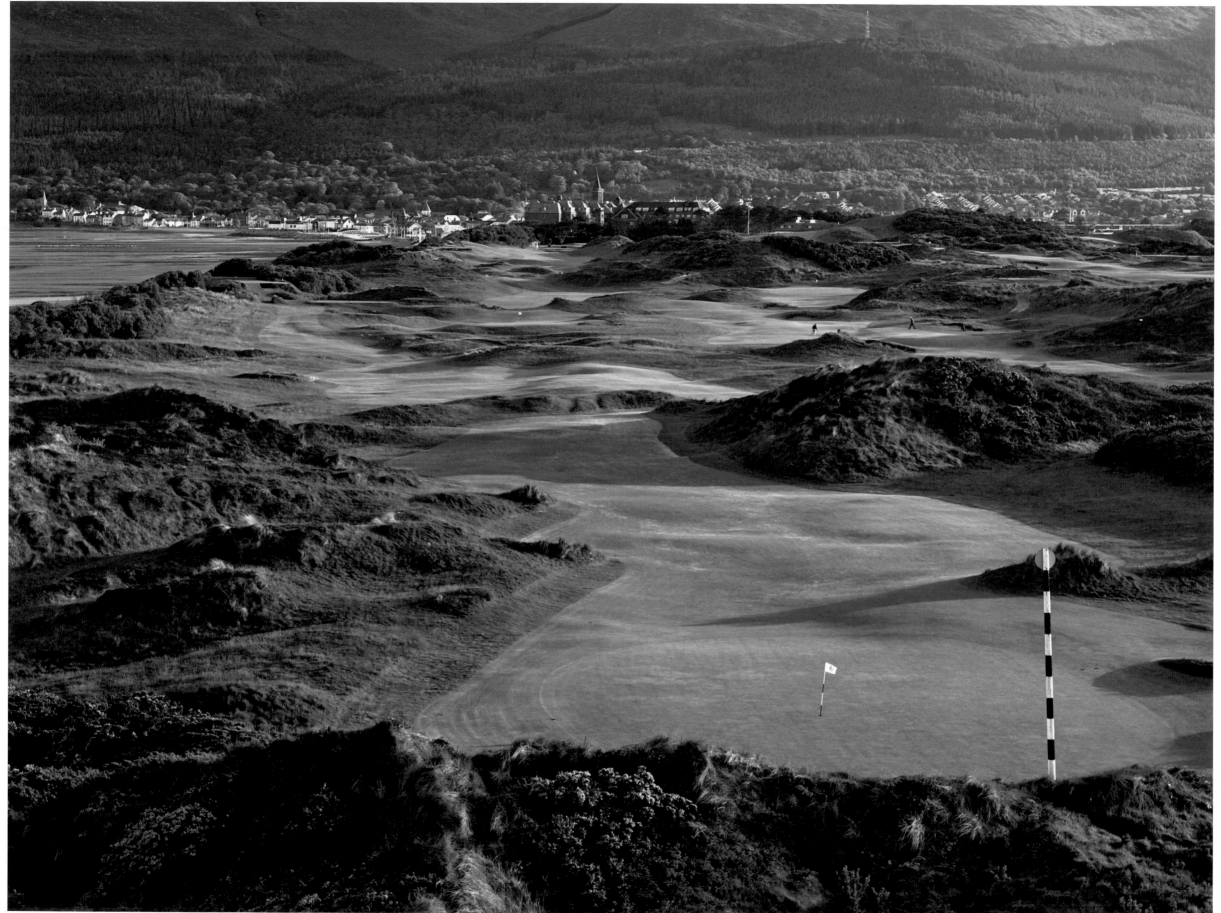

152

CHAMPIONSHIP LINKS, ROYAL COUNTY DOWN GOLF CLUB, NEWCASTLE, COUNTY DOWN, NORTHERN IRELAND. 3RD HOLE, PAR 4, 477 YD. DESIGNER: OLD TOM MORRIS.

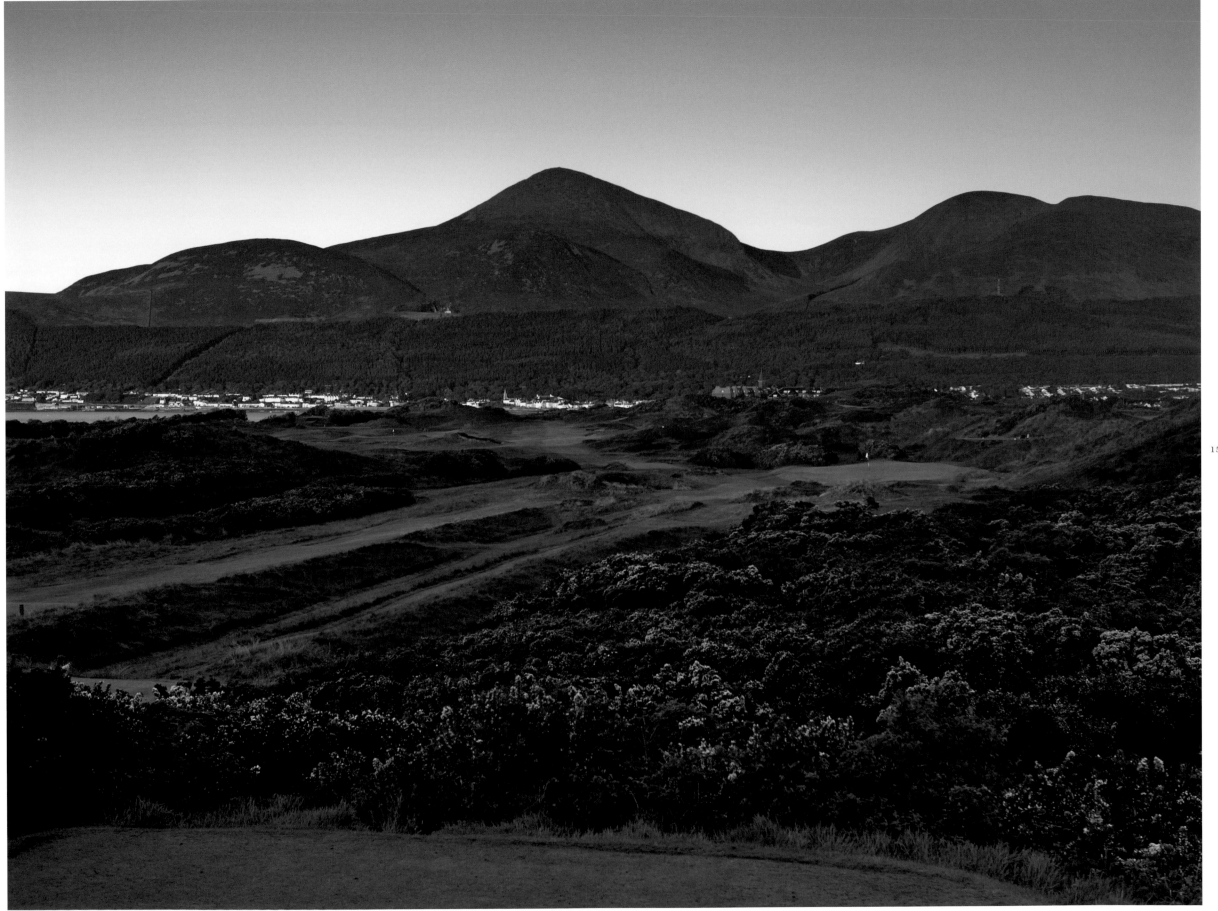

CHAMPIONSHIP LINKS, ROYAL COUNTY DOWN GOLF CLUB, NEWCASTLE, COUNTY DOWN, NORTHERN IRELAND. 2ND HOLE, PAR 3, 213 YD. DESIGNER: OLD TOM MORRIS.

154

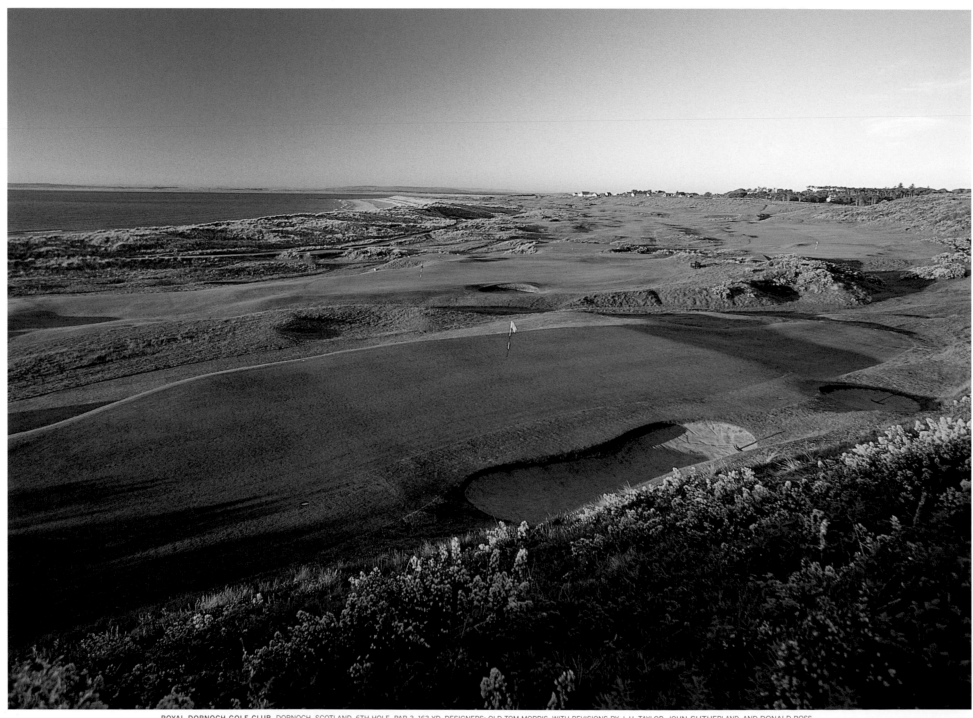

ROYAL DORNOCH GOLF CLUB, DORNOCH, SCOTLAND. 6TH HOLE, PAR 3, 163 YD. DESIGNERS: OLD TOM MORRIS, WITH REVISIONS BY J. H. TAYLOR, JOHN SUTHERLAND, AND DONALD ROSS.

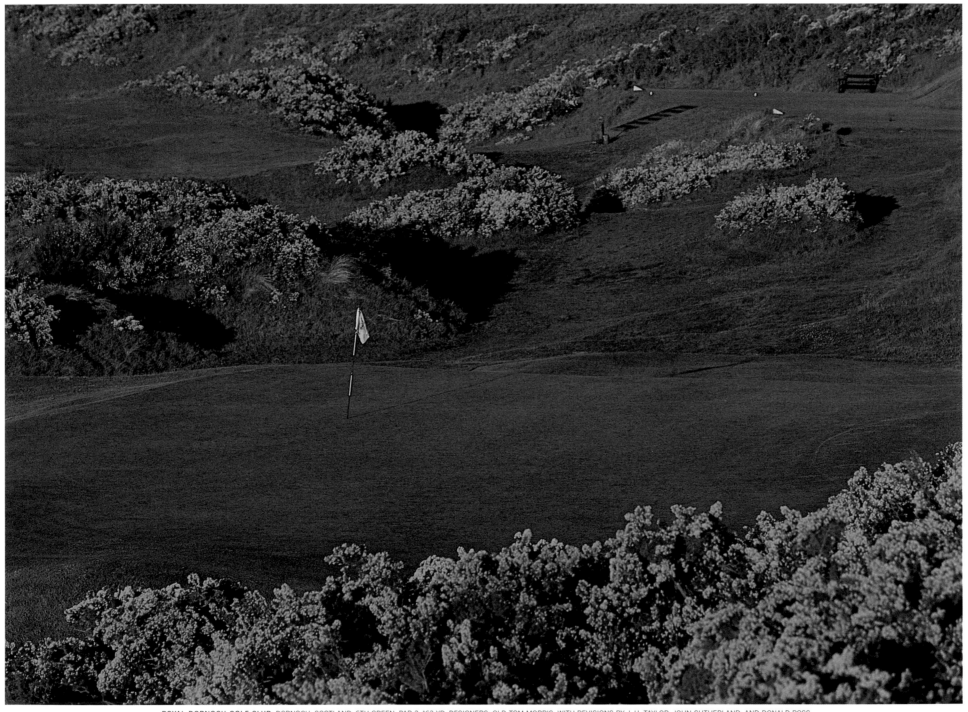

ROYAL DORNOCH GOLF CLUB, DORNOCH, SCOTLAND. 6TH GREEN, PAR 3, 163 YD. DESIGNERS: OLD TOM MORRIS, WITH REVISIONS BY J. H. TAYLOR, JOHN SUTHERLAND, AND DONALD ROSS.

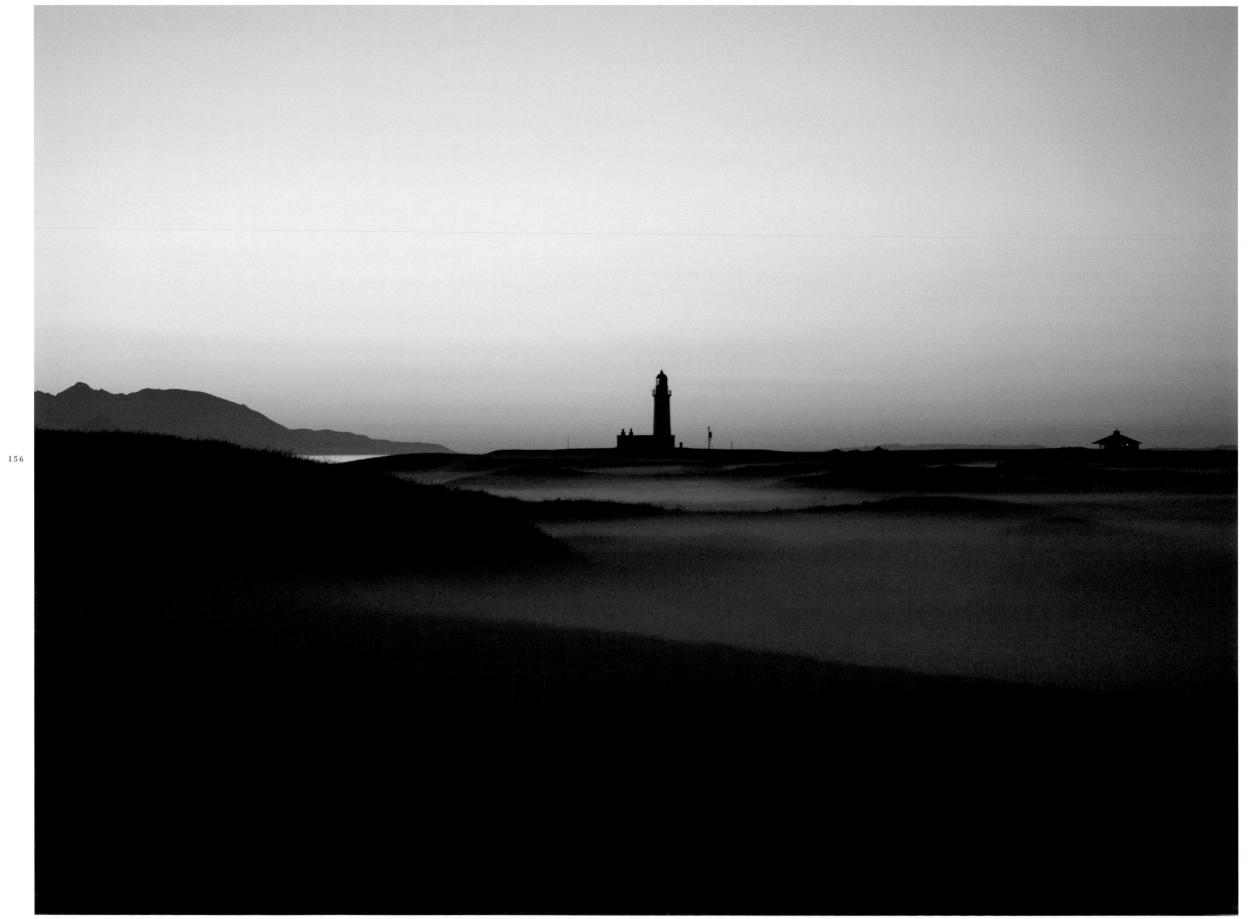

156

WESTIN TURNBERRY RESORT, AYRSHIRE, SCOTLAND. LIGHTHOUSE AND VIEW OF THE AILSA COURSE. DESIGNER: PHILIP MACKENZIE ROSS.

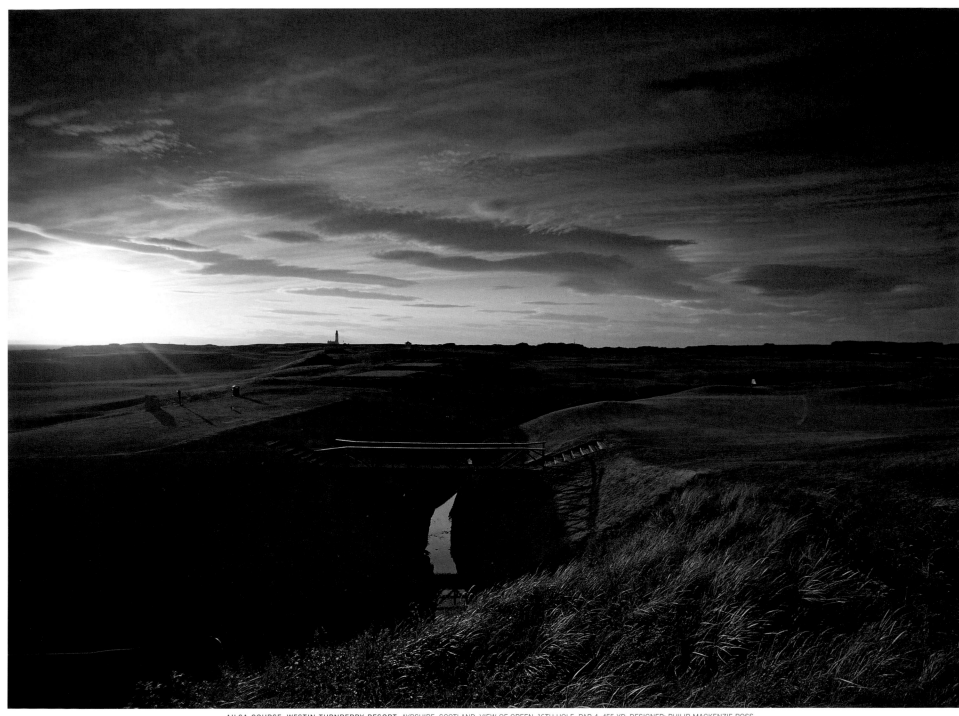

AILSA COURSE, WESTIN TURNBERRY RESORT, AYRSHIRE, SCOTLAND. VIEW OF GREEN, 16TH HOLE, PAR 4, 455 YD. DESIGNER: PHILIP MACKENZIE ROSS.

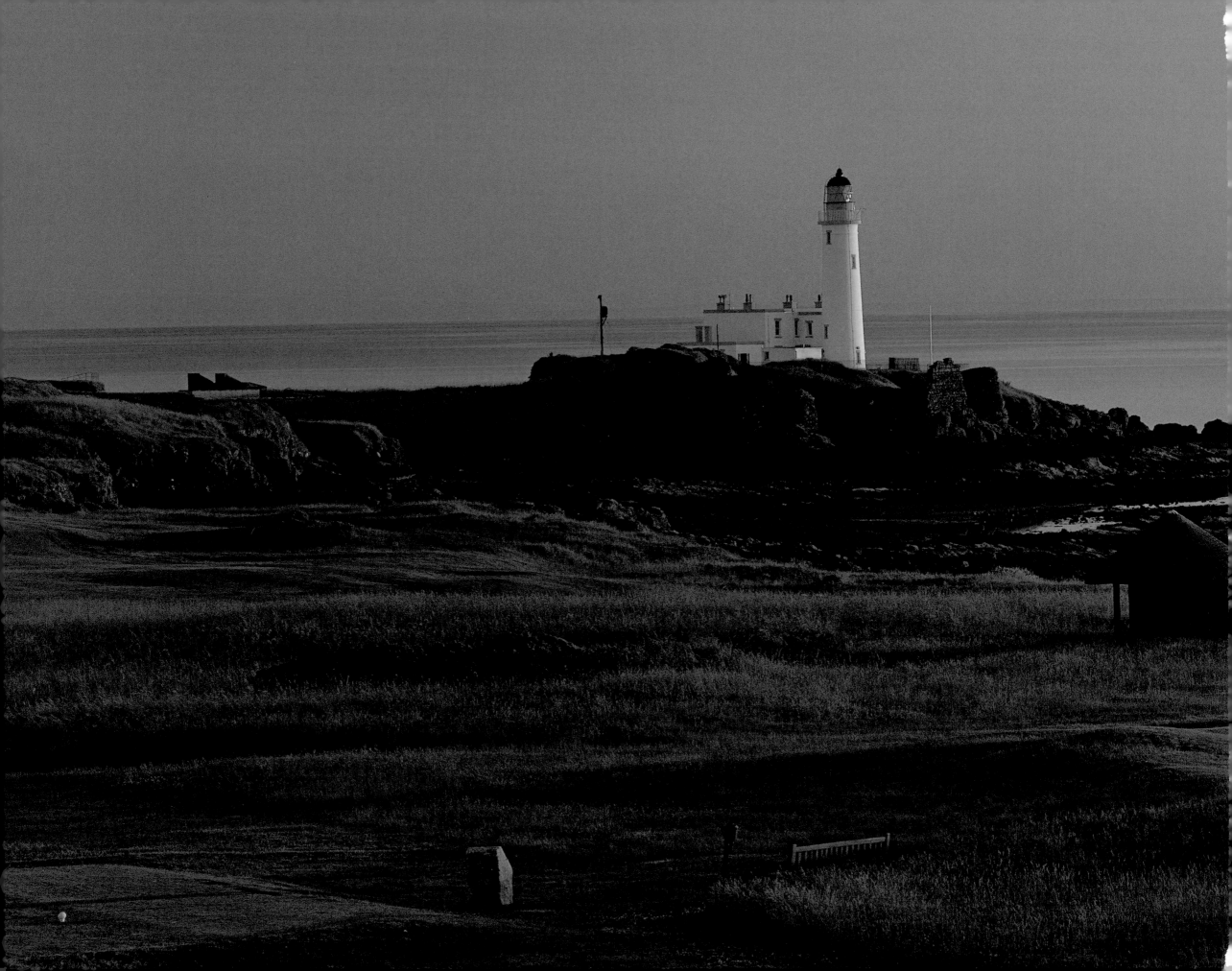

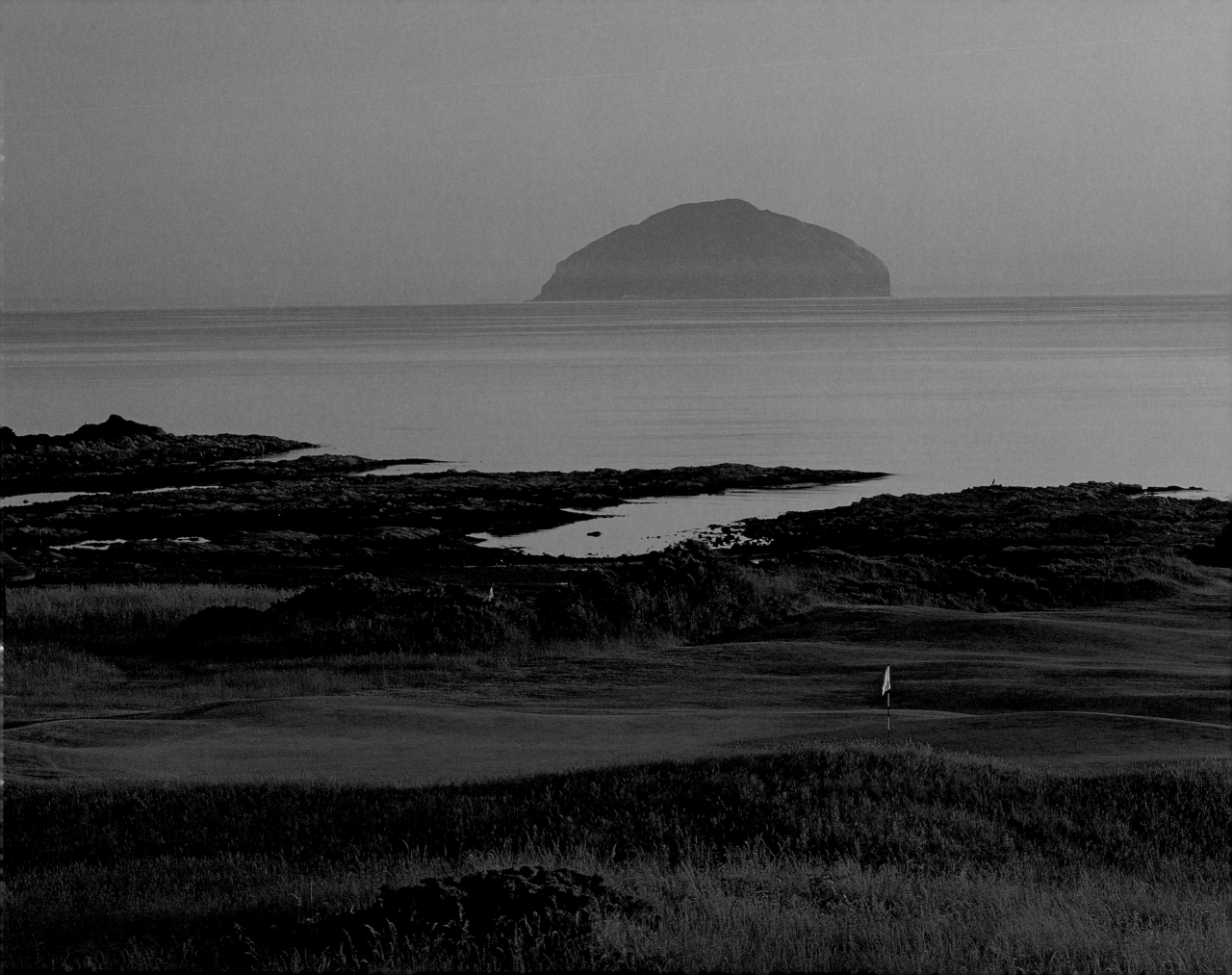

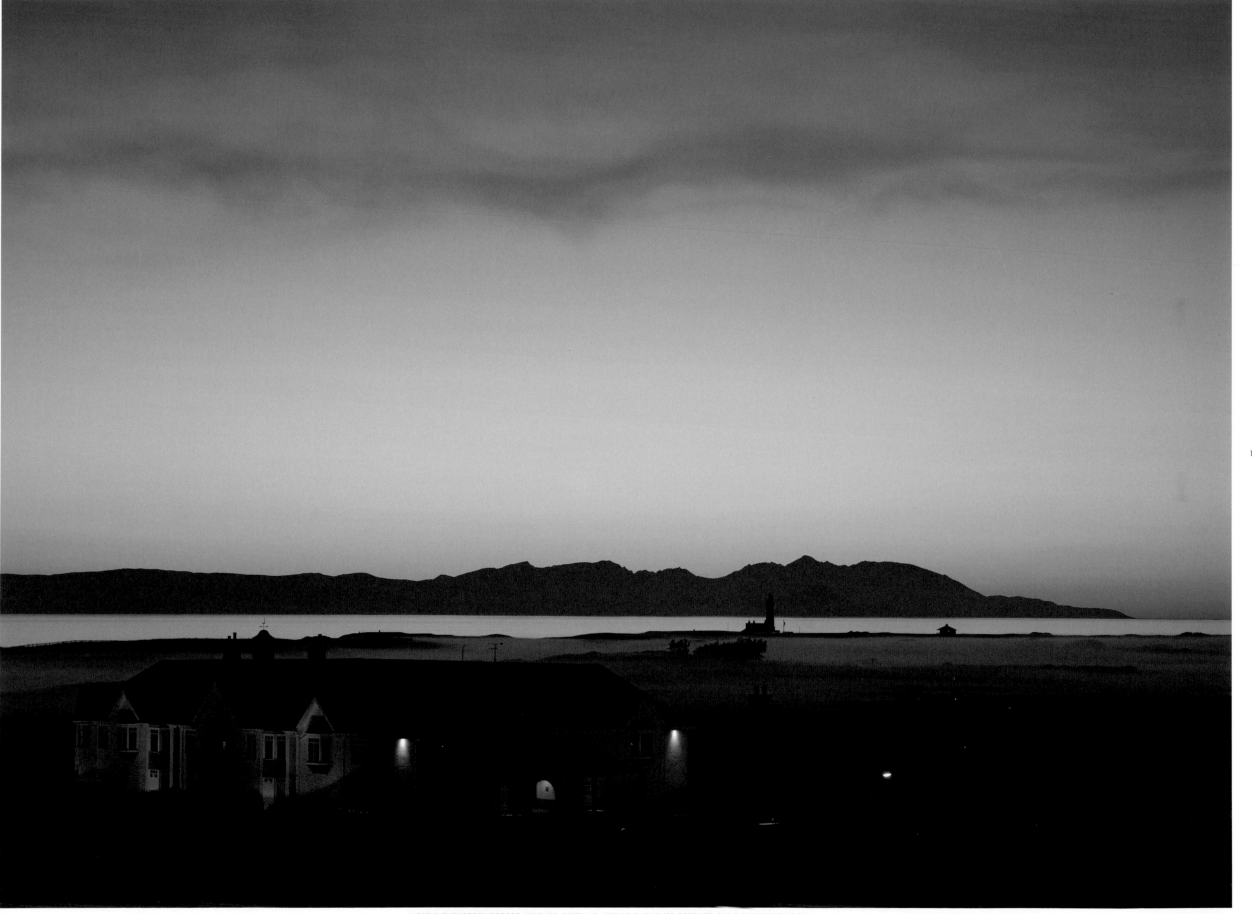

WESTIN TURNBERRY RESORT, AYRSHIRE, SCOTLAND. VIEW OF CLUBHOUSE. DESIGNER: PHILIP MACKENZIE ROSS.

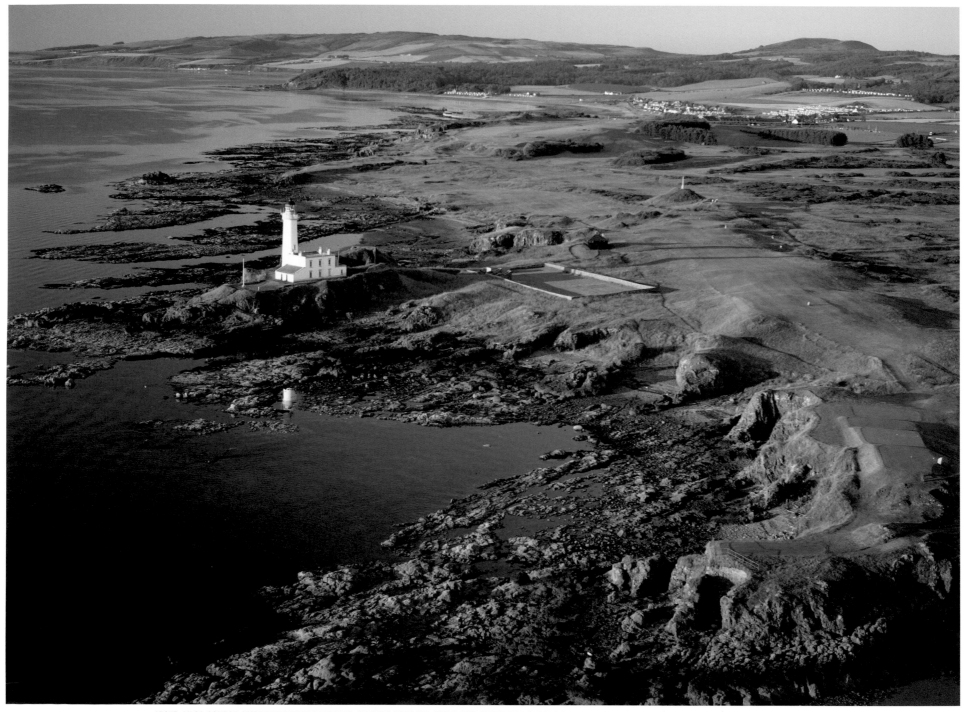

ABOVE: **AILSA COURSE, WESTIN TURNBERRY RESORT**, AYRSHIRE, SCOTLAND. AERIAL VIEW OF THE 9TH HOLE, PAR 4, 454 YD. DESIGNER: PHILIP MACKENZIE ROSS. FOLLOWING PAGES, 160–163:
AILSA COURSE, WESTIN TURNBERRY RESORT, AYRSHIRE, SCOTLAND. 11TH HOLE, PAR 3, 174 YD. DESIGNER: PHILIP MACKENZIE ROSS.

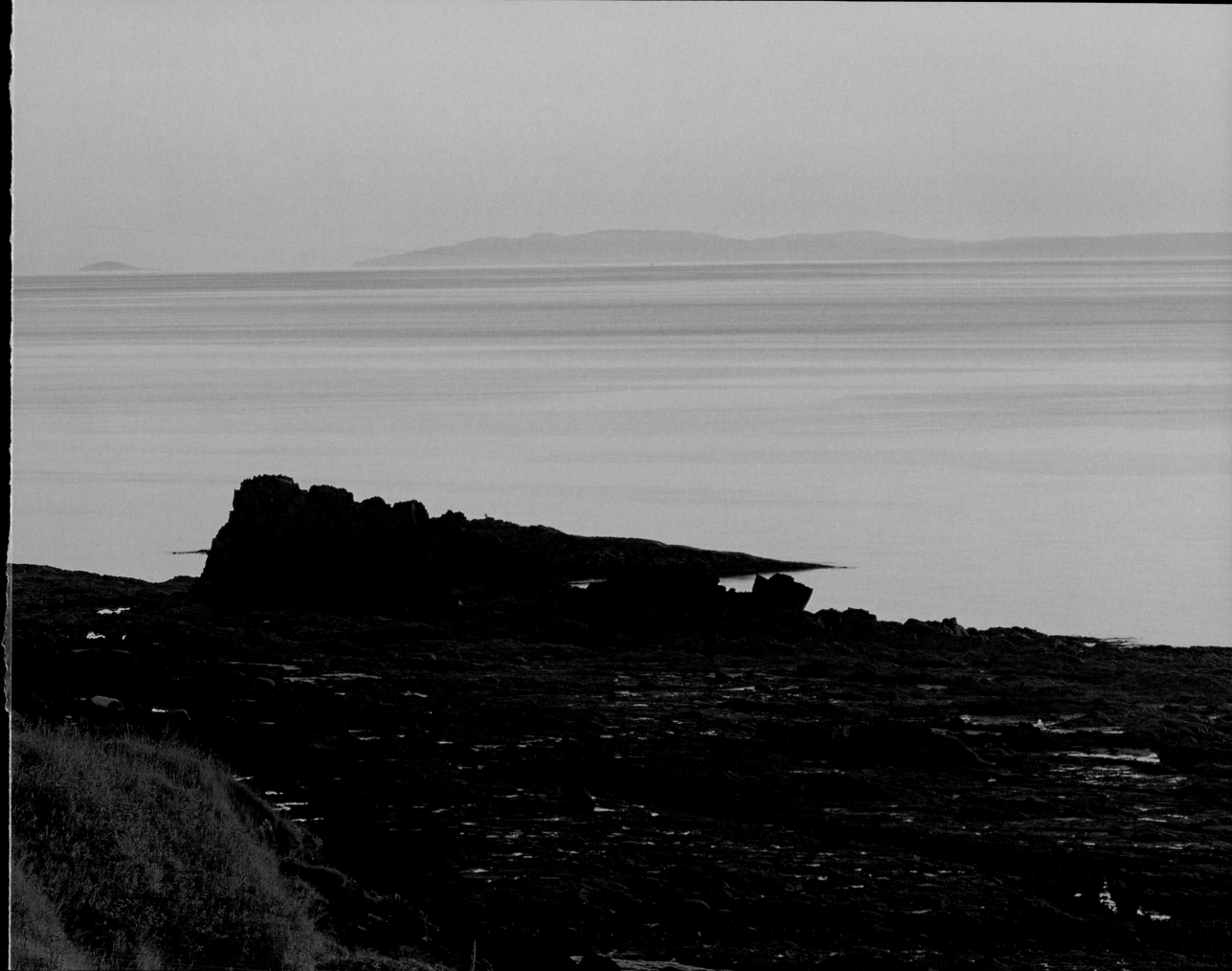

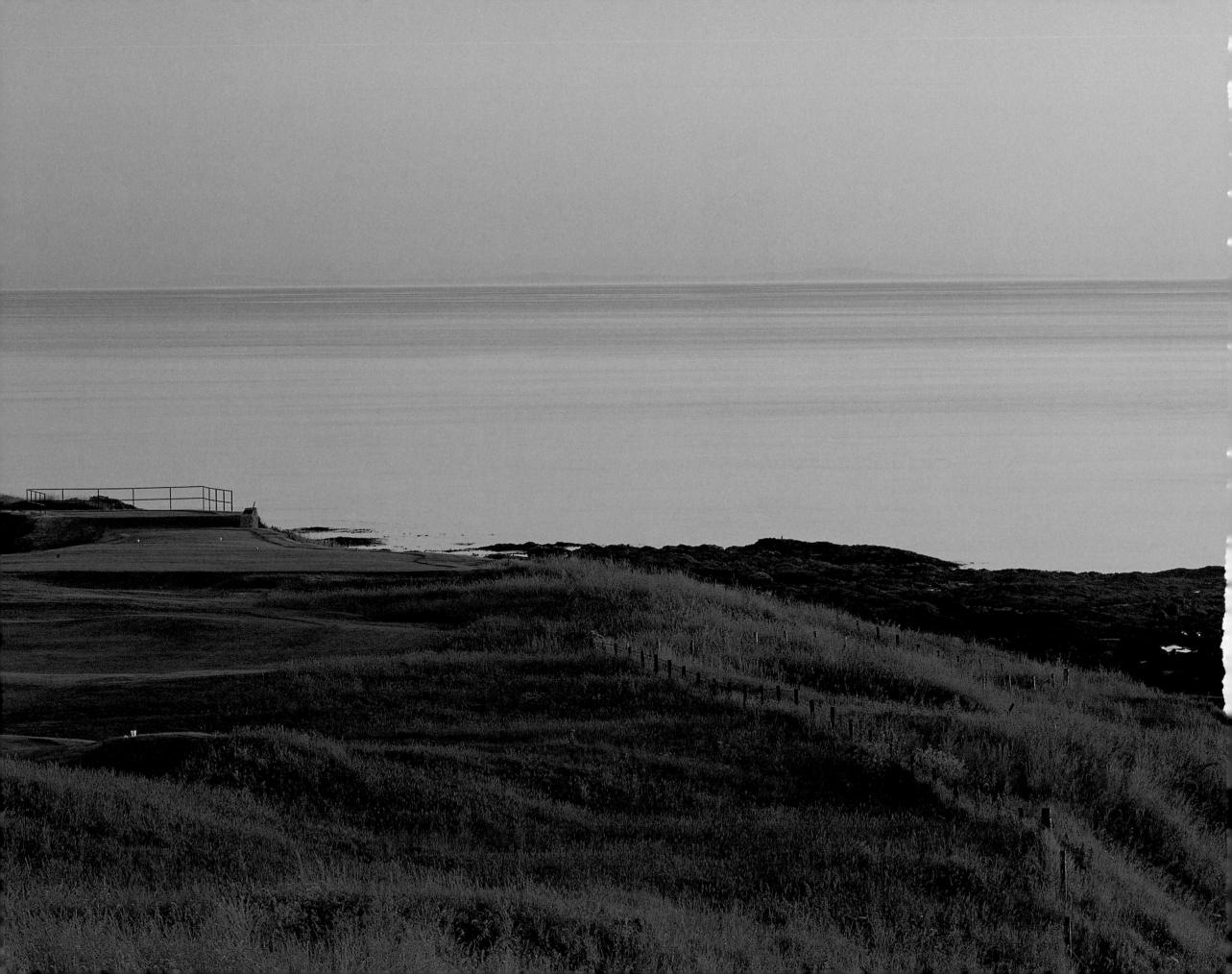

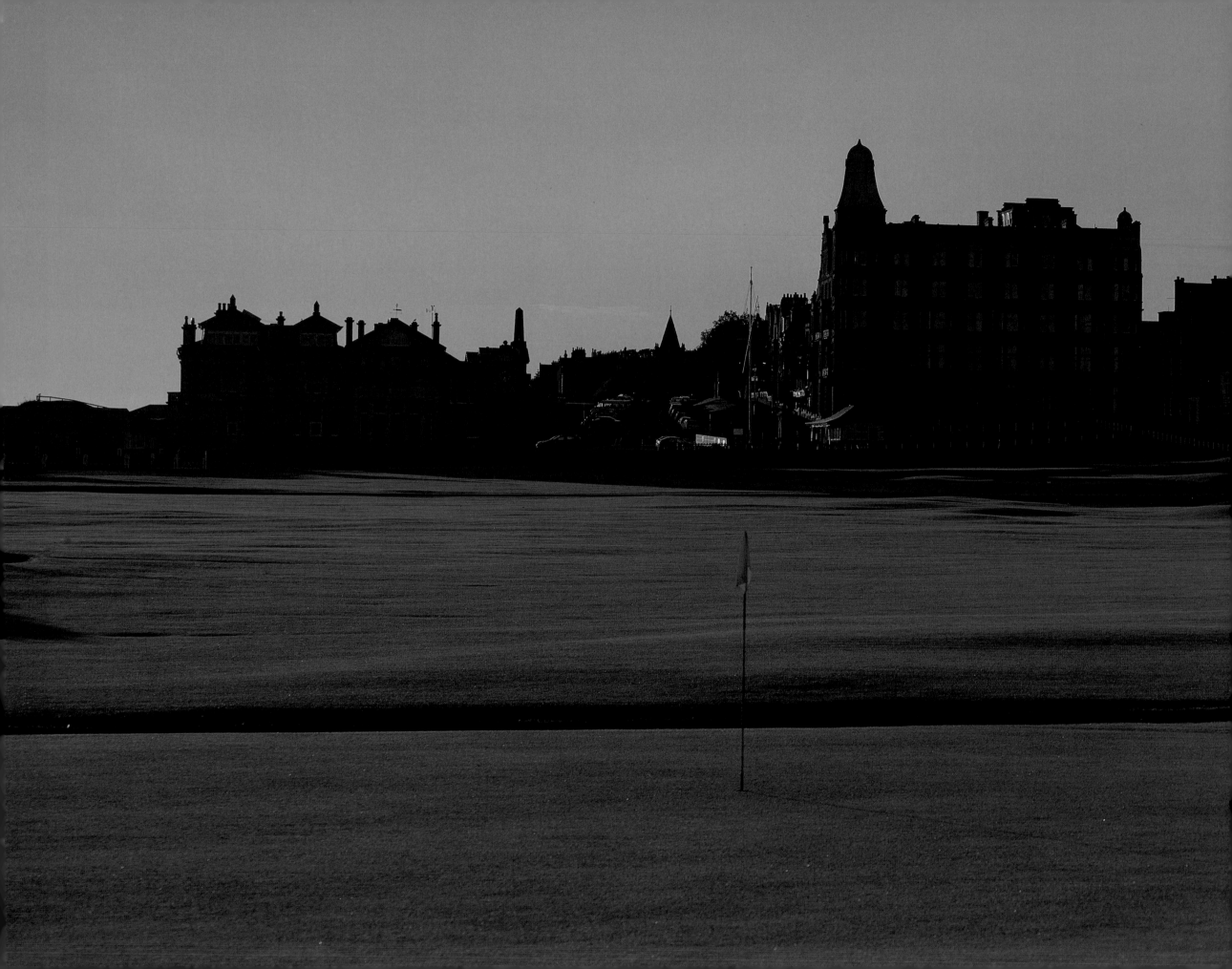

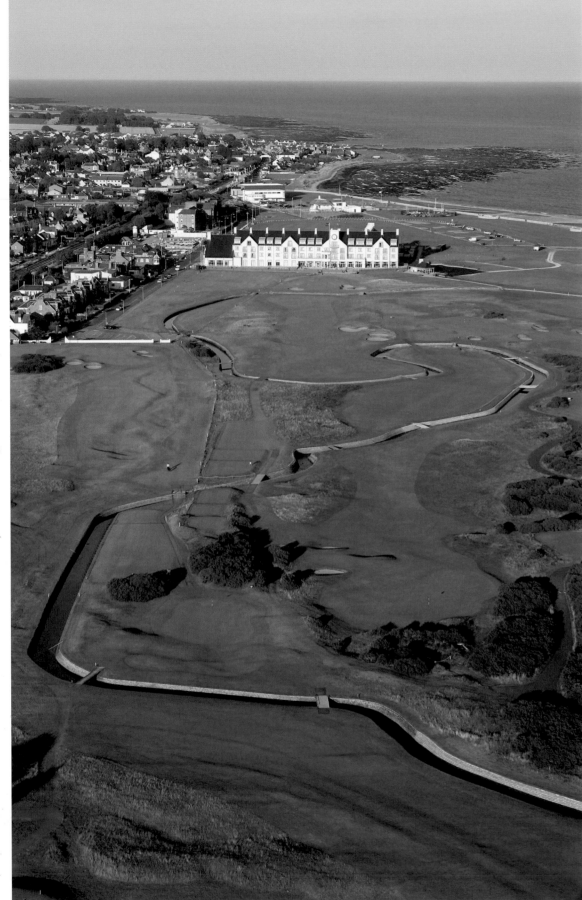

CHAMPIONSHIP COURSE, CARNOUSTIE GOLF LINKS, CARNOUSTIE, ANGUS, SCOTLAND. AERIAL VIEW OF THE 17TH HOLE, PAR 4, 433 YD.,
AND THE 18TH HOLE, PAR 4, 444 YD. DESIGNER: JAMES BRAID.

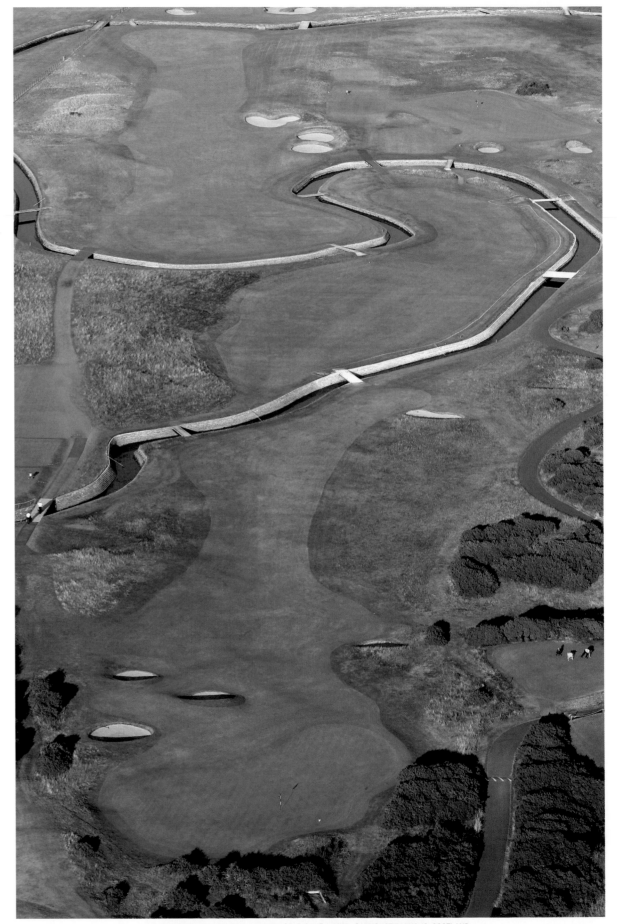

CHAMPIONSHIP COURSE, CARNOUSTIE GOLF LINKS, CARNOUSTIE, ANGUS, SCOTLAND.
AERIAL VIEW OF THE 17TH HOLE, PAR 4, 433 YD. DESIGNER: JAMES BRAID.

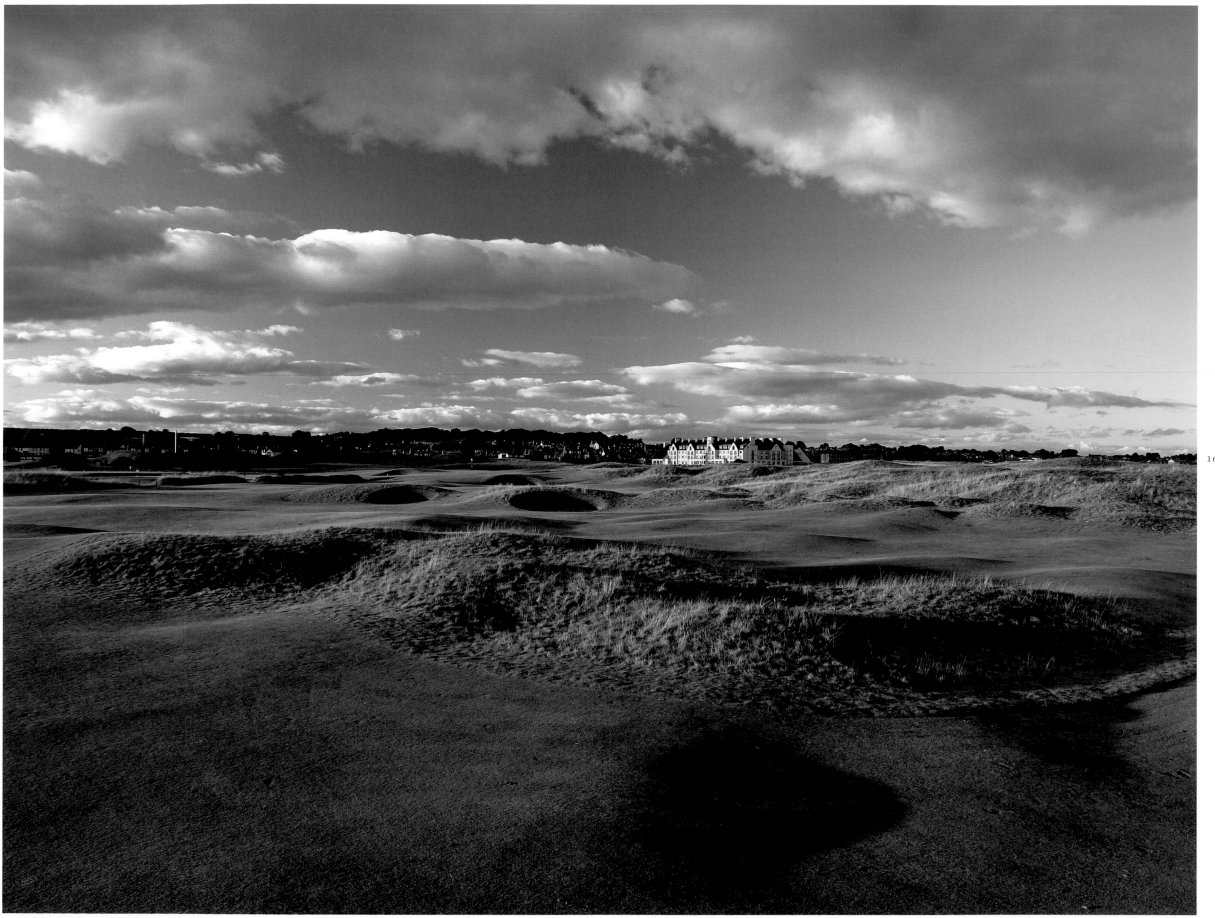

167

CHAMPIONSHIP COURSE, CARNOUSTIE GOLF LINKS, CARNOUSTIE, ANGUS, SCOTLAND. 3RD HOLE, PAR 4, 337 YD. DESIGNER: JAMES BRAID.

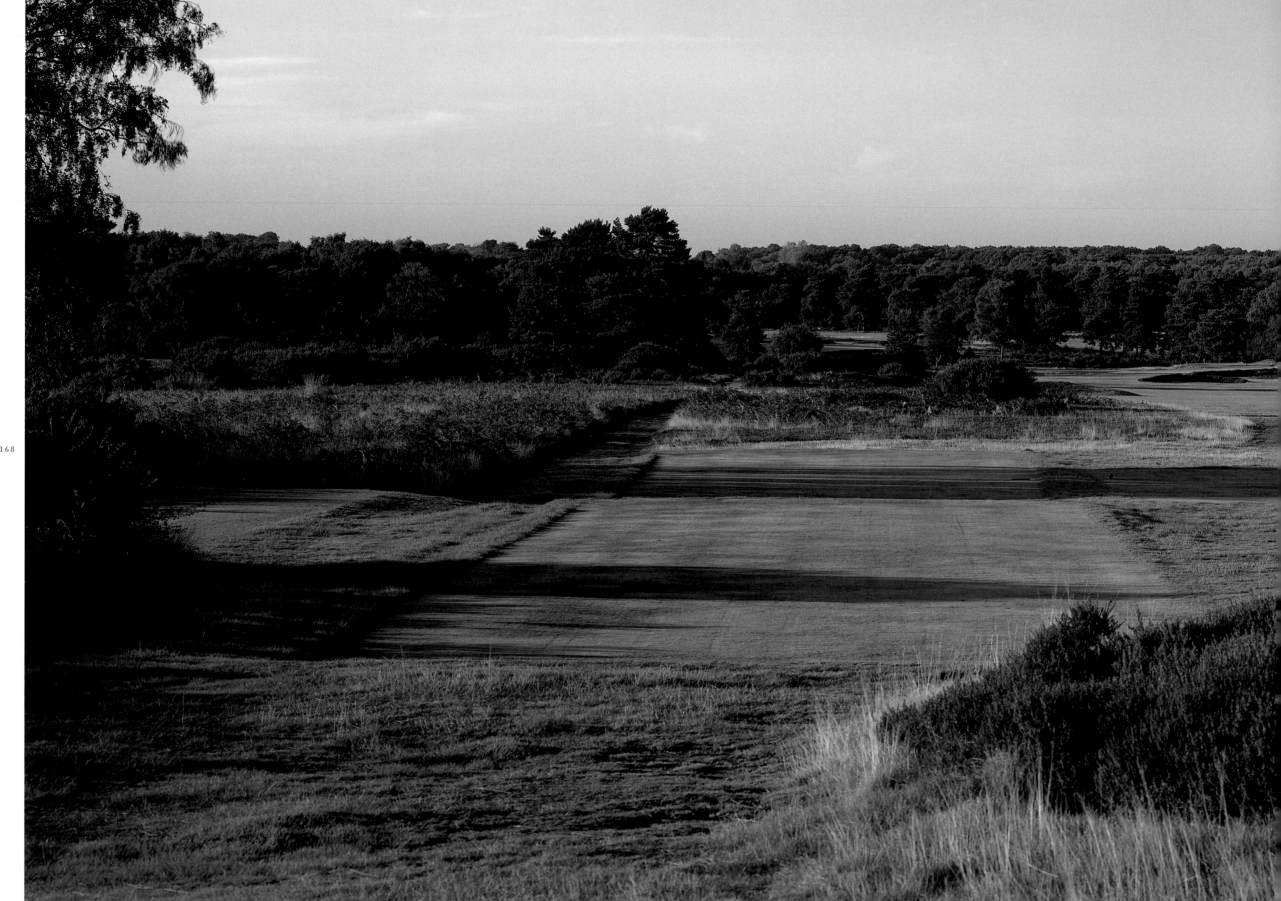

168

OLD COURSE, WALTON HEATH GOLF CLUB, TADWORTH, SURREY, ENGLAND. 14TH HOLE, PAR 5, 569 YD. DESIGNER: HERBERT FOWLER.

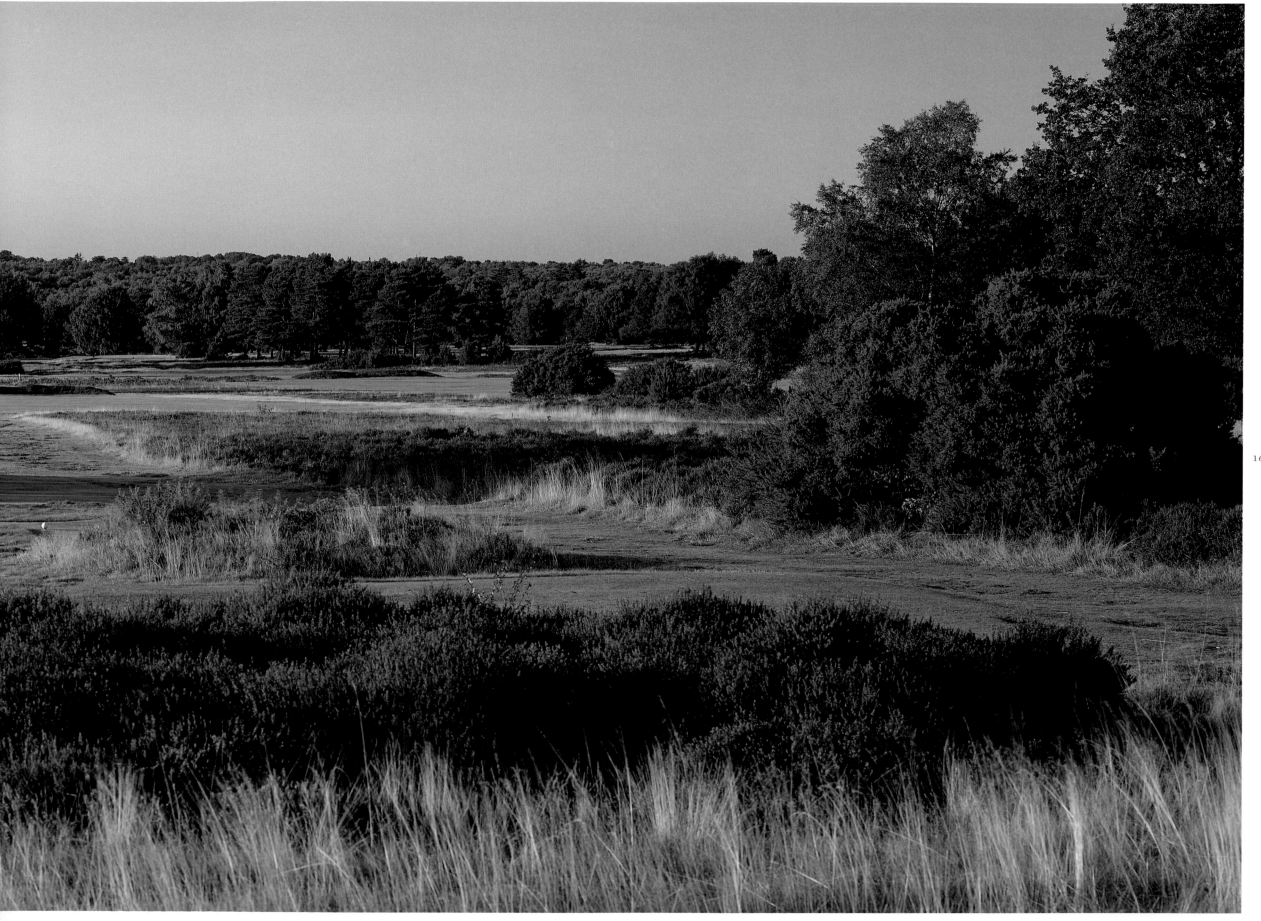

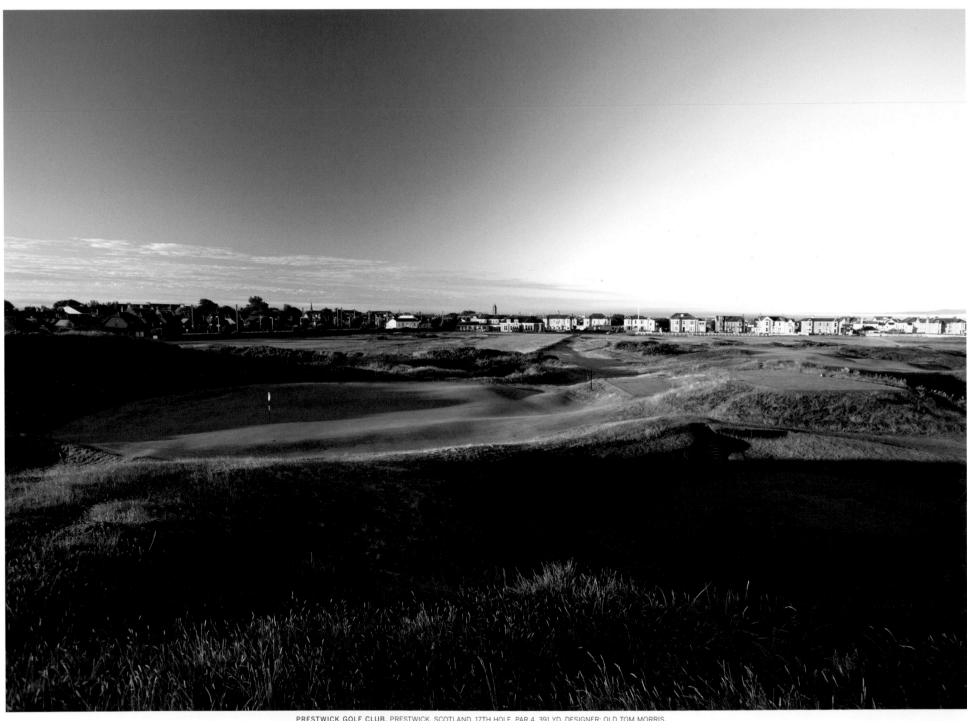

170

PRESTWICK GOLF CLUB, PRESTWICK, SCOTLAND. 17TH HOLE, PAR 4, 391 YD. DESIGNER: OLD TOM MORRIS.

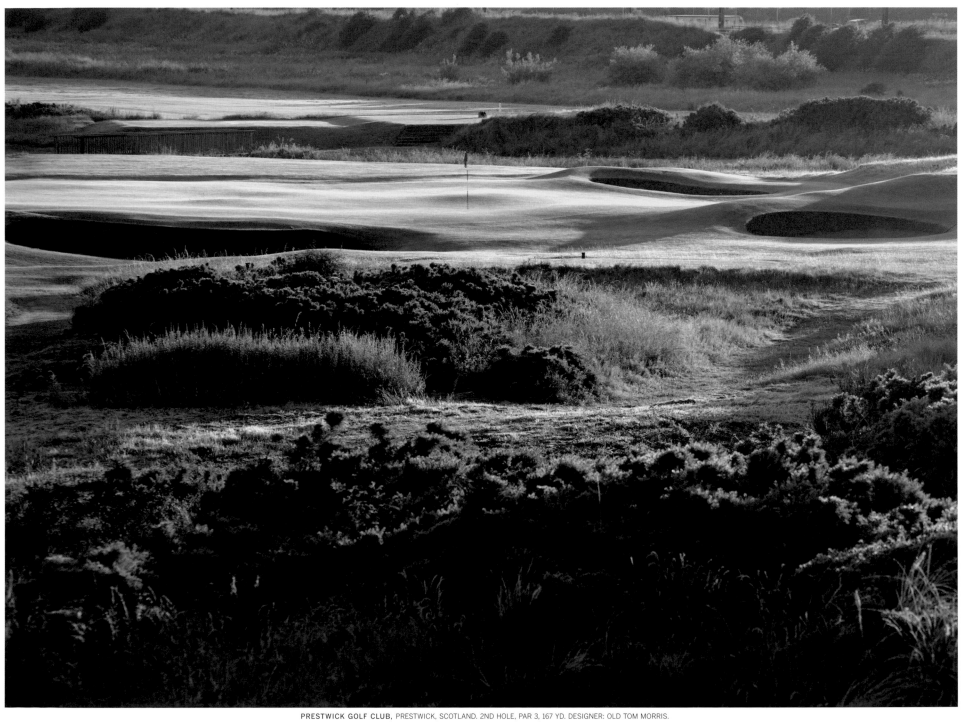

PRESTWICK GOLF CLUB, PRESTWICK, SCOTLAND. 2ND HOLE, PAR 3, 167 YD. DESIGNER: OLD TOM MORRIS.

NEW COURSE, SUNNINGDALE GOLF CLUB, SUNNINGDALE, BERKSHIRE, ENGLAND. 6TH HOLE, PAR 5, 510 YD. DESIGNER: HARRY S. COLT.

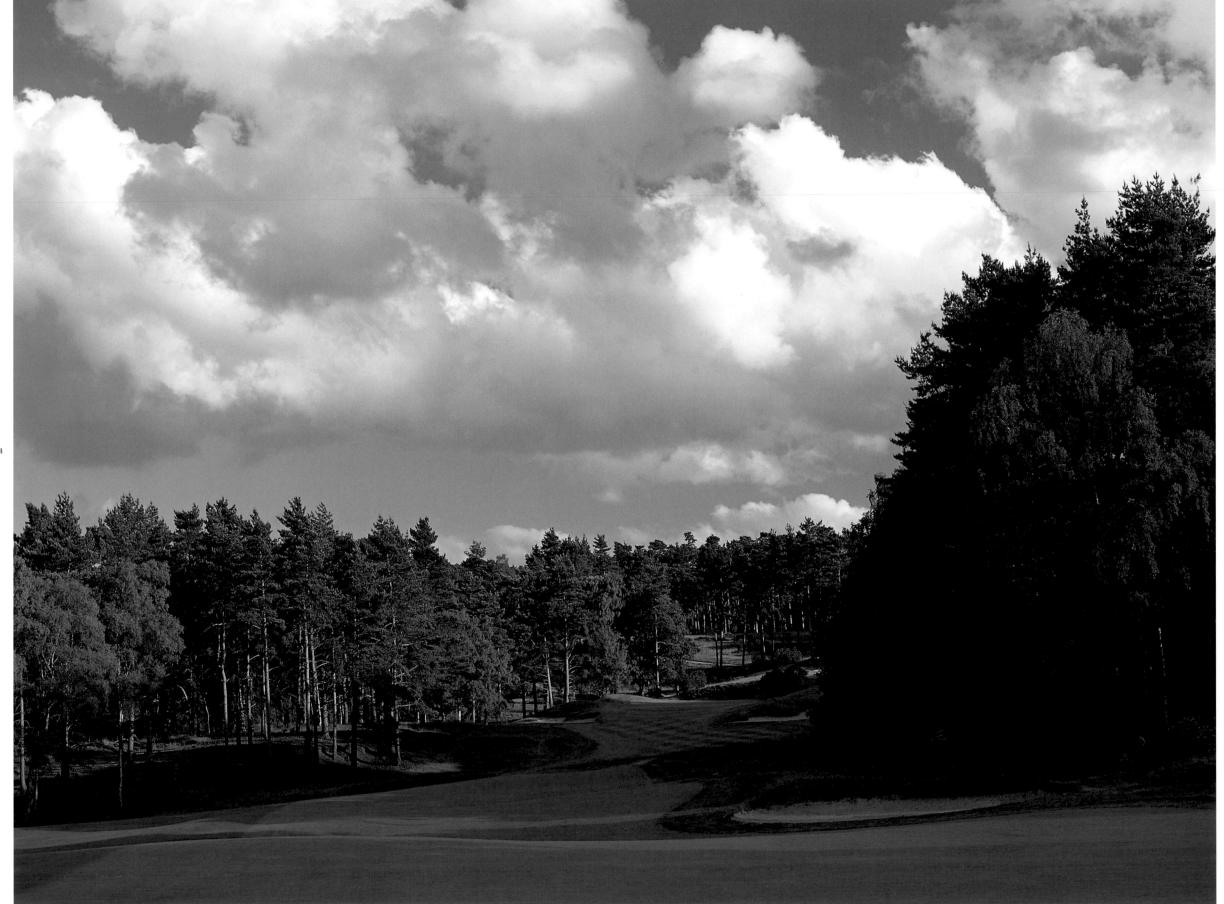

174

OLD COURSE, SUNNINGDALE GOLF CLUB, SUNNINGDALE, SURREY, ENGLAND. 7TH HOLE, PAR 4, 406 YD. DESIGNERS: WILLIE PARK, JR., HARRY S. COLT.

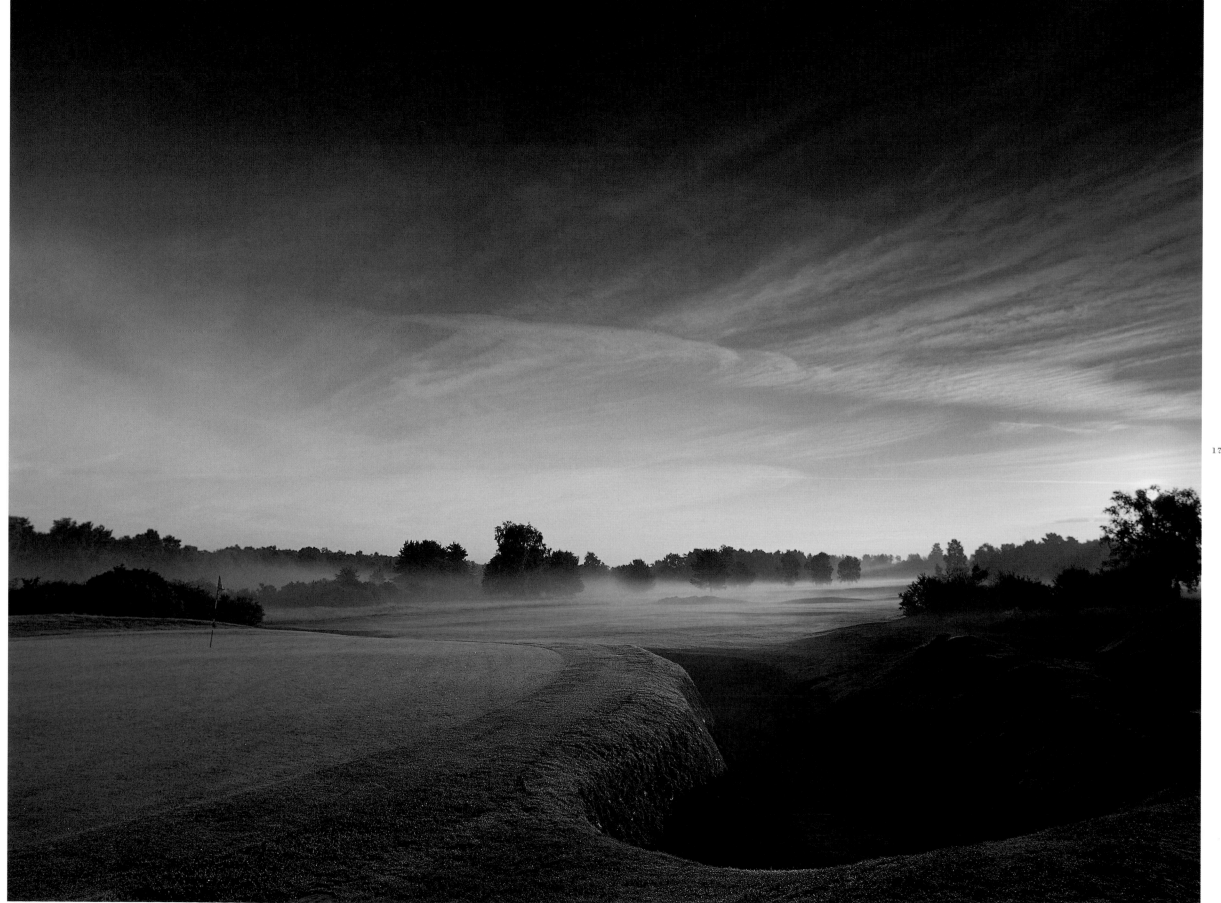

HOTCHKIN COURSE, THE NATIONAL GOLF CENTRE, WOODHALL SPA, WOODHALL SPA, LINCOLNSHIRE, ENGLAND. 4TH HOLE, PAR 4, 414 YD. DESIGNER: COLONEL S. V. HOTCHKIN.

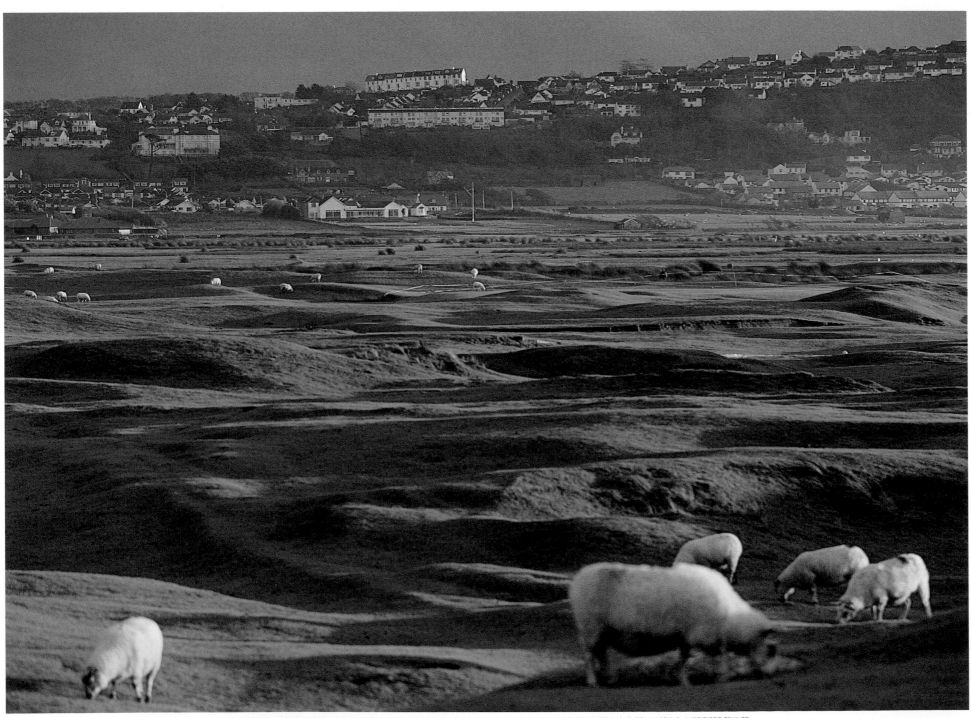

VIEW OF ROYAL NORTH DEVON GOLF CLUB LINKS, WESTWARD HO!, BIDEFORD, DEVON, ENGLAND. DESIGNERS: OLD TOM MORRIS, HERBERT FOWLER.

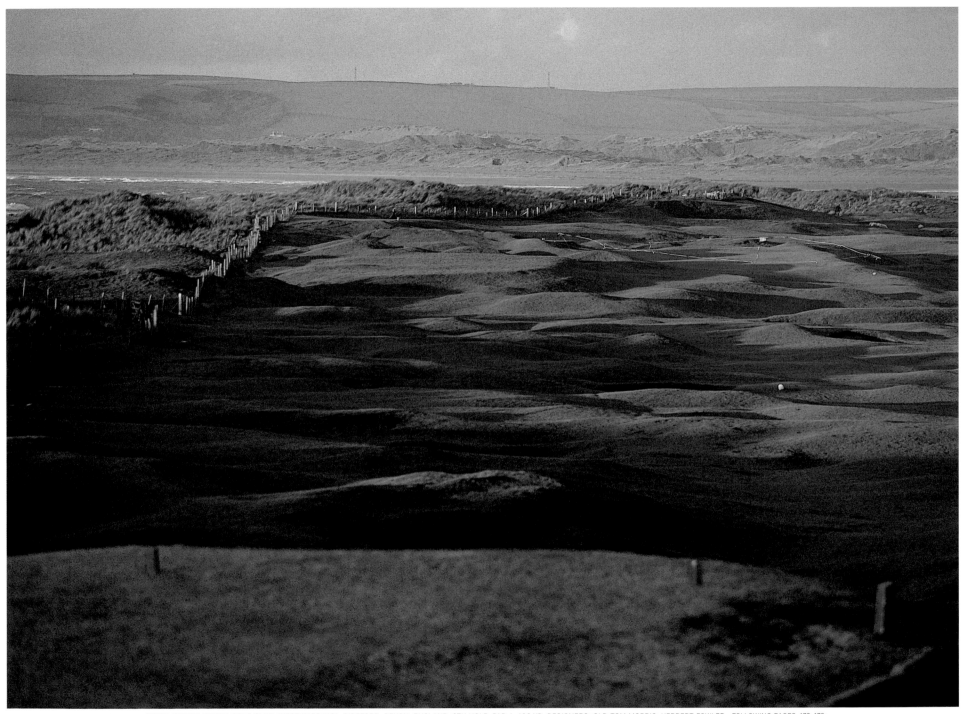

177

ROYAL NORTH DEVON GOLF CLUB, WESTWARD HO!, BIDEFORD, DEVON, ENGLAND. 6TH HOLE, PAR 4, 406 YD. DESIGNERS: OLD TOM MORRIS, HERBERT FOWLER. FOLLOWING PAGES, 178–179:
EUROPEAN CLUB, BRITTAS BAY, CO. WICKLOW, IRELAND. 8TH GREEN, PAR 4, 415 YD.; 11TH HOLE (IN BACKGROUND), PAR 4, 416 YD. DESIGNER: PAT RUDDY.

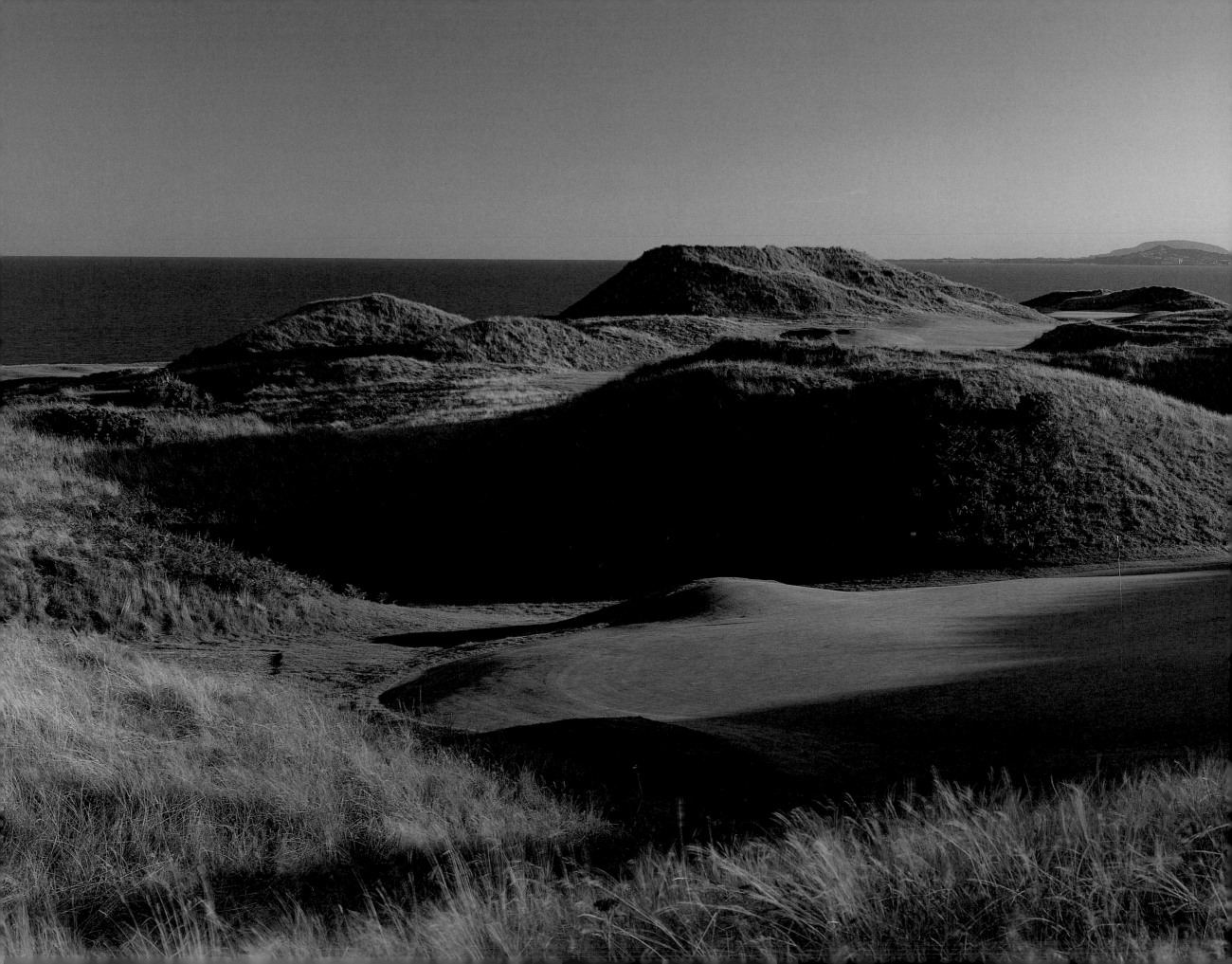

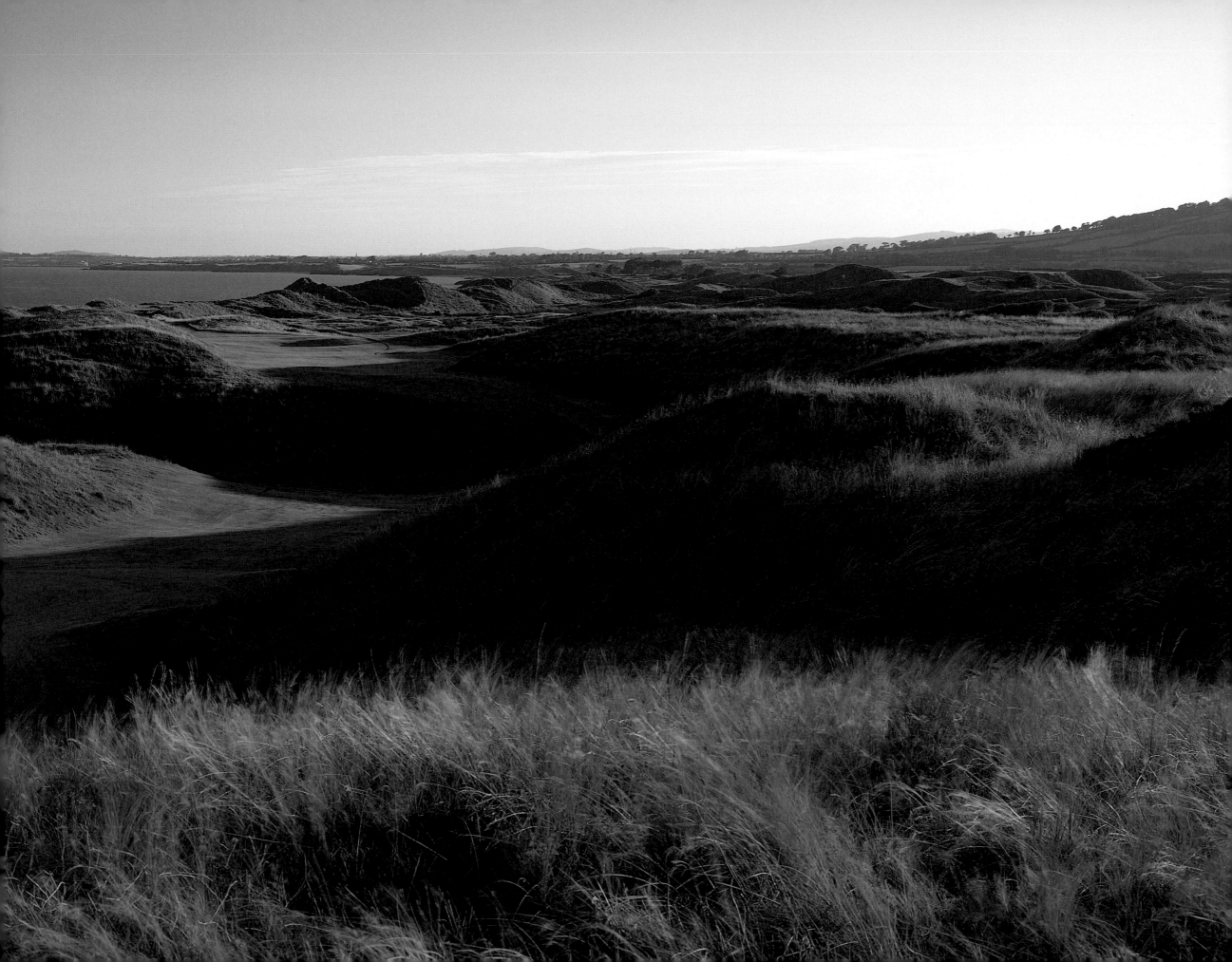

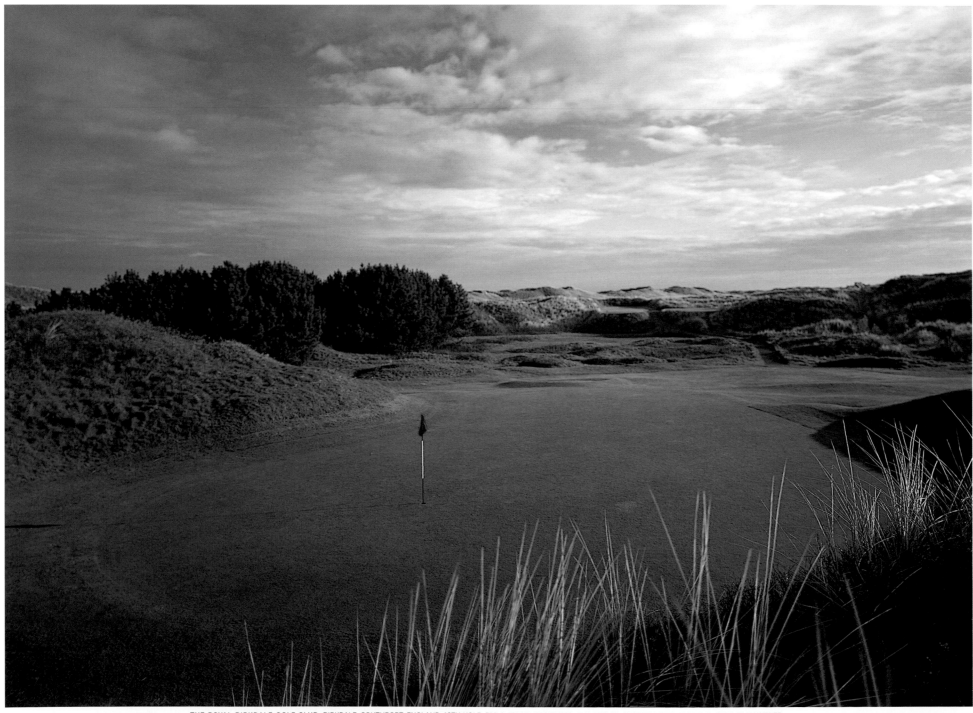

THE ROYAL BIRKDALE GOLF CLUB, BIRKDALE, SOUTHPORT, ENGLAND. 12TH HOLE, PAR 3, 183 YD. DESIGNERS: J. H. TAYLOR, GEORGE LOWE, AND F. F. AND F. W. HAWTREE.

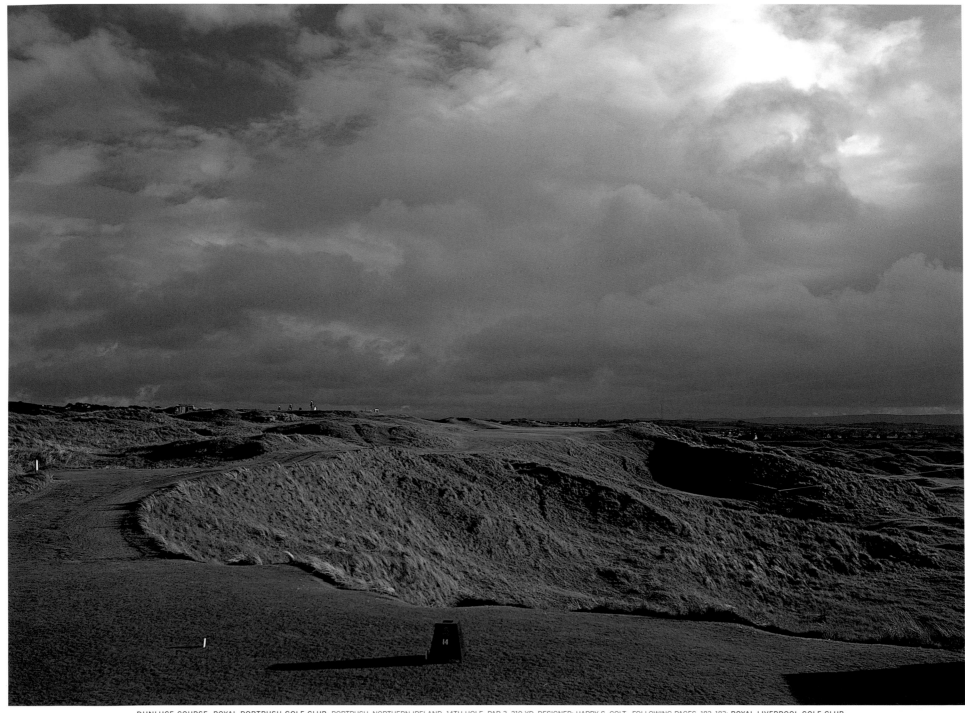

DUNLUCE COURSE, ROYAL PORTRUSH GOLF CLUB, PORTRUSH, NORTHERN IRELAND. 14TH HOLE, PAR 3, 210 YD. DESIGNER: HARRY S. COLT. FOLLOWING PAGES, 182–183: ROYAL LIVERPOOL GOLF CLUB, HOYLAKE, ENGLAND. 11TH HOLE, PAR 3, 193 YD. DESIGNERS: ROBERT CHAMBERS, GEORGE MORRIS, CAMERON SINCLAIR.

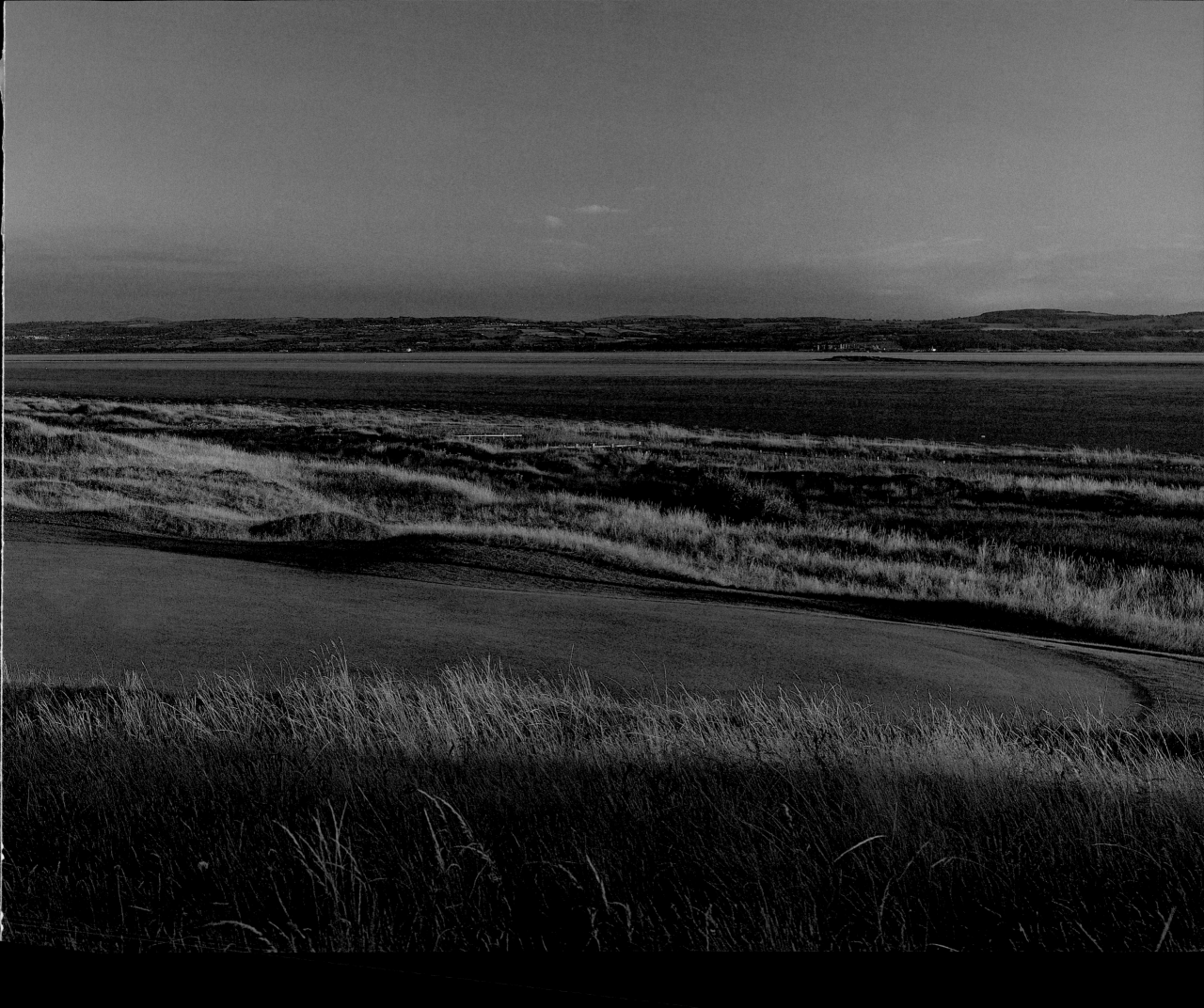

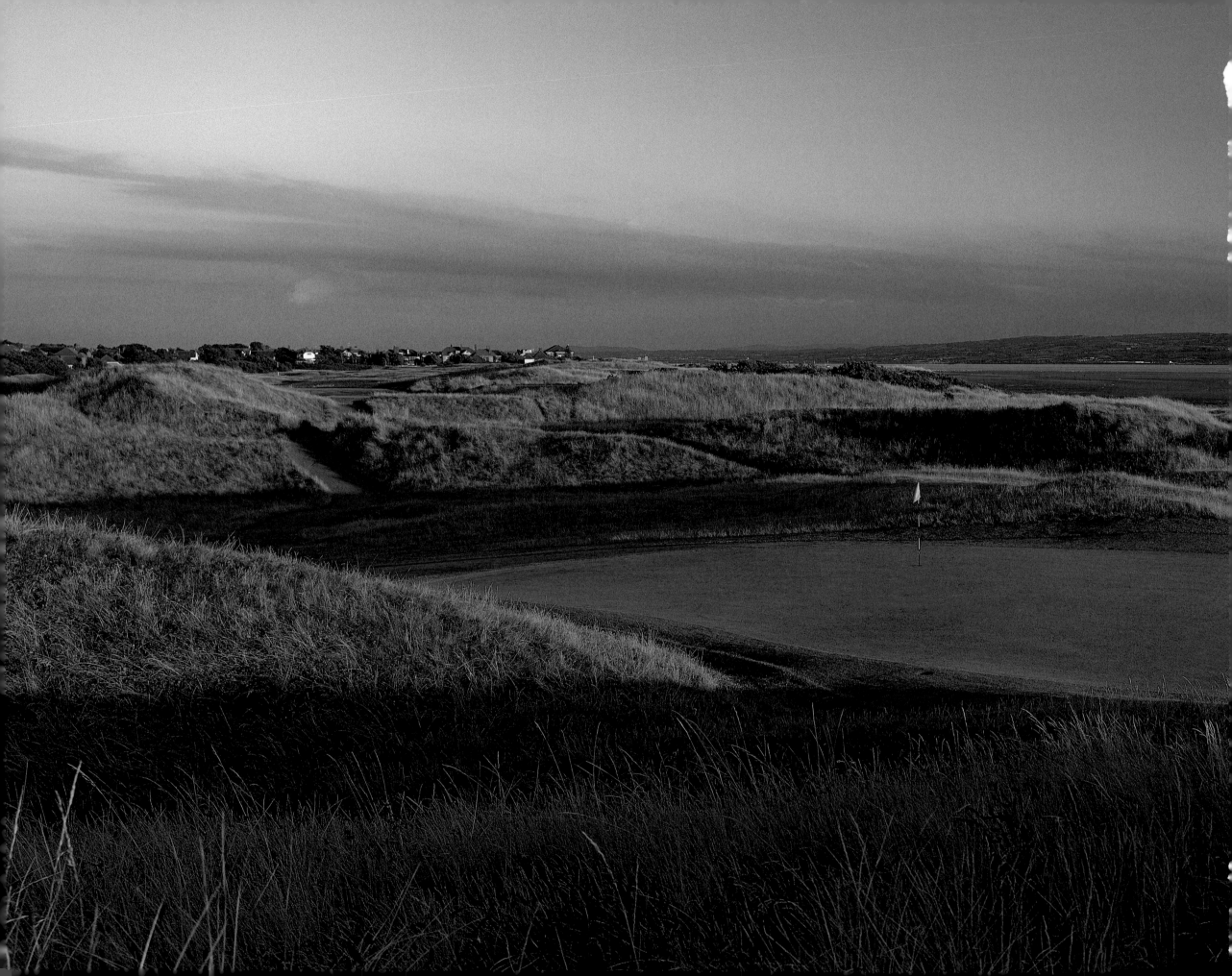

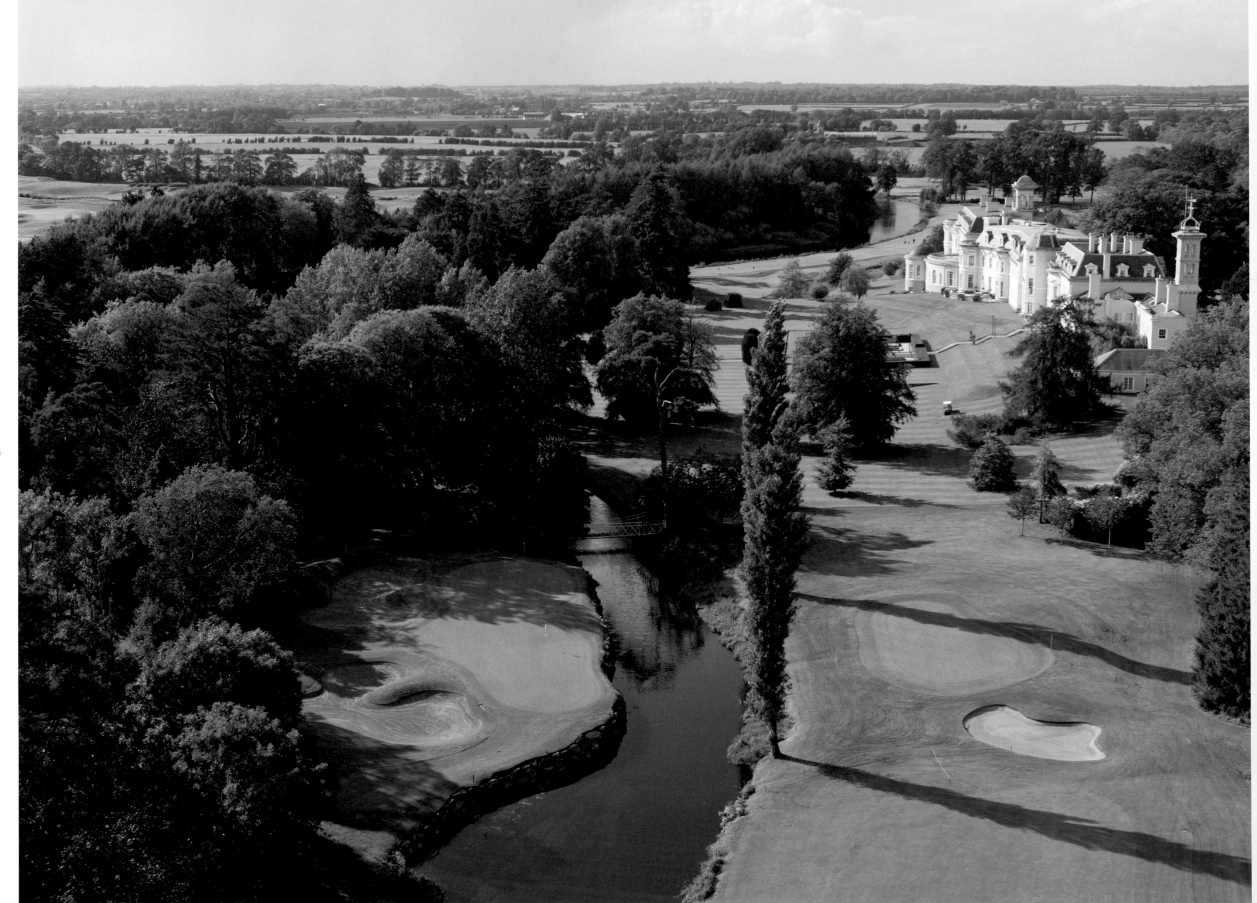

184

PALMER COURSE, THE K CLUB, STRAFFAN, CO. KILDARE, IRELAND. 7TH HOLE, PAR 5, 570 YD. DESIGNER: ARNOLD PALMER.

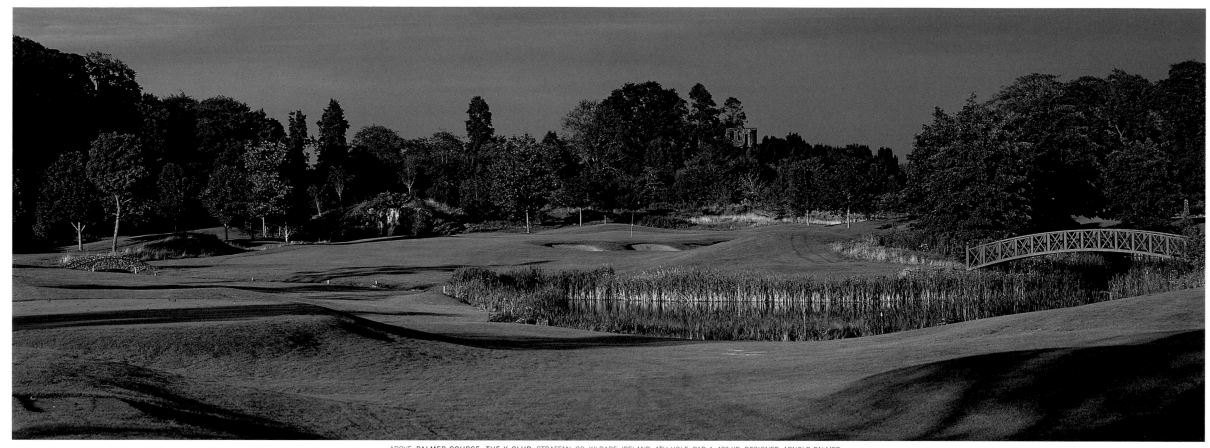

ABOVE: **PALMER COURSE, THE K CLUB,** STRAFFAN, CO. KILDARE, IRELAND. 4TH HOLE, PAR 4, 423 YD. DESIGNER: ARNOLD PALMER.

BELOW LEFT: **PALMER COURSE, THE K CLUB,** STRAFFAN, CO. KILDARE, IRELAND. 3RD HOLE, PAR 3, 173 YD. DESIGNER: ARNOLD PALMER. BELOW RIGHT: **PALMER COURSE, THE K CLUB,** STRAFFAN, CO. KILDARE, IRELAND. 15TH HOLE, PAR 4, 478 YD. DESIGNER: ARNOLD PALMER.

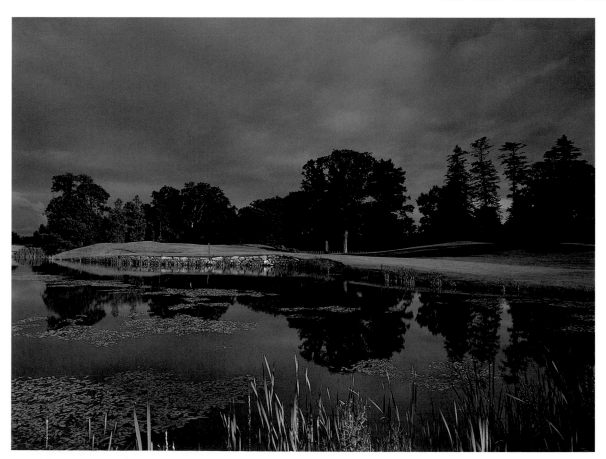

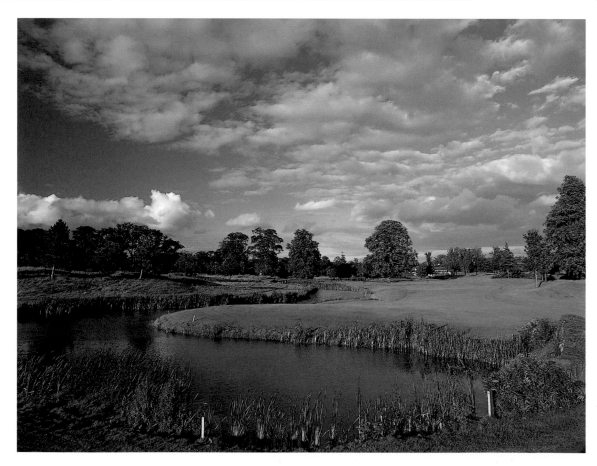

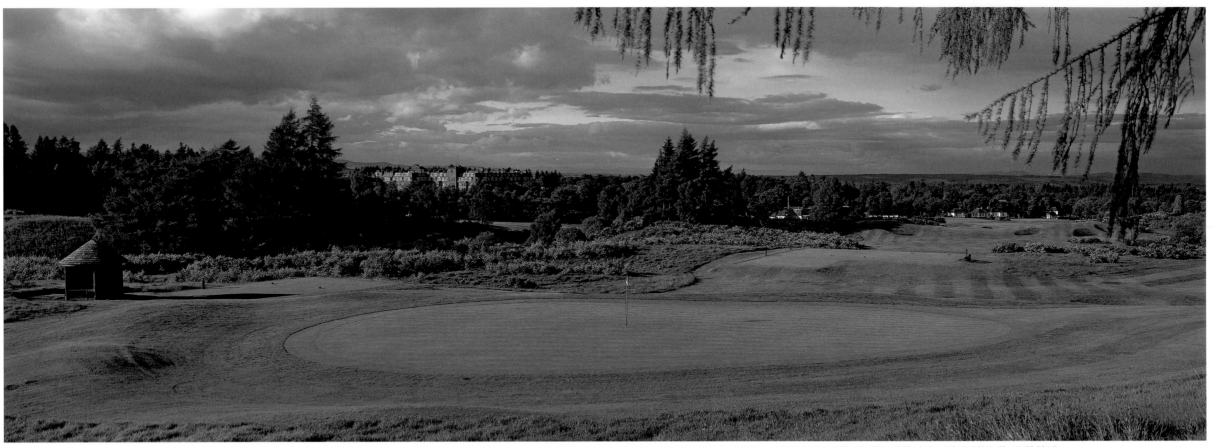

ABOVE: **KING'S COURSE, GLENEAGLES HOTEL**, AUCHTERADER, SCOTLAND. 17TH HOLE, PAR 4, 377 YD. DESIGNER: JAMES BRAID. BELOW: **KING'S COURSE, GLENEAGLES HOTEL**, AUCHTERADER, SCOTLAND. 18TH GREEN, PAR 5, 525 YD. DESIGNER: JAMES BRAID.

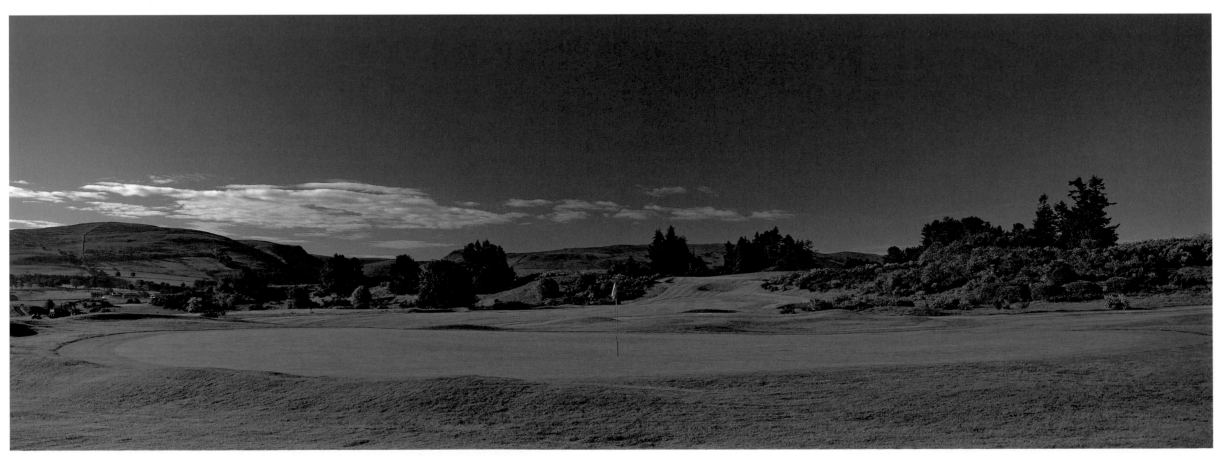

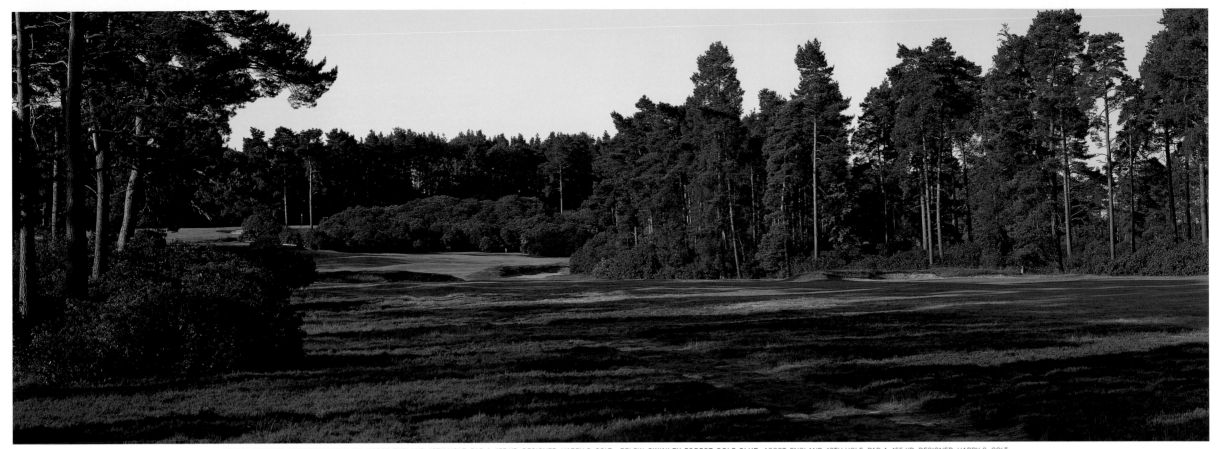

ABOVE: **SWINLEY FOREST GOLF CLUB,** ASCOT, ENGLAND. 12TH HOLE, PAR 4, 455 YD. DESIGNER: HARRY S. COLT. BELOW: **SWINLEY FOREST GOLF CLUB,** ASCOT, ENGLAND. 12TH HOLE, PAR 4, 455 YD. DESIGNER: HARRY S. COLT.

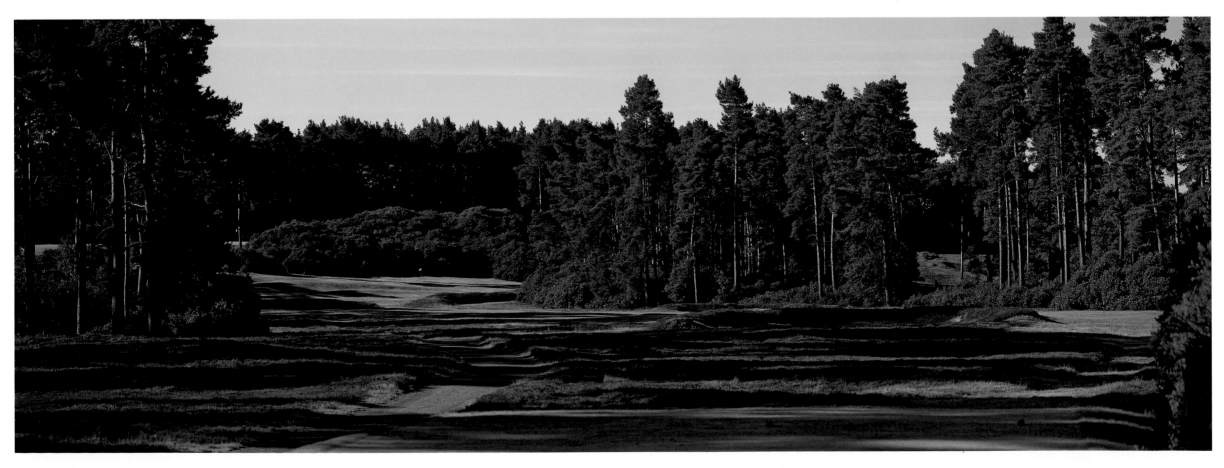

4
ASIA

BLUE CANYON, TAIHEYO CLUB GOTEMBA, HIRONO, KASUMIGASEKI, OCEAN DUNES, SAUJANA, SPRING CITY, TANAH MERAH, WINDSOR PARK

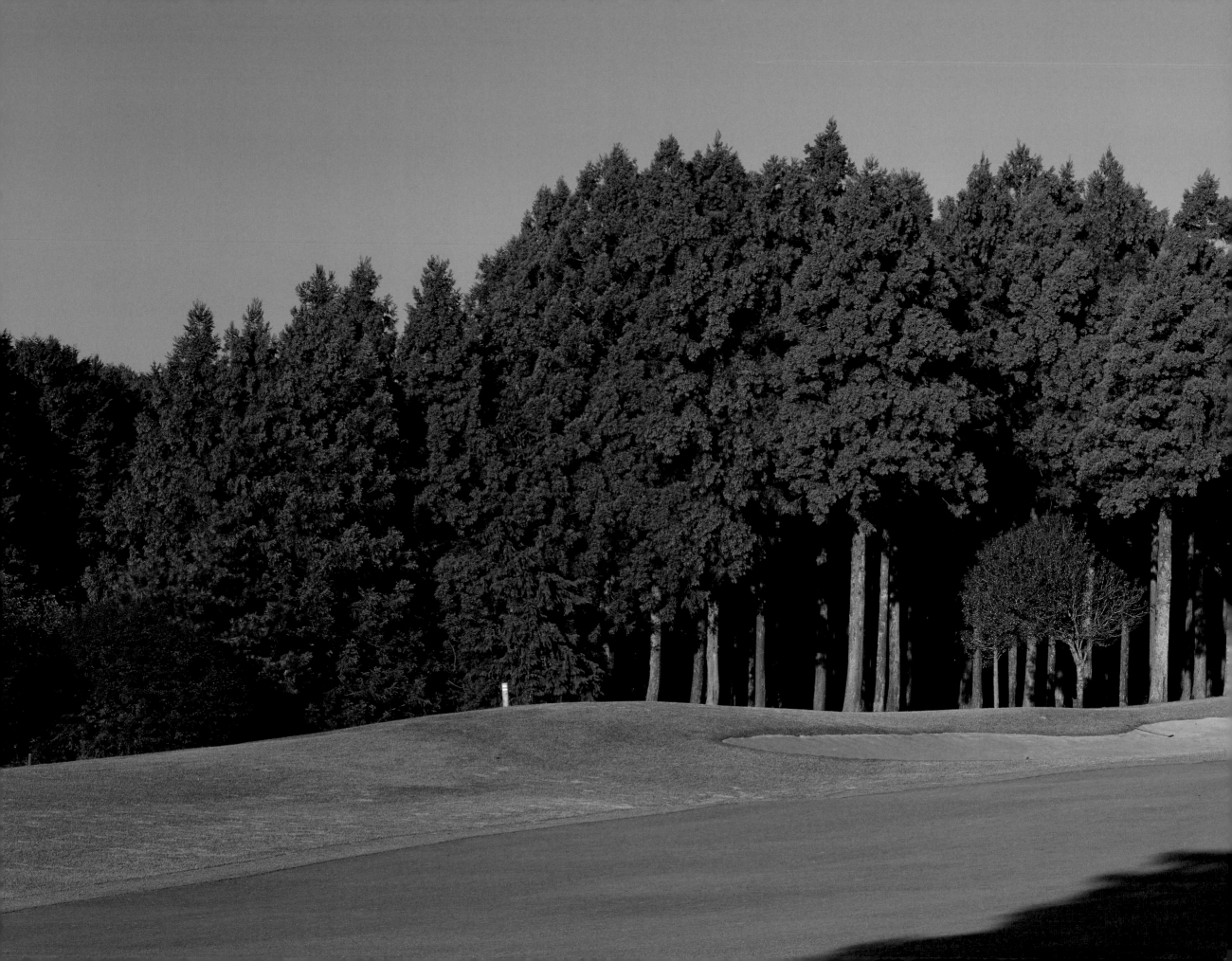

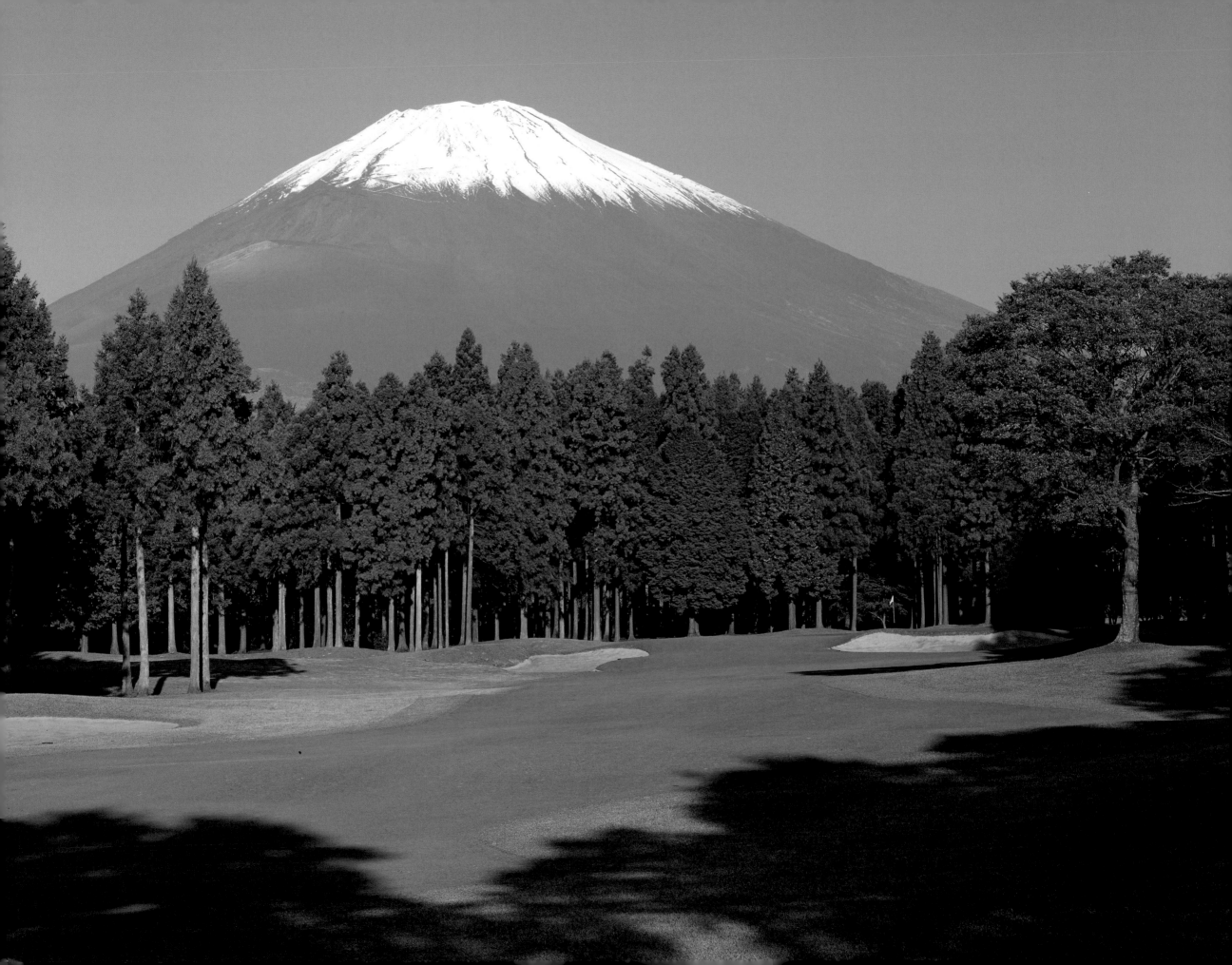

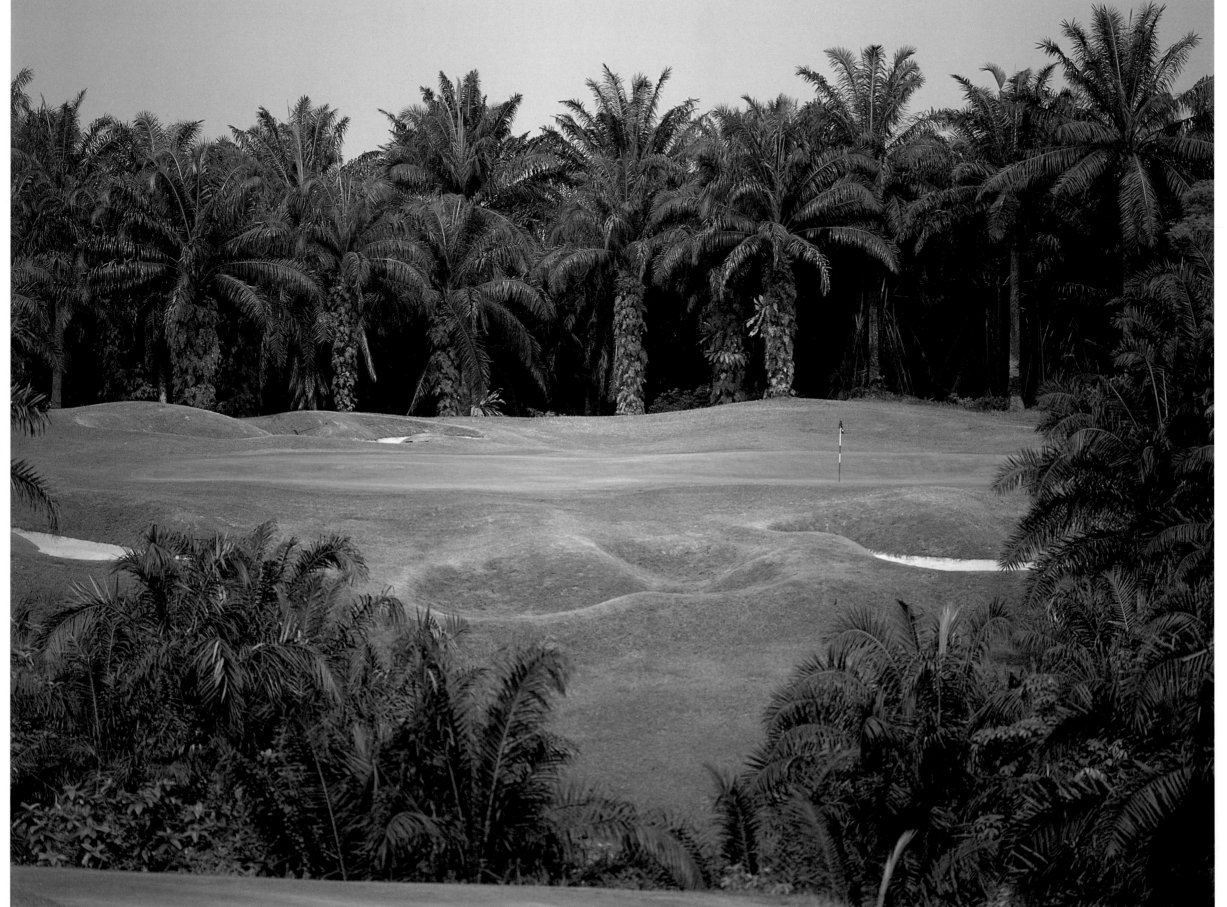

192

PREVIOUS PAGES, 190–191: **TAIHEYO CLUB, GOTEMBA,** SHIZOUKA, JAPAN. 5TH HOLE, PAR 4, 399 YD. DESIGNER: SHIRO AKABOSHI. ABOVE: **THE PALM COURSE, SAUJANA GOLF AND COUNTRY CLUB,** KUALA LUMPUR, MALAYSIA. 2ND HOLE, PAR 3, 204 YD. DESIGNER: RONALD FREAM.

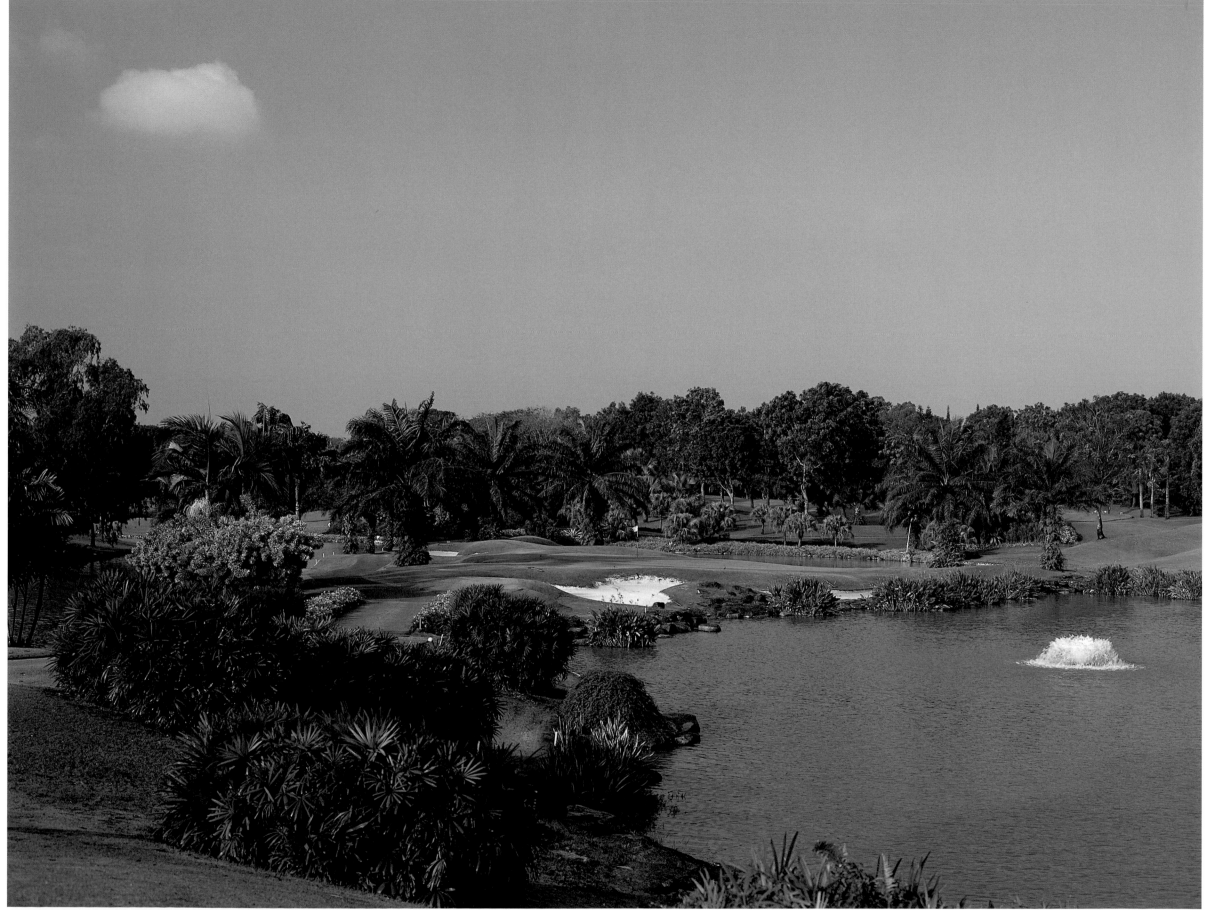

193

ABOVE: **TAMPINES COURSE, TANAH MERAH COUNTRY CLUB,** SINGAPORE. 17TH HOLE, PAR 3, 170 YD. DESIGNERS: CHRIS PITMAN, TAN PUAY. FOLLOWING PAGES, 194–195: **OCEAN DUNES GOLF CLUB,** PHAN THIET, BINH THUAN, VIETNAM. 18TH HOLE, PAR 5, 512 YD. DESIGNER: NICK FALDO.

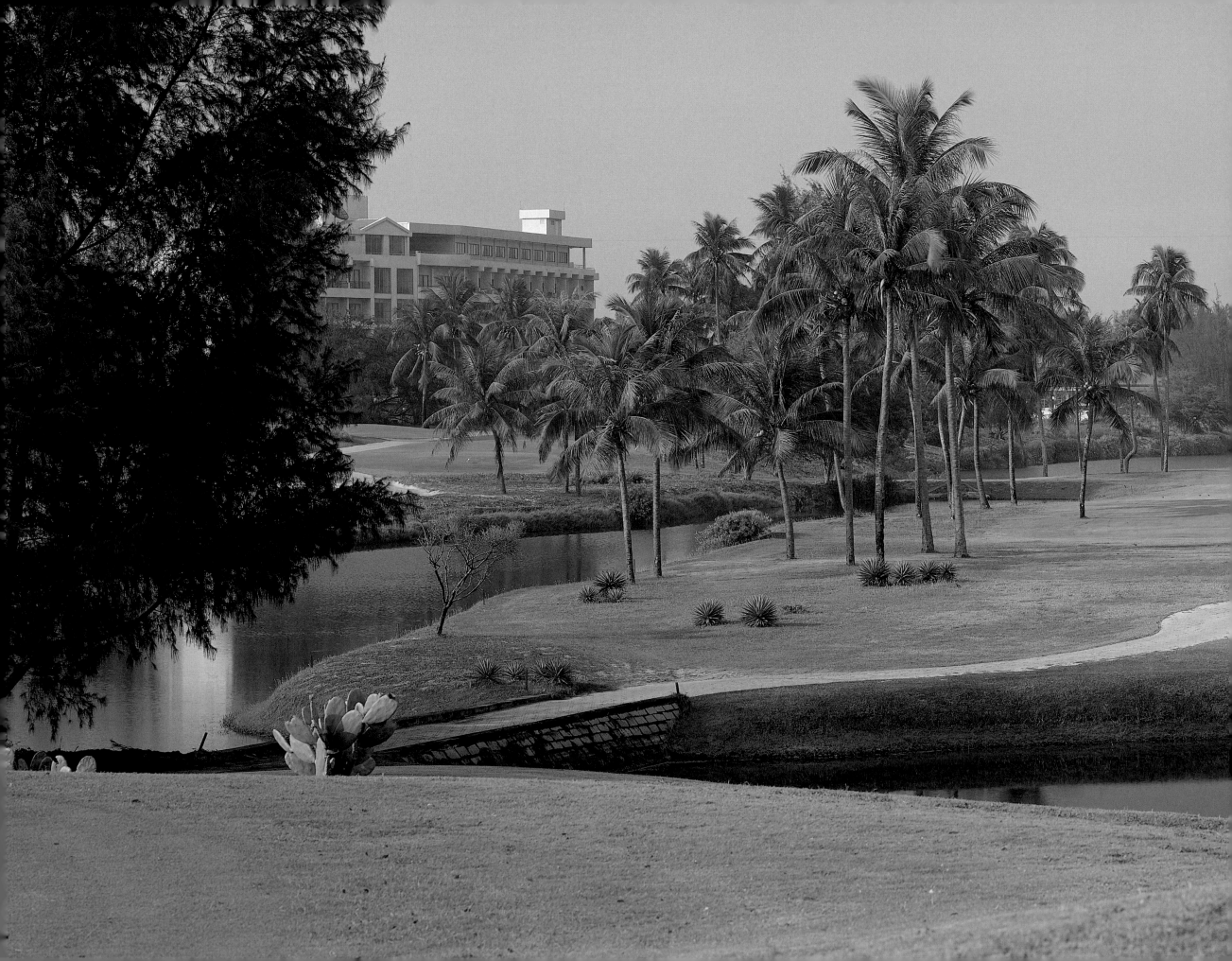

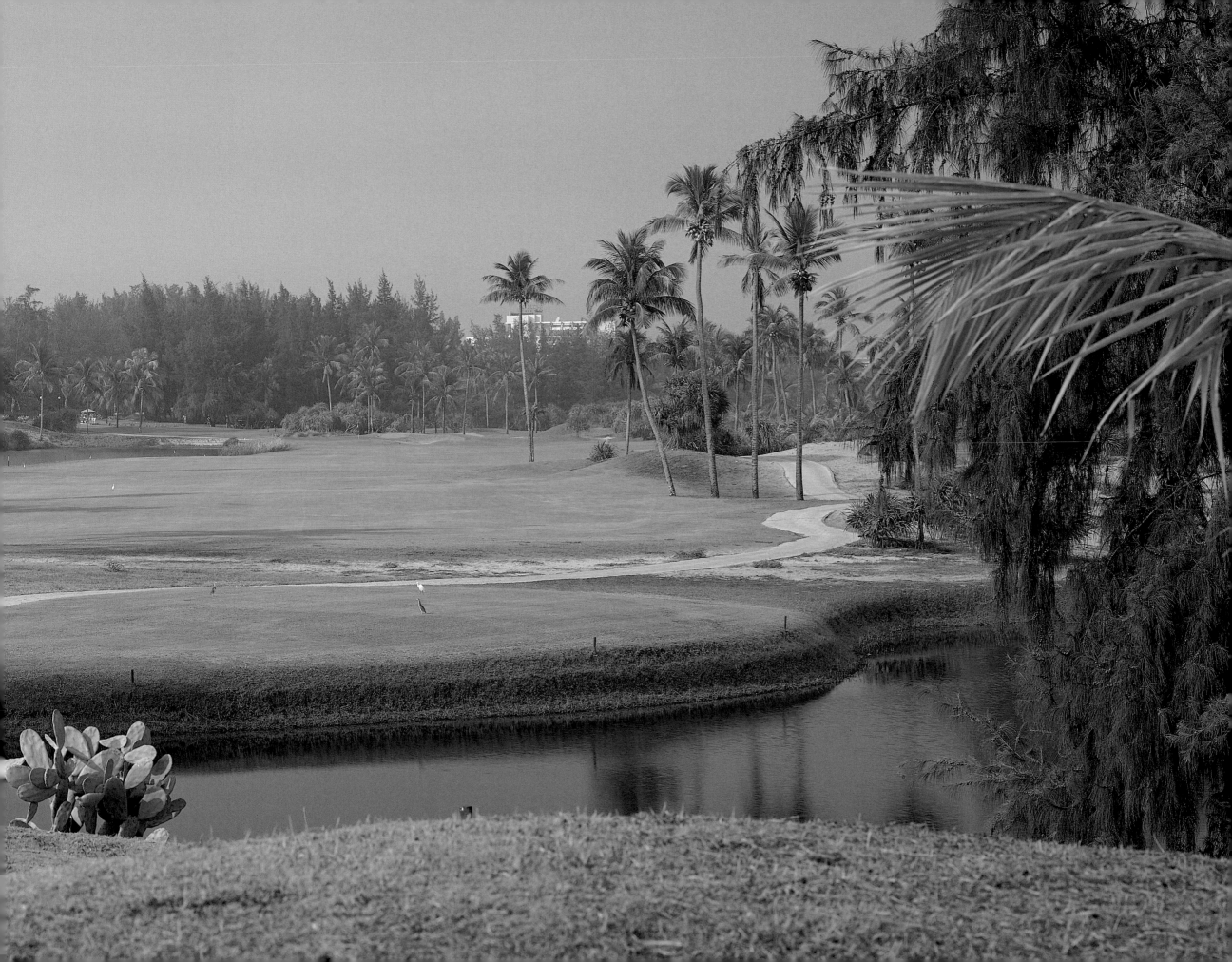

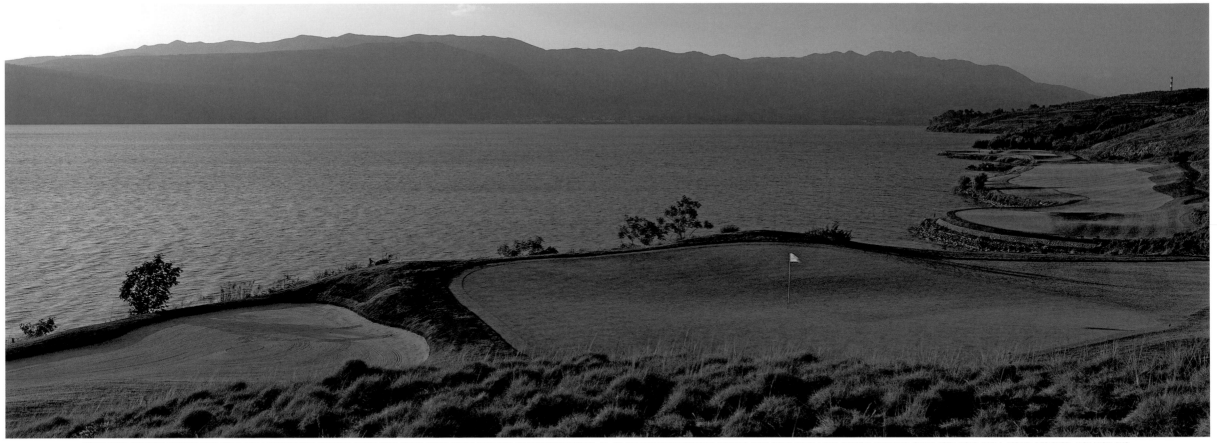

ABOVE: **LAKE COURSE, SPRING CITY GOLF AND LAKE RESORT**, KUNMING, CHINA. 10TH GREEN, PAR 3, 190 YD. DESIGNER: ROBERT TRENT JONES, JR. BELOW: **MOUNTAIN COURSE, SPRING CITY GOLF AND LAKE RESORT**, KUNMING, CHINA. 18TH HOLE, PAR 4, 465 YD. DESIGNER: JACK NICKLAUS.

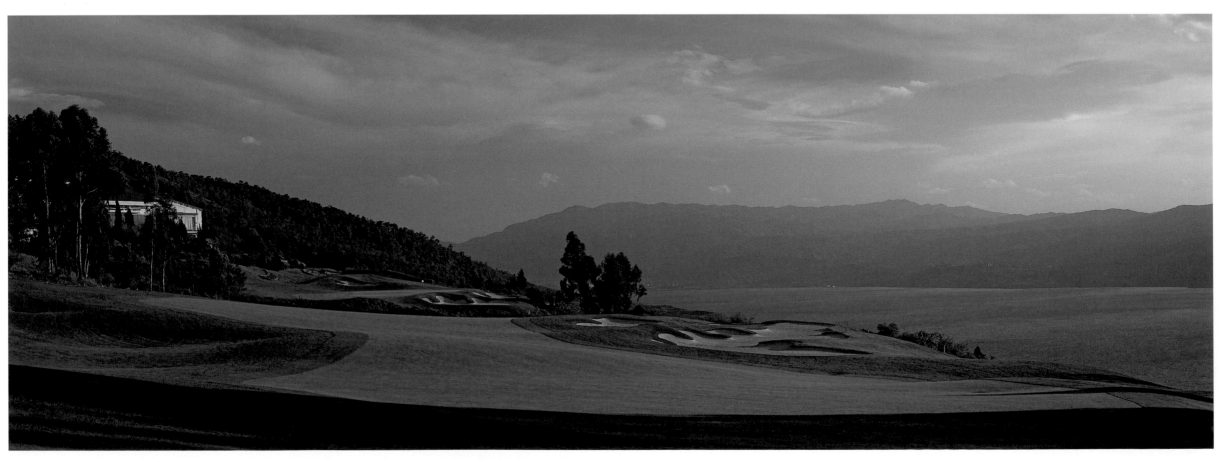

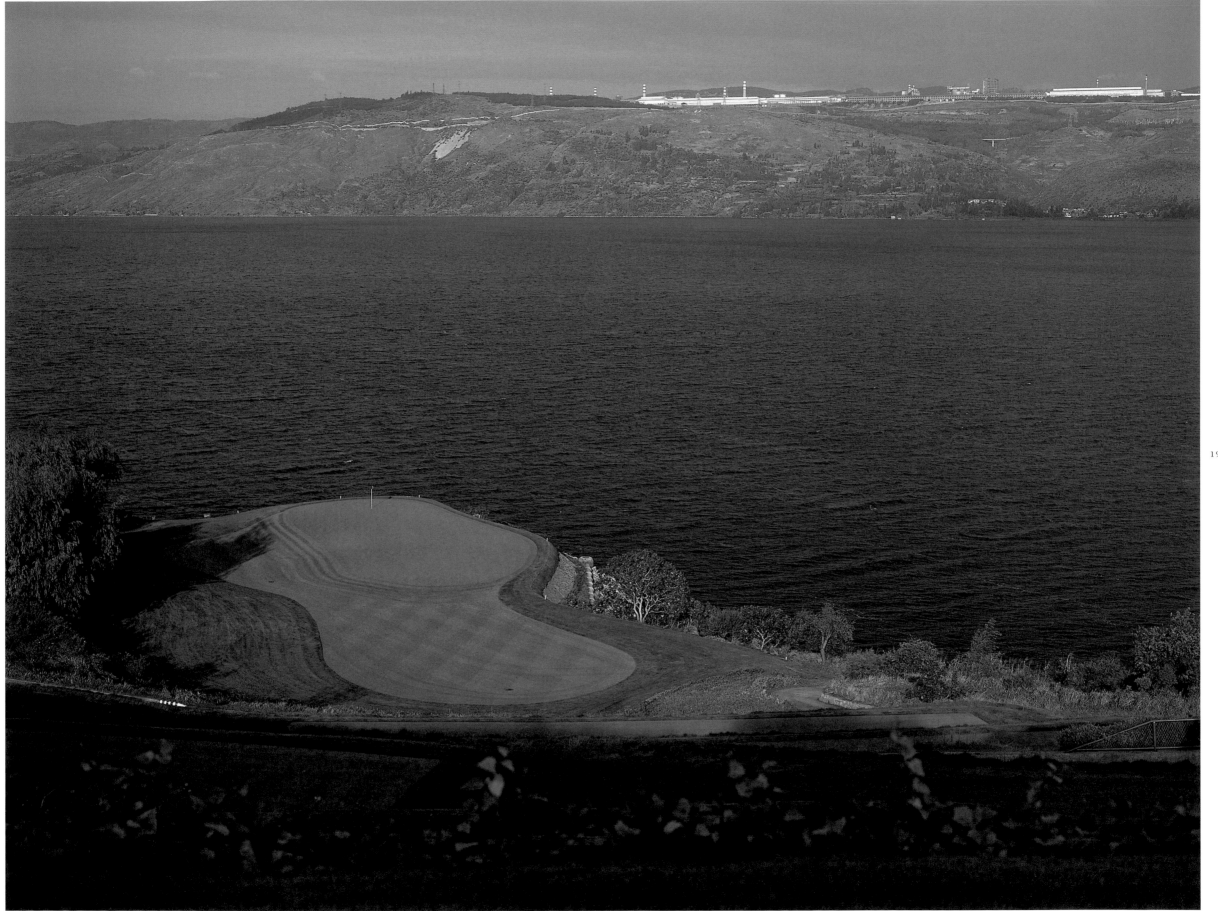

197

ABOVE: **LAKE COURSE, SPRING CITY GOLF AND LAKE RESORT,** KUNMING, CHINA. 8TH HOLE, PAR 3, 172 YD. DESIGNER: ROBERT TRENT JONES, JR.

FOLLOWING PAGES, 198–199: **WEST COURSE, KASUMIGASEKI COUNTRY CLUB,** SAITAMA, JAPAN. 16TH HOLE, PAR 3, 144 YD. DESIGNERS: SEIICHI INOUE, TAIZO KAWATA, KINYA FUJNTA, CHARLES H. ALISON, SHIRO AKABOSHI.

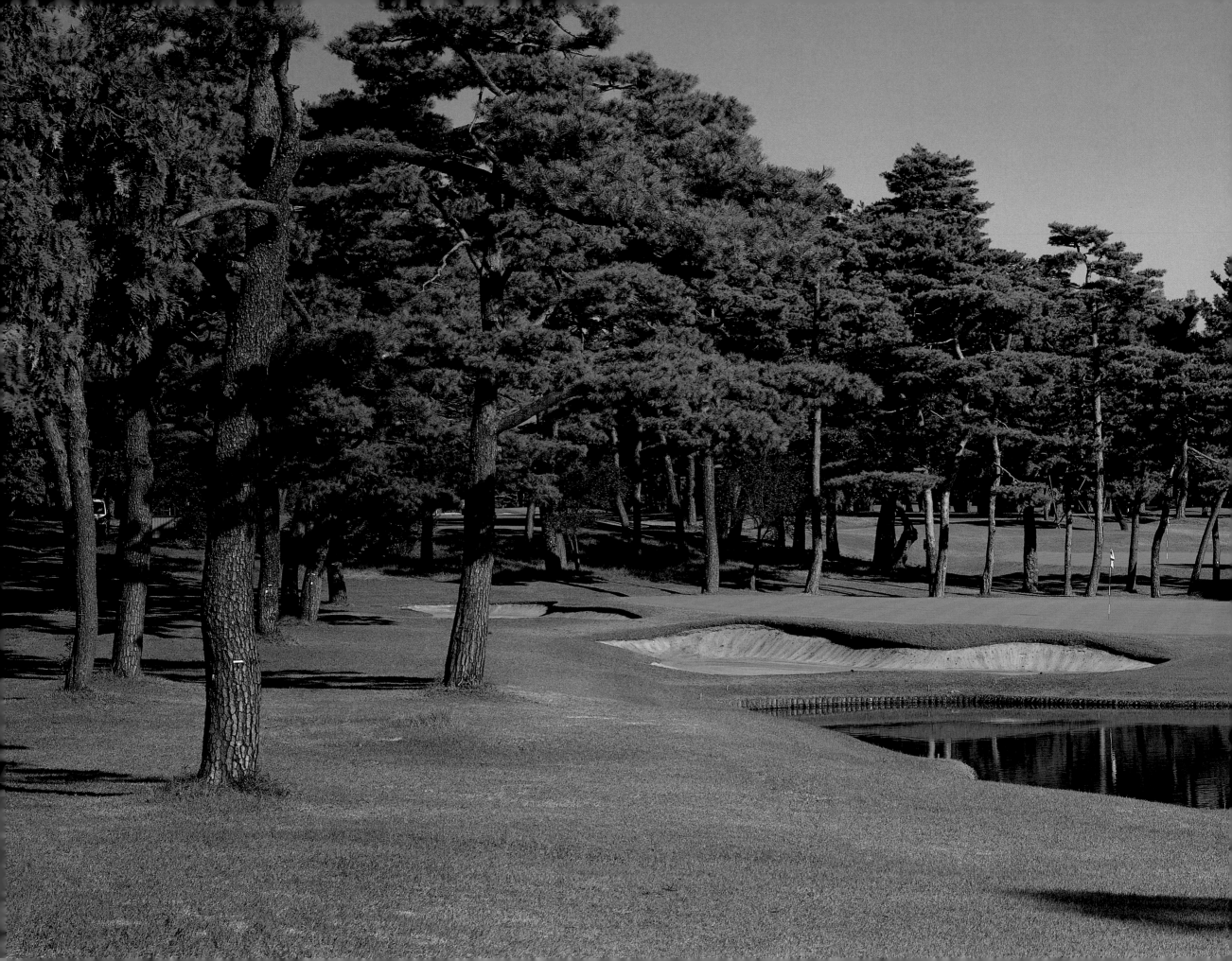

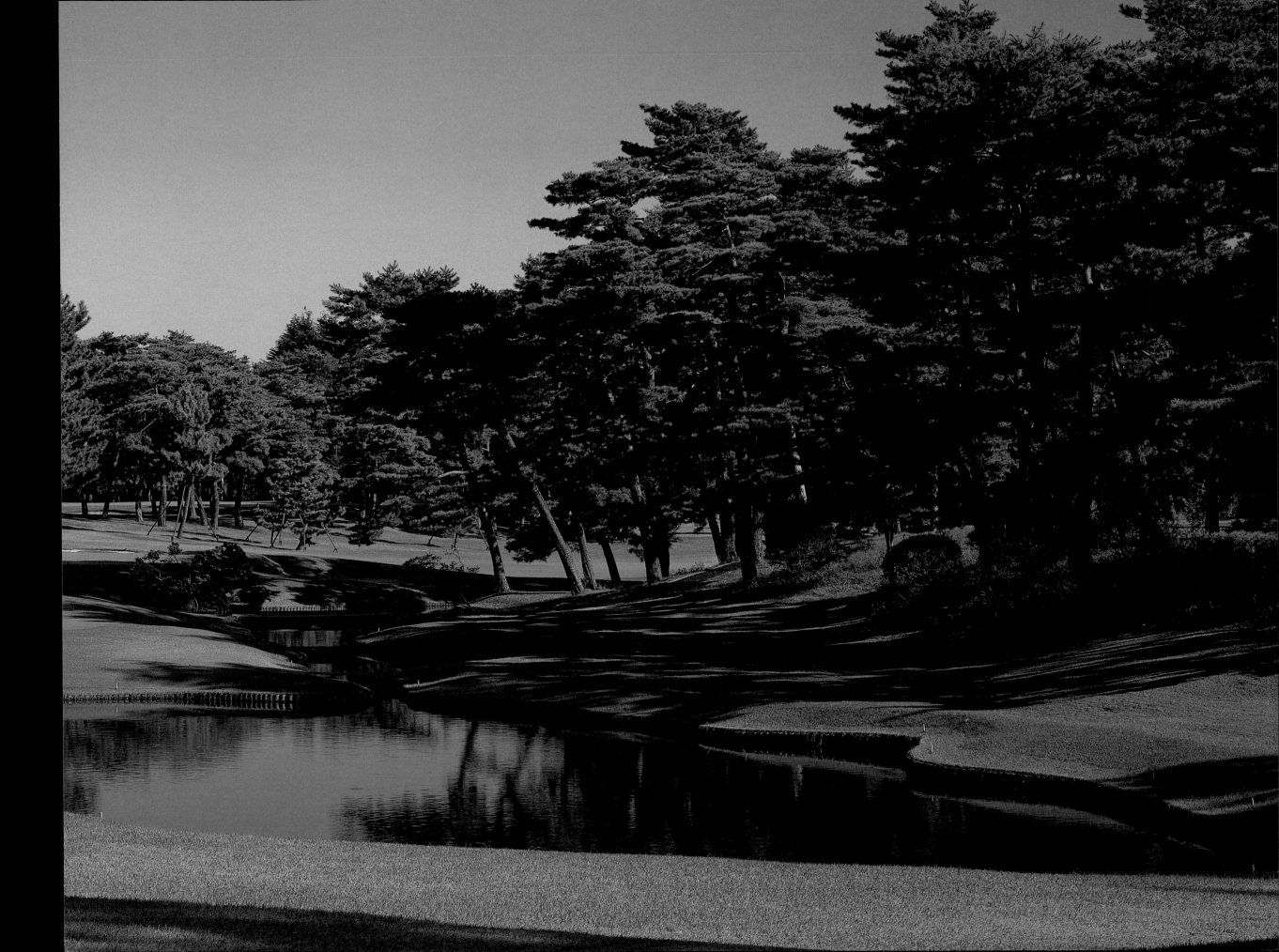

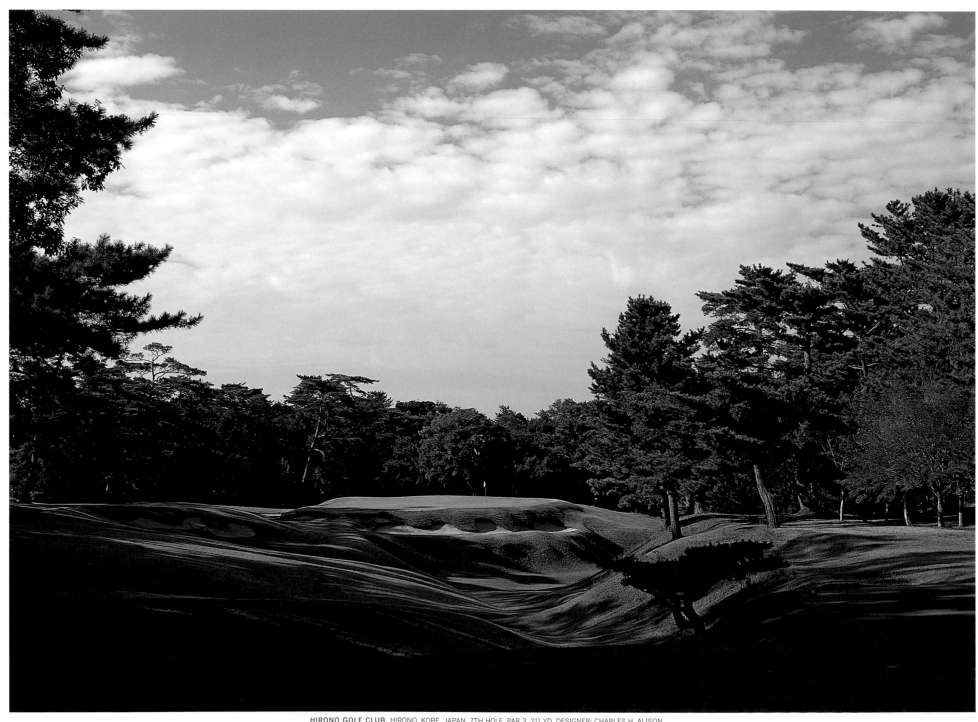

HIRONO GOLF CLUB, HIRONO, KOBE, JAPAN. 7TH HOLE, PAR 3, 211 YD. DESIGNER: CHARLES H. ALISON.

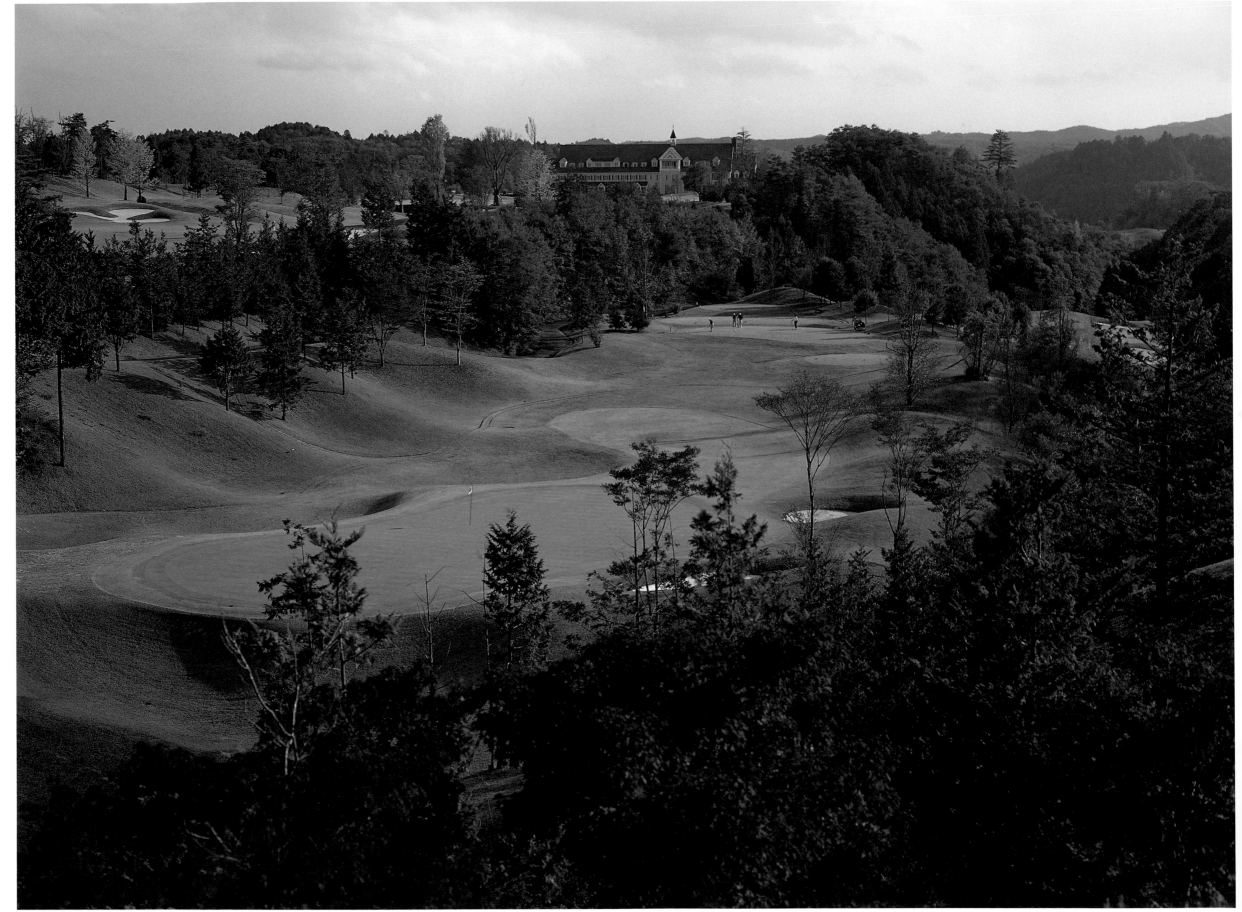

204

WINDSOR PARK GOLF AND COUNTRY CLUB, IBARAKI, JAPAN. 8TH HOLE, PAR 3, 163 YD. DESIGNER: SEIICHI INOUE.

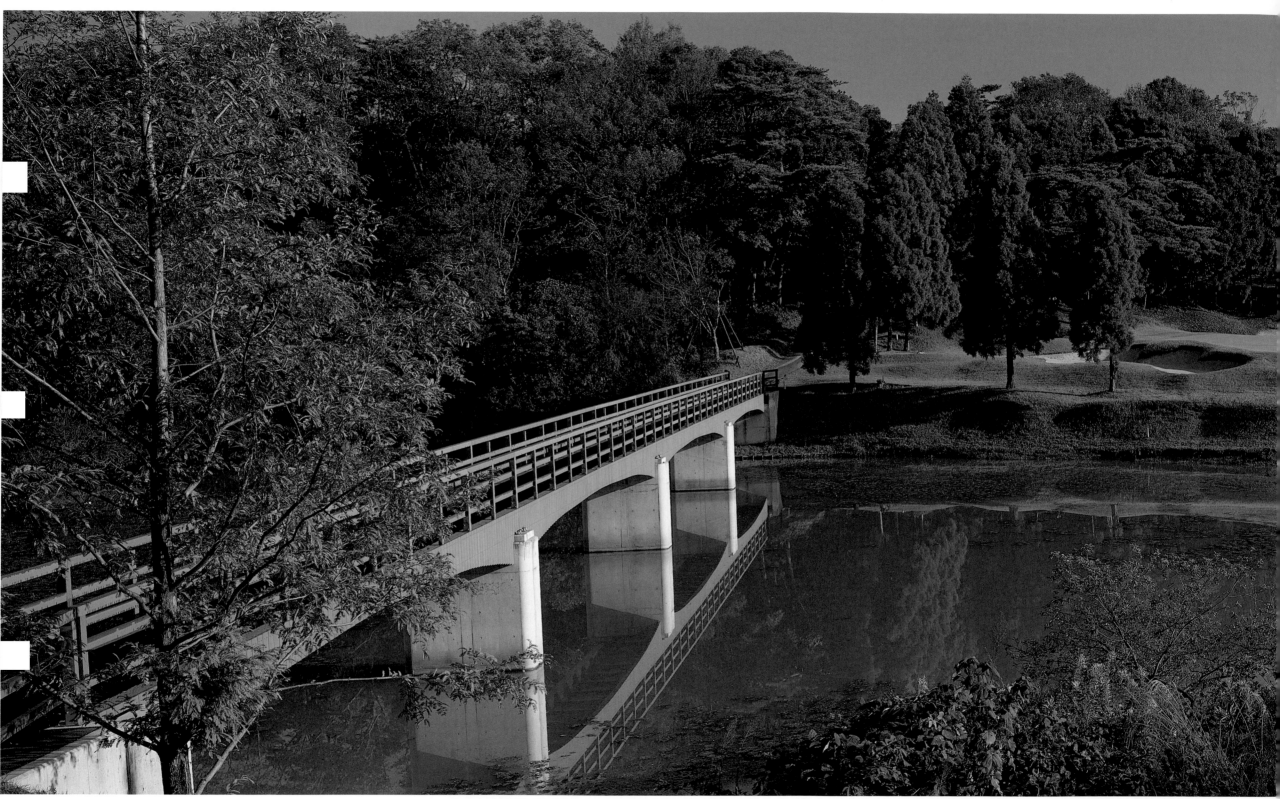

HIRONO GOLF CLUB, HIRONO, KOBE, JAPAN. 13TH HOLE, PAR 3, 167 YD. DESIGNER: CHARLES H. ALISON.

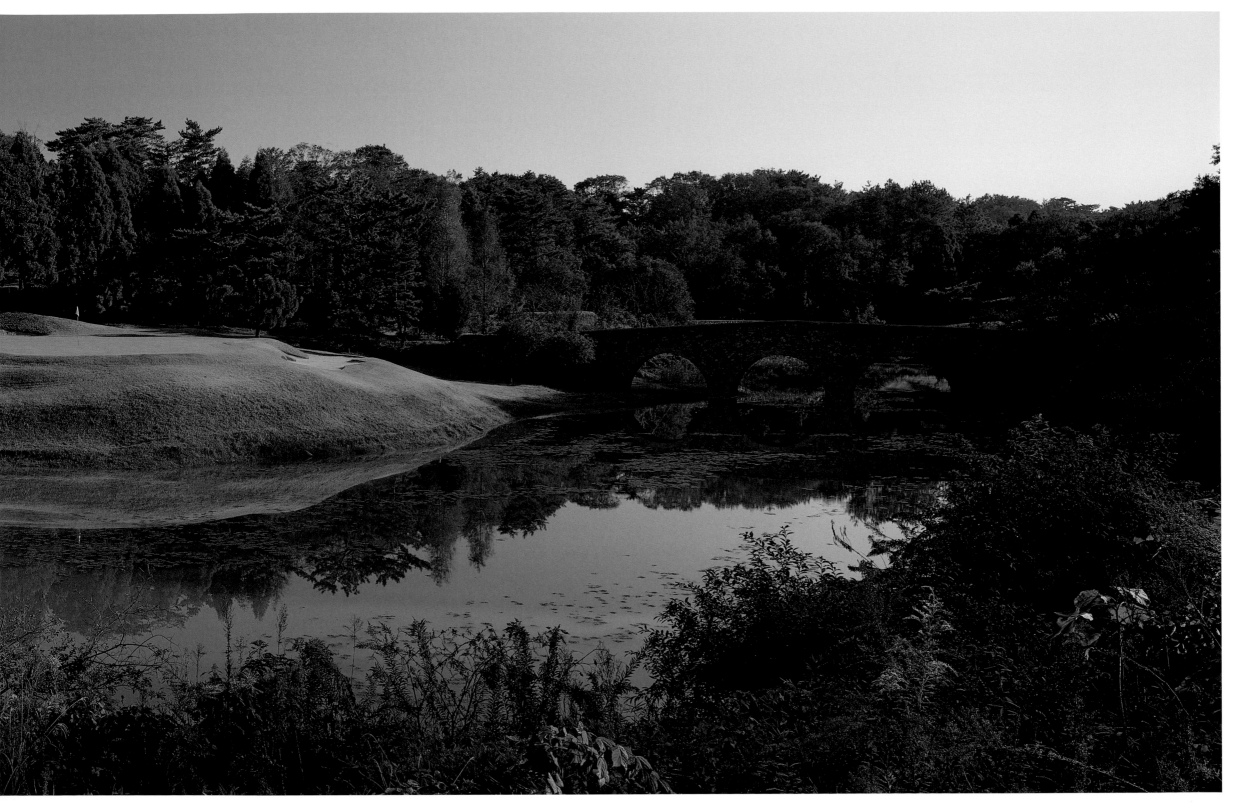

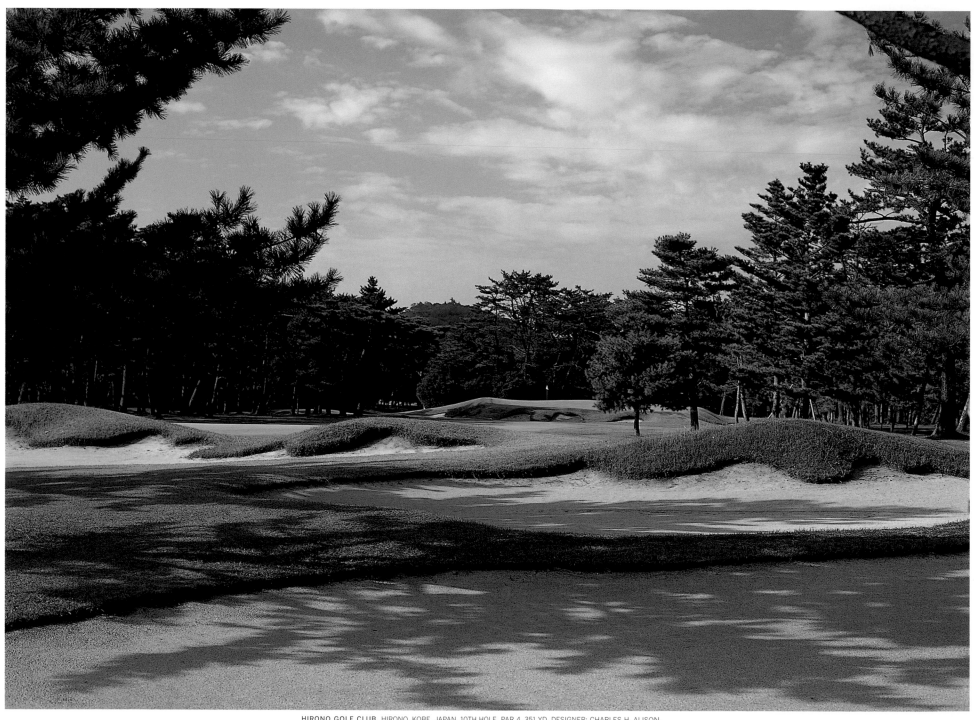

HIRONO GOLF CLUB, HIRONO, KOBE, JAPAN. 10TH HOLE, PAR 4, 351 YD. DESIGNER: CHARLES H. ALISON.

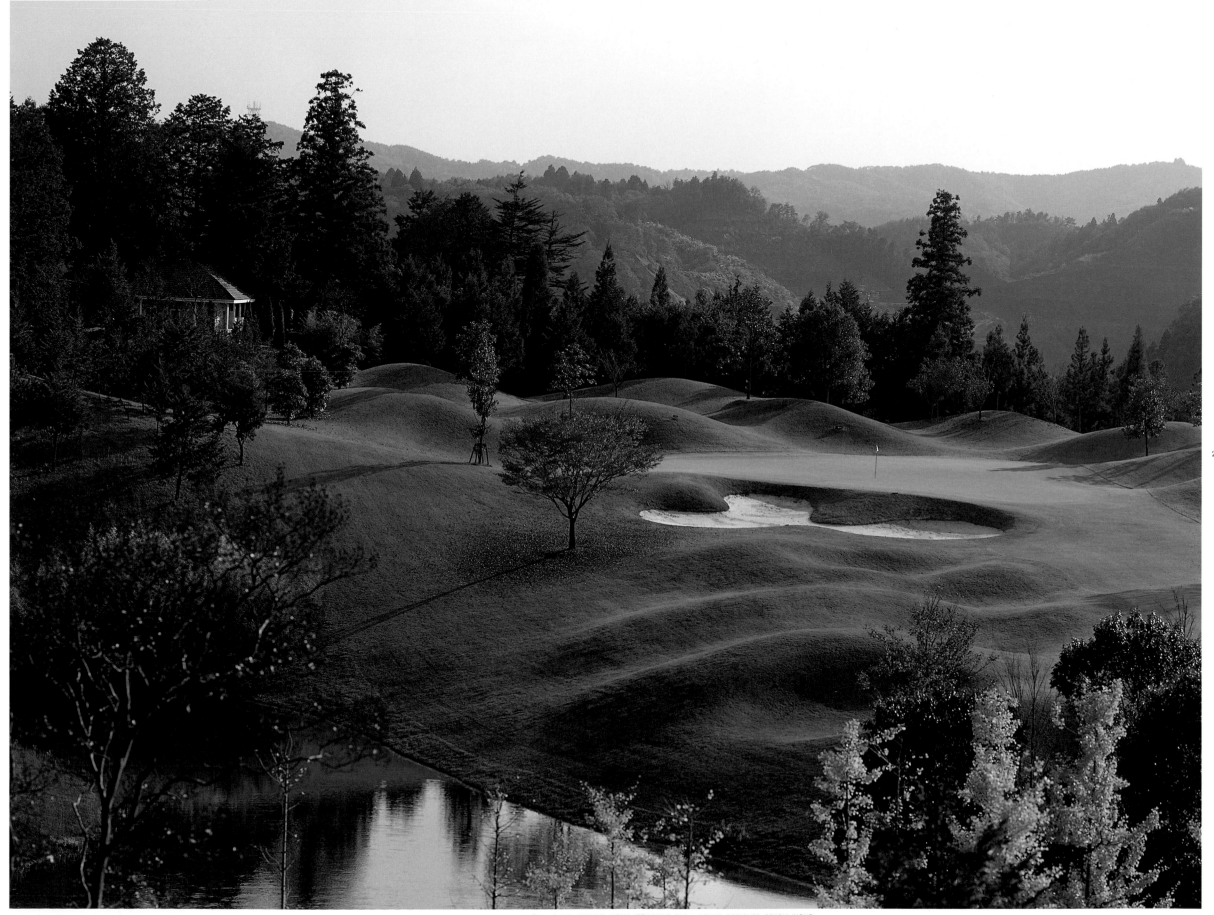

205

WINDSOR PARK GOLF AND COUNTRY CLUB, IBARAKI, JAPAN. 13TH HOLE, PAR 4, 465 YD. DESIGNER: SEIICHI INOUE.

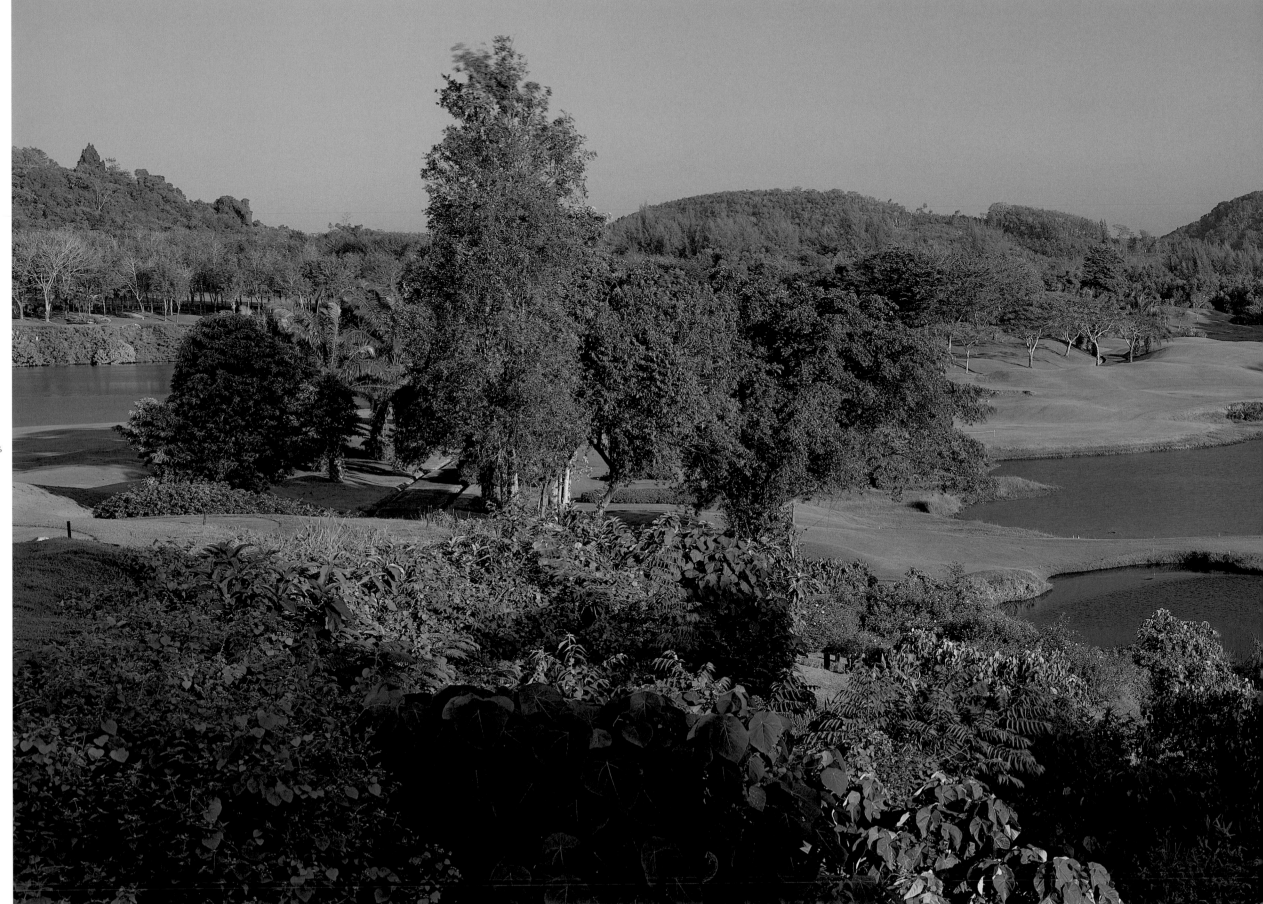

206

CANYON COURSE, BLUE CANYON COUNTRY CLUB, PHUKET, THAILAND. 14TH HOLE, PAR 3, 194 YD. DESIGNER: YOSHIKAZU KATO.

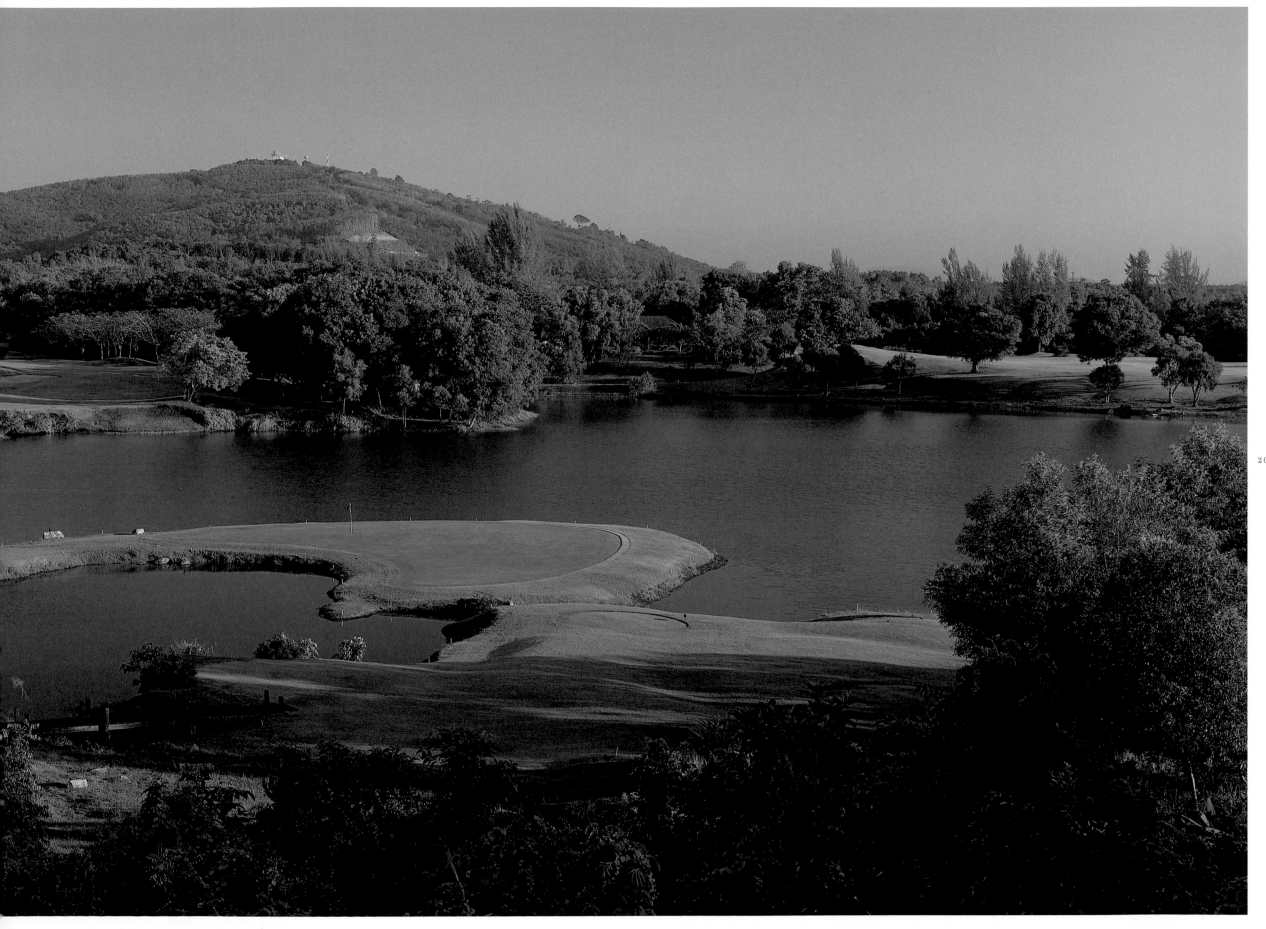

5

SOUTH AMERICA AND CARIBBEAN

GÁVEA, JOCKEY CLUB, LOS LEONES, ROYAL WESTMORELAND

210

CLUB DE GOLF LOS LEONES, SANTIAGO, CHILE. 13TH HOLE, PAR 4, 438 YD. DESIGNER: ALISTER MACDONALD.

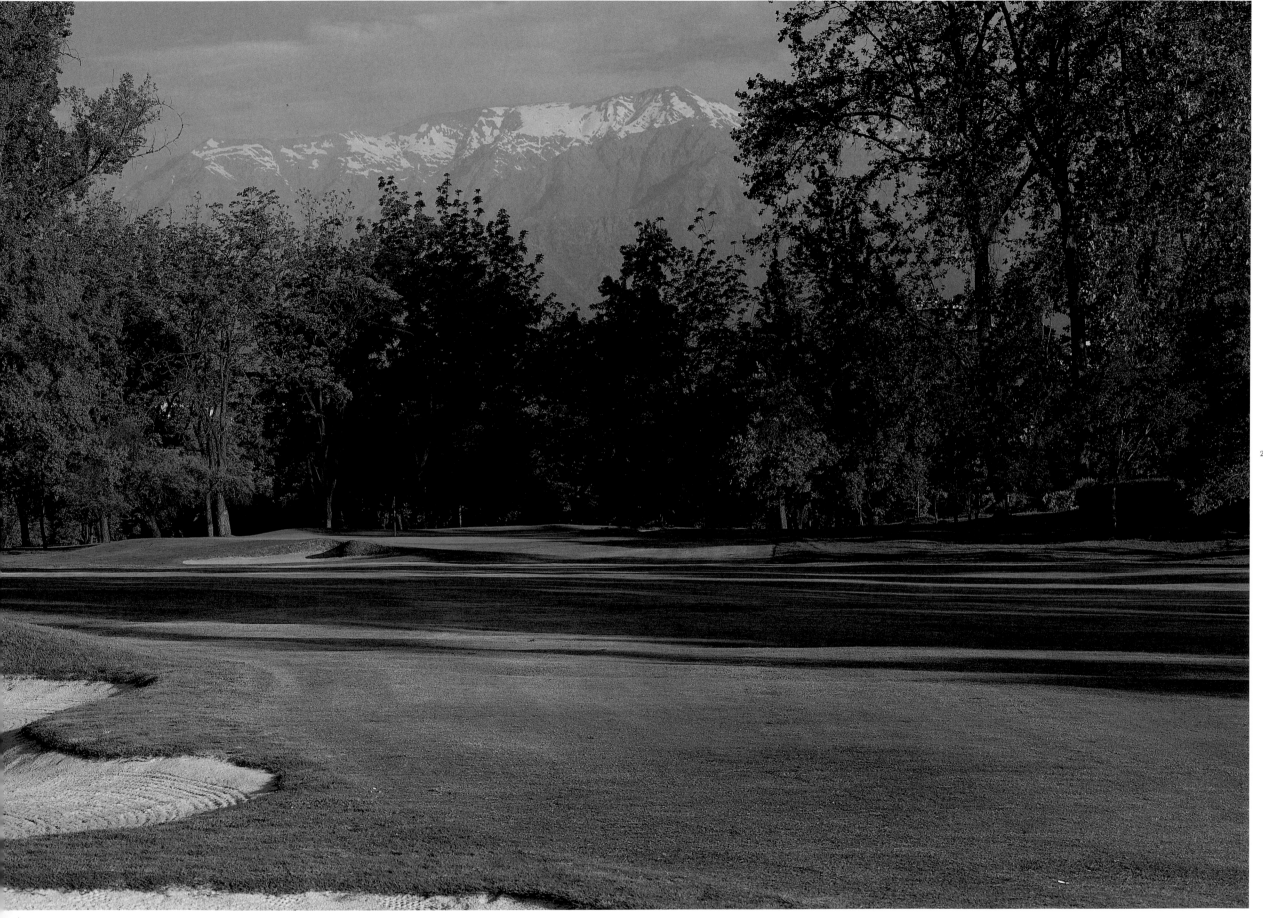

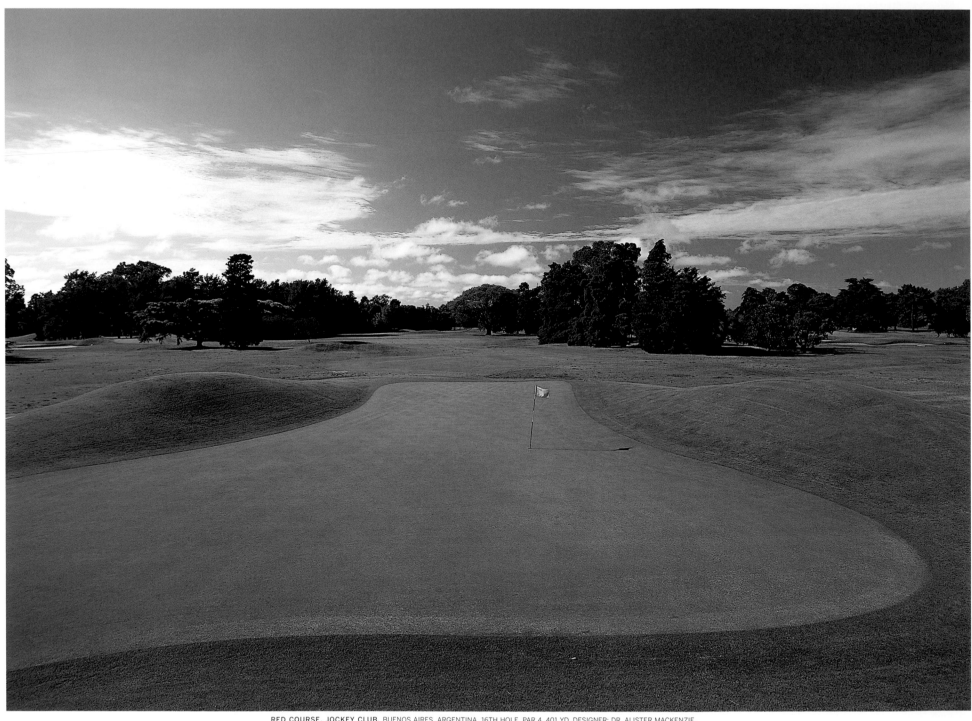

RED COURSE, JOCKEY CLUB, BUENOS AIRES, ARGENTINA. 16TH HOLE, PAR 4, 401 YD. DESIGNER: DR. ALISTER MACKENZIE.

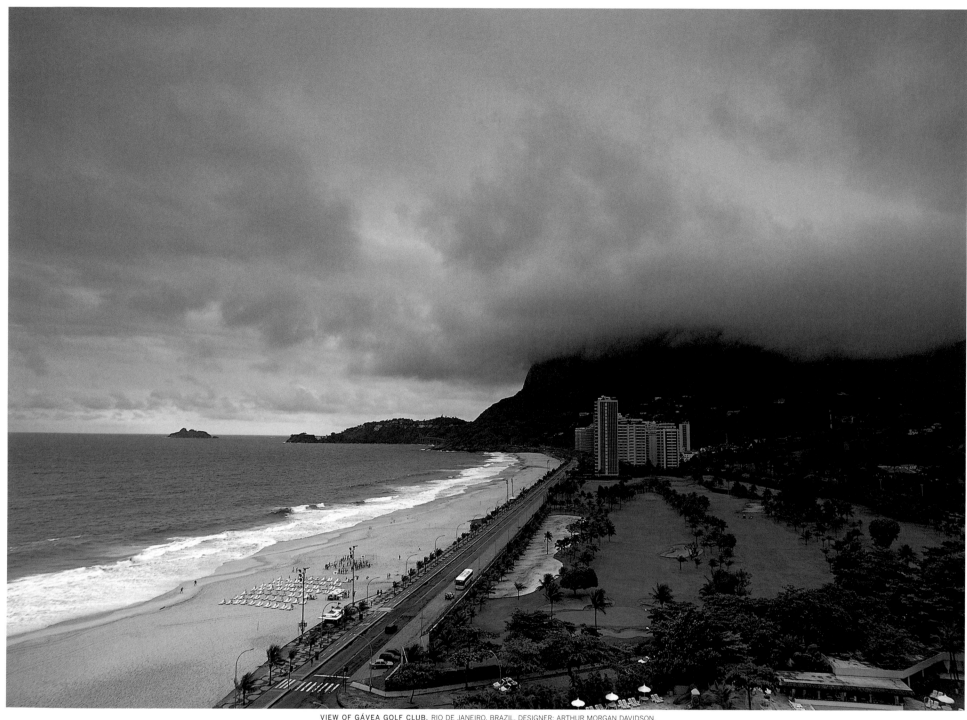

VIEW OF GÁVEA GOLF CLUB, RIO DE JANEIRO, BRAZIL. DESIGNER: ARTHUR MORGAN DAVIDSON.

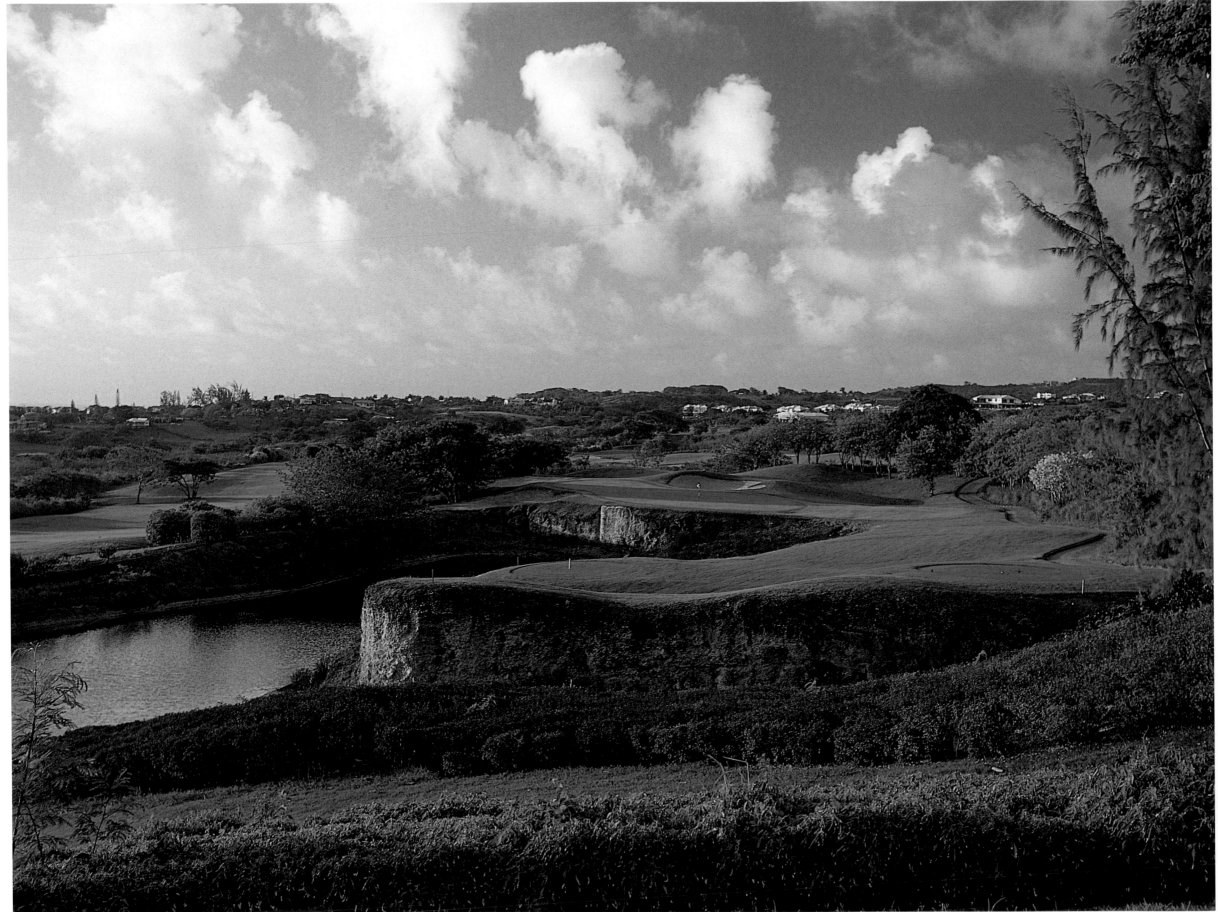

214

ROYAL WESTMORELAND, ST. JAMES, BARBADOS. 7TH HOLE, PAR 3, 161 YD. DESIGNER: ROBERT TRENT JONES, JR.

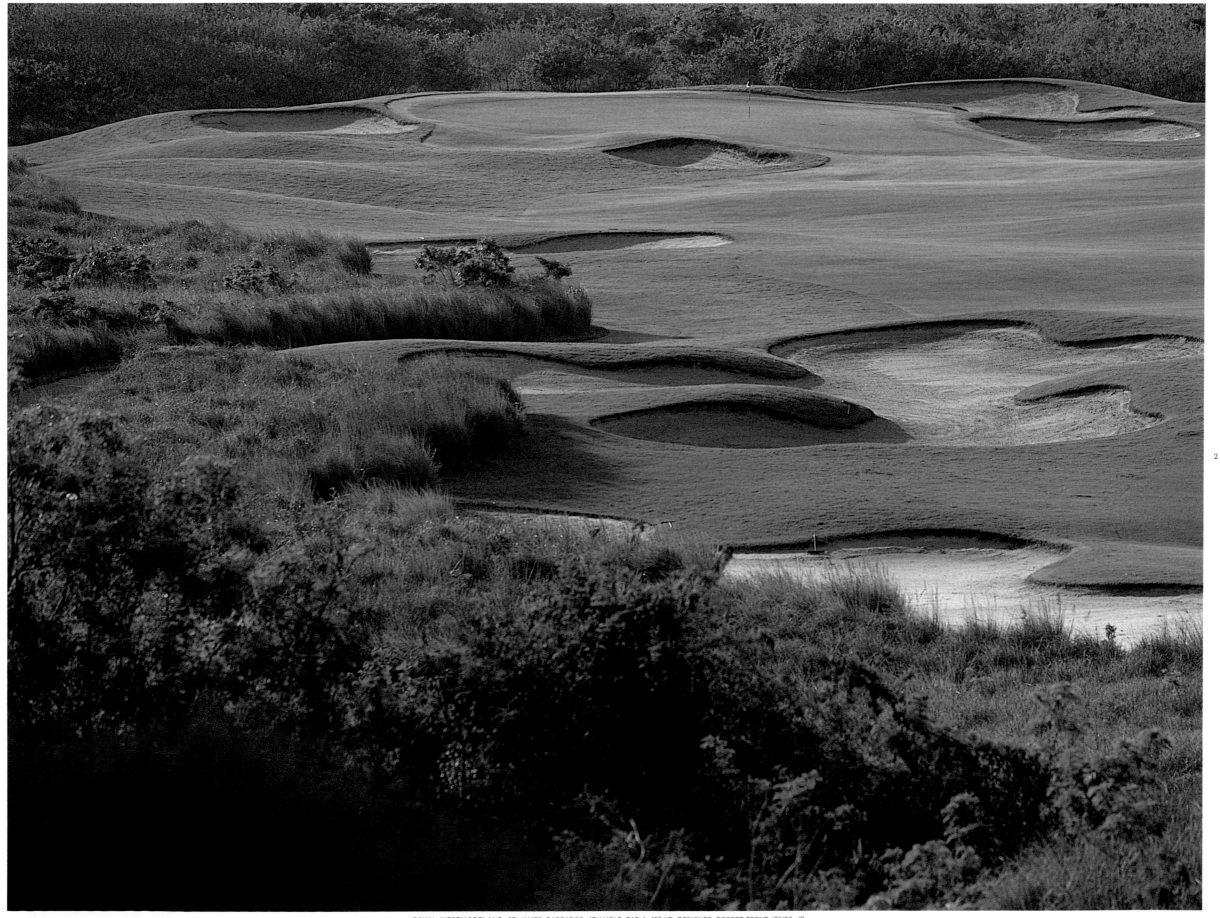

215

ROYAL WESTMORELAND, ST. JAMES, BARBADOS. 4TH HOLE, PAR 4, 455 YD. DESIGNER: ROBERT TRENT JONES, JR.

6

MIDDLE EAST AND AFRICA

DUBAI CREEK, EMIRATES GOLF CLUB, FANCOURT COUNTRY CLUB ESTATE, ONE&ONLY LE TOUESSROK, LEOPARD CREEK

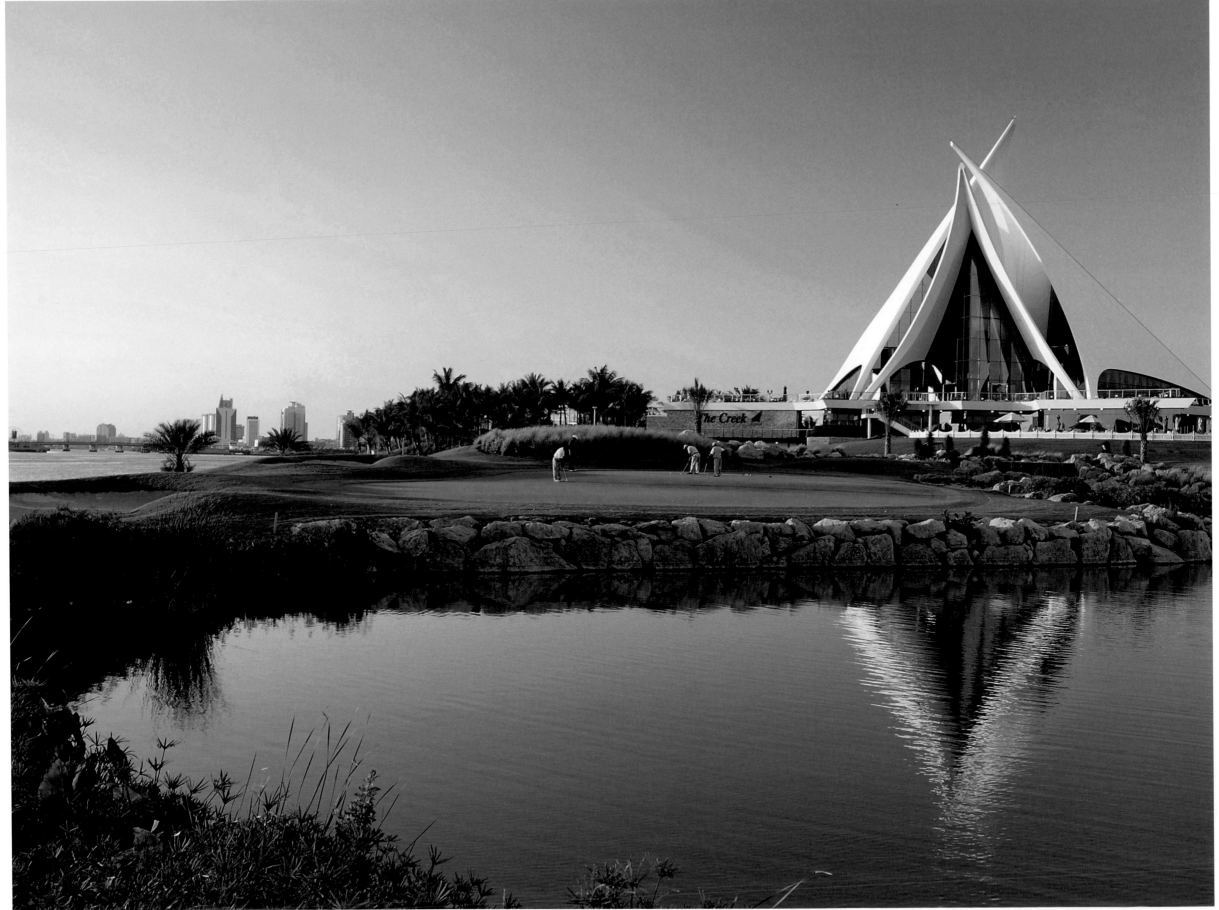

DUBAI CREEK GOLF AND YACHT CLUB, DUBAI, UNITED ARAB EMIRATES. 18TH HOLE, PAR 4, 424 YD. DESIGNERS: KARL LITTEN, THOMAS BJORN.

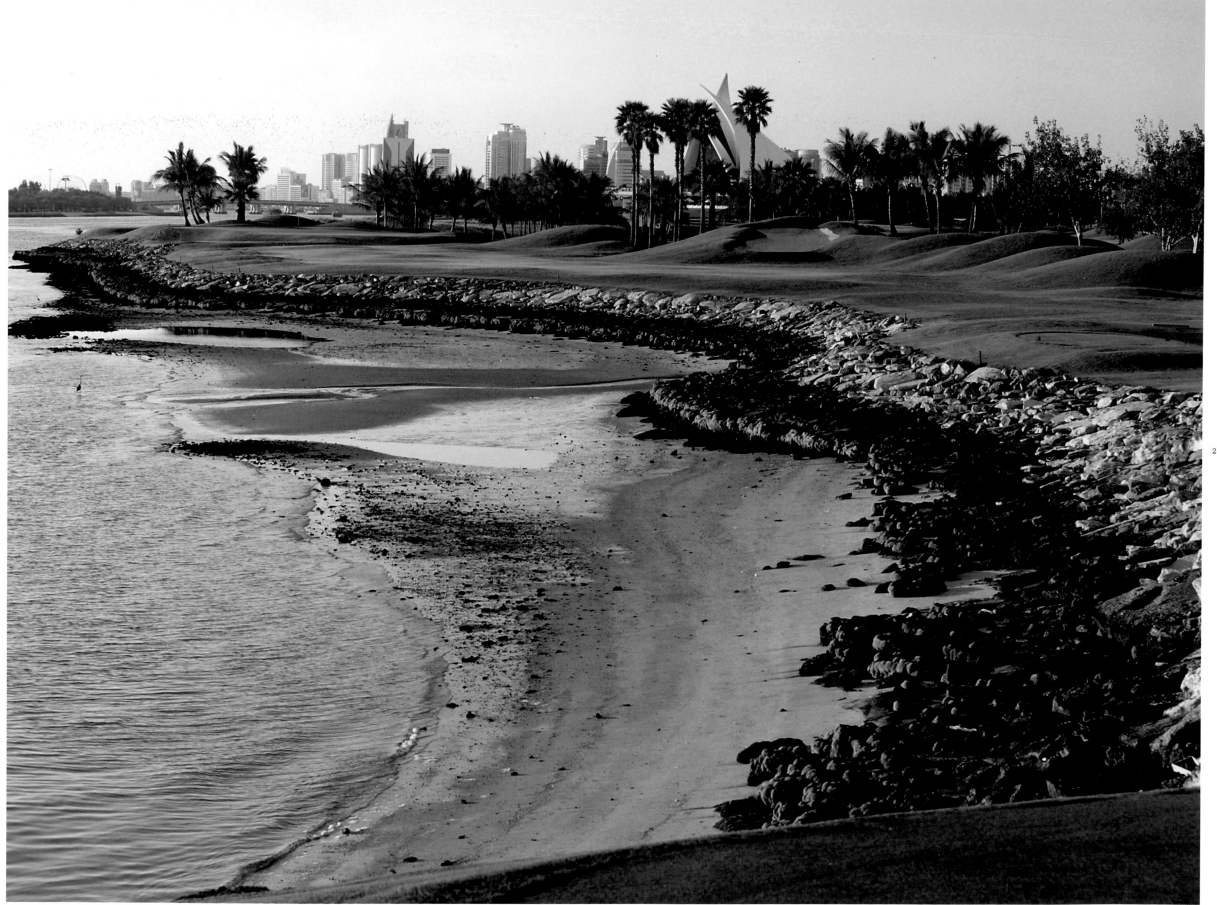

ABOVE: **DUBAI CREEK GOLF AND YACHT CLUB**, DUBAI, UNITED ARAB EMIRATES. 17TH HOLE, PAR 4, 354 YD. DESIGNERS: KARL LITTEN, THOMAS BJORN. FOLLOWING PAGES, 220–221: **MAJLIS COURSE, EMIRATES GOLF CLUB**, DUBAI, UNITED ARAB EMIRATES. 8TH HOLE, PAR 4, 434 YD. DESIGNER: KARL LITTEN.

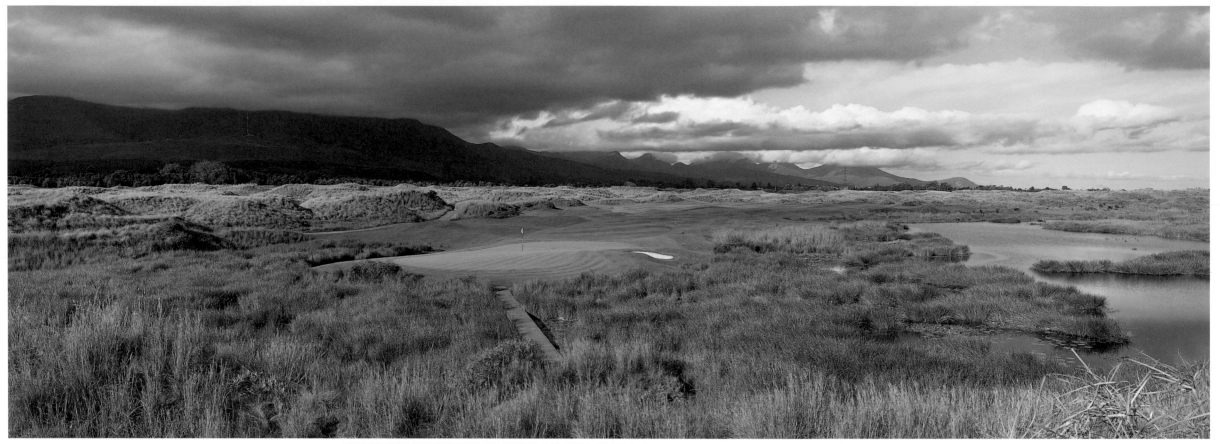

ABOVE AND BELOW: **FANCOURT HOTEL AND COUNTRY CLUB ESTATE**, GEORGE, SOUTH AFRICA. 15TH HOLE, PAR 4, 465 YD. DESIGNER: GARY PLAYER.

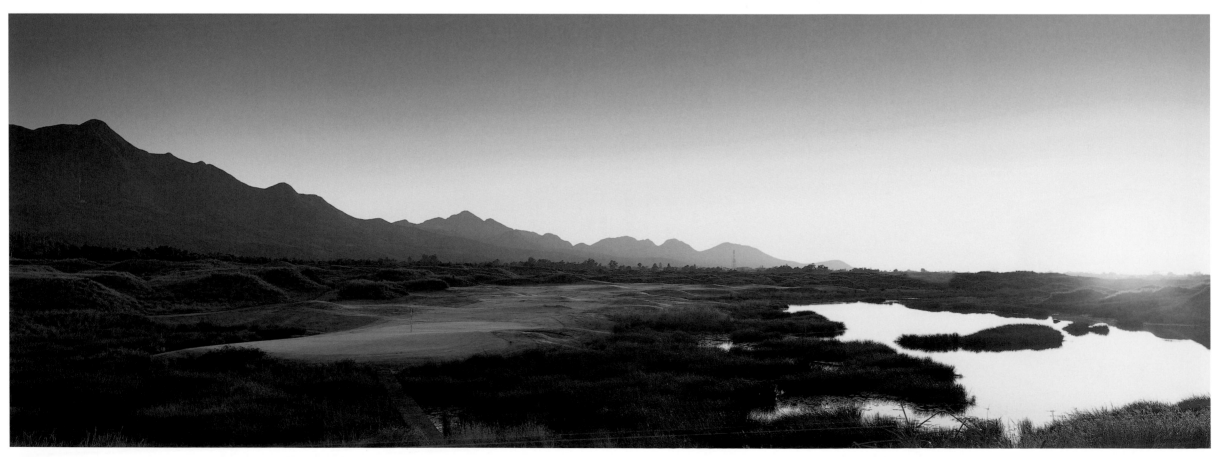

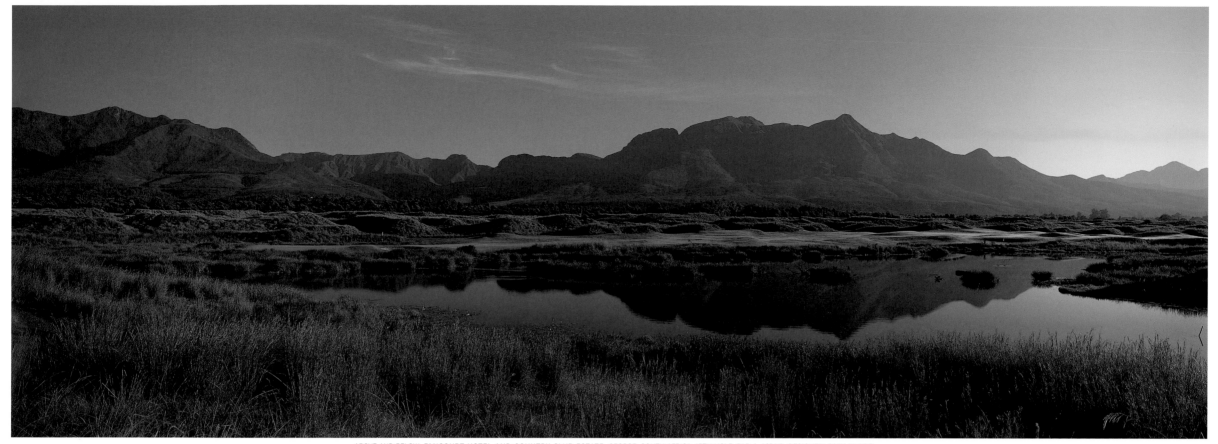

ABOVE AND BELOW: **FANCOURT HOTEL AND COUNTRY CLUB ESTATE,** GEORGE, SOUTH AFRICA. 15TH HOLE, PAR 4, 465 YD. DESIGNER: GARY PLAYER.

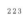

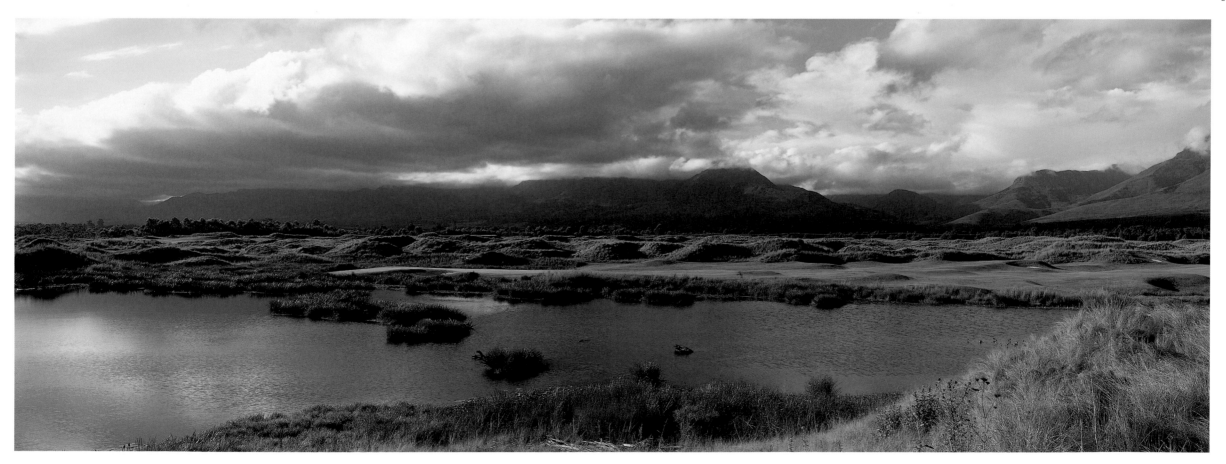

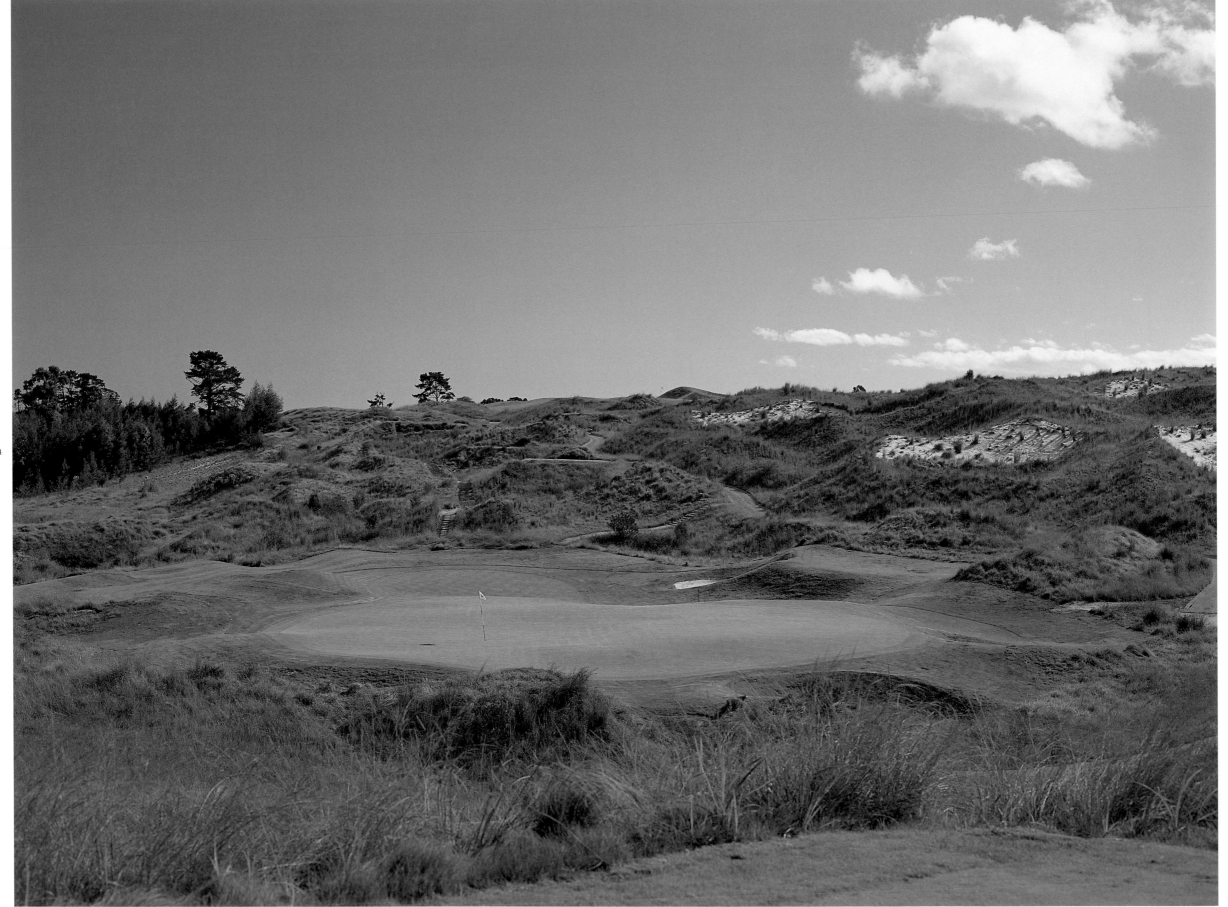

224

FANCOURT HOTEL AND COUNTRY CLUB ESTATE, GEORGE, SOUTH AFRICA. 2ND HOLE, PAR 3, 237 YD. DESIGNER: GARY PLAYER.

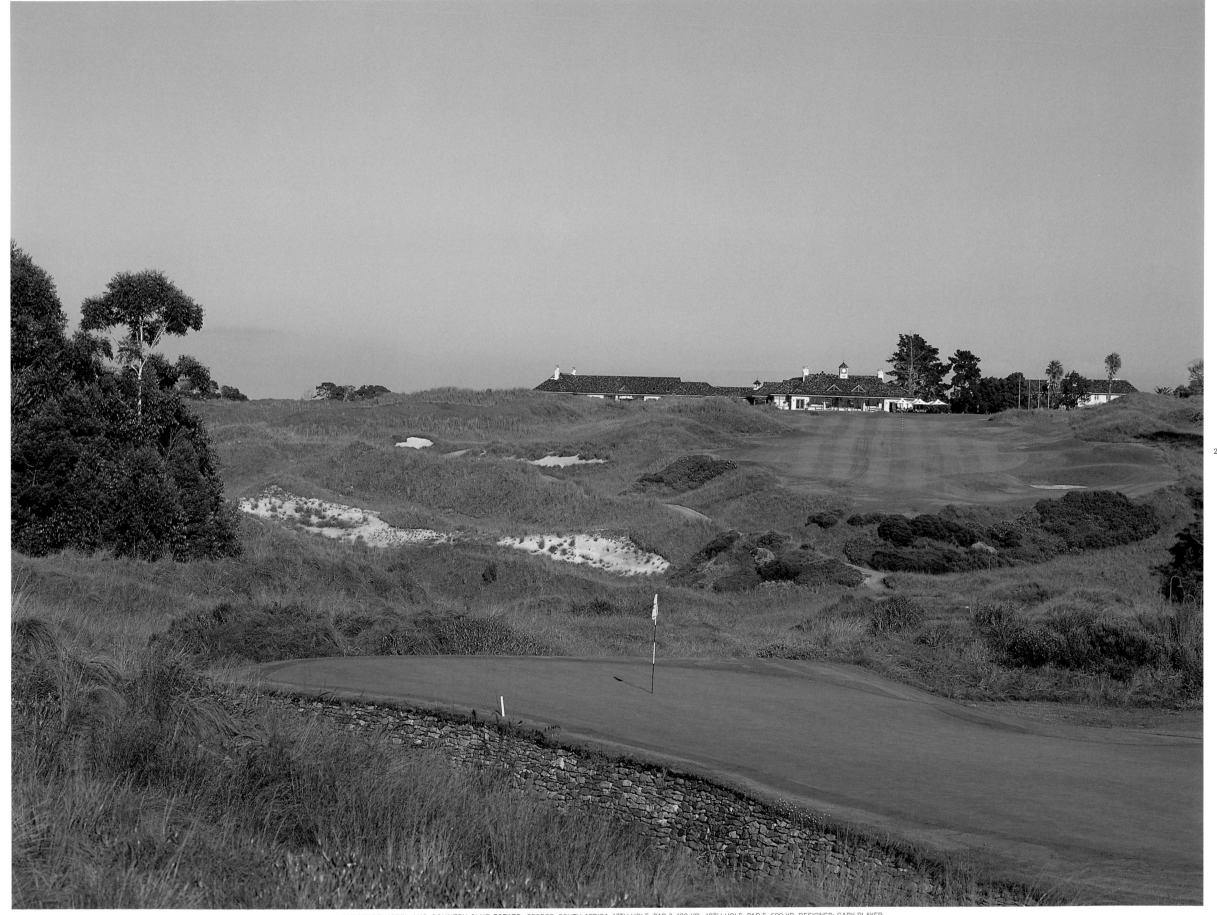

FANCOURT HOTEL AND COUNTRY CLUB ESTATE, GEORGE, SOUTH AFRICA. 17TH HOLE, PAR 3, 199 YD.; 18TH HOLE, PAR 5, 609 YD. DESIGNER: GARY PLAYER.

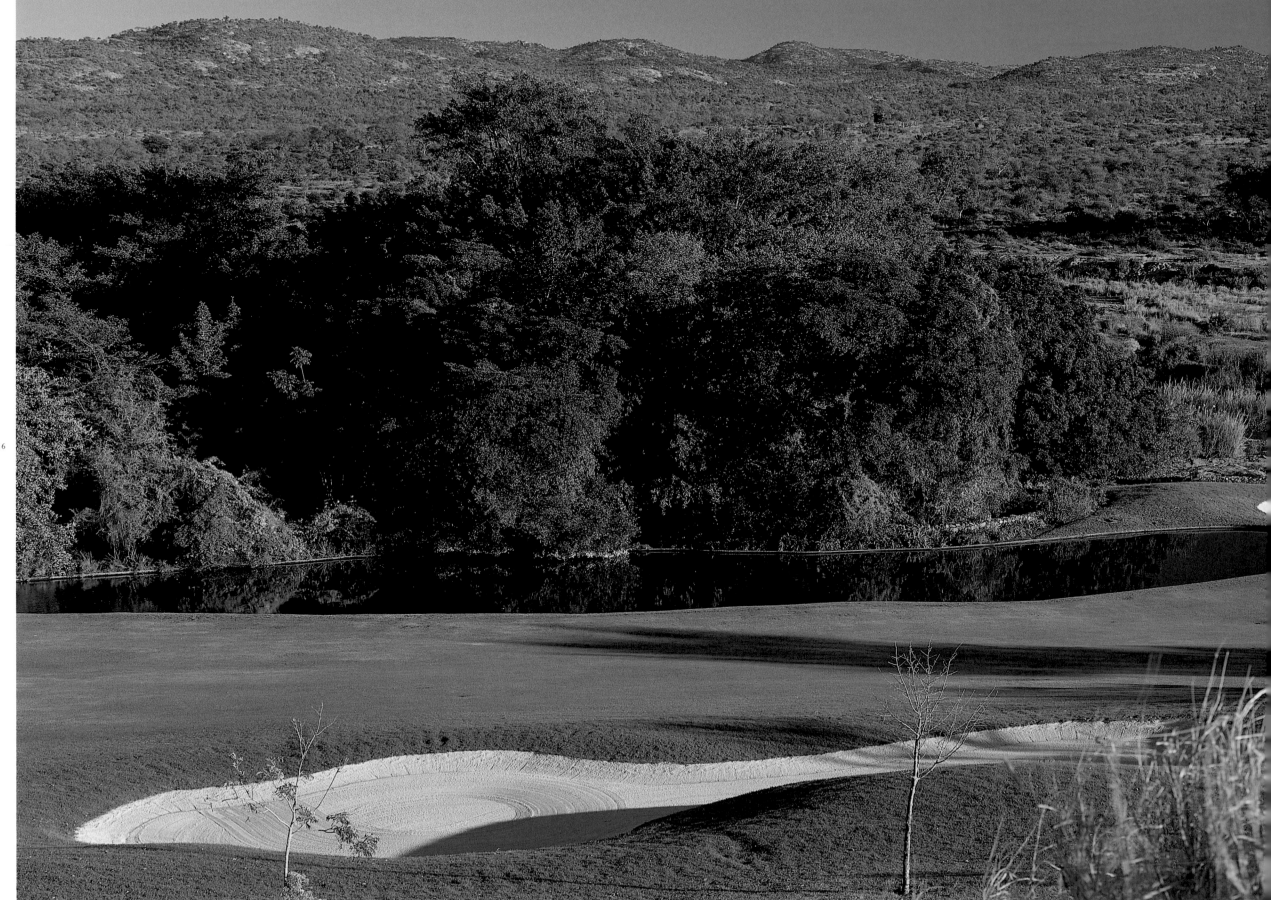

226

LEOPARD CREEK COUNTRY CLUB, MALELANE, MPUMALANGA, SOUTH AFRICA. 13TH HOLE, PAR 5, 505 YD. DESIGNER: GARY PLAYER.

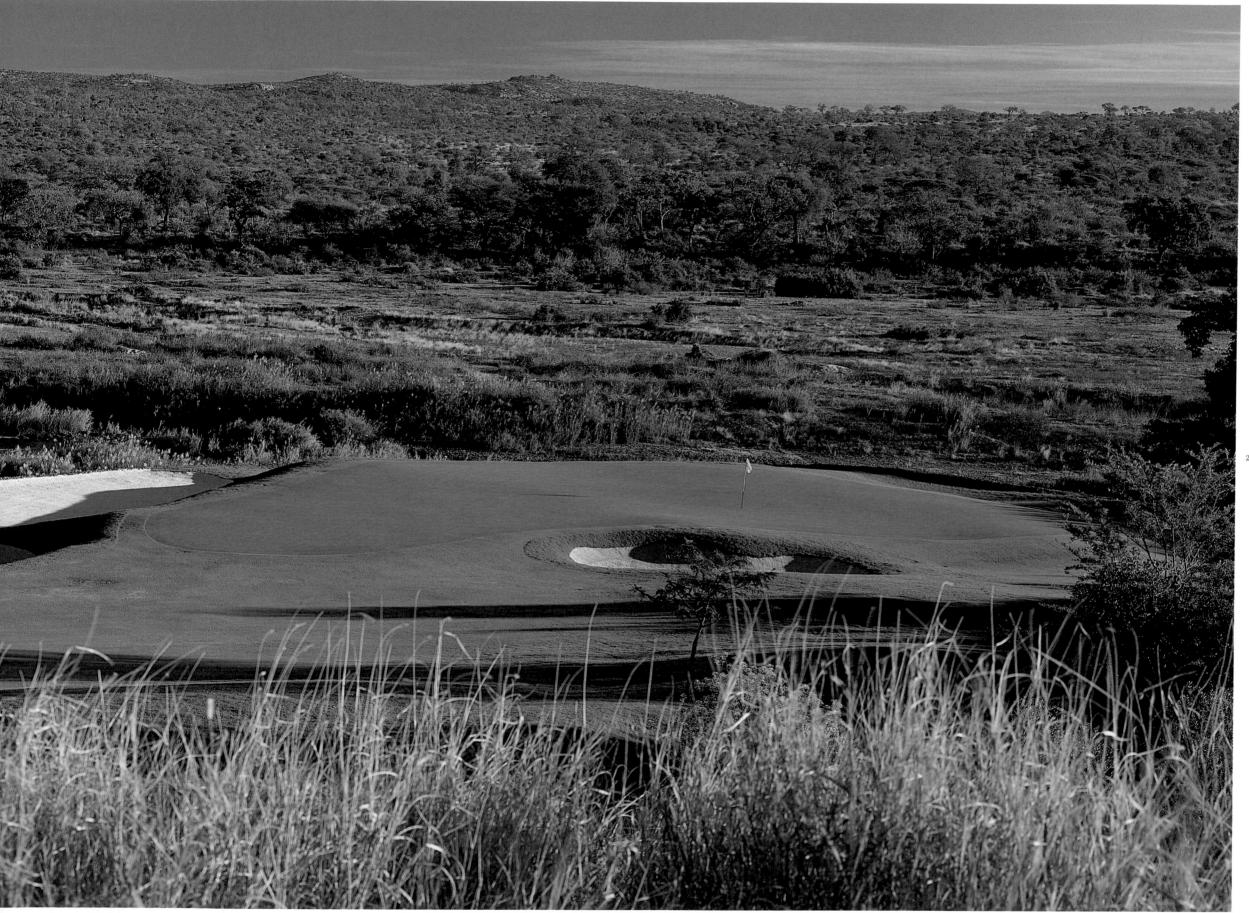

228

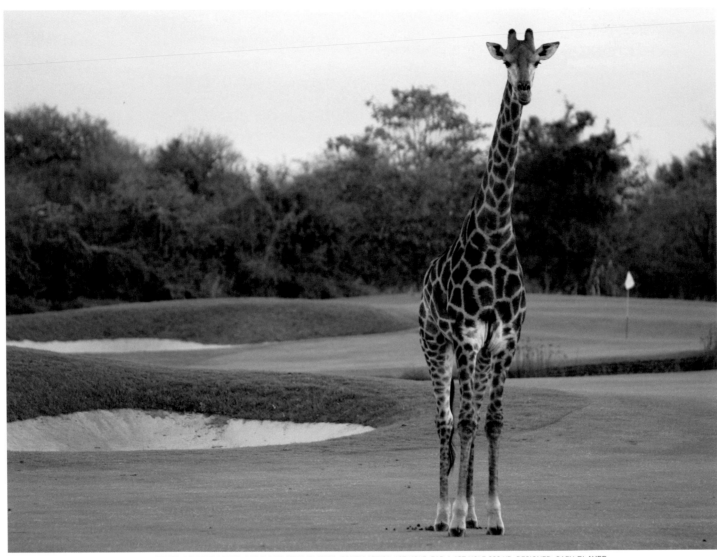

LEOPARD CREEK COUNTRY CLUB, MALELANE, MPUMALANGA, SOUTH AFRICA. 1ST HOLE, PAR 4, 1ST HOLE 383 YD. DESIGNER: GARY PLAYER.

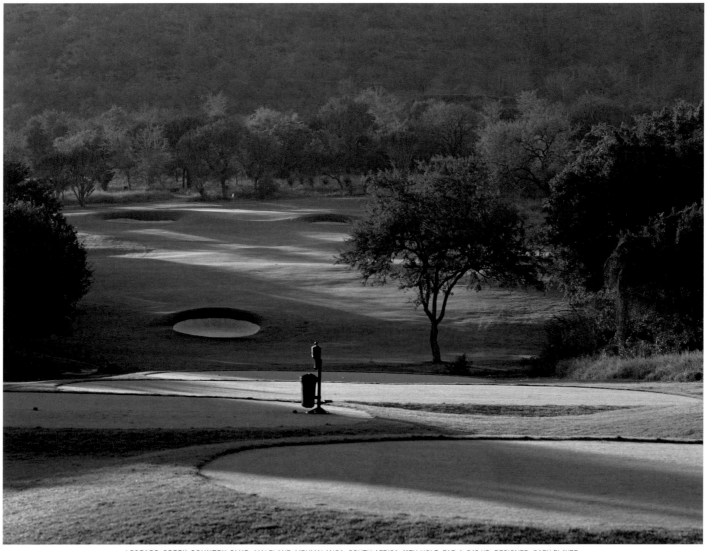

LEOPARD CREEK COUNTRY CLUB, MALELANE, MPUMALANGA, SOUTH AFRICA. 11TH HOLE, PAR 4, 343 YD. DESIGNER: GARY PLAYER.
FOLLOWING PAGES, 230-231: **LEOPARD CREEK COUNTRY CLUB,** MALELANE, MPUMALANGA, SOUTH AFRICA. 9TH HOLE (LEFT),
PAR 5, 492 YD.; 18TH HOLE (RIGHT), PAR 4, 435 YD. DESIGNER: GARY PLAYER.

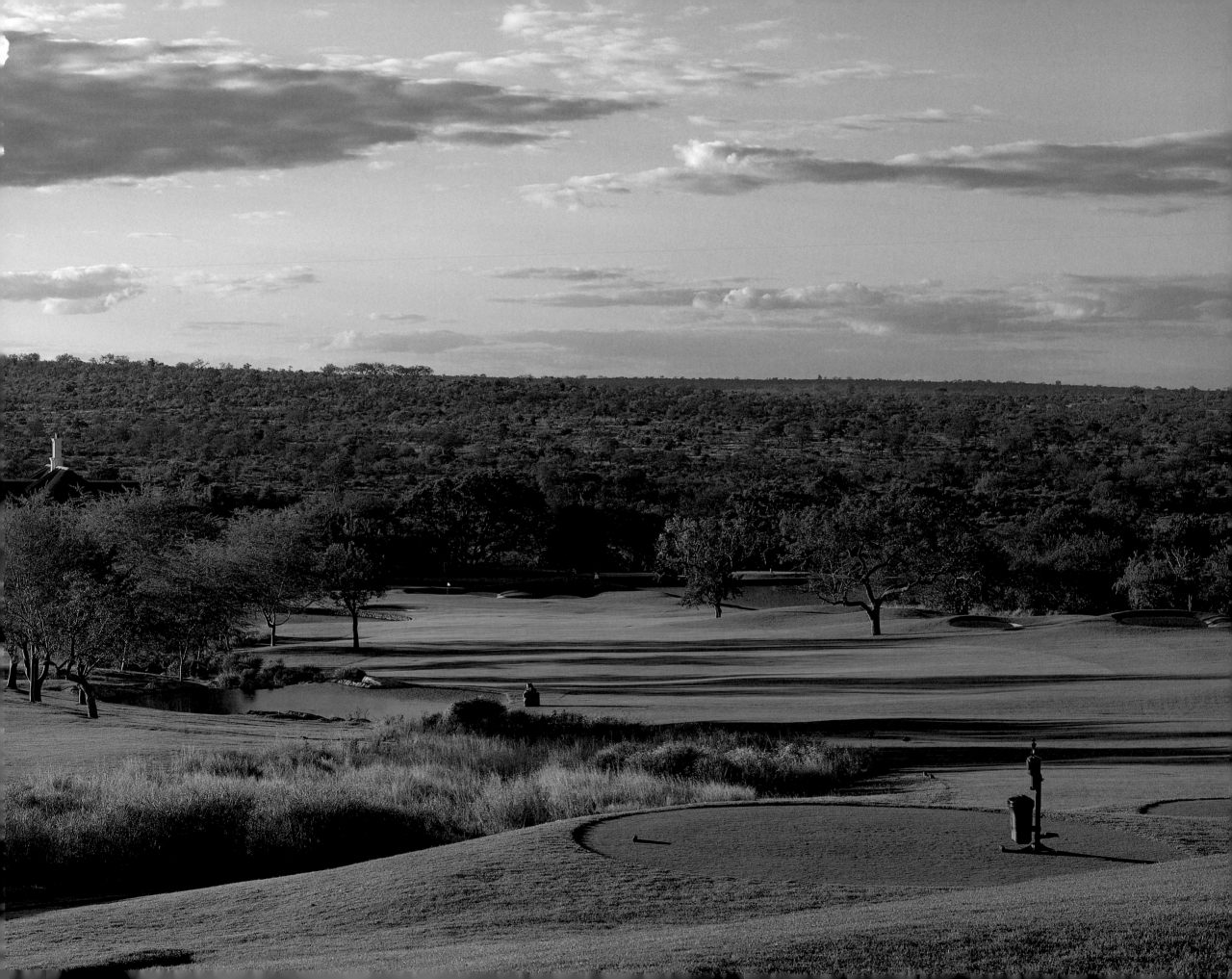

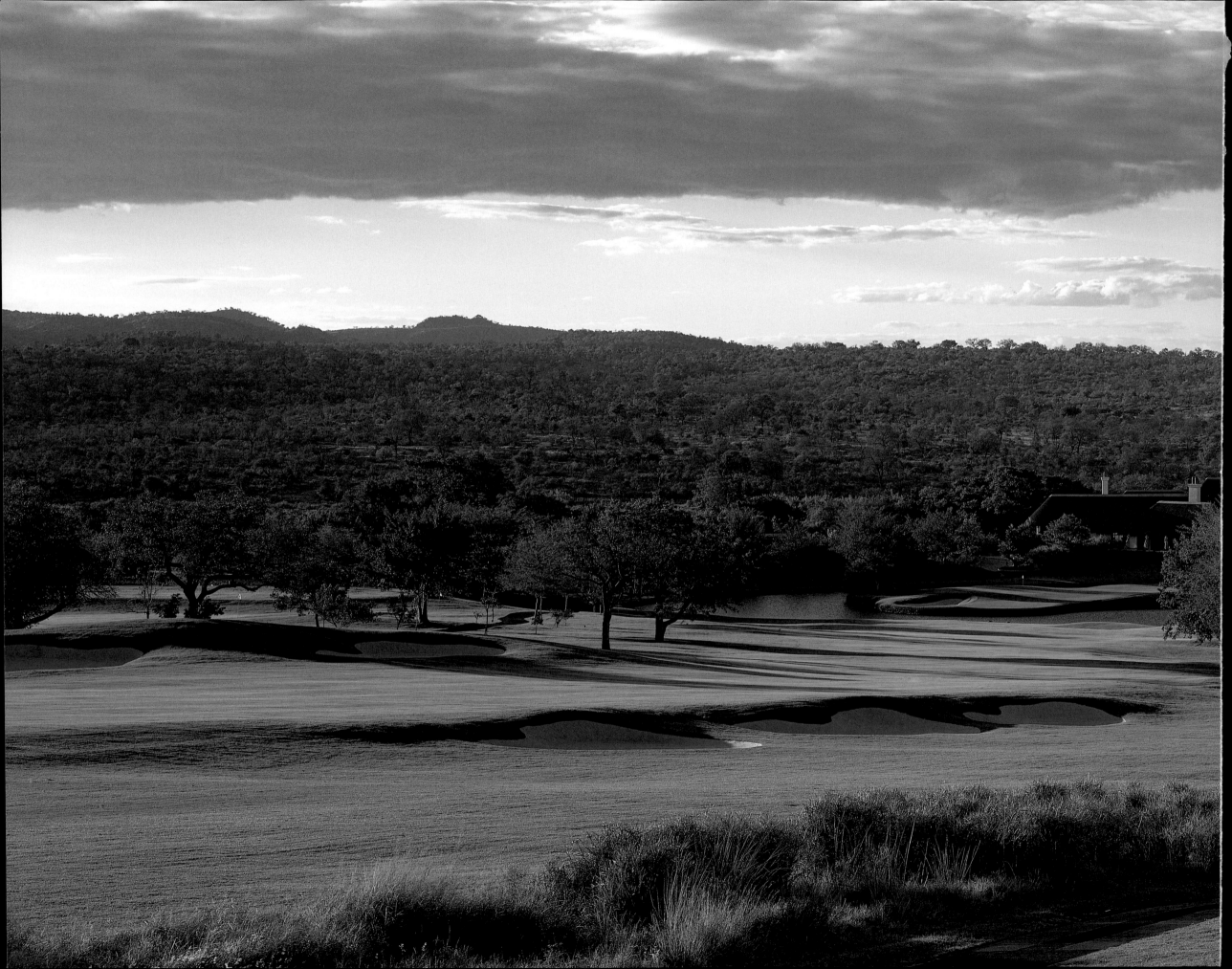

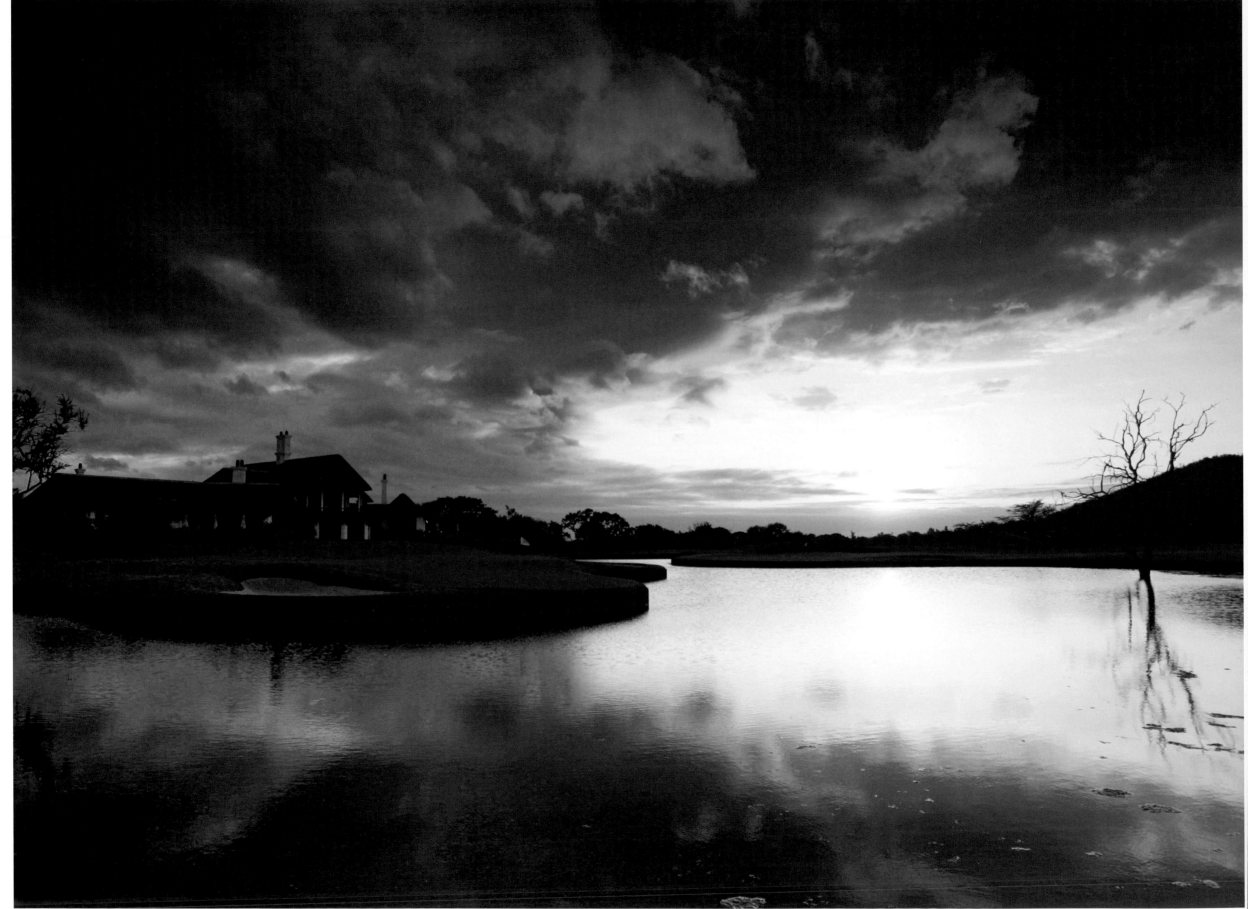

232

LEOPARD CREEK COUNTRY CLUB, MALELANE, MPUMALANGA, SOUTH AFRICA. 9TH HOLE, PAR 5, 492 YD. DESIGNER: GARY PLAYER.

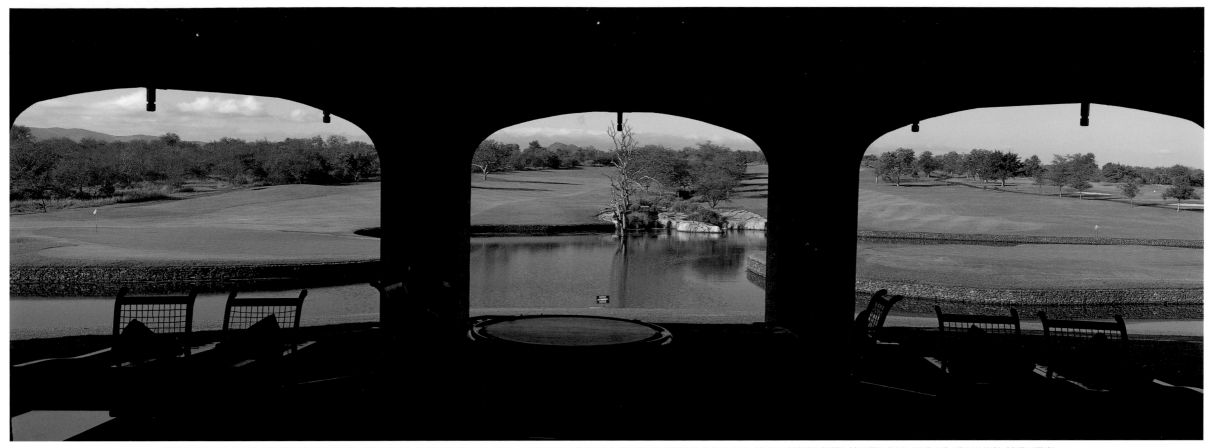

ABOVE: **LEOPARD CREEK COUNTRY CLUB,** MALELANE, MPUMALANGA, SOUTH AFRICA. VIEW OF 18TH AND 9TH GREENS, AND THE CLUBHOUSE. DESIGNER: GARY PLAYER. BELOW: **LEOPARD CREEK COUNTRY CLUB,** MALELANE, MPUMALANGA, SOUTH AFRICA. VIEW OF 9TH AND 18TH GREENS TOWARD THE CLUBHOUSE. DESIGNER: GARY PLAYER.

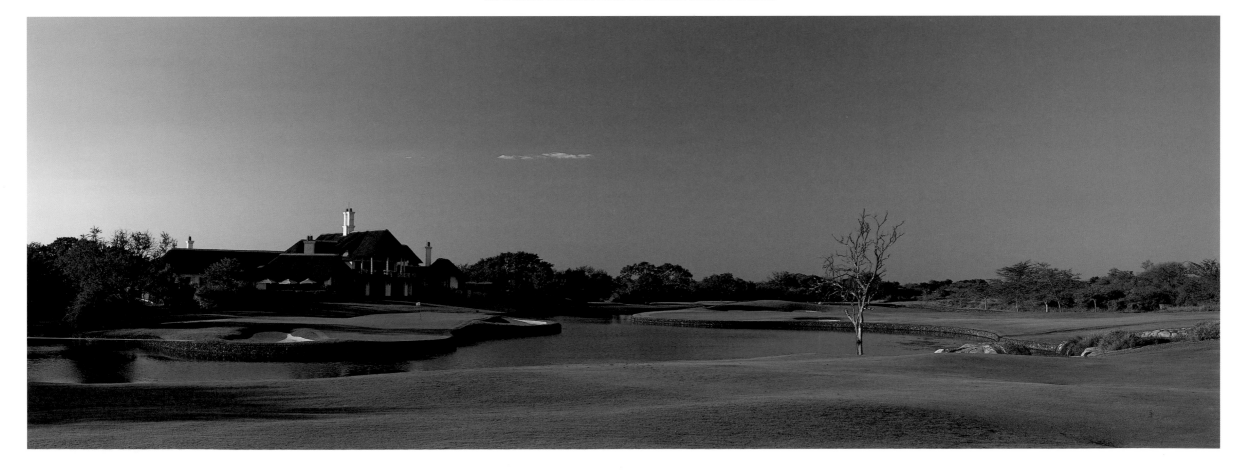

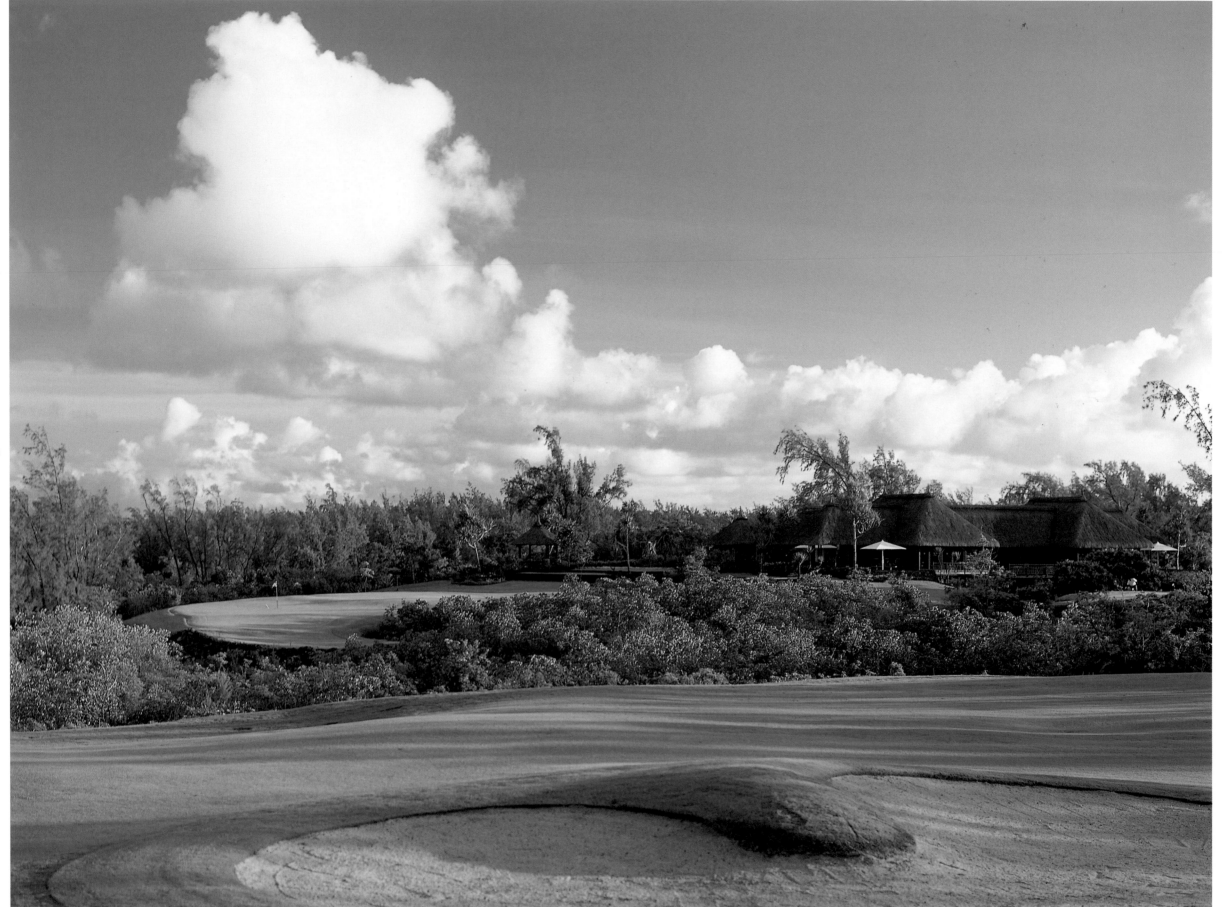

234

ONE&ONLY LE TOUESSROK, ILE AUX CERFS ISLAND, TROU D'EAU DOUCE, MAURITIUS. 18TH HOLE, PAR 4, 420 YD. DESIGNER: BERNHARD LANGER.

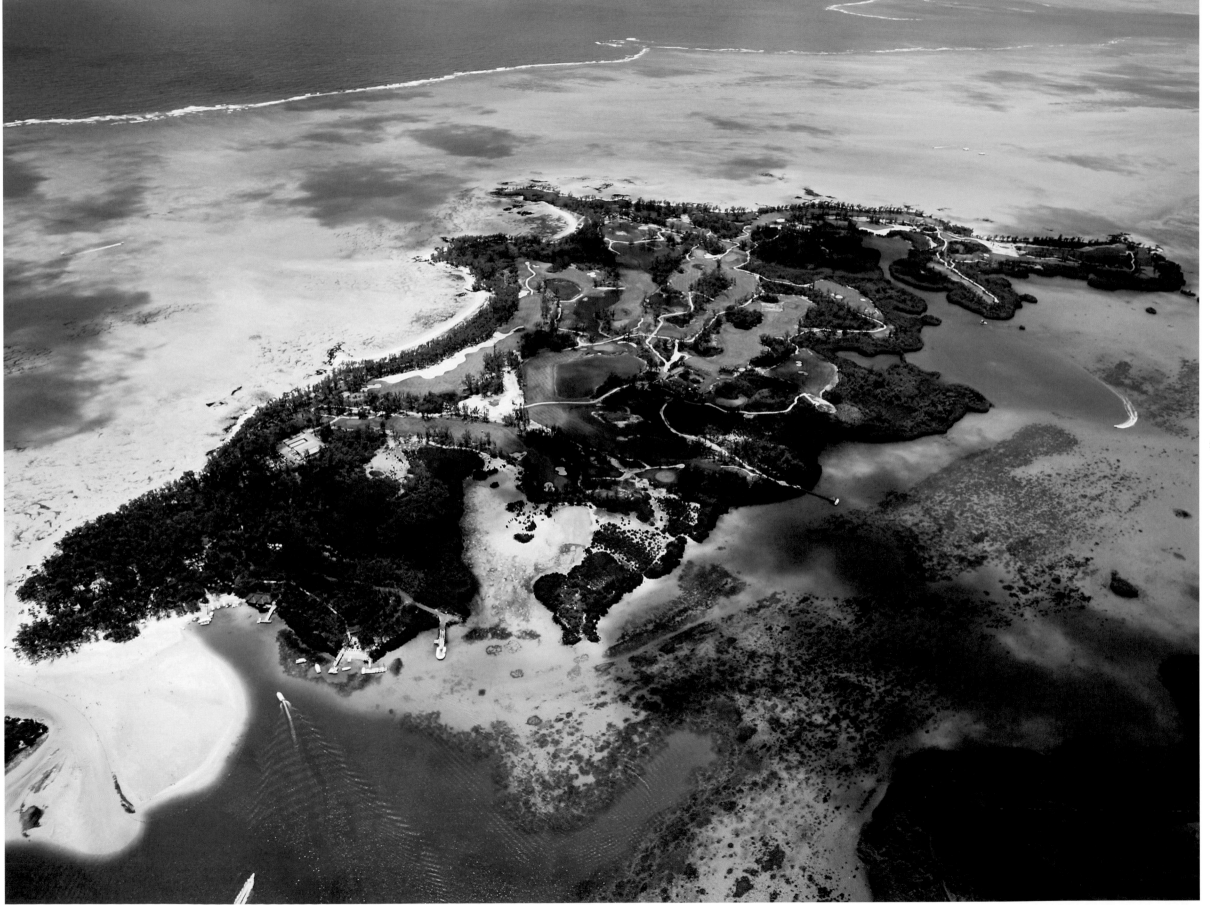

ONE&ONLY LE TOUESSROK, ILE AUX CERFS ISLAND, TROU D'EAU DOUCE, MAURITIUS. AERIAL VIEW OF THE GOLF COURSE. DESIGNER: BERNHARD LANGER.

7

NEW ZEALAND AND AUSTRALIA

CAPE KIDNAPPERS, KAURI CLIFFS, KINGSTON HEATH, LAKE KARRINYUP, NEW SOUTH WALES, PARAPARAUMU BEACH, ROYAL MELBOURNE

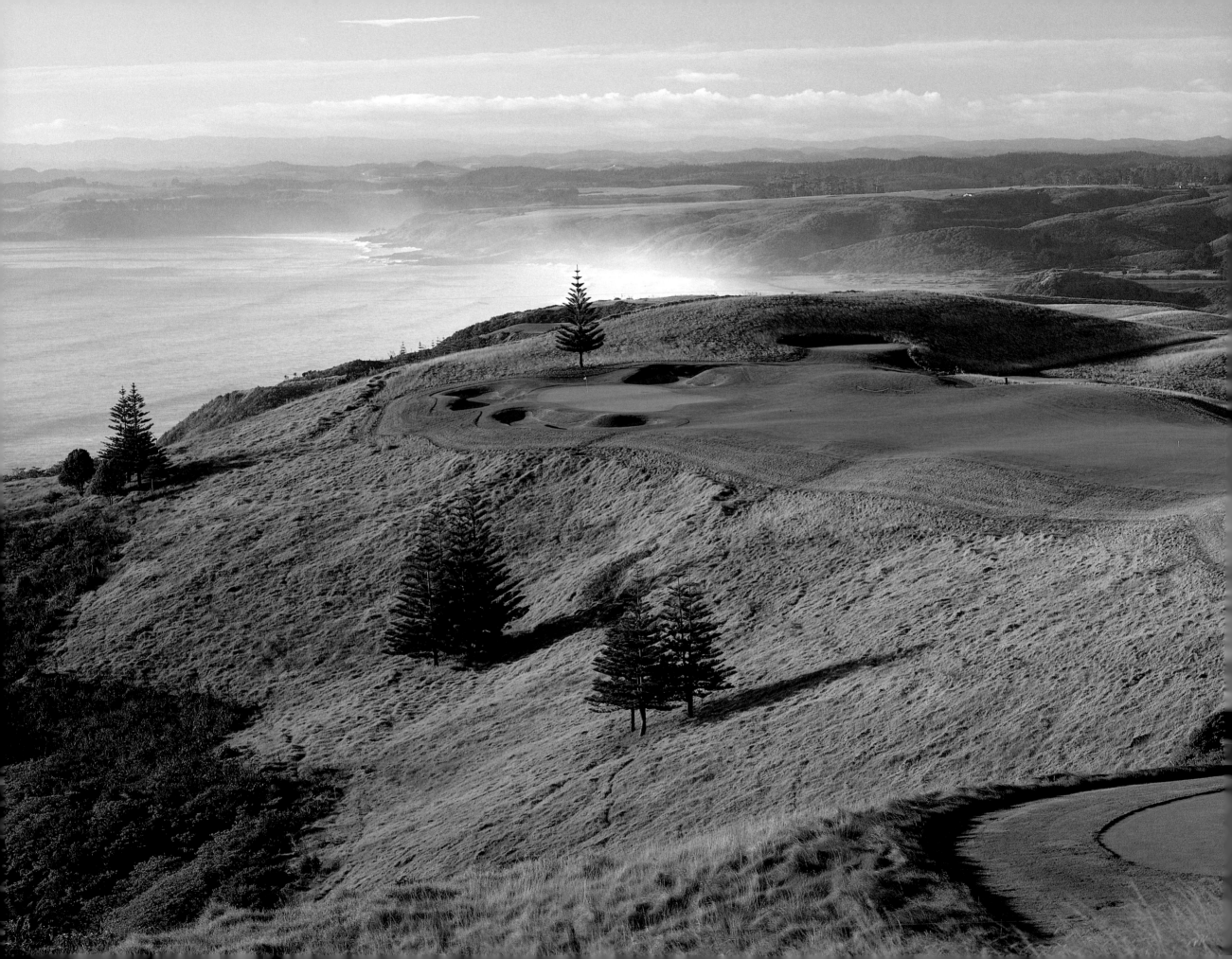

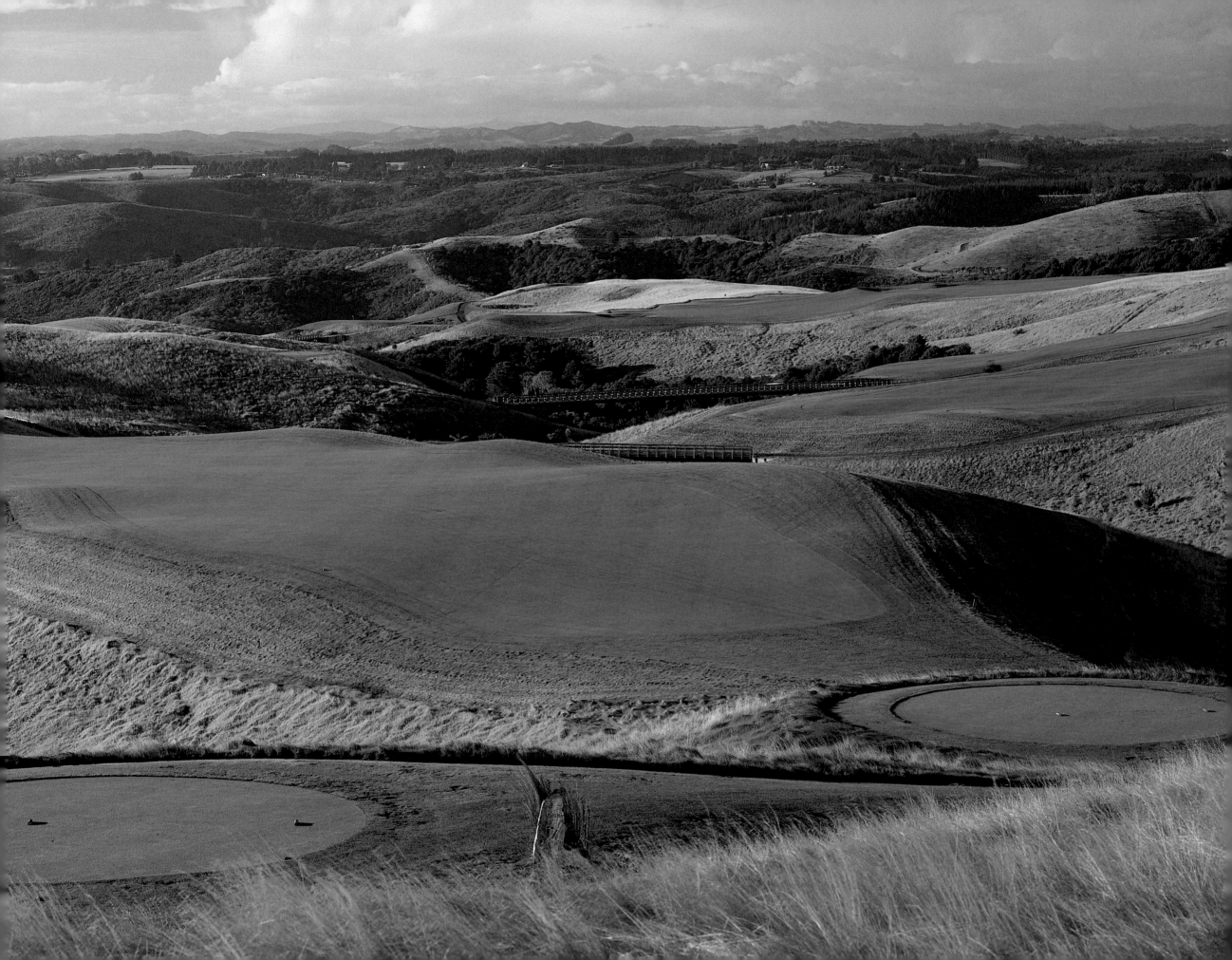

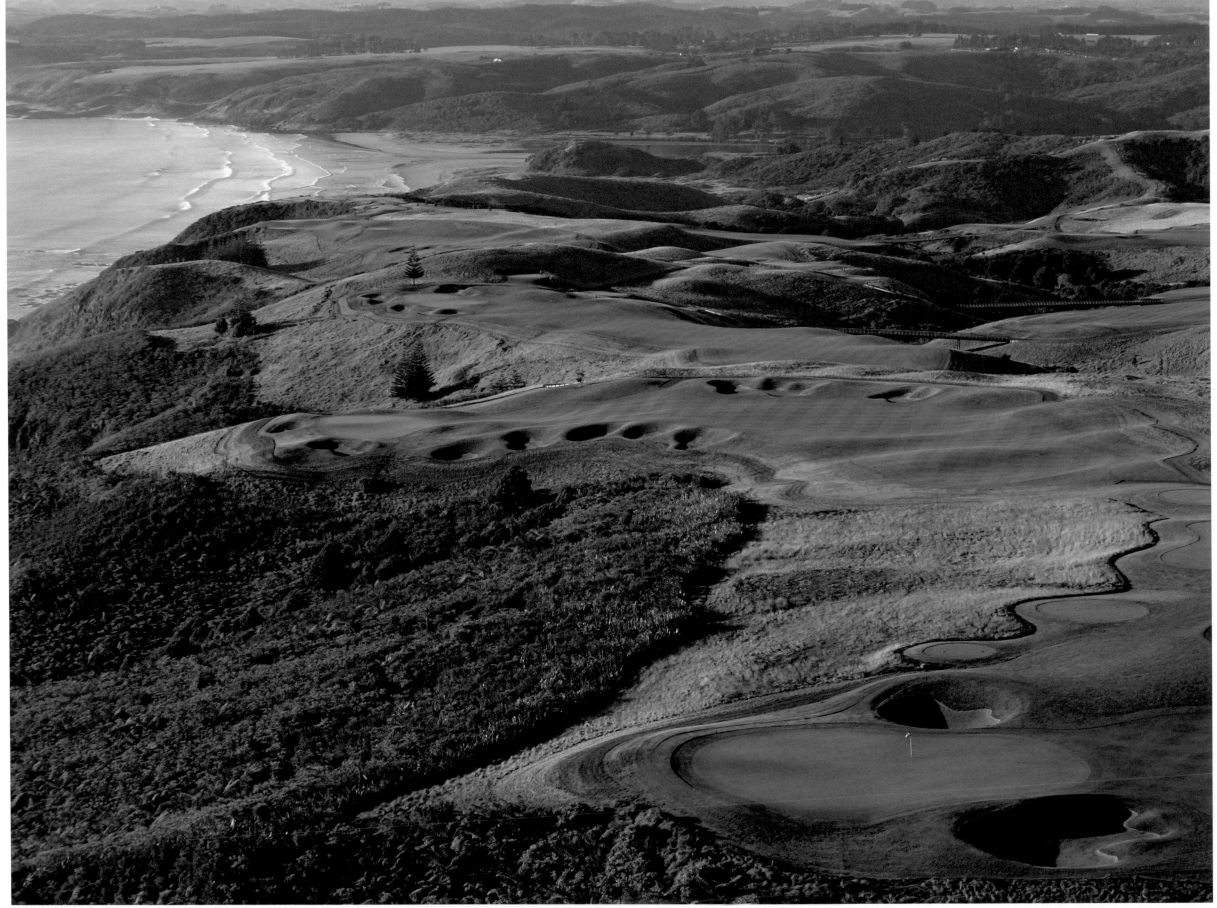

240

PREVIOUS PAGES, 238–239: **KAURI CLIFFS**, MATAURI BAY, NORTHLAND, NEW ZEALAND. 17TH HOLE, PAR 4, 472 YD. DESIGNER: DAVID HARMAN. ABOVE: **KAURI CLIFFS**, MATAURI BAY, NORTHLAND, NEW ZEALAND. 16TH HOLE, PAR 4, 369 YD. DESIGNER: DAVID HARMAN.

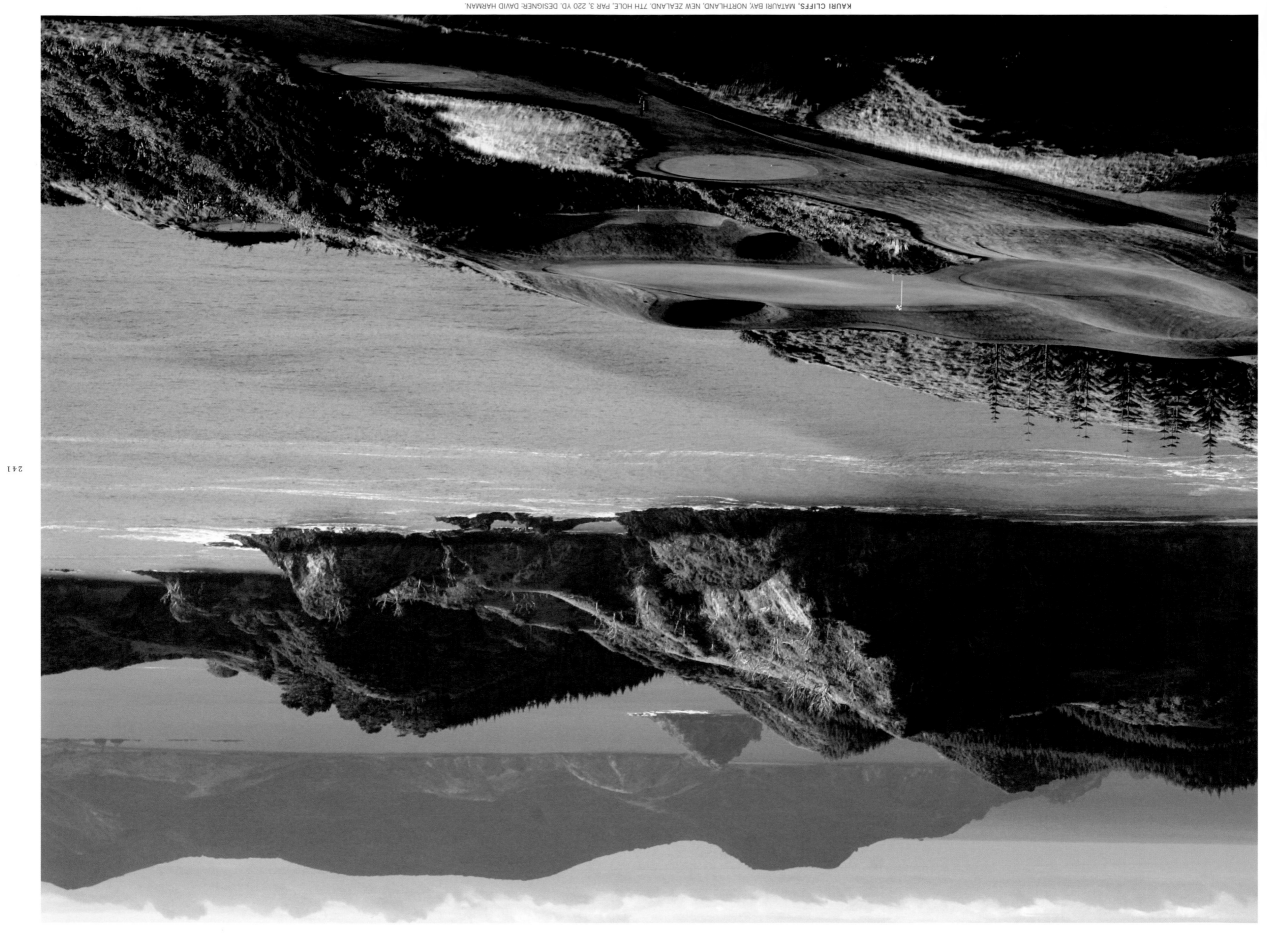

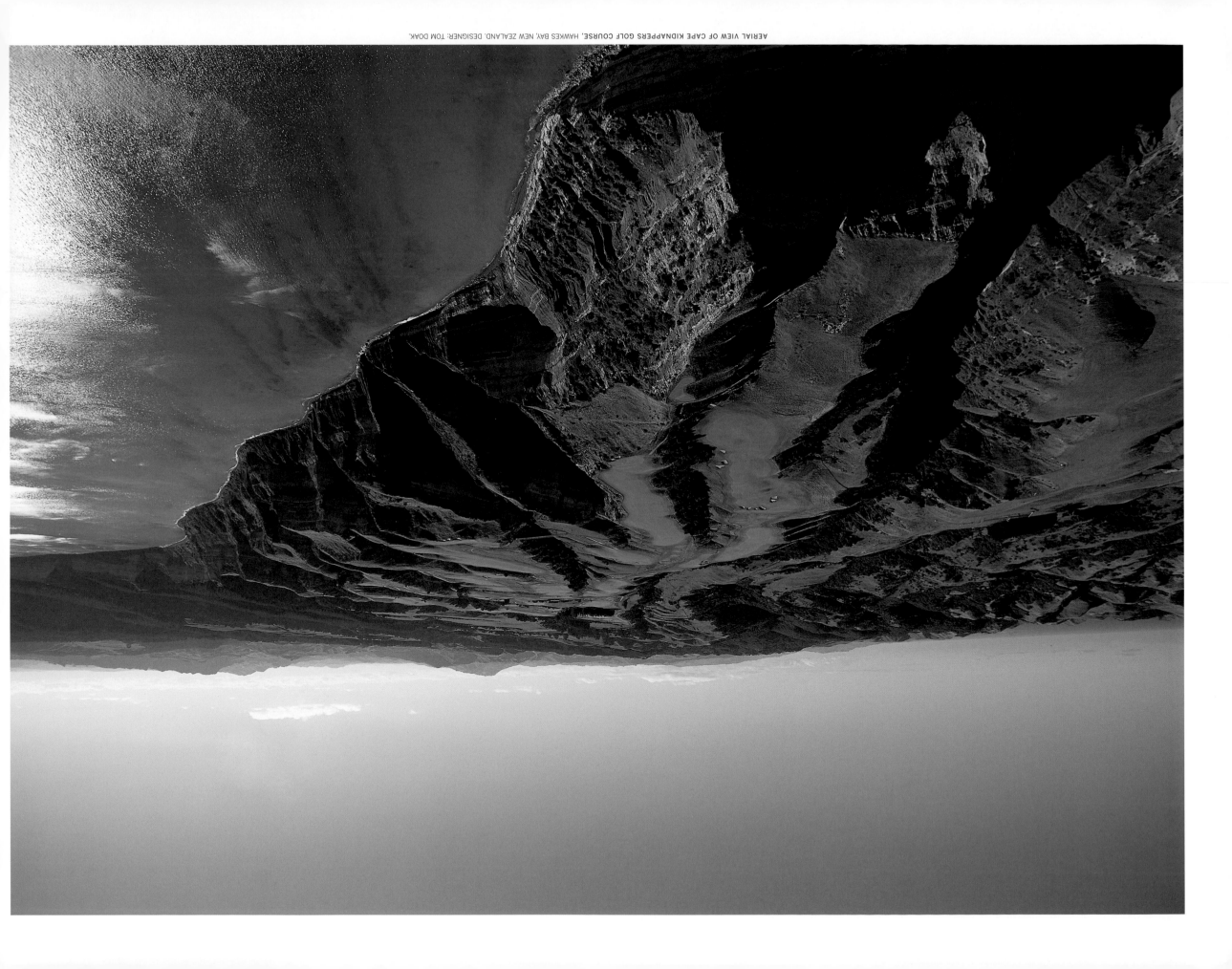

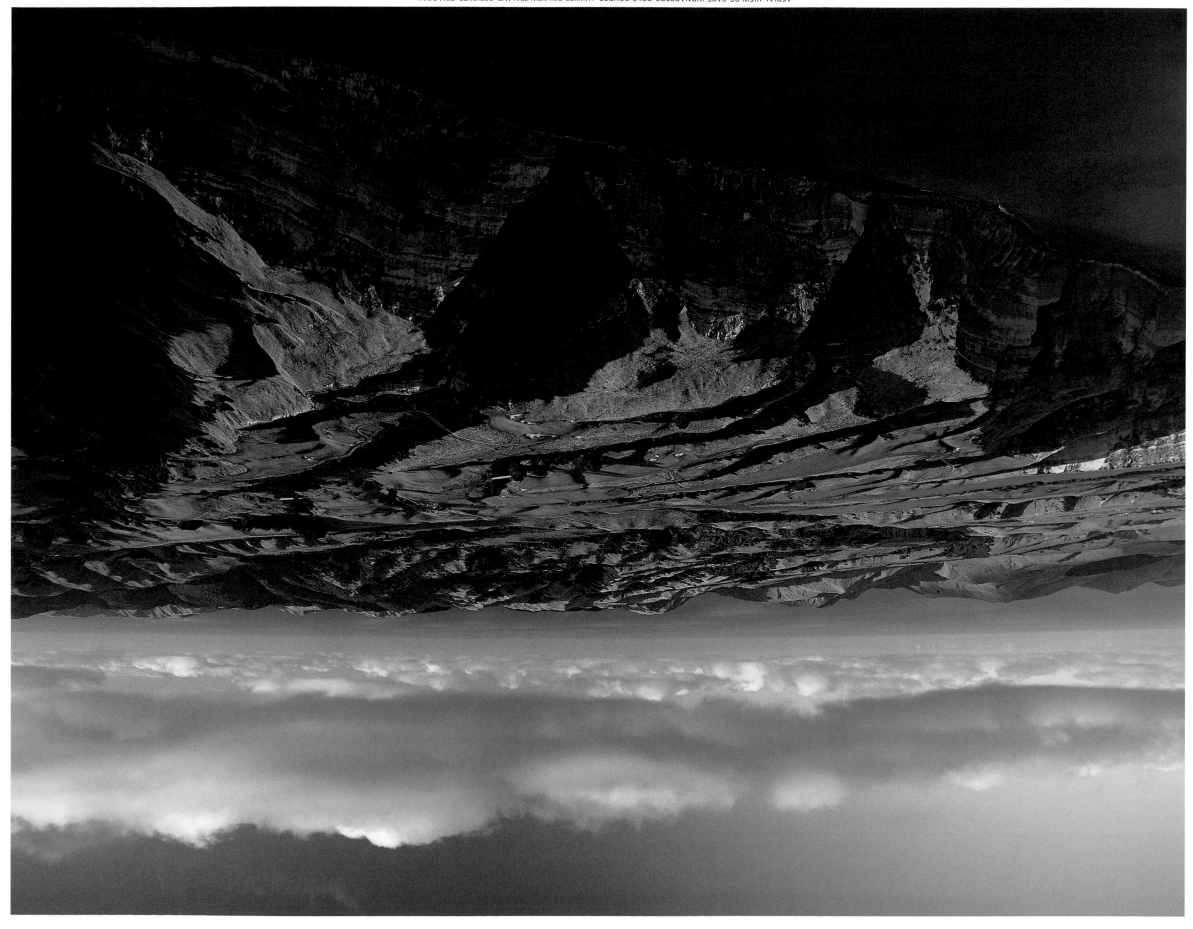

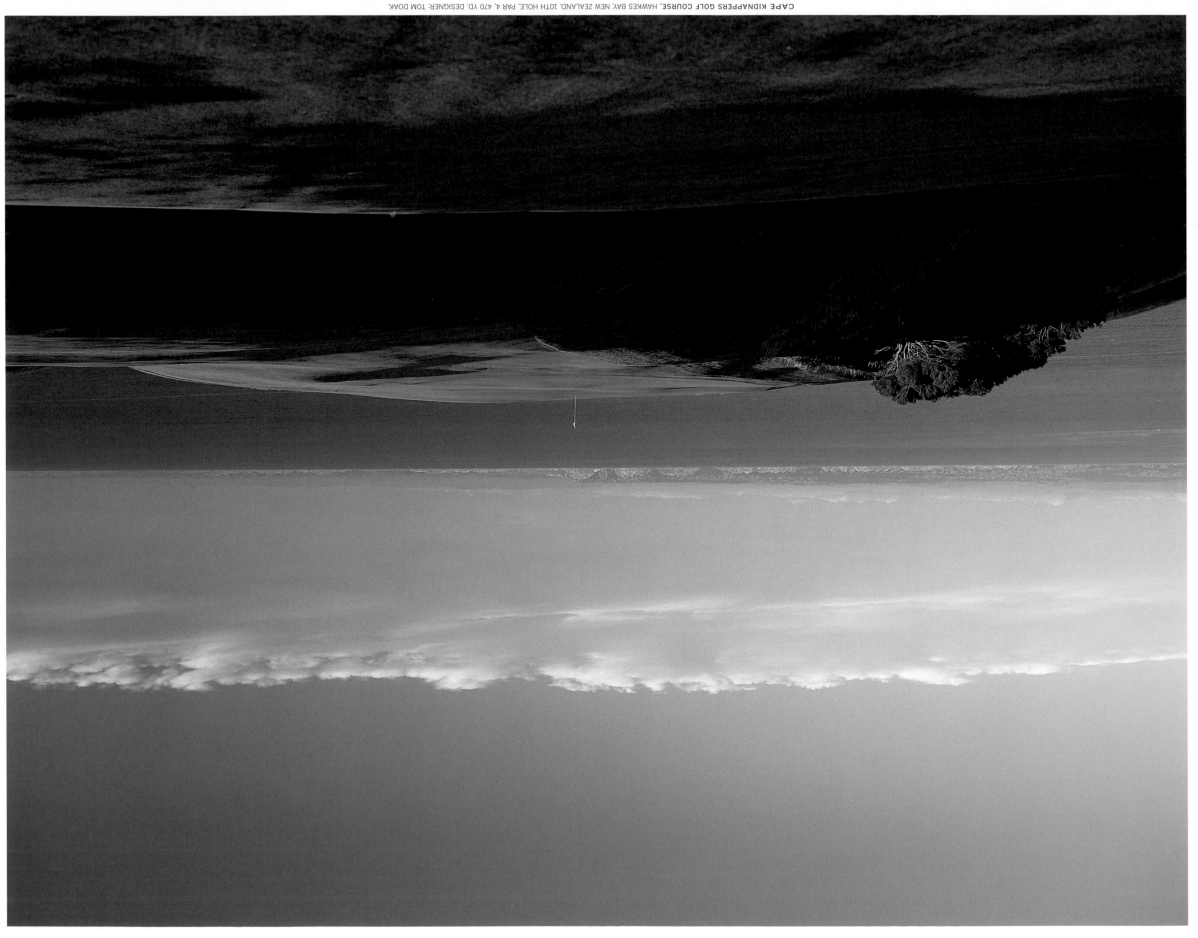

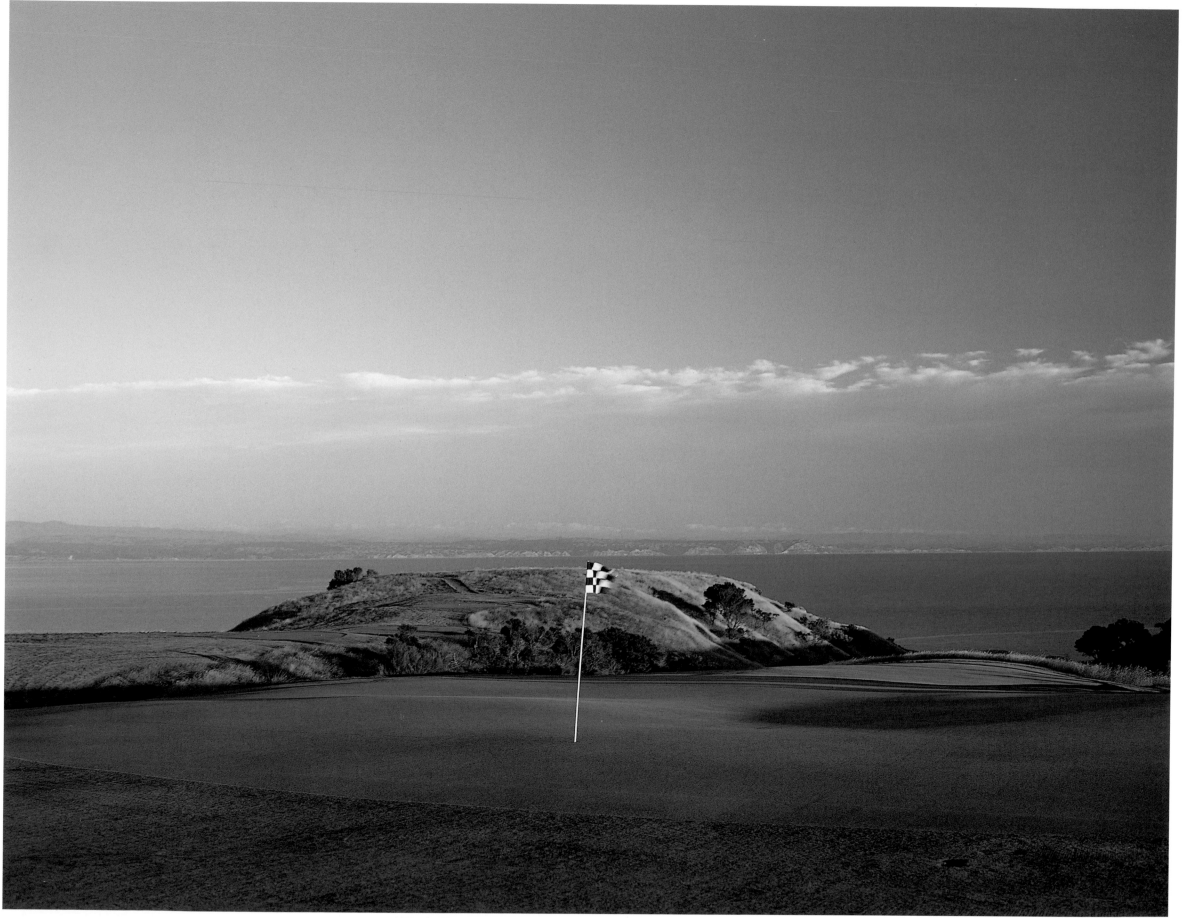

CAPE KIDNAPPERS GOLF COURSE, HAWKES BAY, NEW ZEALAND. 11TH HOLE, PAR 3, 224 YD. DESIGNER: TOM DOAK.

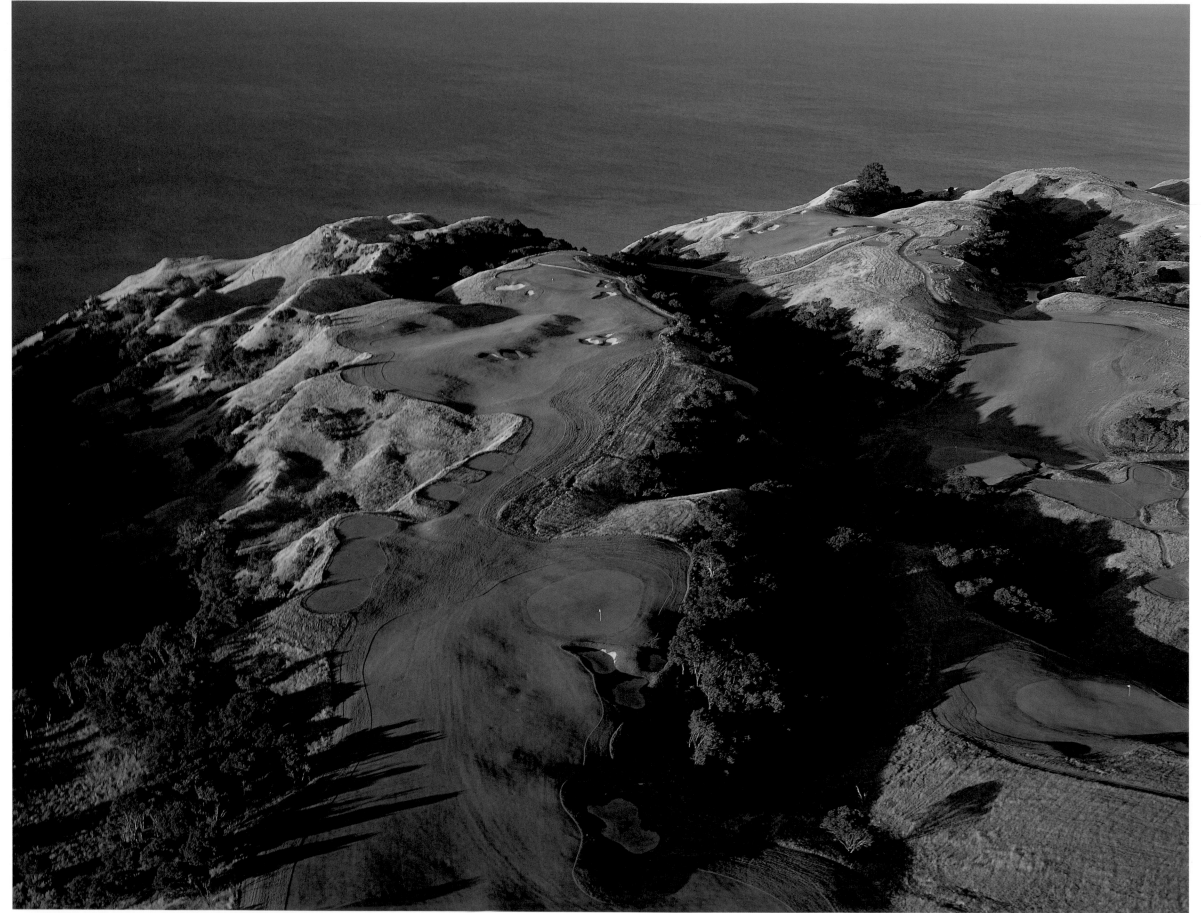

247

CAPE KIDNAPPERS GOLF COURSE, HAWKES BAY, NEW ZEALAND. AERIAL VIEW OF 4TH, 5TH, AND 6TH HOLES. DESIGNER: TOM DOAK.

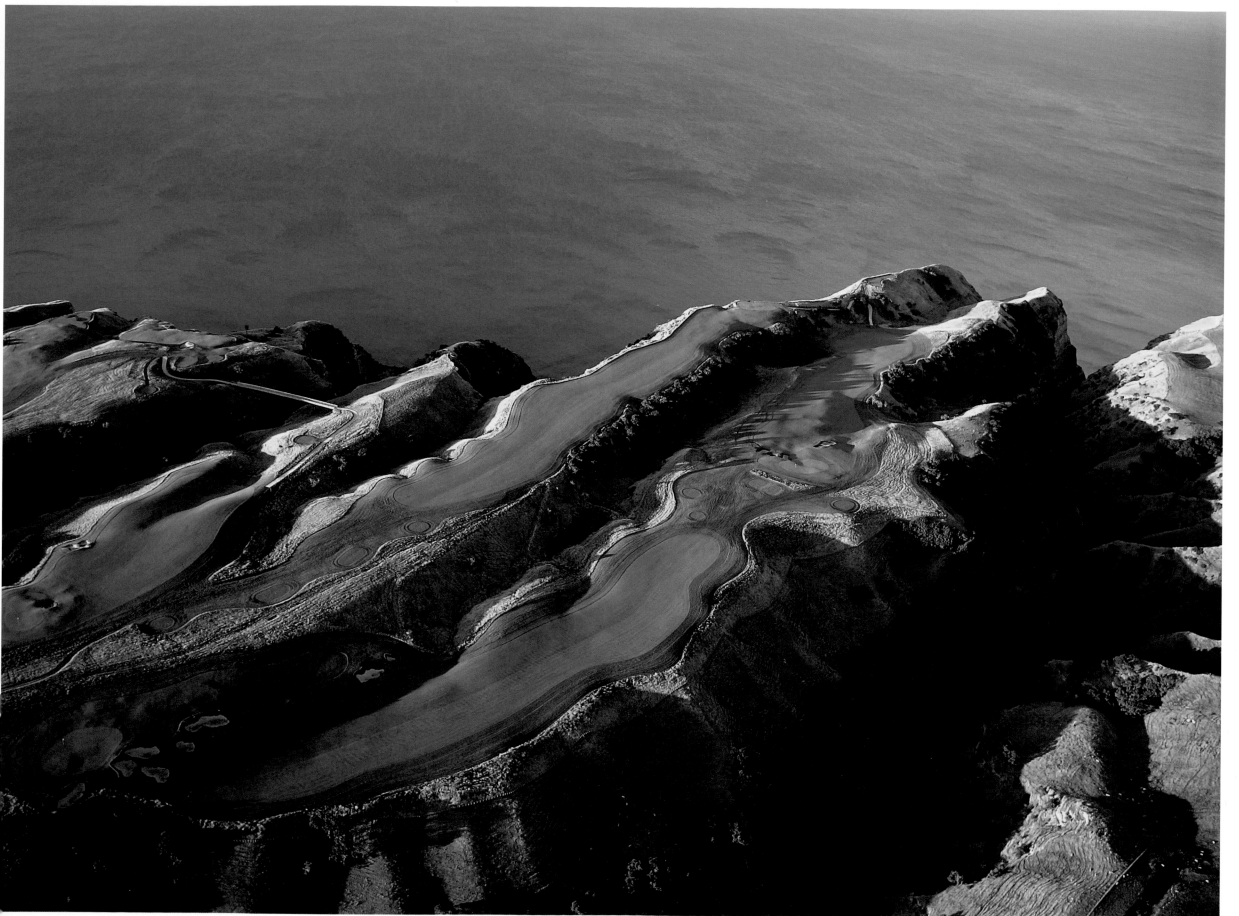

CAPE KIDNAPPERS GOLF COURSE, HAWKES BAY, NEW ZEALAND. AERIAL VIEW OF 13TH, 14TH, 15TH, 16TH, AND 17TH HOLES. DESIGNER: TOM DOAK.

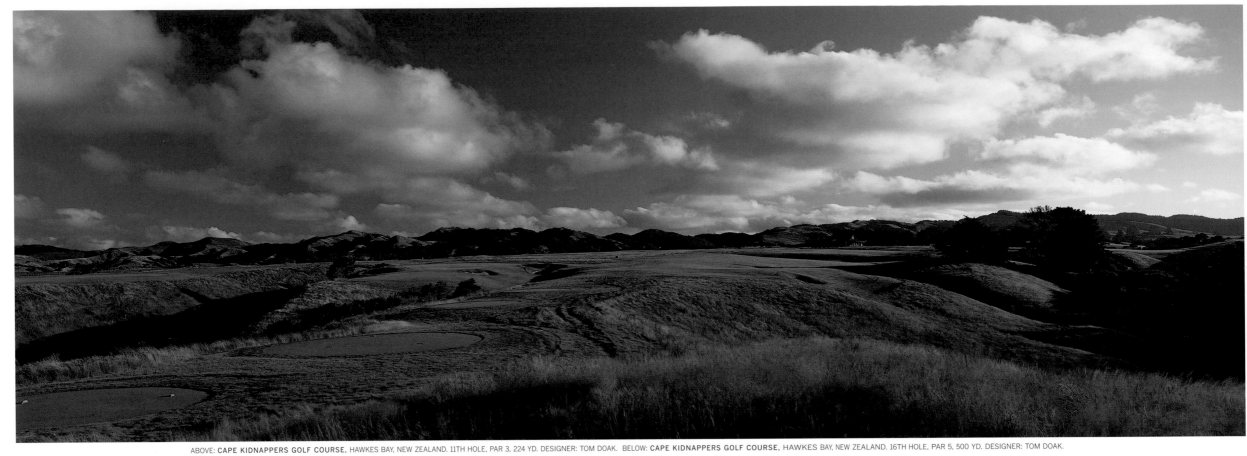

ABOVE: **CAPE KIDNAPPERS GOLF COURSE**, HAWKES BAY, NEW ZEALAND. 11TH HOLE, PAR 3, 224 YD. DESIGNER: TOM DOAK. BELOW: **CAPE KIDNAPPERS GOLF COURSE**, HAWKES BAY, NEW ZEALAND. 16TH HOLE, PAR 5, 500 YD. DESIGNER: TOM DOAK.

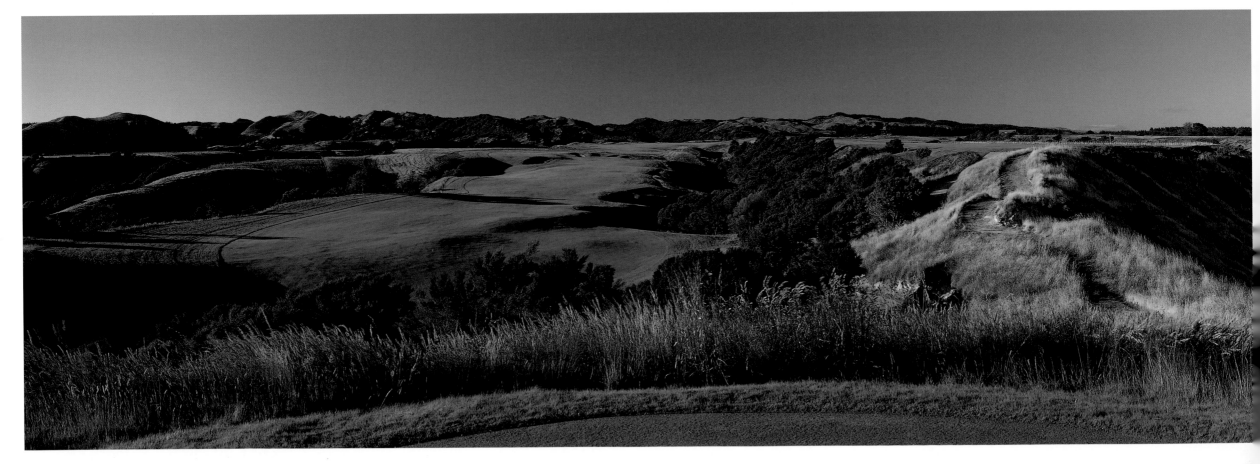

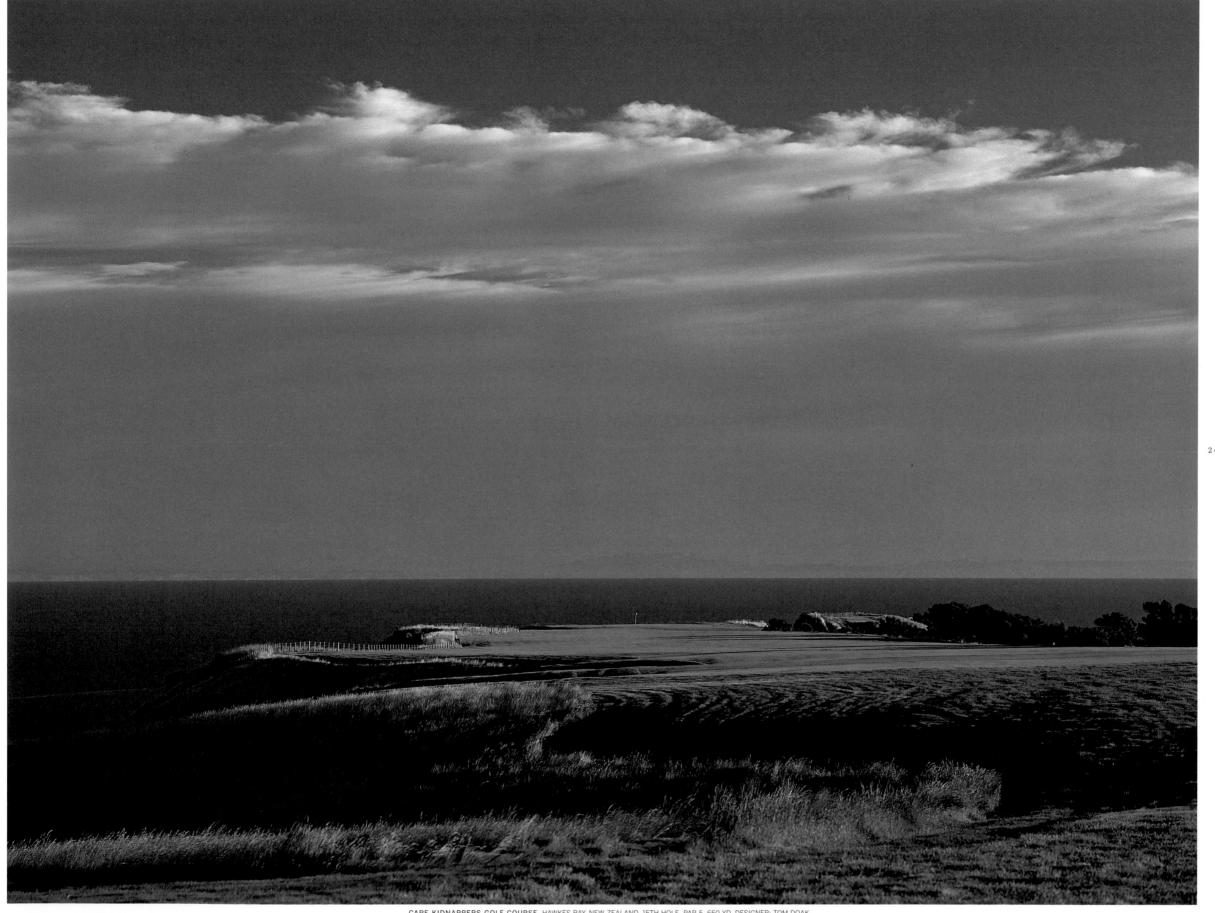

CAPE KIDNAPPERS GOLF COURSE, HAWKES BAY, NEW ZEALAND. 15TH HOLE, PAR 5, 650 YD. DESIGNER: TOM DOAK.

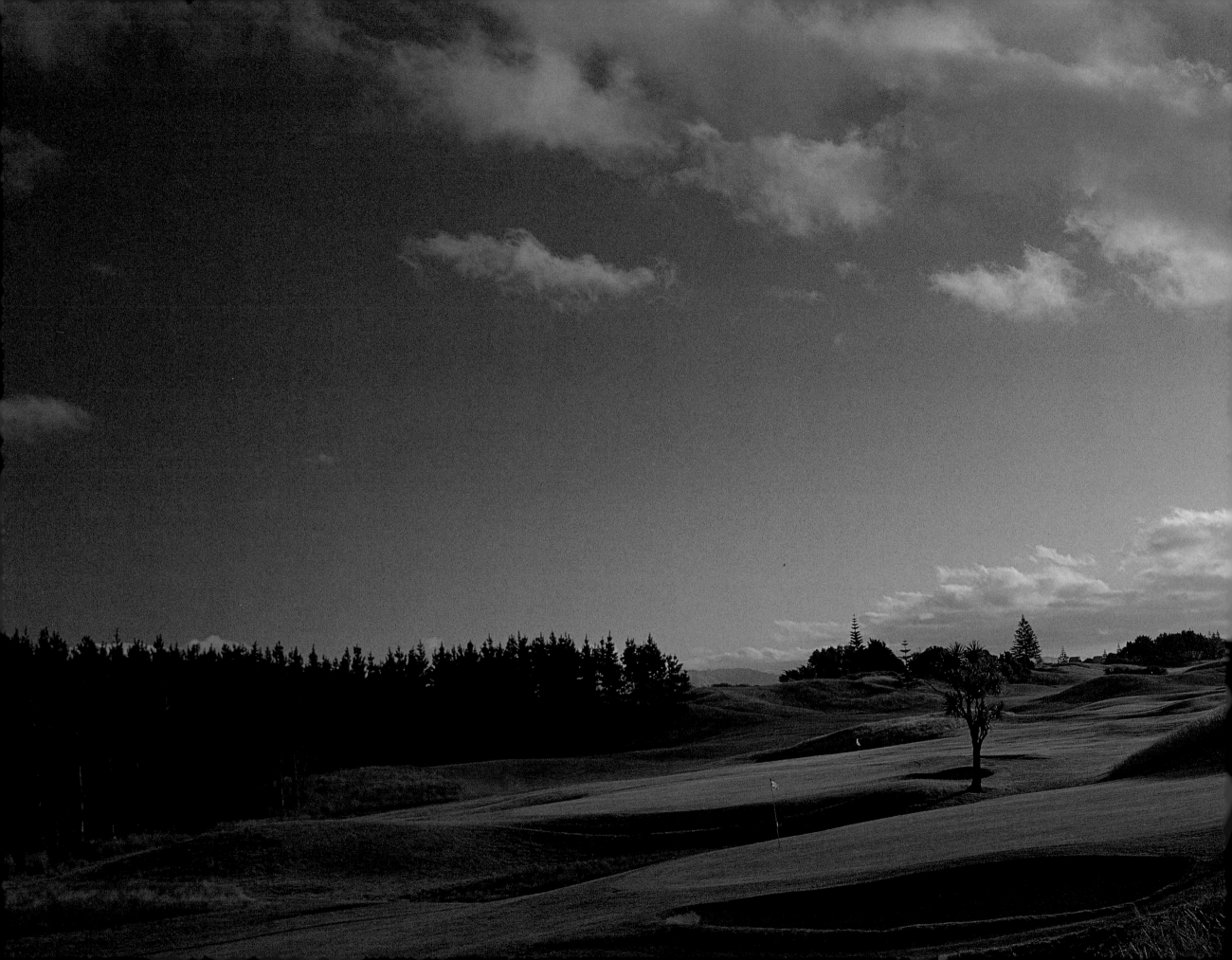

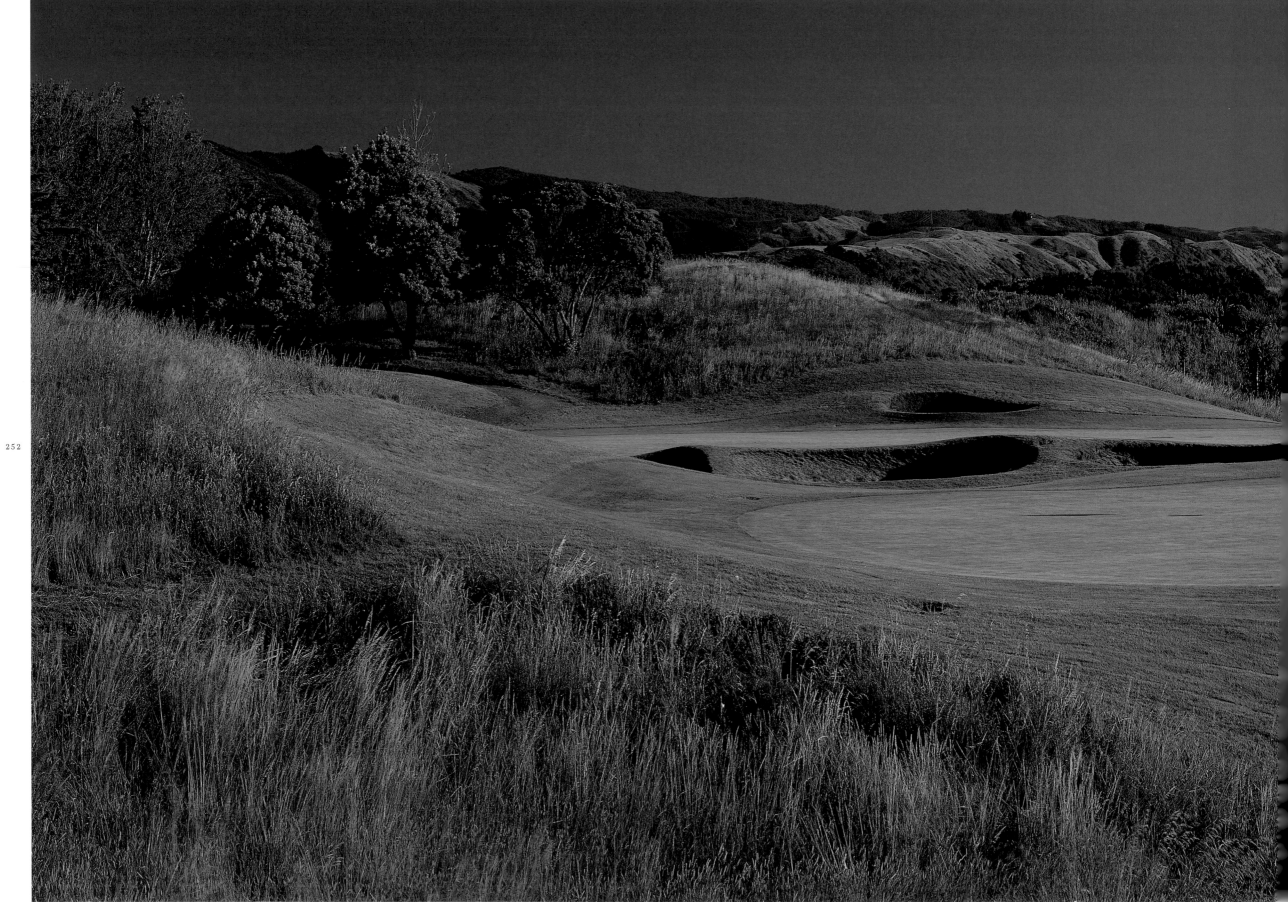

252

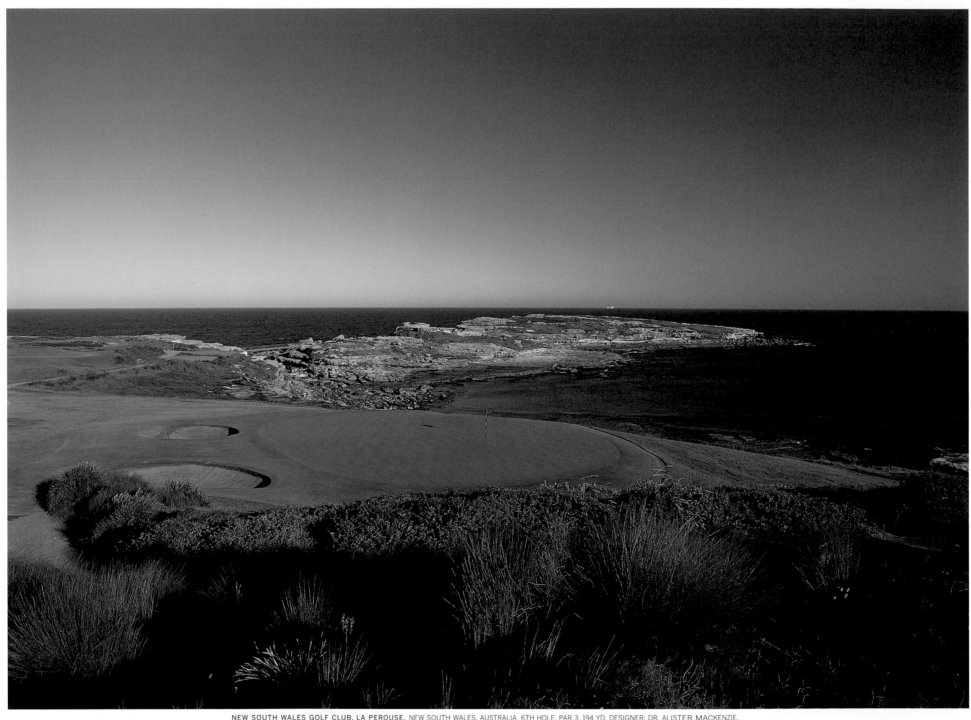

NEW SOUTH WALES GOLF CLUB, LA PEROUSE, NEW SOUTH WALES, AUSTRALIA. 6TH HOLE, PAR 3, 194 YD. DESIGNER: DR. ALISTER MACKENZIE.

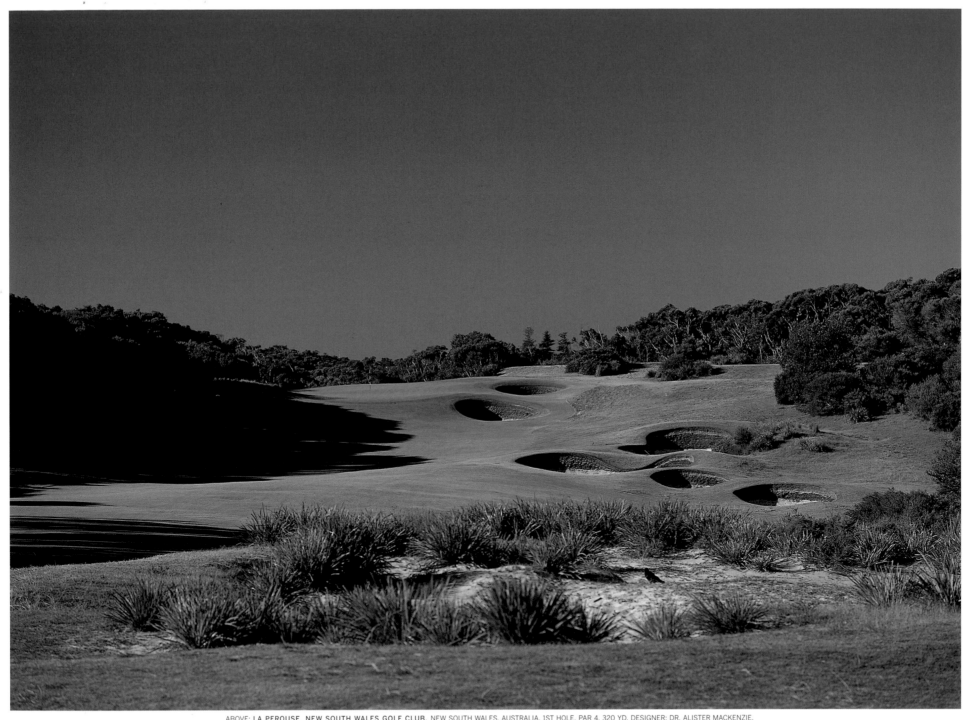

ABOVE: **LA PEROUSE, NEW SOUTH WALES GOLF CLUB,** NEW SOUTH WALES, AUSTRALIA. 1ST HOLE, PAR 4, 320 YD. DESIGNER: DR. ALISTER MACKENZIE.
FOLLOWING PAGES, 256–257: **LAKE KARRINYUP COUNTRY CLUB,** PERTH, WESTERN AUSTRALIA. 17TH HOLE, PAR 3, 200 YD. DESIGNER: ALEX RUSSELL.

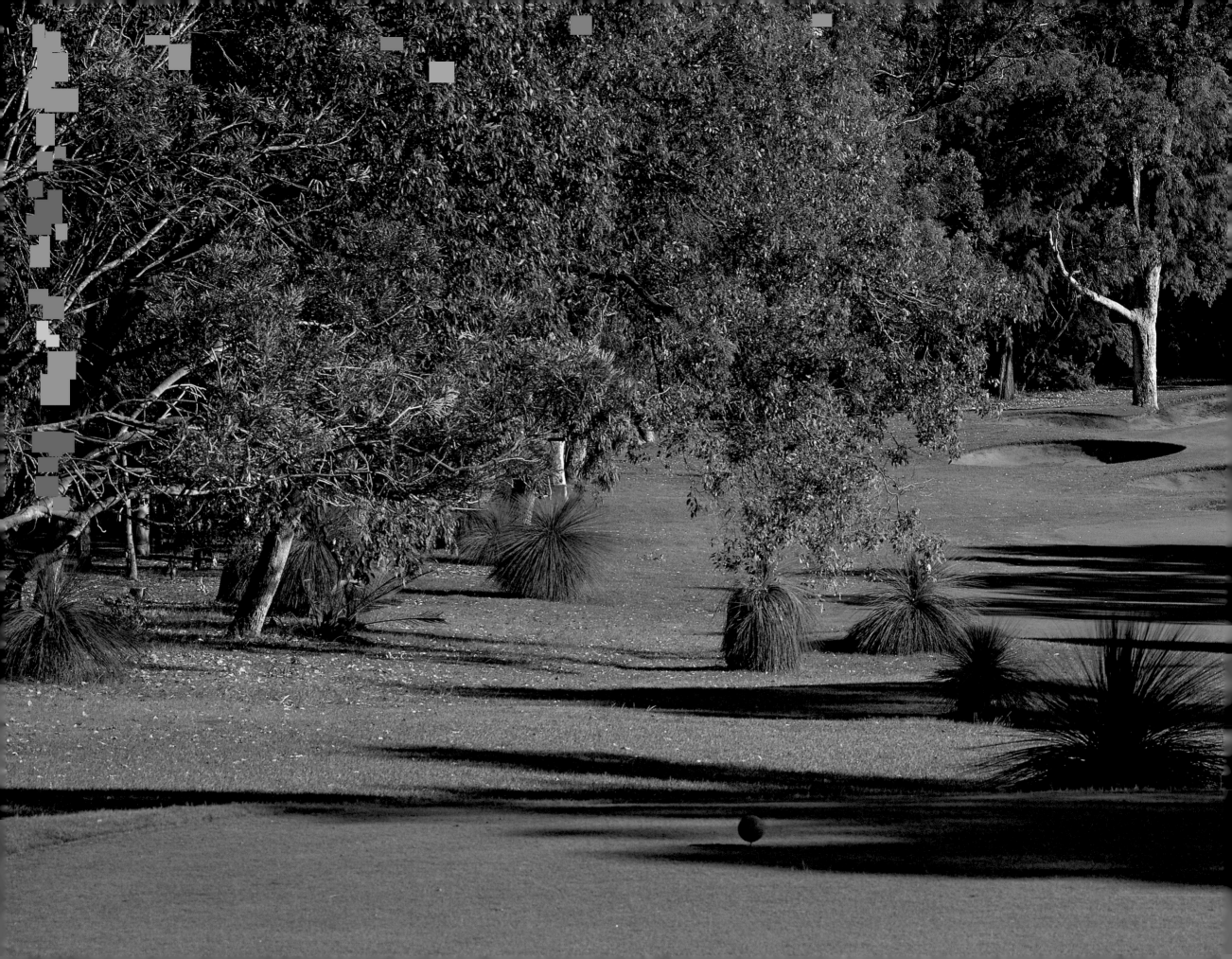

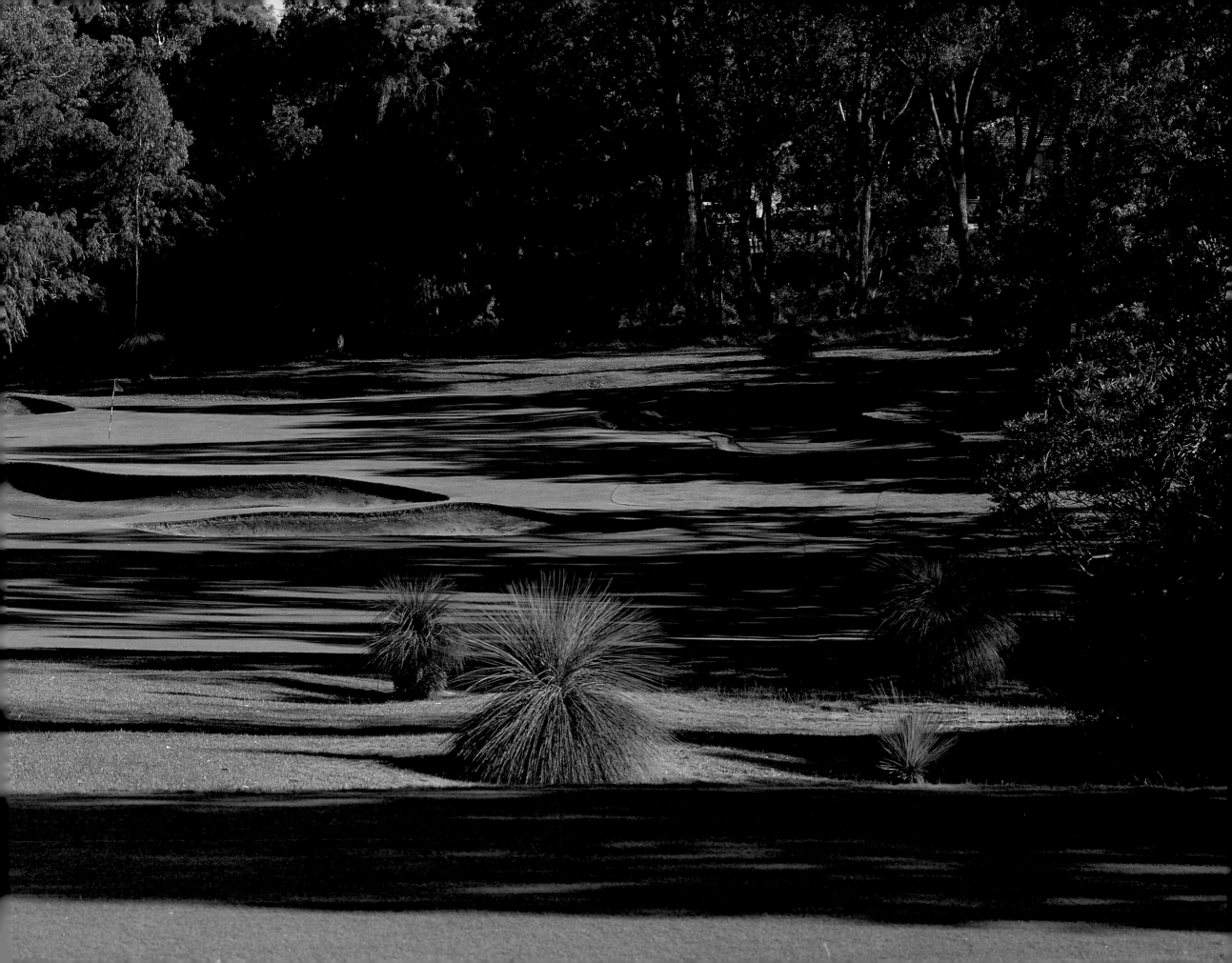

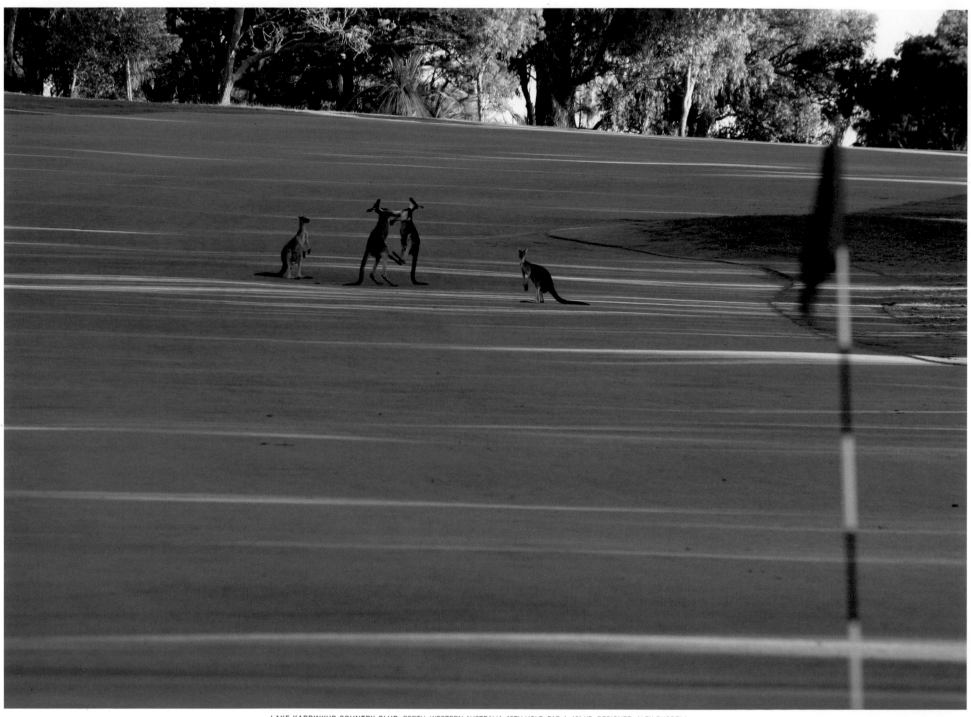

LAKE KARRINYUP COUNTRY CLUB, PERTH, WESTERN AUSTRALIA. 13TH HOLE, PAR 4, 421 YD. DESIGNER: ALEX RUSSELL.

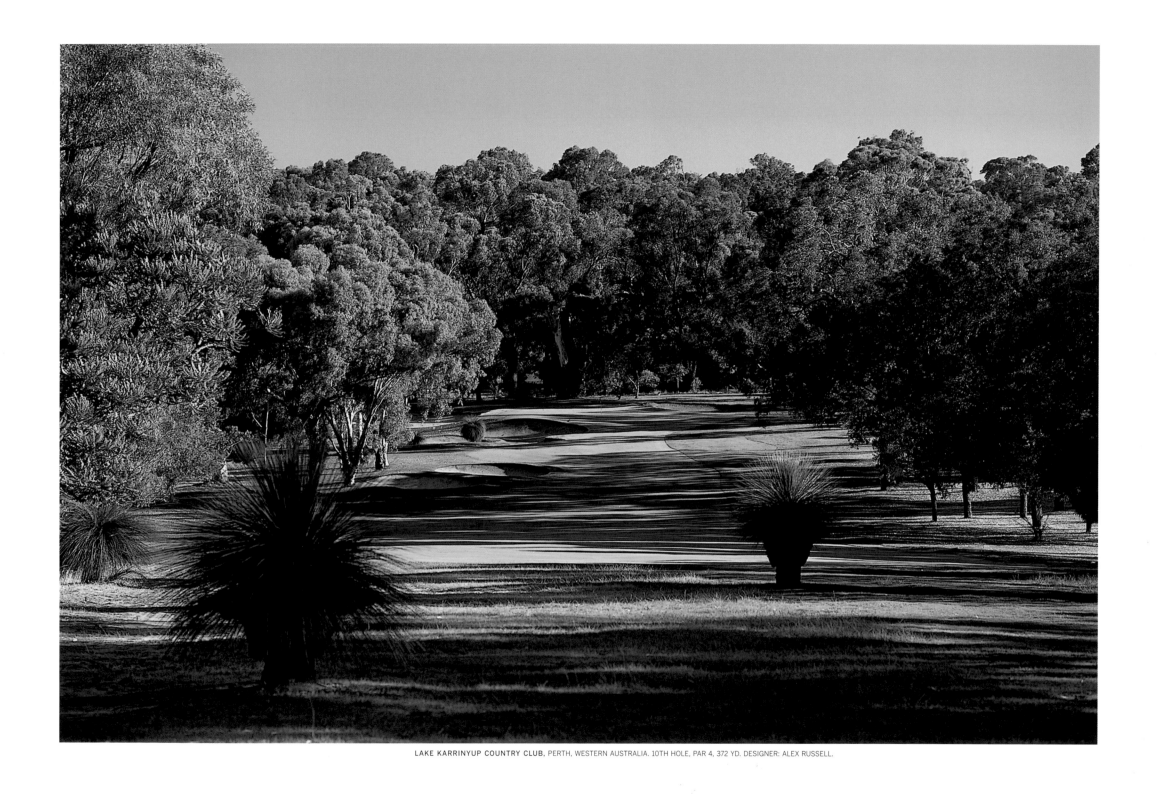

LAKE KARRINYUP COUNTRY CLUB, PERTH, WESTERN AUSTRALIA. 10TH HOLE, PAR 4, 372 YD. DESIGNER: ALEX RUSSELL.

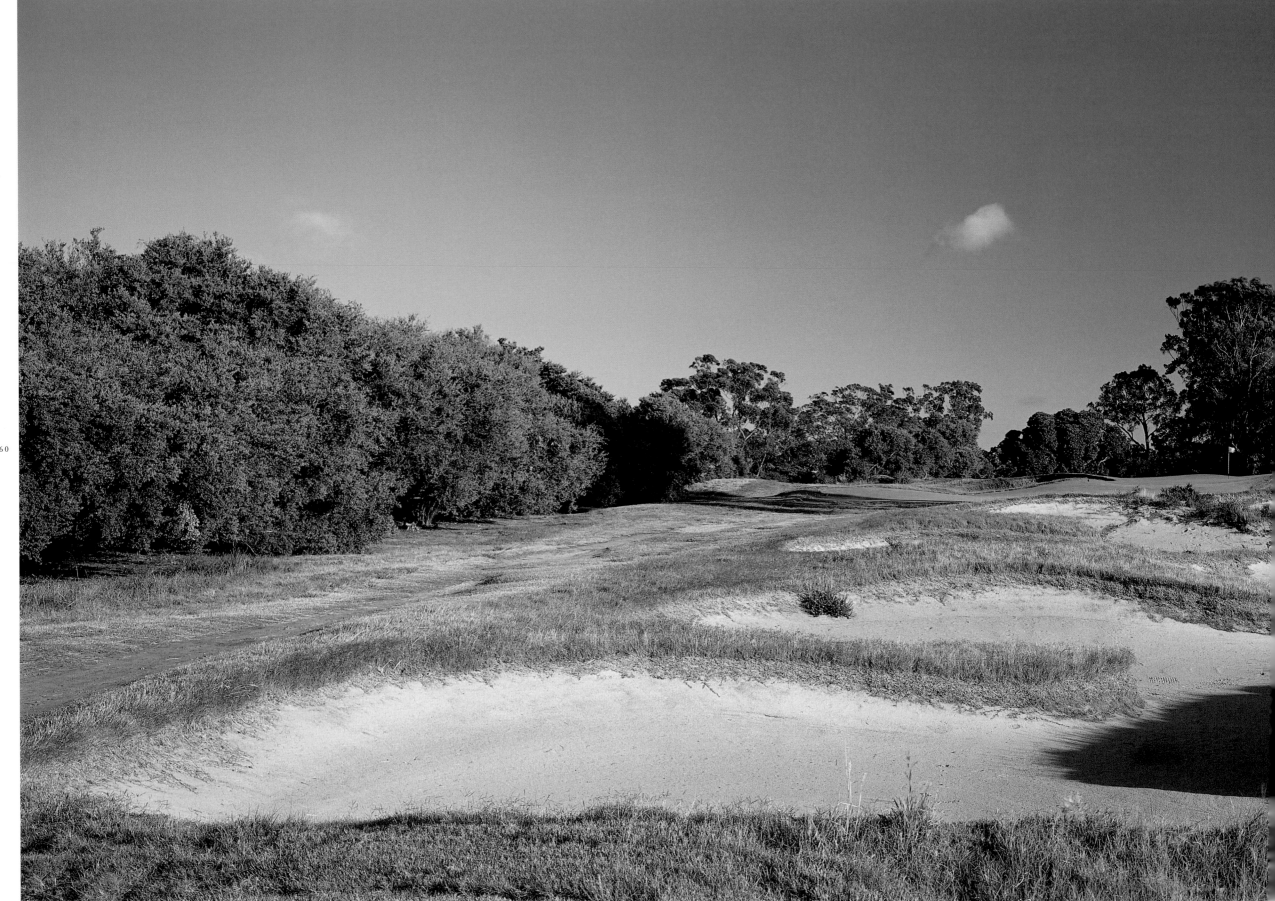

KINGSTON HEATH GOLF CLUB, CHELTENHAM, VICTORIA, AUSTRALIA. 15TH HOLE, PAR 3, 155 YD. DESIGNERS: DAN SOUTER, DR. ALISTER MACKENZIE.

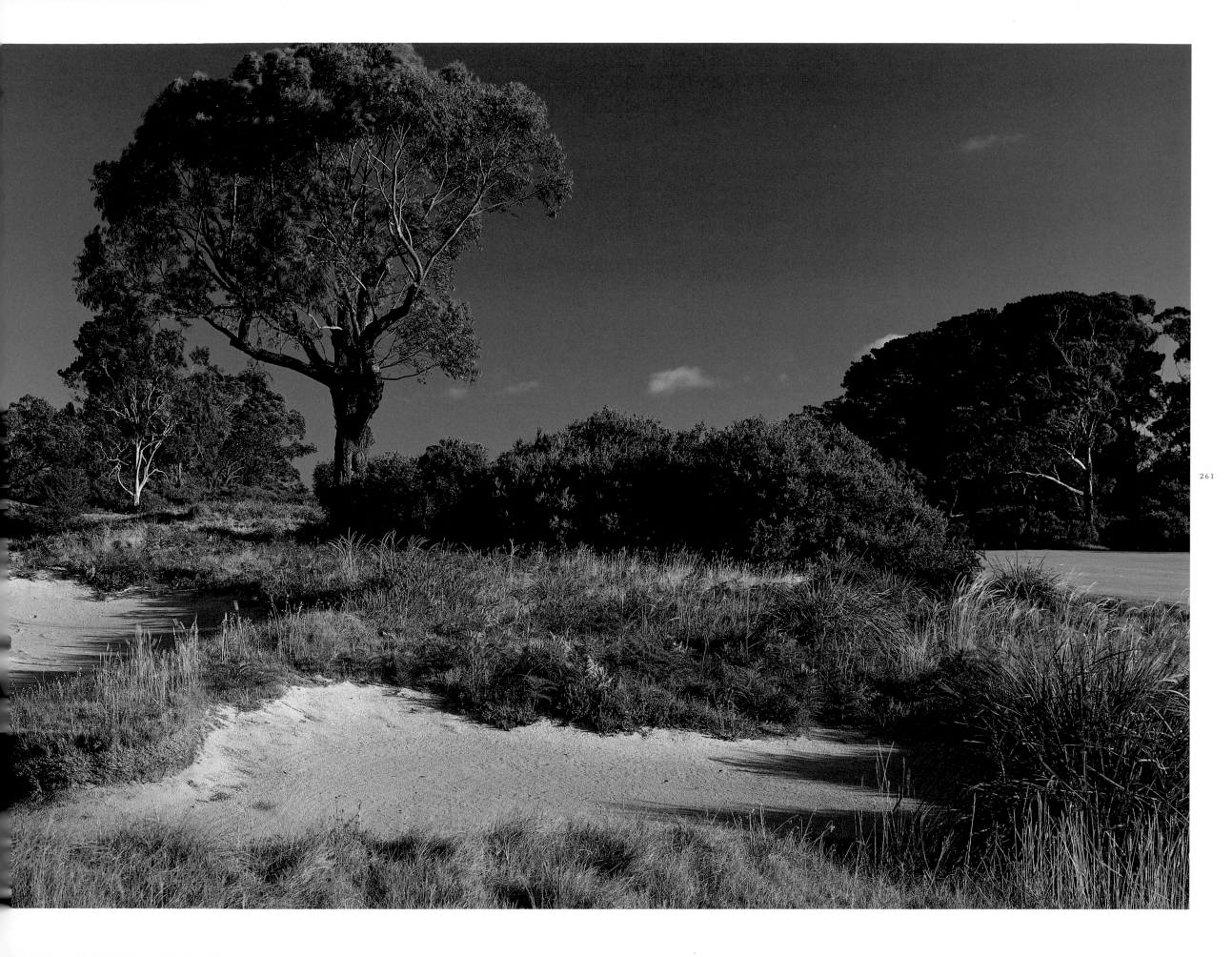

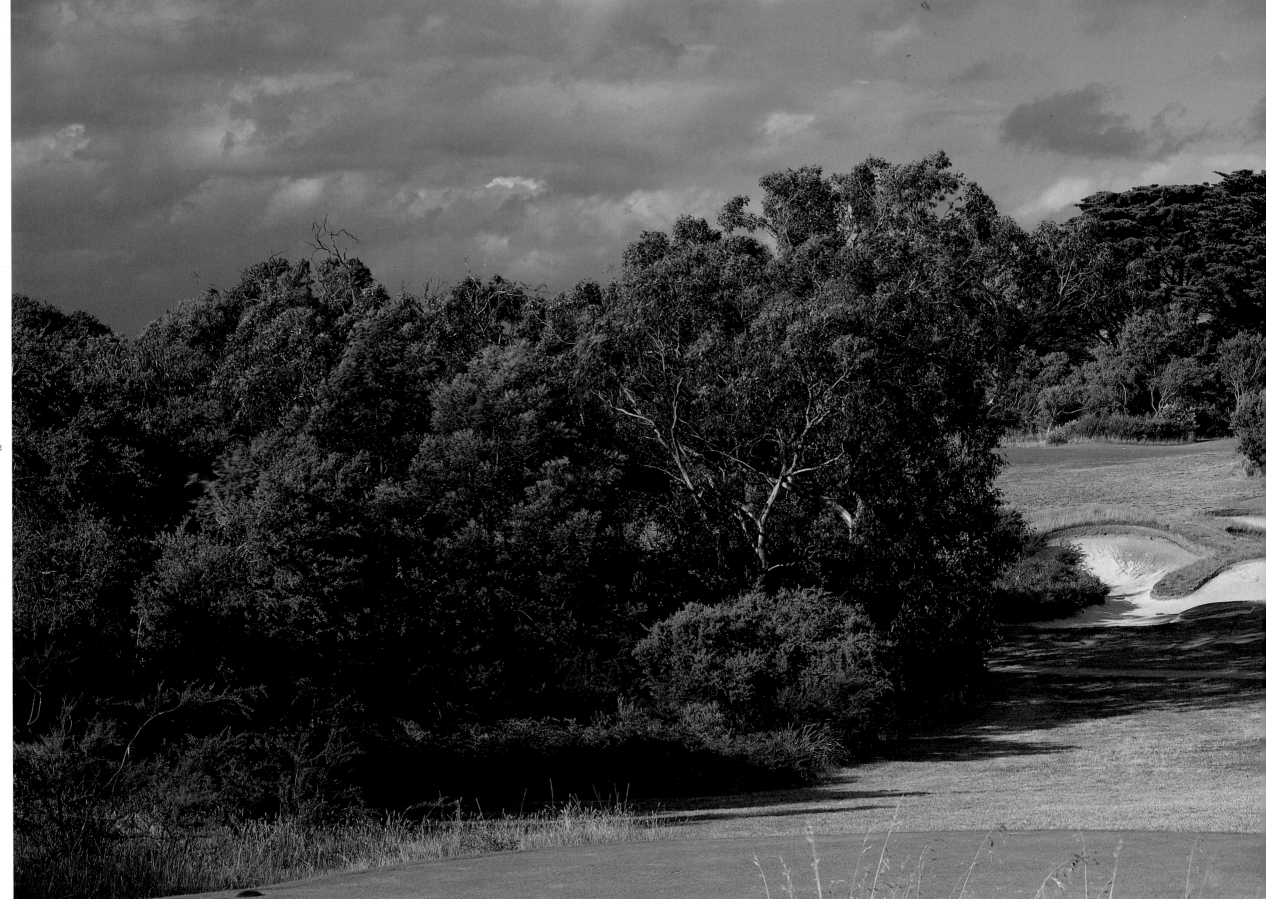

262

WEST COURSE, ROYAL MELBOURNE GOLF CLUB, MELBOURNE, VICTORIA, AUSTRALIA. 5TH HOLE, PAR 3, 165 YD. DESIGNER: DR. ALISTER MACKENZIE.

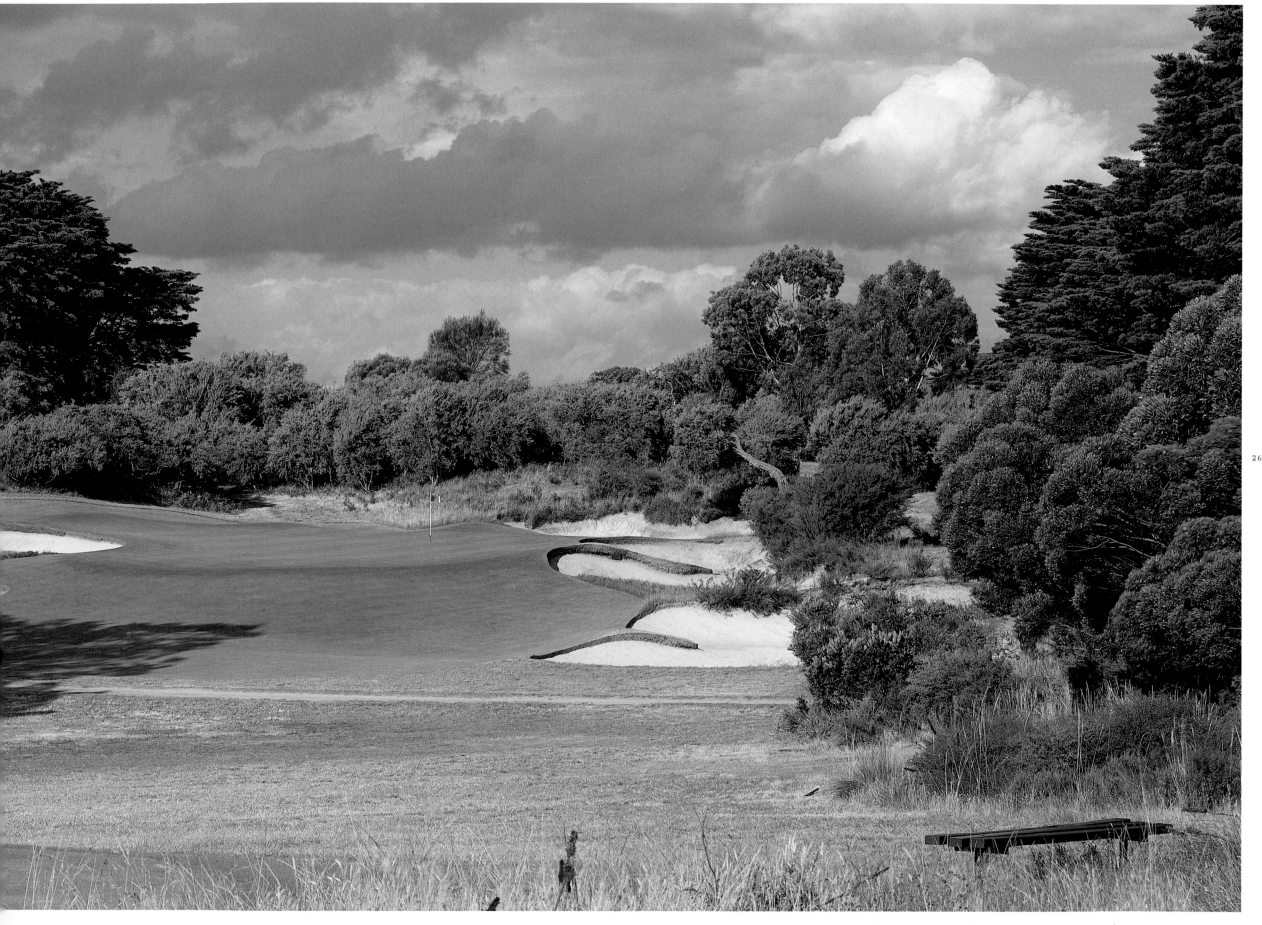

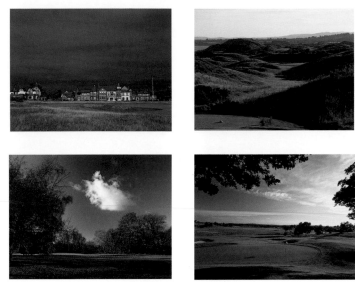

ACKNOWLEDGMENTS

Charles Miers; Jessica Fuller; Maria Pia Gramaglia, Production Department at Rizzoli; John Klotnia and
Brad Simon at Opto Design; Sir Michael Bonallack; Ernie Els; Steve Smyers; Gordon Simmonds, my lifeline to
information and to many of the wonderful courses in the book; Adrian Murrell and Lee Martin at Getty Images;
Travel Places, my long-suffering travel agent; Canon Cameras, UK; Graham Rutherford at Fuji Film, UK;
Genesis Photo Lab London.

Thanks to all the golf club owners, managers, secretaries, professionals, communication managers,
and anyone else who helped me along the way—there were so many.

And to the courses where I enjoy my golf as a member:

CLOCKWISE, FROM TOP LEFT:
ROYAL LIVERPOOL GOLF CLUB, HOYLAKE, ENGLAND.
EUROPEAN CLUB, BRITTAS BAY, IRELAND.
HAYWARDS HEATH GOLF CLUB, HAYWARDS HEATH, ENGLAND.
EAST SUSSEX NATIONAL GOLF CLUB, EAST COURSE, UCKFIELD, ENGLAND.